How to Digitize Video

NELS JOHNSON
WITH **FRED GAULT** AND **MARK FLORENCE**
SAN FRANCISCO CANYON COMPANY

John Wiley & Sons, Inc.
New York • Chichester • Brisbane • Toronto • Singapore

To Cathie, who remained in Sacramento

This text is printed on acid-free paper.

Words in this publication in which the Author and Publisher believe trademark or other proprietary rights may exist have been designated as such by use of Initial Capital Letters. However, in so designating or failing to designate such words, neither the Author nor the Publisher intends to express any judgment on the validity or legal status of any proprietary right that may be claimed in the words.

This publication is designed to provide accurate and authoritative information in regard to the subject matter covered. It is sold with the understanding that the publisher is not engaged in rendering legal, accounting, or other professional service. If legal advice or other expert assistance is required, the services of a competent professional person should be sought. FROM A DECLARATION OF PRINCIPLES JOINTLY ADOPTED BY A COMMITTEE OF THE AMERICAN BAR ASSOCIATION AND A COMMITTEE OF PUBLISHERS.

Copyright © 1994 by San Francisco Canyon Company.

Published by John Wiley & Sons, Inc.

All rights reserved. Published simultaneously in Canada

Reproduction or translation of any part of this work beyond that permitted by section 107 or 108 of the 1976 United States Copyright Act without the written permission of the copyright owner is unlawful. Requests for permission or further information should be addressed to the Permissions Department, John Wiley & Sons, Inc.

Library of Congress Cataloging-in-Publication Data

How to digitize video / by the San Francisco Canyon Company : edited
 by Keith Weiskamp.
 p. cm.
 Includes biographicsl references andindex.
 ISBN 0-471-01440-0 (paper with CD-ROM)
 1. Motion pictures--Editing--Data processing. 2. Video tapes--Editing--Data processing. I. Weiskamp, Keith. II. San Francisco Canyon Company.
 TR899.H69 1994
 778.596--dc20 94-3149

Printed in the United States of America

10 9 8 7 6 5 4 3

Table of Contents

Introduction — xi
How This Book Is Organized xii
The CD-ROM xiv
Acknowledgments xvi

1 Setting the Context — 1
Sharpening the Focus 2
Forging a New Way to Communicate 4
Contrasting Two Worlds 5
Redefining Video/Viewer Interaction 7
Letting Personal Computers Run the Show 8
Confirming the Vehicle 11
Weathering the Changes 12

2 Pushing the Envelope — 15
Quantity Is Job One 16
The M Word 18
Multimedia Is Dead! Long Live Multimedia! 22
Identifying Our Standards 25
Mountains of Data 26
Get Out Your Calculator 28
Spinning the Bottlenecks 30
Lowered Expectations 31
The Acid Test 32
Beyond Bandwidth 33
A Question of Balance 35

3 Predicting the Present — 37
What Desktop Video Really Costs 39
How Much Time Do You Need? 44

New Maps of Hell 47
You Must Take It with You 47
Compact Discs: The Devil You Know 49
Industry Players 51
Who's Going to Get Sued? 52

4 Understanding the Meta System · 55

New and Improved Bottlenecks 56
Hidden Assets 57
The Core System 59

5 Macintosh Systems · 69

Fewer Bucks for the Bang 71
Bring Out Your Dead 73
Beyond Here Lie Monsters 74
System Tuning 75

6 Mac Capture Cards · 77

The Holy Trinity 78
SuperMac Digital Film 80
Radius Video Vision 82
RasterOps Editing Aces Suite 84
New Video EyeQ 2.0 85
SuperMac Video Spigot 87
Sigma Designs Movie Movie 88

7 PC Systems · 91

Naming Your Poison 92
Express, Local, and Magic Buses 93
Working on the SCSI Chain Gang 96
Retrofitting Your PC 97
Audio and Video Peripherals 98
Tuning Your System 99

8 PC Capture Cards — 101
A Different World 101
Intel Smart Video Recorder 103
Media Vision Pro MovieStudio 104
Creative Labs Video Spigot for Windows 105
Creative Labs Video Blaster 106
VideoLogic Captivator 107
Sigma Designs WinMovie 109

9 Mass Storage Devices — 111
Hitting the Big Time 112
SCSI Standards 113
SCSI System Tuning 120
Inter-Platform Benefits 122
Hard Drives 123
Hard Disk Arrays 124
Virtual Luggage Racks 125
Soon They Will Be Folding Space 129
Networks 130

10 Using Desktop Video Software — 131
Windows-Based Software 132
Mac-Based Software 144

11 Video Hardware Standards — 159
Getting the Right Perspective 160
Simplifying the Issues 161
Tape Standards 162
Video Signal Standards 166
Broadcast Standards 168
Time Code Standards 171
Edit Control Protocols 174
The Ten Commandments of Hi-8 Videotape Management 179

12 VCRs, Cameras, and Laser Disc Players — 183

Video Tape Decks 184
Video Cameras 196
Laser Disc Players 205
 High Production Values 205

13 Audio Hardware Standards — 209

Audio Standards on Video Equipment 210
Analog Audio on the Mac and PC 218
 Analog Audio on the Macintosh 219
 Analog Audio on the PC 221

14 Solving Analog Video Problems — 225

Time Base Correction 226
Dropout Problems 228
Other Gray Areas 229
What Is Nonlinear Editing? 231
How to Shoot Video for Digitization 233

15 How PCs Digitize Video — 235

Meta System Redux 236
What the Capture Card Does 236
What the CPU and Hard Drive Do 244
 Data Transfer Management 245
 Encoder Execution 247
Bottlenecks Revisited 248

16 Movie File Formats — 249

The QuickTime File Format 250
The Video for Windows File Format 260
Sound Encoding Formats 266
 Interleaved Audio and Video 268
How to Read and Write AVI Movie Files 269
Which File Format Is Better? 271

17 Movie Compressor Types — 273

Audio Compression 274
The QuickTime Codecs 275
The Video for Windows Codecs 280
The QuickTime for Windows Decompressors 284
Other Codecs 284
Decompressor Selection at Playback Time 285

18 The Mechanics of Movie Playback — 289

Composition of a Movie Data Stream 290
The Assembly Line Perspective 291
What Key Frames Are 292
What Frame Differencing Is 294
A Movie with a Difference 296
Components and Data Handlers 298

19 Test Driving Windows and Mac Systems — 305

A Basic Video for Windows Capture 306
A Basic Macintosh Capture 312

20 Exploring Frame Rates and Sizes — 317

Observing Frame Rate Differences 318
Framing a Perspective 319
Choosing the Best Frame Rate 320
Increasing the Frame Rate 321
The Milli Vanilli Factor 322
Observing Frame Size Differences 322
Choosing the Best Frame Size 324

21 Exploring Image and Audio Quality — 327

Observing Movies with Different Color Depths 328
Observing Movies with Different Quality Settings 330
Choosing the Best Color Depth and Image Quality 333
Observing Audio Quality Differences 336
Choosing the Best Audio Quality 338

22 Developing Capture Strategies — 339

How Platforms Determine Capture Environments 340
 Mac Envy Lives 341
On-the-Fly versus Frame-Accurate Digitization 342
The Value of Preliminary Captures 347
15 Steps to Better Movies 348

23 Fixing Fresh and Damaged Movies — 353

Cleaning Up Fresh Captures on the Mac 354
 Real Digitizers Don't Use Premiere 355
Repairing Damaged Captures on the Mac 357
Cleaning Up Fresh Captures Under Windows 360
 Real Digitizers Don't Use Premiere for Windows, Either 360
Repairing Damaged Captures under Windows 361
 Fixing Problems in QuickTime for Windows Movies 362

24 Using MovieShop and MovieAnalyzer — 363

Using MovieShop 364
Using MovieAnalyzer 378
Using ComboWalker 380
A Few Words from George Cossey 381

25 Making Movies Look and Sound Better — 383

Separating Technical and Aesthetic Issues 384
Making Movies Look Better on the Mac 385
Making Movies Sound Better on the Mac 390
Making Movies Look Better on the PC 392
Making Movies Sound Better on the PC 395

26 Talking with Developers — 397

About Eden Interactive's Project 398
Remaining Faithful to Analog Sources 399
Working On the Bleeding Edge 401
Is an Analog Background Necessary? 402
How Much Effort Is Required? 404
The Importance of Audio 406
Looking Forward 407
About Critical Path 409
Desktop Video Hurdles 410
Your Papers, Please 412
The Role of the Camcorder 413
Talking Shop 415

27 Mastering a CD-ROM — 419

Understanding Cross-Platform Playability Issues 420
Using a CD-ROM Burner 427
Creating a CD-ROM Production Timeline 429

28 Setting Up a Production Studio — 433

Basic Studio Setup 434
 Practical Tips 434
 Technical Tips 435
 Using the Meta System 436

Assembling a Mac Studio 436
 Computer Equipment 437
 Movie Making Software 437
 Video Equipment 437
 Miscellaneous Equipment 438
 Wiring Things Together 439
Assembling a PC Studio 440
 Computer Equipment 440
 Movie Making Software 441
 Video Equipment 441
 Miscellaneous Equipment 441
 Wiring Things Together 441

Glossary 443

Suggested Reading List 451

QuickTime 451
Multimedia Production 451
Windows Multimedia Production 452
Visual Design/Interface Design 452
Directories 453
Miscellaneous 453
Magazine Articles 453

Index 455

Introduction

This book is about making movies on personal computers—and enjoying it in the process. It is not a product roundup or a promotional document on multimedia. We have developed some of the software that drives this emerging industry, and have run it on most of the current hardware. We have also published several CD-ROMs, including the first commercial QuickTime for Windows product. Titled *Canyon Clipz*, it is full of old movie clips and music videos that we digitized, and is playable on both the PC and Macintosh.

You do not need to be a programmer or a video technician to understand the material we'll present. While professional video editors might figure out right where to look for information on certain issues or techniques we discuss, our only prerequisite is that you are an experienced computer user interested in getting video in and out of your Mac or PC. If you are excited about making desktop video movies, we believe you'll find this book extremely valuable.

But first, let's be realistic. For the average consumer, the movies being made now with a personal computer do not fill a monitor or look just like television. (You can do this with special hardware, but people who will watch your movies play on normal computers probably cannot.) Because of the current state of the technology, desktop video movies generally play in smaller windows and at frame rates less than analog video or film.

More importantly, the best desktop videos aren't merely the result of digitizing good-quality source material (although it helps greatly). Each successful desktop video production is a delicate balance of frame rate, window size, image clarity, sound resolution, and compressor choice. Furthermore, each production is different and there are few, if any, standards to guide you—which is one of the main reasons we wrote this book.

Fortunately, you can make compelling, sophisticated desktop videos with surprising sound quality with the tools currently available for Microsoft Windows-based PCs and Apple Macintoshes (there are other desktop platforms that handle video,

but this book does not address them). More importantly, learning the tools and strategies now for creating professional productions will give you the skills and knowledge required for when full-screen desktop video becomes the broadcast quality standard. Which is going to be soon.

This book will provide you with a reliable, field-tested distillation of the systems and approaches now in use (and on the horizon) for capturing analog video from a camera, VCR, or professional video deck to a digital format stored on a desktop computer. Editing captured material and adding special effects are also covered, but the principal focus is digitization.

As with any new enabling technology, the first crop of players has rushed in, staked out its territory, and strained its credibility—you can do most of the things advertised, and some only in certain ways. Working under these conditions, this book will make assertions about how best to accomplish particular tasks, solve specific problems, and achieve desired results, all of which will be supported by sample sequences on the companion CD-ROM. Where a single best solution cannot be established, we'll provide you with various alternatives, along with an explanation of the trade-offs involved.

To make the best looking and sounding movies possible, you need to start with the highest quality video source possible—ideally, tape that you've shot with digital in mind. We'll show you how to calibrate your tools as well as provide techniques that will help you get the best results in less-than-ideal conditions.

Even if you have no control over the source quality, much of your approach to digitization will still be highly quantifiable. In other words, if you are working on a production that must incorporate video footage never intended for digitization, we will show you ways to produce desktop movies from it without doubting whether, say, frame rate should take precedence over image clarity, or wondering if image clarity should have priority over sound quality. It is essentially a juggling act, and this book will help you sort it out.

How This Book Is Organized

We have divided the book into three parts. Depending on your needs, each part can be used on a standalone basis. First, we build a broad perspective by answering the question, *why digital video?* This question might seem rhetorical—and it does pursue a very fast-moving target—but it has a concrete answer that will provide you with a context for the rest of the overview. If you are a teacher,

consultant, corporate planner, or are just interested in learning about producing digital videos, we're sure you will find this section of interest.

Second, we talk about assembling systems capable of creating professional-quality desktop movies. We begin by describing a completely generic set of components, so you can see what each one is supposed to do. We then recast it on real platforms with specific components. As we mentioned earlier, this is not a product survey. As fast as this technology is evolving, if it was, our book would be outdated by the time it was published.

Instead, we create a *meta system* with placeholders for equipment (hardware and software) that performs specific functions. We then review the best products on the market as candidates for filling those positions. If you are a producer ready to exhaust a budget for such equipment, this section will help serve as your shopping list. If you need to know where the strong and weak performance links are in typical systems and how to work around them if necessary, this section will be valuable to you.

Finally, we get into digitizing. We'll assume you have covered the first two sections and are now ready to make some noise. This section will help you to avoid the many rat holes and land mines that come with digitizing video. If you have made the investment necessary to digitize professional-quality desktop movies, you'll do well to learn from our mistakes. It is actually possible to spend days chasing down certain types of problems only to find out the solution lies ninety degrees in another direction or can be achieved with a single piece of equipment available at Radio Shack. The CD-ROM included with this book contains example clips you can use to help you to understand the techniques we offer in this section.

Taken together, the three parts of this book will guide you forward down the path from skeptical trend observer to being a dedicated desktop video cutter. If you have taken the trouble to buy this book or even browse this preface, you are already on your way. We are convinced you will find it is a course worth pursuing.

Digital is winning and pulling even further ahead. It is clearly the growing pains that precipitate the tedious arguments about digital's viability (remember the debates between audio CDs and vinyl records?). Analog is still viable for the passive enjoyment of audio and video media, at least for the time being, but if you want to get into things like non-linear editing, navigable movies, and digital manipulation of images, and start cruising on Al Gore's *National Information Superhighway One*, you will have to go digital.

From the beginning, there has been the promise that video will change the way we use our personal computers. That change is finally underway. As technologies that incorporate computers, video, communication, and publication continue to converge onto the desktop, the most visible, provocative, and prominent results of these combinations will involve desktop video.

Knowing how to make effective desktop movies will be the key to capitalizing on this convergence, and you'll have some fun along the way. A thoughtful application of the techniques suggested in this book will allow you to digitize video that retains essential qualities of the source but which may then be further manipulated to produce whole new sets of effects. We just want to make sure you lose as little as possible in the translation.

The CD-ROM

The CD-ROM that comes with this book contains movies both in QuickTime and Microsoft AVI format. To view the AVI movies, you should have Video for Windows 1.1 installed on your computer. Video for Windows is available from a variety of sources. For example, you can download it from CompuServe. If in doubt, please contact Microsoft directly.

To view the QuickTime movies under Windows, you should install QuickTime for Windows from the enclosed CD-ROM. Run *d:*\SETUP.EXE from the Windows Program Manager File/Run menu (where "*d:*" is the drive letter of your CD drive). Run this program even if you have QuickTime for Windows installed (it won't automatically overwrite your existing copy) as it creates a unique Program Manager group entry for the software on this CD-ROM. To view the QuickTime movies on a Mac, you need to have installed the QuickTime extension provided on the CD-ROM. You must also have the MoviePlayer program which we provide on the CD-ROM.

To Get the Best Performance

Make sure your computer is fast enough. The minium PC requirement is for a 33MHz 386 with 4MB of RAM. Much better is a 33MHz 486. Your CD-ROM drive must be at least MPC-compatible. That is, its data transfer rate must be 90kb/s or better. The new, double-speed drives are excellent choices. Your PC video card must support at least 256 colors.

You need a sound card for your PC! Good choices are the SoundBlaster/Pro 16, the ProAudio Spectrum/16, or the Microsoft Sound System, although other brands give excellent results.

If You Experience Problems

In rare instances, some PC video cards may not work with the movies on this CD-ROM. You may see streaks of color on the screen, or your computer will hang up. If this occurs, in the QTW.INI file in your Windows directory, replace:

```
[Video]
Optimize=Hardware
```

with:

```
[Video]
Optimize=Driver
```

If you can't find a [Video] section, or it doesn't contain an Optimize=Hardware line, simply add the lines above.

Copyright and Permissions

The following QuickTime for Windows™ files are copyright © Apple Computer, Inc: QCMC.QTC, QTIM.DLL, QTIMCMGR.DLL, QTVHDW.DLL, QTNOTIFY.EXE, QCMC.QTC, QTCVID.QTC, QTJPEG.QTC, QTRAW.QTC, QTRLE.QTC, QTRPZA.QTC, QTSMC.QTC.

Certain illustrations in this book are used with permission of their copyright holders:

Figure 2.4. Gettysburg CD-ROM cover art, 1994 Turner Publishing, Inc. and Swfte International, Ltd. All Rights Reserved. CD artwork provided by Turner Pictures, Inc.

Figure 3.3. Photo courtesy Compton's New Media.

Figure 3.4. Photo courtesy Intel Corporation.

Figure 3.9. Leftmost image © 1992, 1993 by Creative Multimedia Corporation. Middle image from video of "The Living Body Series," licensed courtesy of the Altschul Group Corporation. Copyright 1993 by Creative Multimedia Corporation. Rightmost image from the Patient Education Illustrations, reprinted with

permission from Resident and Staff Physician. Copyright 1991-92, 1993 by Romain Pierson Publishers, Inc.

Figures 12.1, 12.2, 12.3, and **12.5** courtesy of Sony Electronics, Inc.

Grateful acknowledgment is also made to all other providers of illustrative materials used in this book.

Copyright information concerning the QuickTime and Video for Windows movies on the companion CD-ROM for this book may be found in the README text files included on the CD-ROM.

This CD-ROM is a production of:

San Francisco Canyon Company, Inc
150 Post Street, Suite 620
San Francisco, CA 94108
(415) 398-9957
(415) 398-5998 (fax)

AppleLink: CANYON
Internet: canyon@download.com

Acknowledgments

The authors would like to thank the following people for their assistance: Robert Purser, Paul Lundahl, Christine Perey, Tim Byars, Jeff Tiedrich, Nick Gorski, Richard Comfort, Keith Hatounian, Steve Patzer, Dana Plautz, Carl Johnson, Steve Alten, Galan Bridgman, Shreesh Taskar, Evan Cooper, Arthur Mrozowski, Jeff Medeiros, Jim Stockford, Art Rothstein, Britt Peddie, John Botke, Lori Rittweger, Matthew London, and Minoo Saboori.

Special thanks to Keith Weiskamp, Paul Farrell, Vince Emery, and the Coriolis Group production team—Pat Vincent, Rob Mauhar, Brad Grannis, and Barbara Nicholson.

Chapter 1

Setting the Context

GO AHEAD AND SHOOT THOUSANDS OF PICTURES—JUST DON'T PUT ANY FILM IN THE CAMERA FOR A WHILE.

What if, in addition to manipulating spreadsheet data or laying out text and graphics in a desktop publishing program, you could use your personal computer to capture, edit, and view movies and other video files? You can with digital video, an exciting, fast emerging computer technology that few "outsiders" are even familiar with.

You might have already seen or read about various products that incorporate PC-based digital video—the CD-ROM version of *A Hard Day's Night*, for instance, or a kiosk that gives you insider travel information using an interactive video program. This is the kind of technology we'll be exploring.

Just as desktop publishing revolutionized the creation and publication of books, magazines, and documentation, digital video is making it possible for anyone with a personal computer and a little imagination to create desktop movies.

In this chapter, we'll show you:

- How digital video is evolving
- Where it is going

...ow it differs from multimedia
The advantages of developing desktop digital video
Some of the different digital video processes

Sharpening the Focus

In this book, we'll address digital video only as it is implemented on the personal computer. Basically, we'll show you:

- How to make and store movies on a PC, generally with special video capture and compression hardware
- How to play back such movies on a PC, generally *without* the need for any special decompression hardware

We need to make this distinction because other types of digital video are already commonplace and used extensively in motion picture production, video post-production, and the information kiosk industry. Those particular industries, however, involve whole different sets of standards that are already established.

In other words, *high-end* digital video is required by the film and television industries because it is the only way to create many kinds of special effects and nonlinear editing—in effect, to make better productions faster and cheaper. Much of this high end digital video is actually stored on tape as opposed to hard disk or optical systems (as the word digital implies).

Desktop digital video, on the other hand, is important to personal computer environments for notably different reasons, which we'll discuss in a minute. If you're new to digital video, keep this distinction between the two fields in mind for periodic reality checks. Figure 1.1 shows some of the digital video equipment being used today. While high-end video and desktop video are distinctly different technologies, be aware that both of these worlds will merge in the very near future.

Tip: In this book, the terms *Personal computer* and *PC* apply to both Macintoshes and DOS-based machines running Microsoft Windows. We'll generally use them in a neutral sense to mean both platforms, but when either one needs to be specifically singled out we'll do so.

Sharpening the Focus

Figure 1.1
Different Types of Digital Video in Use

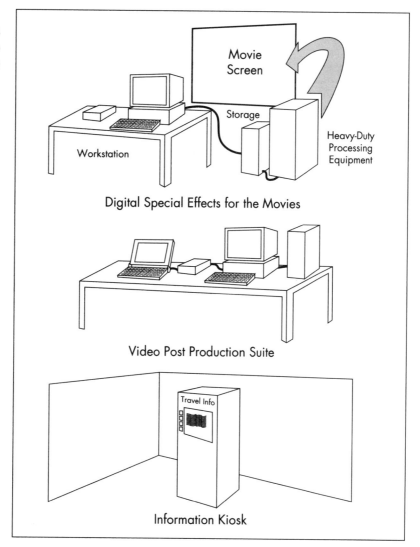

Because several industries, such as high-speed digital communications and commercial publishing, are already dependent upon PCs, these machines are currently setting the stage for the explosion of desktop video. Certainly, anyone who works at a computer screen all day, such as a graphic designer, programmer, or stockbroker, already has a sense of the growing importance of PC technology, and the places where such PC-dependent industries overlap. Figure 1.2 shows some examples of how this technology encompasses our everyday lives.

4 Chapter 1 Setting the Context

Figure 1.2
Intersecting
PC-Based
Technologies

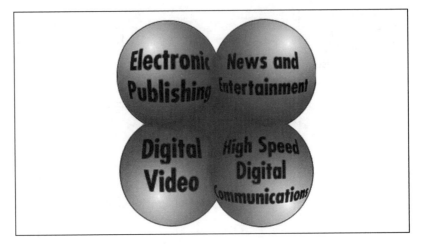

Forging a New Way to Communicate

Digital video is actually making possible a new form of communication by delivering more information per second (with sight, sound, and the power of video editing) than any other digital medium.

If you thrive on being informed but feel overwhelmed by the volume of printed matter you must wade through, as well as the hours of spoon-fed cable TV programming you must endure, digital video publishing will be a major breakthrough. You'll be able to learn more of what you *want* to learn faster, and be more involved in the process.

Digital video will also significantly alter the way you consume mass entertainment and education—witness the breathless press coverage of Hollywood's courtship of Silicon Valley, the music industry's CD to CD-ROM migration, the incorporation of digital movie clips into the Sega and Nintendo video game worlds, virtual universities and classrooms, and the promise of all sorts of interactive communication via the highly touted 500+ channel digital expressway.

Figure 1.3
Communicating with Video Instead of Text

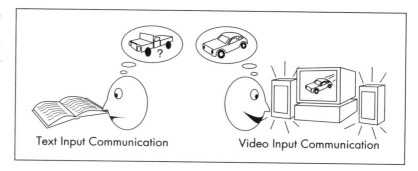

If your imagination hasn't been stirred yet, get ready for a world where moving images and sound replace streams of text as the basis for electronic publishing and private electronic document interchange, as shown in Figure 1.3. At the moment, imagination drives this new industry (as opposed to huge sales volumes of hardware and software).

Contrasting Two Worlds

Before continuing, we need to differentiate digital video from the competition. We'll start with the inevitable comparison to analog video, but this comparison only works up to a point, since digital video is a new kind of communication, not just a new way to deliver analog video.

As a broadcast medium, analog video is used to transmit information, such as news, weather, and public television, and entertainment, such as prime time sitcoms, after-school specials, and cable movies. As a medium for data storage and retrieval (video tapes, laser discs, and so on), analog video is essentially used to deliver entertainment. In both cases—broadcast and home video—images and sound are projected into our fields of perception and command our attention.

Because analog video is basically only as a form of one-way *mass* communication, it can't be fully compared to digital video. Neither broadcast nor home video involves, for example, the composition of a video document by a person sitting at a desk with a computer who can then transmit the document to a

remote audience (for possible response) or make as many perfect copies of it as he or she wishes.

You might think that this is a loaded example, but it represents an ideal that many people involved with the production of digital video carry close to their hearts (and wallets). More to the point, it illustrates how digital video differentiates itself from analog. That is, digital video can be used and exploited as an independent publication medium—people at home producing and dispersing finished movies through non-traditional channels, as shown in Figure 1.4. This idea dovetails into the brave new communication context we introduced earlier.

The other basic difference between digital and analog video is that digital video enjoys *random access* while analog is only capable of *sequential access*. This is not a new idea—it is the conceptual distinction between audio cassettes and audio compact discs, and a crucial difference between data storage devices on computers. What it means for digital media, such as desktop movies, is that a user can quickly jump to any point in a movie, or to any new movie, without having to first wind the medium forward or backward. Interactivity, as we'll discuss shortly, greatly depends on this feature.

Of course, many cutting edge users (ultimately they will be mainstream consumers) will go out and buy CD-based, interactive games with video clips and QSound (sounds apparently

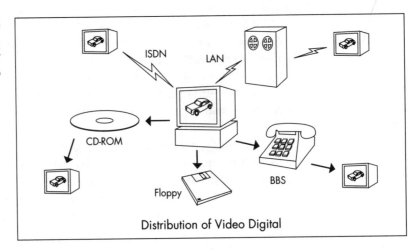

Figure 1.4 Distribution Channels for Desktop Video

Redefining Video/Viewer Interaction

coming from changing directions), and then fantasize about developing similar titles with industrial strength tools and Hollywood budgets. But the real fun, especially now while things are fresh, will be in creating and transmitting original video documents, for both profit and pleasure on your own PC.

Compared to watching a rented analog video created by actors and producers who don't know you exist, desktop digital video shared among networks of PC users promises to be a very new and exciting form of communication indeed. Digital video is *not* a variation on the laser disc; it is a type of computer data, as you'll soon discover.

Redefining Video/Viewer Interaction

Another significant issue raised by comparing analog and digital video is analog's passive nature. But again, the comparison only goes so far. Our first point was that digital video can easily be used for more highly focused, independent communication and publication, whereas analog can not. What we would like to stress now are digital's *interactive* qualities and potential. The thing we want to emphasize most is that desktop digital video is interactive because it runs on a personal computer.

In other words, video is now just another data type for PCs to process. This makes it interactive by nature, since almost all PC programs depend on user interaction. Whether you are writing a letter with a word processor, sending E-mail to someone's Internet address, or composing music with a MIDI (Musical Instrument Digital Interface) application, you need to interact closely with your PC. Television, of course, is *not* interactive by nature, although new technologies such as CD-I (Compact Disk Interactive) are pushing it in this direction. Figure 1.5 illustrates the distinction between passive and interactive video.

Introducing video into a computing environment can seem both strange and normal. (Much of this perception actually depends on the screen size of the movie you are watching, such as quar-

Figure 1.5
Passive versus Interactive Video

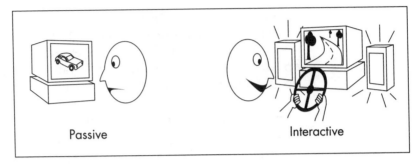

ter screen versus full screen.) The strangeness results from the combination of several conflicting perceptions: When a movie is running, you're likely to just watch it. But being a personal computer user, you've been conditioned to interact with your PC.

Even while the movie plays and the computer is pumping data as fast as possible, the PC is waiting for you to input something. So, here's the paradox: watching video on our TV sets has taught us to be passive, but the computer is designed for human interaction. This is the kind of interactive irony only high-end video game fanatics are currently comfortable with.

Letting Personal Computers Run the Show

Characterizing video sequences as data carries a certain satisfaction; it makes them manageable. As users, we know how to package data into files and transport them among different kinds of storage devices, as shown in Figure 1.6. We are used to accessing such data randomly. We are experienced in logging onto networks and remote electronic bulletin boards to transmit and retrieve all kinds of data. Now we can treat video data files in exactly the same way.

As long as we're tackling some of the big questions related to digital video, let's discuss why the PCs are qualified to handle digital video—as opposed to inventing some new kind of consumer gadget for this purpose. We have already justified the *existence* of the media; we now need to justify its vehicle.

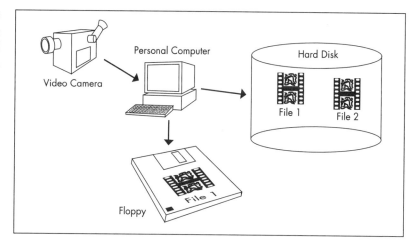

Figure 1.6
Video Data being Packaged into PC Files

Earlier we noted how high-end digital video is already a standard in certain vertical markets on specialized hardware platforms. A good example is the Hollywood special effects industry as exemplified by companies like Industrial Light and Magic. Computers generally control the machines that process this particular type of digital video, but it is otherwise quite different from the PC-based variety we have discussed so far. And it writes its own ticket, both financially and philosophically.

Because audiences are dazzled by the finished sequences produced by this world class equipment, and film makers (both traditional and desktop-based) lust after access to it, there has been a lot of market pressure to downsize it. Unfortunately, we don't have a suitable, commercial, desktop vessel to shoehorn it all into—kind of like the Democratic party's ongoing search for presidential candidates. Certain advanced consumer products like the Video Toaster (analog) and SGI Indy offer sophisticated effects processing, but the real goal is a total digital desktop solution at or near consumer prices.

This dream is kept alive by the fact that, sooner or later, *everything* gets downsized to the desktop. Mainframes, flight and combat simulators, automotive diagnostic centers—hardly any large scale technology is immune from being forced down a funnel with a PC at the bottom, as illustrated in Figure 1.7. So-called *online* digital editing systems (for assembling broadcast-ready

 Chapter 1 Setting the Context

Figure 1.7
True Digital Video versus Desktop Video

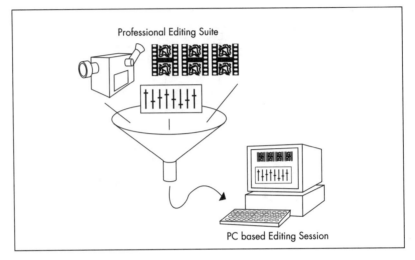

productions) are currently on deck for this transformation, and the professionals who will use them are waiting with high expectations.

Meanwhile, while all this is happening on the high end of the digital video spectrum, the existing PC world is awash in *multimedia* (ah, multimedia—almost as loaded a term as interactive). We will cover this more thoroughly in the next chapter when we differentiate multimedia from desktop video.

The significance is that video and audio standards for PCs are being developed by companies like Apple, Microsoft, and IBM from the ground up, as system software extensions, so that PCs can conform to them as efficiently as possible—the alternative being to try to retrofit to other standards later. The promise is that you will use computers for everything: home video entertainment, business communications, and off-site education.

Concerns about data storage and throughput limitations get raised (see Chapter 2), but at least the industry is trying to think ahead (multimedia was long considered a solution in search of a problem while its superstar—video—was still in diapers). As mentioned previously, all of this development is being done with the goal of treating the tantalizing audio and visual events issuing from personal computers as standard data processing output.

The challenge was that a lot of new, sophisticated hardware and software had to work together (especially on the Windows side), but soon it started meshing well enough to get a major press buzz going. Hardware and software manufacturers were naturally aware of the big fish out there named *Real Digital Video*, and were looking for ways to reel it in and make money off it. Some of them also thought they could set their own standards and do the whole thing themselves.

Confirming the Vehicle

We've been defending the idea that PCs are appropriate vehicles for digital video. After all, nobody wants to spend time and money learning how to use new tools while wondering if the underlying platform is going to change. And, it would be nice if all the core technology could fit into one box.

The most effective argument for PCs as the machines worthy of carrying digital video to the masses is tied to the justification for the medium itself. Simply put, the personal computer is the platform that can do digital video the most justice. Not only can PCs convert video into data usable by millions of other PCs, they are getting more powerful every year, as illustrated in Figure 1.8.

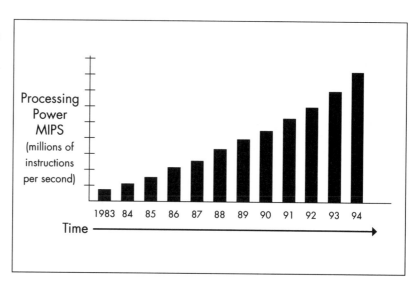

Figure 1.8 The Evolution of PC Processing Power

The fact that broadcast quality digital video will ultimately downsize to PCs to facilitate the jobs of video professionals is almost a red herring. It will be great when it happens, but the anticipation does nothing to qualify the PC as the best host platform. The real *benefit* is that the resulting technology will eventually trickle down to the consumer, where it will generate more money for all the players concerned. When you think about it carefully, it seems reasonable that the PC industry could be the ultimate white knight of digital video (contrary to what video purists are currently saying). Judging by the rate at which new hardware and software are being pumped into the market to exploit this technology, manufacturers are comfortable grooming it for this role.

At the risk of sounding obvious, PCs are inextricably linked to modern culture and commerce. As they become more powerful and versatile, their ability to handle digital video will increase proportionally. So, too, will our confidence in the unification of these two technologies.

Weathering the Changes

Although the convergence of video and PCs is becoming more and more seamless, many people in the analog video production industry remain deeply skeptical. Some feel disappointed, others alarmed and betrayed when they see the best that desktop video has to offer.

And they have valid points. The hype surrounding desktop video has promised them many things, especially accessible and affordable nonlinear editing. As technicians getting caught in the crossfire of changing hardware and software standards, however, many just may not be comfortable with their roles as pioneers.

Fortunately, if you are a professional videographer, you can have it both ways. Your current job is safe for the foreseeable future, and you can afford to experiment with desktop video. We will expect to hear some more valid complaints when you are brought in at the eleventh hour by well-funded CD-ROM publishers to put out fires, but this is inevitable.

Weathering the Changes

Your task will be to find ways to make the digitized video clips on the soon-to-ship CD-ROM product look better when played on medium- and low-end personal computers with 256-color video cards and slow CD-ROM drives. This will get frustrating in a hurry as you begin to look for innovative ways to deal with the multiplying problems.

One view of video involves capturing and viewing sequences of extremely lifelike images, a job at which analog excels. Going digital will allow you to explore with great precision the other things that make video such an effective medium. Hopefully, this book will help you to achieve the effects and performance you're seeking.

It is interesting to note that some of the style associated with desktop video is appearing in music videos and TV commercials. However, this style is probably a coincidence and more a result of original experiments with digital effects processors at high-end, post-production facilities. The effect is a certain off-the-tripod look in which action is deliberately compressed (frames dropped), images blurred, and sound unsynched. Sometimes it is quite effective; other times, it just makes you dizzy, especially when it is full-screen.

What is important here is that you can see a particular approach to desktop video taken to its logical extreme. In other words, really good *experimental* desktop video, given its current restrictions, can look like this (with far less effort), or it can strive to emulate smooth analog performance. Or it might take off in a whole new direction that uses elements of both as it matures, having decided that nobody needs more than 15 frames per second anyway.

In a way, this observation narrows our scope even further. What we will do first is concentrate on digitizing from analog tape as faithfully as possible (practice safe videography). Once a good mix of ingredients is identified for ensuring fidelity to the original, you can start having some fun, for better or worse.

Also, as you tool up, there will be a great temptation to rush out and start collecting material without regard for quality issues. Far be it for us to discourage this. But consider a bit of Zen wisdom often passed on in introductory photography books: Go ahead and shoot thousands of pictures—just don't put any film in the camera for a while. This is something worth applying to desktop video making.

Desktop digital video is opening the door to a new type of communication, an exciting, tangible world made possible by the treatment of video sequences as data that can be easily transmitted and exchanged by people with personal computers.

In addition, other PC-related technologies are poised to achieve remarkable synergy when united on the desktop by digital video. But, to prove we are not starry-eyed hype mongers, we will discuss the practical limitations of this technology in the next chapter.

Pushing the Envelope

NO OTHER TECHNOLOGY ADAPTED FOR PCS DEMANDS SUCH STAGGERING AMOUNTS OF INPUT AS DIGITAL VIDEO.

In Chapter 1, we concentrated on digital video's good points. Well, guess what? The medium also has some shortcomings. While its benefits outweigh its problems, digital video does have a number of performance limitations that need to be discussed.

Keep in mind that broadcast-quality digital video does not have these same limitations. Desktop video is limited because of the current state of personal computer hardware and software. But which would you rather have—an Excalibur that you can't take out of the garage or a Trans Am to cruise the open road?

In this chapter, we'll:

- Examine digital video's limitations
- Discuss multimedia's history
- Propose desktop video standards

Chapter 2 Pushing the Envelope

Quantity Is Job One

You can make images move on a computer screen using a number of techniques. All of them work on the principle of the movie projector: If you refresh a viewing surface fast enough, an observer will perceive motion (the refreshment process is actually different for television than for film, but the visual principle is the same). On the personal computer desktop as shown in Figure 2.1, this activity is best suited to the more powerful PCs and Macintoshes, though even 8086-based machines and Apple IIs are capable of simulating *some* types of action.

Starting with Intel 386 and Motorola 68030 processors (more so the 486 and 040 chips), PCs are becoming powerful enough to run animation in the manner of arcade style video games. Though not truly photographic in image quality, video-intensive software products from companies such as Electronic Arts and Spectrum Holobyte have enabled desktop computers to display action sequences that look and sound progressively closer to television.

Figure 2.1
A Desktop Movie Playing on a Computer Screen

Quantity Is Job One

Software is now available under Microsoft Windows 3.1 and Apple's System 7 to provide even more spectacular effects, especially when combined with recent advances in audio quality. Also, these platforms treat movies as generic, standalone files. Any Windows or Macintosh program can now open and play such movie files (provided the program includes movie handling code). Formerly, movies were either contained in the applications that played them or kept in *proprietary* file formats not playable by most other programs.

These new standalone desktop movies are big. Make that huge. This is because they are composed of hundreds, even thousands, of individual images and sound samples. Now that a movie is considered just another data type (like a bitmap, a font, or text), its size is limited only by the capacity of the media it is stored on. A quarter-screen, three-minute music video, for example, might take up 25Mb, as illustrated in Figure 2.2. Consequently, the only commercially viable distribution mechanism for desktop movies, at least for the time being, is CD-ROM. This is where the performance limitations for desktop video kick in with a vengeance, as we will see later.

It is interesting to think about movie data in relative terms. Once you get used to handling behemoth data slabs filled with nothing but slowly changing pictures and sound, copying them

Figure 2.2
Movie File Size versus Other File Sizes

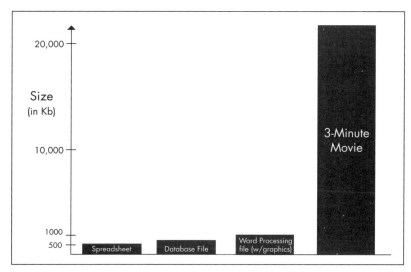

across your network, watching them consume most of your available hard disk space, your perception of them changes. You may start believing that nature really does abhor a vacuum.

In Chapter 1 we claimed that PCs are up for the job of handling desktop video. Part of our case was built on the argument that handling movies as *data* was the PC's specialty. Although the quantity of data resulting from video digitization can obviously go through the roof, we still believe the PC is the right machine for the task.

Our point is that while PCs cannot yet be substituted for TVs and VCRs in the dens and living rooms of the world, they are surely headed in that direction. Of course, some behavioral conventions will have to change for this to happen—which in turn depend on how well interactive entertainment replaces passive entertainment.

While behavioral conventions almost always change more slowly than their associated technology, the single biggest technical obstacle to PCs replacing TVs as movie playing machines is the rate at which digitized video data can be transferred to the PC from removable storage devices such as CD-ROM. This will be demonstrated with examples shortly. But first, a word from our founder.

The M Word

Before desktop digital video there was *multimedia* (as noted in the previous chapter, broadcast-quality digital video is a separate technology that existed prior to multimedia). Before multimedia there were, well, fragments of what later became multimedia, as shown in Figure 2.3. Audio was the bad boy on the block in the early days, and carried a lot of responsibility for selling the overall concept. In hindsight, sound was really the only thing that put the *multi* in multimedia.

Among the other official multimedia components were improved graphics (16 colors), not all that revolutionary at the time, and MIDI, which no one understood well enough to make

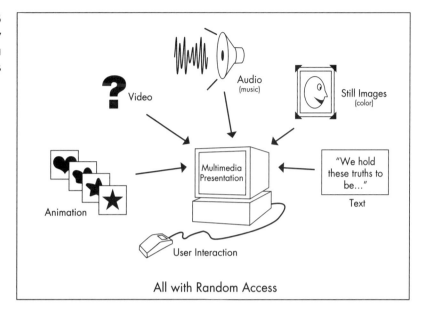

Figure 2.3
Early Multimedia Components

a difference. CD-ROM delivery, they said, was the final flourish, destined to push it all over the top. Oh, and video, too, whenever someone figured out how to define it. Maybe if desktop digital video had gotten off to a better and faster start, CD-ROM technology would be further along by now.

The basic idea behind multimedia was to make money by selling the sizzle. PCs were not just business tools anymore—they could now open doors to foreign languages, exotic plants and animals, classical music, and world geography. Sex, psychoactive experiences, and rock and roll seemed conspicuously excluded—especially *loud* rock and roll (fortunately, video is changing this). Multimedia was thus tricked out in wholesome, educational garb calculated to appeal to parents of fast-track grade schoolers and affluent junior high school students.

Rafts of empowering and politically correct multimedia products floated into retail software stores and the warehouses of computer product mail order companies, where they were met with a generally lukewarm response sales-wise (nonfamily oriented multimedia products, sold through separate channels, made a decent profit for some people). Figure 2.4 shows the range of CD-ROM products currently available.

Figure 2.4
Some Popular Multimedia Titles

Although each passing year was proclaimed to be *The Year of Multimedia* by one personal computer magazine columnist or another, multimedia has finally slipped in and set up shop—in much the same way that the VCR took much longer than expected to finally catch on. Is it a coincidence that both had a lot to do with the evolving nature of how people use video? No one can say for certain.

Until video came along, the question of limitations hardly ever surfaced during the first wave of multimedia. You could buy a really slow CD-ROM drive and still be on the serrated edge of personal computing. Audio files were big, but generally exhibited no size-related performance problems. The same went for the new, richer looking picture files. Perhaps the absence of performance restrictions was for the best. The last thing that multimedia needed at its coming out party was negative publicity.

Regardless, many good multimedia titles now exist and are making profits. The best are doing something even more important—they are driving the market. Many are based on action and adventure subjects and include decent animation and video sequences. The majority are game oriented (a useful thing

to remember is that not all CD-ROM titles are multimedia products). Some even have music video themes—*loud* music videos. See the suggested reading list appendix for other books devoted exclusively to the subject of multimedia.

On the hardware side of early multimedia, standards of sorts (for instance the MPC specification, as shown below) were established for IBM-compatible multimedia by manufacturers who wanted to sell sound and upscale graphics cards, and CD-ROM drives.

On Macs, sound and superior graphics capability were already built in and generally taken for granted. Apple also spearheaded the integration of CD-ROM drives onto the desktop. Again, for both platforms, video was always out there as the final star in the multimedia constellation, but never very well defined by the original standard setters.

The MPC Specification

The MPC 1.0 specification, announced in November 1990, consisted of both minimum and recommended standards for the Multimedia PC and was actually fairly detailed. The key points of the minimum standard were:

1. A 286 10MHz CPU (upgraded to a 386SX early in 1992)
2. 2Mb of RAM
3. A 30Mb hard drive
4. A 640 x 480 VGA monitor and graphics adapter capable of displaying 16 colors
5. 8-bit monaural sound with a 22.05KHz sampling rate
6. A CD-ROM drive with a data transfer rate of 150 kilobytes per second

Later, in the MPC Level Two specification, the ante was raised:

1. A 4865 x 25MHz CPU (upgraded to a 386SX early in 1992)
2. 4Mb of RAM
3. A 160Mb hard drive
4. A 640 x 480 SVGA monitor (65, 536 colors)
5. 16-bit sound (stereo)
6. A 300kbs CD-ROM drive

Multimedia Is Dead! Long Live Multimedia!

The multimedia video situation has recently changed. With the arrival of affordable video capture cards, both Apple's QuickTime and Microsoft's Video for Windows are now accepted vehicles for the digitization and presentation of synchronized video and audio content (so-called *time-based media*). QuickTime is actually the more mature product, and also runs under Windows. As we will see in the product evaluation section of the second part of this book, capture cards are proliferating and quickly falling into performance quality categories.

People are buying and using this equipment. Some of them are just having fun, others are struggling to achieve impossible performance levels. Still others have accepted the inherent limitations and are looking for ways to work within them. As noted earlier, good quality video sequences digitized with consumer grade capture cards are showing up in commercial CD-ROM titles.

Following the outline at the start of the chapter, we would like to make two proposals to establish a workable perspective on this new terrain. First, we suggest a middle ground between multimedia and high-end digital video. Most people in the PC industry already know what these movies look and sound like. If you haven't experienced this technology yet, you could play some of the movies on the CD-ROM that comes with this book.

We would like to call this new medium, officially, *desktop video*. Until now, our use of this term has been generic, simply to differentiate it from its relatives. Going forward, we will designate it to mean specifically those movies digitized with PC capture cards. Our second proposal, coming up, involves giving *desktop video* an ID card and a driver's license.

You could well ask at this point, "Isn't this just part of the next wave of the overall multimedia game plan?" The fast answer is that the environment is far too competitive for there to be an

overall strategy. Manufacturers and software developers are, in fact, working furiously to invent superior proprietary technologies to guarantee their very survival, especially in the data compression arena so crucial to video performance.

> ### *Video Jargon Break*
> Before continuing, let's take a jargon break. Up to this point, our use of buzz words, acronyms, and general computer lingo has, we hope, been kept to a bare minimum. In the material that follows, however, we will be using a number of terms that we'll need to define. Here are some of them:
>
> AVI: The Microsoft standard for desktop video, also called Video for Windows (VfW). AVI stands for Audio/Video Interleave. VfW files carry the AVI extension.
>
> QuickTime: Apple Computer's standard for desktop video (and beyond). QuickTime movies can play on both Macs and Windows machines.
>
> Compressor: A means for encoding movie data to make it playable on a PC. An associated *decompressor* is required to actually play the movie. A *codec* is, generally, a compressor/decompressor pair.
>
> CinePak: A codec implemented for both QuickTime and AVI. CinePak is an asymmetrical codec, meaning that movies encoded with it take a long time to compress, but decompress very rapidly at playback time.
>
> Color Depth: Essentially, the range of colors a movie can display. For example, an 8-bit color depth means 256 colors, 24-bit color means 16 million colors, and 16-bit color means either 32 thousand or 65 thousand colors, depending on how it is implemented.
>
> Sample: A digital representation of an analog signal, which can be used by digital hardware to reproduce a close approximation of the analog image or sound. Digital video is a technology built on sampling.

A better, more complex response begins, "Perhaps it started that way, but..." We believe that a major, mid-course correction has occurred—assuming there was an overall strategy. Desktop video has, in effect, gone native—it refuses to be packaged as off the rack multimedia. In doing so, however, it has incorporated most of multimedia's original ingredients: sound, high quality graphics, and CD-ROM delivery. At the very least, it *is* the next generation of multimedia, not merely part of it. This is why we suggest positioning desktop video on its own between multimedia per se and broadcast-quality digital video.

We recognize that the term *desktop video* is already in play by the press and hardware vendors. Nevertheless, it carries no specific industry standards (for instance, frame rate, color depth, or audio attributes) for either playback or capture. Broadcast analog video, by contrast, is always 30 frames per second—okay, *60 fields* per second. Unfortunately, many equipment manufacturers make inflated performance claims for their products which the press then translates *into* standards without actual field testing.

This leads into our second proposition. We believe that desktop video cannot be taken seriously as a production environment or communication medium until both activities—capture and playback—can be performed with reasonable and agreed to parameters. What we will do next, therefore, is present a list of such parameters and then substantiate them using calculations showing hardware throughput capacity versus movie data rate requirements.

When we use the term *desktop video* in the future, it will be in this new context and will imply our proposed standards. If we talk about doing something specific with a desktop movie, such as putting it on a floppy disk or transmitting it somewhere, this is the kind of movie we mean. With these standards in mind, we can talk more specifically about the overall limitations of the medium. Also, they will be useful in the third part of this book when we actually start digitizing.

Identifying Our Standards

In this section, we'll present our standards for desktop video movies. We will assume you will use the CinePak compressor for Mac QuickTime movies (for Windows QuickTime movies also, if you are going cross-platform). For AVI movies only, we also recommend the Indeo Video codec for overall playback performance comparable to CinePak (Indeo movies take far less time to compress when captured with Intel hardware). Our proposed standards are:

1. Frame size: 240 x 180 pixels
2. Frame rate: 10 to 15 frames per second, depending on slow or fast action in original content
3. Color depth: 24-bit (millions of colors), automatic for CinePak and Indeo codecs
4. Audio attributes: 22.05KHz, 8-bit, monaural (22.254KHz for the Mac)
5. Adjusted data rate: 90 kilobytes per second (kbs) if target delivery system is a single-speed CD-ROM drive, 150 kbs for a double-speed CD-ROM drive, 300 kbs if playable from hard disk

You may have some objections here, especially about the frame size, so let's review the focus. We have found that using these values for capturing video sequences will produce faithful, respectably performing movies for the widest possible desktop video audience. Current capture hardware can do much better than this, of course, and a movie with such improved performance attributes will likely exhibit them on the system that captured it—but then what are you going to do with that movie? Figure 2.5 shows the difference between PCs used to capture movies and PCs used to play movies back.

If you want other people to see and be influenced by your work, you have to make sure it plays as well as possible on *their* systems. Most of them probably have not made the same investment as you in CPU horsepower and peripheral hardware. Consequently, you will have to scale things back a bit when you digitize. Such restrictions can be irritating but are, again, necessitated by the limitations of the medium.

Figure 2.5
How Powerful Production Machines Differ from Playback-Only PCs

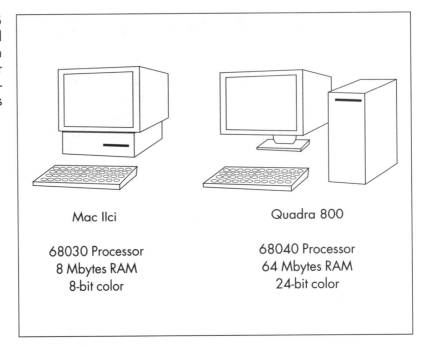

It is important to note that the values in the above list are interdependent and apply only to video (as opposed to, say, animation, which embraces other criteria). For instance, a movie with no sound can have a higher frame or data rate. A sequence with very fast and blurry action in the source video should probably be pushed to 15 frames per second, as should a sequence with a person shot in close-up where lip synch is critical. In any event, the list completely comprises our proposed attribute profile for desktop video movies. Now let's talk about what the limitations really are, and then go on to quantify them.

Mountains of Data

As noted earlier, desktop movies are files composed of individual frames, similar to celluloid movies (this is a safe general analogy as far as it goes). Each movie frame is composed of data representing a separate image. Apple's QuickTime and Microsoft's Video for Windows (AVI) each have their own proprietary file formats for assembling these images.

Figure 2.6
Flow of Data from Storage to the Screen

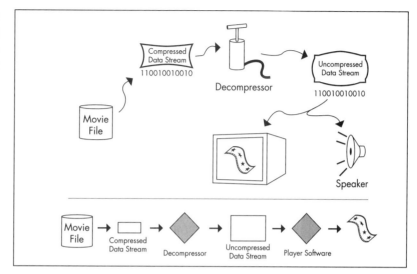

When some program *plays* a movie, it streams this movie data from a storage medium (a CD-ROM or hard drive, for example) through a decompressor and onto the screen, as illustrated in Figure 2.6. Many other important things happen as well, but this is the essence. Video and audio data are streamed simultaneously, since they are interleaved together in the movie file.

In general, the most performance-critical part of this process (assuming the movie is efficiently constructed and optimized) is the transfer of data from the storage medium. While the PC's *internal* bus speed and the efficiency of the compressor and decompressor are also very important (remember that playing a movie well is a balancing act for even the fastest PCs), an absolutely huge amount of data has to be shoveled into a movie's furnace to keep it running smoothly—no other technology adapted for PCs demands such staggering amounts of input (the stock market may be an exception).

Unfortunately, the devices that currently do the shoveling for average computer users (CD-ROM drives and standard hard-disk drives) cannot keep up with the data requirements of full-screen movies. In fact, they can barely satisfy the needs of quarter screen movies. Such movies will play, but performance will range from marginal (quarter screen) to completely unacceptable (full screen).

Chapter 2 Pushing the Envelope

In full-screen mode, you will see movie frames individually painted on the screen, and most of them won't be shown at all. If there is an audio track, it will likely break up. Movies in the quarter-screen range will appear jerky, as many frames will be dropped. In a moment, we will see why this is inevitable.

Before the rocket science begins, you should note that a more detailed discussion of the mechanics of movie construction, capture, and play is presented at the beginning of Part Three of this book. Topics such as compression, frame differencing, frame dropping, key frames, interleaving, and quantization will all be covered there. Since this is an overview, we will keep our buzz word list short and the sample computations as dramatic and uncomplicated as possible.

Get Out Your Calculator

Let's get to the bad news first, then scale our expectations back accordingly. We'll start with a hypothetical movie based on an attribute set very close to true digital video:

1. Movie frame size: 640 x 480 pixels
2. Color depth: 16 million colors (24-bit)
3. Frame rate: 30 frames per second (fps)
4. Audio properties: 44.1KHz, 16-bit, stereo

To calculate this movie's data rate requirement, we can use the equation:

N = *Total data rate requirement* in kilobytes per second (kbs)
 = *Video requirement* (kbs) + *Audio requirement* (kbs)

Breaking down the separate video and audio components yields:

Video requirement
 = 30 (frames)
 x [640 x 480] (pixels per video frame)
 x 3 (bytes per pixel for 24-bit color)
 = 27,648,000 bytes per second

Audio requirement
 = 44,100 (sample quality)
 x 2 (for stereo—left and right channels)
 x 2 (16-bit sample size)
 = 176,400 bytes per second

Solving for N returns a data rate value of close to 28Mb per second. The average personal computer hard drive delivers a sustained data rate of approximately 300 kbs (much less for CD-ROM). This is a ratio of close to a hundred to one, bad news indeed. But before we get too depressed, let's talk briefly about data compression (remember this is an overview—in Part Three we'll cover compressors and decompressors in much more detail).

Compression is the cold heart of both QuickTime and Video for Windows. It is implemented by these technologies in the form of *codecs* (compressor/decompressor). Under Windows, codecs are DLLs (dynamic link libraries) and drivers. On the Macintosh, they are built into the QuickTime system extension. Independent developers may write new codecs as long as they conform to published specifications.

Simply put, compressors compact a movie's data, thus making the movie play smoothly. Without them, desktop video would be like a bad slide show. The most useful video codecs make movies play smoothly by manipulating their frames in a way that allows some of the original movie data to be discarded. Others, as shown in Figure 2.7, retain such data but are less efficient.

The current optimal codec for movies produced to play on both PCs and Macs (dubbed *cross-platform* movies) is named *CinePak*.

Figure 2.7
The Effect of Compression

Uncompressed Pixels in a Frame					
Green	Green	Green	Green	Green	Blue

Compressed Pixels in a Frame (RLE example)

5 Greens	Blue

Previously it was called *Compact Video* under QuickTime. Movies produced with Video for Windows only are often compressed with Intel's *Indeo* codec. Again, please see the discussion at the beginning of Part Three. Your personal results may vary when comparing these and other codecs.

Similar to compression in its effect is a process called *data rate adjustment* (an ominous reference to the movie *Brazil*). Both QuickTime and Video for Windows have the capability to simplify individual movie frames so that the decompressor requires less data to keep up with the frame rate requirement. This process gives the movie a slightly blurry look, depending on the new data rate selected, but it can ensure smoother playback and better lip synching. We will use both normal compression and data rate adjustment in the examples that follow.

Let's return to the first calculation (remember this is for full screen). Applying reasonable compression can get our 28Mb per second down as low as 2Mb per second, still a long way from home (300 kbs). Utilizing data rate adjustment can reduce this further, but you will invite blurring, which looks worse in larger-frame movies than in smaller ones. It is not surprising that even hard disk *arrays* coupled with onboard hardware decompression struggle to give complete movie viewing satisfaction at full screen levels.

Spinning the Bottlenecks

What does our first calculation prove? For one thing, it puts in perspective the issues we raised earlier in this chapter. Desktop video's biggest overall bottleneck is the data transfer rate (or *bandwidth*) of the device that supplies movie data to the computer. Specifically, we are talking about CD-ROM drives, although to a lesser extent this also applies to standard hard drives. As we will see in Part Three, data bus speed can also be a factor, especially on Intel-based PCs with ISA buses.

It is ironic that one of the main things that positively differentiates desktop video from broadcast-quality digital video is responsible for creating this limitation. In other words, desktop video promises a new and better form of communication

through portable, transmittable digital movies, but the discs that such movies currently play from can't spin fast enough to supply even close to full-screen images, let alone quarter screen.

The implication is that desktop video is going to be limited to rather small frame sizes until either CD-ROM bandwidth is greatly expanded or some fast and cheap removable storage device is invented (or codecs imbedded in chips are devised that can extract more frames in less time from thinner data streams). If you have seen any of the current products containing QuickTime or AVI movies, you know that these clips tend to be sized less than a quarter of the screen. Now you know why.

Although this computation was easy to set up, perform, and learn from, we hope it sets the tone for our overall approach to understanding desktop video on a quantitative basis. Proceeding in this manner is not just the key to appreciating the limitations of the medium, it also provides a way of ensuring that your movies will perform as efficiently as possible.

Lowered Expectations

Let's next consider a movie with a more realistic attribute set. As you can see, it generally falls within our formal definition of desktop video—less than a quarter of a screen in size, true color but only minimal sound quality. In fact, these are the attributes for the movie CHP2_1.AVI on the companion CD-ROM:

- Movie frame size: 240 x 180 pixels
- Color depth: millions of colors (24-bit)
- Frame rate: 15 frames per second (fps)
- Audio properties: 11.025 KHz, 8-bit, monaural

Let's adjust our previous equation to:

N = *Total data rate requirement* (kbs)
 = *Video requirement* (kbs) + *Audio requirement* (kbs)

Breaking down the separate video and audio components yields:

Video requirement
 = 15 (frames)
 x [240 x 180] (pixels per video frame)

x 3 (bytes per pixel for 24-bit color)
= 1,944,000 bytes

Audio requirement
= 11,025 (sample quality)
 x1 (for mono—only one channel)
 x1 (8-bit sample size)
= 11,025 bytes

Doing the arithmetic yields a data rate requirement of almost two million bytes per second, almost seven times what our average hard drive is capable of delivering. Applying the appropriate compressor can bring the data rate requirement down to approximately 300 kbs, just about right for playing from our average hard drive. Subjecting the movie to data rate adjustment finally gets it down to CD-ROM levels. Actually playing CHAP2_1.AVI from the companion CD-ROM should register decent performance and verify our computations.

The Acid Test

Let's perform one final calculation, which we suggest as a basic litmus test for any movie that performs badly. The movie from our last calculation, CHAP2_1.AVI, has a size of approximately 1.3Mb. We also know that its duration is roughly 14 seconds. Since it is reasonable to assume that all the movie data will be displayed in the time that the movie takes to play, let's use the above statistics to test this assumption.

Doing the requisite division:

1,300,000 bytes / 14 seconds = 92,857 bytes per second

tells us that approximately 93,000 bytes per second (93 kbs) of movie data must be delivered to the program playing the movie to ensure that none (or very few) of the movie's frames are dropped and its performance thus impaired.

This is good news, since it is very close to the performance of most single speed CD-ROM drives. With a calculated data rate of 93 kbs, our movie is pretty much guaranteed to have all of its data displayed during its running time, regardless of what stor-

age device it is being played from. Unfortunately, you cannot deduce much else about CHP2_1 based on the result of this calculation, outside of what you see and hear when the movie plays (unbroken audio can be expected when these overall data rate numbers work).

Beyond Bandwidth

Leaving the real word behind for a moment, let's assume we had a way to get data as fast as we wanted from CD-ROM discs and hard drives. What is the next obstacle on the road to broadcast quality video on the personal computer? Basically, there are two things: the PC processor speed and its internal bus rate, as shown in Figure 2.8. Let's look at these in greater detail, but only for the sake of completeness.

On a Macintosh Quadra 950 equipped with a SuperMac Digital Film capture card, you can observe 60 fields per second, 640 x 480 digital video. Because the movie is being decompressed with the help of the capture card (not just the CPU), the CPU is free to handle the rest of the activities involved in playing the movie. In other words, when the chip is finally powerful enough to do both decompression and movie process management, and the data bus is wide enough, there will be no bottleneck on the CPU side.

As for the internal bus speed, this is the rate at which data is moved around inside the PC and onto the screen. Macs and Intel-based PCs have different standards, and there are at least two separate and distinct standards (typically ISA and EISA)

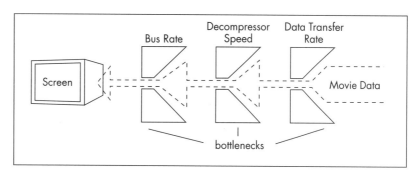

Figure 2.8
Progressive Bottlenecks for Desktop Video

for Intel-based machines. For the sake of this discussion, we can consider ISA to have a sustainable bus speed of roughly 5,000 kbs and both EISA and NuBus (the current Mac standard) rates to be between 8,000 and 10,000 kbs. Two emerging standards for high-end PCs are *PCI* and *local bus video* which allow for video data to be moved onto the screen via a separate data path, thus improving performance.

Clearly, based on our prior calulations, the reason the Quadra/Digital Film combination can handle full motion, full screen video is because NuBus machines are up for the job. ISA PCs without local bus video, by contrast, may have a problem playing movies with frame sizes larger than specified by our desktop video standard.

A reasonable question here might seem, how far down the CPU ladder will a high end capture card take up the slack? We have found that this solution for full-motion, full-screen video does not extend down to the Mac IIci. Trying to interpolate between IIci and Quadra 950 class machines to save money is not recommended, however, especially given the price of top of the line capture cards. Besides, it assumes you really want to get full-screen, full-motion performance in our more modest (as defined) *desktop video* world, which we left only for the sake of argument.

The important thing to remember is that CPU speed is indeed a potential bottleneck for achieving full-screen digital video, once bandwidth problems are solved, but the argument is almost philosophical. By the time data throughput rates climb out of the cellar, mature Pentium and PowerPC class chips will likely be common and able to easily handle both decompression and movie management completely in software.

On the Intel-based PC side, it is true that a 486 DX2 66 machine will play desktop video movies (by our definition) measurably better than a 386 DX 33, but this is not a bottleneck in the larger sense. Our focus has been hard limitations to the grand scheme of digital video—not incremental plateaus you can achieve by making a hardware upgrade of the magnitude suggested above.

A Question of Balance

Despite the promise of desktop video rolled out in Chapter 1, we have now seen that the medium carries a substantial handicap, both for desktop producers eager to have their work seen by a large audience (via CD-ROM) and for anyone who just wants to have fun exploiting the medium and communicating with desktop video.

The challenge is to make movies that look and sound as good as possible using a data stream that supports a movie frame size of slightly less than a quarter of a screen. This will be accomplished by applying the right formula of compressor, frame size, frame rate, color depth, sound sample size, and data rate.

To take the guesswork out of combining these values, we have provided a working set of standards that we believe will produce high-quality desktop movies from most source video tape, regardless of the imposed limitations. Of course, you will want to capture and observe enough movies of your own to really get a feel for it, but if you are serious you will be doing this anyway.

Predicting the Present

DESKTOP VIDEO GIVES THE AMATEUR VIDEOGRAPHER THE POWER TO MAKE A LOT OF DISCARDABLE DESKTOP MOVIES.

If you are reading the chapters in the first part of this book sequentially, you should now have a clear idea of where digital video—make that *desktop video*—fits in the continuum of computer-based communication technology. Nevertheless, we are still operating in a partial vacuum. Although we have discussed desktop video's technical limitations and how it is converging with other developing PC-dependent industries, we still have not grounded desktop video in the all too real world of time, money, and copyright issues.

We still need to cover the areas that will make working with desktop video seem like a traditional occupation (or an expensive habit), as illustrated in Figure 3.1. If you are planning to make movies, you are going to have to spend some nontrivial dollars on tools. Do you remember that vacation you had scheduled? Maybe you'll need to postpone it. In addition, if you plan to do anything commercial with your movies after they are digitized, you should be aware of the increasingly litigious atmosphere engulfing this medium.

Chapter 3 Predicting the Present

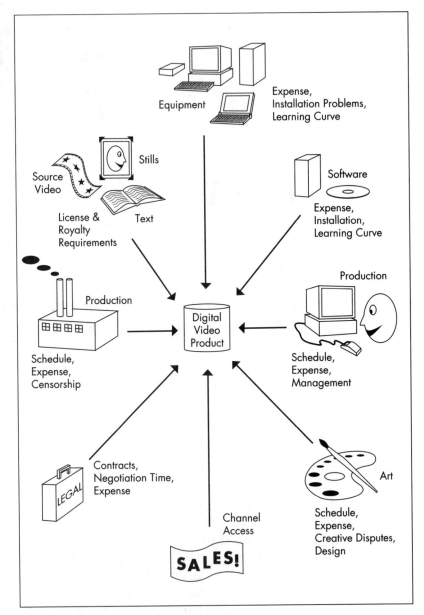

Figure 3.1
Desktop Video Taking on the Real World

This chapter will show you:

- How much various capture systems actually cost
- How much time an actual capture session can consume
- How desktop video can be distributed and transmitted
- How desktop video is entering the mainsteam

The rest of Part 1 will be devoted to the nontechnical issues surrounding desktop video. Parts 2 and 3 of this book *will* be purely technical.

We want to keep your enthusiasm level high, but there are some sobering things to keep in mind as you browse the new product ads in *DeskTop Video World* or rotoscope mustaches onto a captured Madonna video.

What Desktop Video Really Costs

Although you may be excited to think of an all-digital world where desktop video files are created and passed around like desktop publishing documents, the reality is that the price of entry to this world is almost prohibitive. This is true for both professional desktop producers (who need professional equipment) and for people who want the fastest possible machines with the biggest monitors just to watch desktop movies on. If you are still ready to buy some of the black and gold chips, please read on.

Macintosh systems are still generally more expensive than their IBM-compatible counterparts. This imbalance could change when the Mac PowerPC-based machines become widely available. Top-of-the-line capture cards are also generally costlier for the Mac, but they offer much greater capability. Unfortunately, this extra capability may be a wasted miracle for most fledging desktop video producers.

Using a variation on the *meta-system* model presented in the next chapter, we'll now show you some back-of-the-envelope estimates for both deluxe and metal scraping digitization studios for Macs and PCs. Most of the pure video gear will be usable on both platforms. If you need a more detailed approach to system setup costs right now, skip the rest of this chapter and jump to the second part of this book.

The Mac Overdrive Suite

The system described in Table 3.1 is suitable for the professional desktop video developer who can afford better equipment time. Figure 3.2 shows what such a system can look like when assembled. Mail order prices are used wherever possible.

Table 3.1 A High-End Mac-Based System	
Component	Price
Hardware	
CPU: Quadra 950	$3,500
Extra Memory: 24Mb	$1,000
Monitor: High End 20" Multiscan	$2,100
Capture Card: Video Vision Studio	$3,400
Disk Storage: 2 2-Gigabyte SCSI Hard Disks	$3,600
Optical Reader: Double Speed CD-ROM Drive	$400
Optical Writer: Sony CDR 700E or compatible	$7,000
AV Gear	
VTR: Sony EVO 9800 or compatible	$5,000
Time Base Corrector: External unit with controller	$1,500
Monitor: NTSC 19" with overscan	$300
Camera: Sony TR 101 or compatible	$1,100
Speakers: Multimedia size and home stereo class	$400
Software	
Editing: Adobe Premiere	$500
Effects: VideoFusion and After Effects	$2000
Rotoscoping: Adobe Photoshop	$600
Authoring: Macromind Director	$800
TOTAL:	$33,200

Figure 3.2 A High-End Mac-Based System

The Mac Sub Genius System

The configuration listed in Table 3.2 will serve the dedicated amateur. Clearly, the key word here is dedication. Figure 3.3 provides an example for this scaled-back setup.

Table 3.2 A More Modest Mac-Based System

	Component	Price
Hardware	*CPU:* Quadra 650	$2,300
	Extra Memory: 8Mb	$400
	Monitor: High End 15"	$600
	Capture Card: Video Spigot or Movie Movie	$400
	Disk Storage: 1-Gigabyte Hard Disk	$1,000
	Optical Reader: Double Speed CD-ROM Drive	$400
AV Gear	*VTR:* Consumer grade VHS Deck	$400
	Time Base Corrector: Internal unit with controller	$1,000
	Monitor: NTSC 19"	$300
	Camera: Sony TR 101 or compatible	$1,100
	Speakers: Multimedia size and home stereo class	$400
Software	*Editing:* Adobe Premiere	$500
	Effects: VideoFusion	$700
	Authoring: Macromind Director	$800
	TOTAL:	$10,3000

Figure 3.3 A Scaled-Back Mac-Based System

The PC Rock and Roll Suite

As with its Mac counterpart, the collection of gear shown in Table 3.3 is for the desktop video developer who has his or her project funded. Again, mail order prices are used when appropriate. Figure 3.4 shows the scope of such a system.

Table 3.3 A High-End PC-Based System

	Component	Price
Hardware	*CPU:* 486 DX2 66 with 16Mb RAM	$4,000
	Monitor: High End 16" Multiscan	$800
	Capture Card: Intel ISVR or Media Vision PMS	$500
	Disk Storage: 2 2-Gigabyte SCSI Hard Disks	$3,600
	Optical Reader: Double Speed CD-ROM Drive	$400
	Optical Writer: Sony CDR 700E or compatible	$7,000
AV Gear	*VTR:* Sony EVO 9800 or compatible	$5,000
	Time Base Corrector: External unit with controller	$1,500
	Monitor: NTSC 19"	$300
	Camera: Sony TR 101 or compatible	$1,100
	Speakers: Multimedia size and home stereo class	$400
Software	*Editing:* ATI MediaMerge	$300
	Authoring: AimTech Icon Author	$5,000
	TOTAL:	$29,900

Figure 3.4 A High-End PC-Based System

The PC Above Average System

Even though targeted for the more independent desktop producer, our lower end Windows-based configuration (Table 3.4) still separates the true believers from the dilettantes. Figure 3.5 shows how it might look in a production setting.

Table 3.4 A More Modest PC-Based System		
	Component	Price
Hardware	*CPU:* 486-33 with 8Mb RAM	$2,500
	Monitor: High End 14"	$600
	Capture Card: WinMovie or Video Spigot	$400
	Disk Storage: 1 Gigabyte Hard Disk	$1,000
	Optical Reader: Double Speed CD-ROM Drive	$400
AV Gear	*VTR:* Consumer grade VHS Deck	$400
	Time Base Corrector: Internal unit with controller	$1,000
	Monitor: NTSC 19"	$300
	Camera: Sony TR 101 or compatible	$1,100
	Speakers: Multimedia size and home stereoclass	$400
Software	*Editing:* ATI MediaMerge	$300
	Authoring: Visual Basic or Macromind Action!	$500
	TOTAL:	$8,900

Figure 3.5
A More Modest PC-Based System

Now that you have regained consciousness (hopefully), we can mention that even the low-end solutions we just suggested are not cut to the bone. All you really need to digitize a short movie clip is a low-end capture card, a cheap VCR, and less than a 100Mb of hard disk space. You won't be able to do much with the clips you capture this way, but you'll get several days worth of distraction and you'll discover if you have a taste for desktop video. Like photography, the costs all go up from here—only faster.

How Much Time Do You Need?

In an ideal world, all you need to do is push the *Play* button on your VCR, click *Capture* on your digitizer interface, and then sit back, and enjoy the show (in the long run, this can turn out to be the most boring part of making desktop movies). In reality, you'll discover that some of your captured frames didn't come out right, your audio has strange clicking noises, or your monster external SCSI (Small Computer System Interface) unit doesn't have enough storage space even when your system says you have enough. Let's explore a worst case scenario:

You have a four-minute music video on a VHS tape that you need to have ready for a trade show in a week. Your task is to make a straight ahead QuickTime for Windows movie from the tape, using the CinePak compressor. Nothing fancy, but the movie has to look and sound as if a high price downtown studio did the work.

No problem. You have just tooled up your home studio with both Mac and Windows machines and are ready to start cranking. What you are really proud of is your serially controllable Sony VTR, which can guarantee frame-accurate captures. Naturally, you have promised to deliver the finished desktop movie on a Syquest platter well within the week, maybe earlier.

Since you are new to the exciting second career of desktop digitizing, you decide to jump right in. You copy the video over to the Sony VTR, fire up GrabGuy on your Mac, set the compressor to no compression, mark the in and out points, and click the *Record* button. Your external hard disk has over 500Mb

free, which should be plenty. GrabGuy informs you that it has begun to rock and roll, but after a few minutes you see that it's going to take a while.

You come back after lunch and find that your system has terminated unexpectedly. After a few minutes of troubleshooting, you discover that your hard disk is full. You clear out the garbage, but the Finder says that only a couple hundred megabytes are now available. After some unrewarding research, you decide to reformat, which takes a while, but it gives you a chance to think. If you are really having a disk space problem, you could break the video into sections and glue them together later.

When you're finally done reformatting, you fire up GrabGuy again, but it doesn't work. You turned the extensions off to do the format. GrabGuy comes up again and you set it to capture the first third of the video. Even though it's going to take one-third as long, it still gives you enough time to get a cup of coffee.

You return to find that the capture completed successfully. Unfortunately, capturing the second third of the video will produce a file as big as the first, and both won't fit on your hard disk. *No problem.* You'll run MovieShop on the first section using CinePak to compress it to a manageable size, then repeat this step for the second section after you capture it. This process will have to run overnight (it can take up to 12 hours, depending on what kind of Mac you have).

Since you won't jump without looking anymore, you decide to run the first section through MoviePlayer frame by frame to make sure everything is cool. Doing so shows a strange symptom: Some of your frames are skewed and have ragged black edges. You check both the VHS and Hi-8 tapes, but they both seem fine. You cancel your dinner date and do the capture again.

This time you watch. Sure enough, at the spots where the first capture frizzed out, it happens again in GrabGuy's monitor window. You stop the capture and flip on the NTSC monitor connected to the Sony. Firing up a third capture, you see the same thing on your computer screen but not on the NTSC monitor. In

Figure 3.6
The Myriad of Settings That Might Solve Your Problem

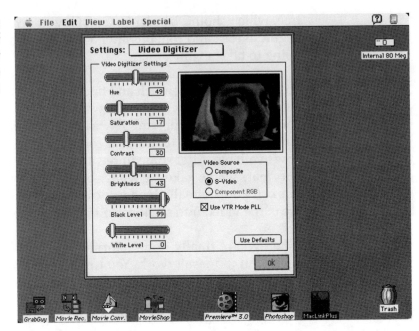

captures four through ten you try different brightness contrast, and saturation settings as shown in Figure 3.6.

Now you are not only hungry, but your Advil bottle is empty. You can't compress section one tonight without solving this problem. Unfortunately, the local video supply store can't help you because they're closed by now. You try to excise the bad segments with MoviePlayer, but even cutting a single frame seriously screws up the sound. Maybe you could do an end run around the problem by stripping out the bad frames then using Premiere to snap in a fresh copy of the sound track.

Cut to day four. You have been clued to the world of Time Base Correction after only marginal success with Premiere (the lip synching never worked out exactly right) and have decided to shell out another grand for a TBC (Time Base Corrector) card. Finally, your captures are now clean. Compression of the first couple of sections ran on nights two and three. The third one will run tonight and you can glue them together in the morning.

If you've been through this yourself, you know that the stage is

still set for disaster. If you haven't, you may be somewhat skeptical at this point. Either way, these are the sorts of issues that are going to take up weeks of your time. If you have only one machine, *all* of your tasks are on the critical path. The best advice we can give you here is not to make any professional commitments until you have practiced on a few medium to large projects with your own material.

New Maps of Hell

Like desktop publishing, desktop video gives the amateur videographer tremendous power to make a lot of discardable desktop movies. This is assuming that you are not going to stick to faithful transcriptions of existing video works but instead embark on a career to change the face of the art form.

Desktop video is a very seductive medium that you can spend a lot of time and money on without half trying. Whether that time is spent cursing your equipment or watching your carefully constructed movies tell you something new about your subjects depends on how hard you are willing to work and how disciplined your creative skills are. When you leave scrupulous transcription for original composition, you will be completely on your own—surrounded by piles of powerful and expensive tools.

Some of the trendier art and technology magazines suggest that jamming a bunch of multimedia effects together using video as the glue will produce excellent results. The authors of this book are not videographers, but we seriously suggest that you proceed in this direction only if you have an analog video background and some good ideas about what it is you really want to do. The world needs bad 25Mb abstract videos even less than it needs 20-font, hard-to-read PageMaker documents.

You *Must* Take It with You

A subject we have alluded to occasionally is, for lack of a better word, *portability*. In Chapter 1, we endorsed the personal com-

puter as the champion of desktop video because it treats video as a standard type of data, which is therefore easily transportable and transmittable. In Chapter 2, we reflected on the awkwardness of handling titanic movie data files at the system level (copying, backing up, and so on). Even compressed, the size of such files are off the scale compared to traditional PC file sizes.

Just as video cassettes and laser discs allow video data to be transported among players and editing stations, so too must the means for digital video dispersal be standardized, as shown in Figure 3.7. The current medium, of course, is the CD-ROM, but machines for producing them on the desktop are fairly expensive ($4,000 to $7,000 not including software). Even the blanks are costly (about $25.00 each in small quantities).

Unfortunately, mass production and distribution issues surrounding CD-ROM titles are outside the scope of this book and deserving of yet another book all their own. One excellent reference is *The Education of a CD-ROM Publisher* by Chris Andrews, published by Pemberton Press/Eight Bit Books, Wilton, CT, 1993.

You can put a ten-second desktop movie on a floppy disk, but you need to play it from your hard disk for acceptable perfor-

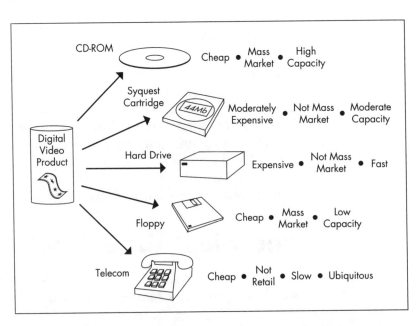

Figure 3.7 Desktop Video Dissemination Channels

mance. You could disperse longer movies archived on sets of floppies (to unarchive onto a hard disk), but this gets unwieldy and there is no guarantee that your client will be able to do the unarchiving. (We could get into the merits of self-extracting archives here, but it wouldn't lead to a real solution since the process is still awkward at best when it comes to large movies.)

Removable storage devices such as Syquest and Bernoulli drives provide a way to transport movies on a person-to-person basis—you can play movies from them at better rates than from CD-ROM drives. The down side is that the platters they use are too expensive to let go of (about $65.00 each). Some people will get mileage out of this approach for a while, since the platters are erasable, but it is not the *type* of solution that will work in the long run. Neither is the often-discussed flash memory cartridge, which essentially performs the same function as these removable hard-disk drives.

What is required is a cheap blade for a moderately priced razor. Together they must provide both the means of dissemination and the medium from which the movie is played. Which brings us back to the CD-ROM. No other technologies are being seriously discussed as alternatives, and drives with significant performance improvements have been slated for release by several leading manufacturers.

Once CD-ROM discs are fully erasable/rewritable and priced close to floppies, desktop video will take a crucial step forward. When CDWs (CD-ROM writers) cost under $1,000, companies will do business differently. Current performance levels and prices make us all long for something better right now, but we'll have to wait. As you saw in the last chapter, the standards we derived for desktop video are what you can get from CD-ROM right now.

Compact Discs: The Devil You Know

People know how to use compact discs. We've been jamming them in music CD players for years now. There seems to be

something innately satisfying about optical media for most users of high-end audio visual technology. If you can watch randomly accessible desktop movies on your personal computer as easily as you punch up Nirvana tracks on your Discman, you will never go back.

The other form of distribution available to desktop video as a personal computer data type is digital transmission. Even from a nontechnical view, this is one of the most exciting things about this new medium. No longer does video need to be broadcast or beamed via satellite to get to a remote location instantaneously (or, in this case, close to it). You can now send it somewhere with a high speed modem or, on a more modest level, put it up on an electronic bulletin board such as CompuServe or a private subscription BBS for others to download, as shown in Figure 3.8.

In the near future, if all goes according to plan, we will all be able to get data super highway access for this sort of transmission. When that happens, everything is going to start changing very fast indeed. As the argument grows that screens full of text are *not* the future of computer-based newspaper and magazine publishing, so too will the argument grow for *much more* desktop video.

Figure 3.8
Desktop Video Transmission Channels

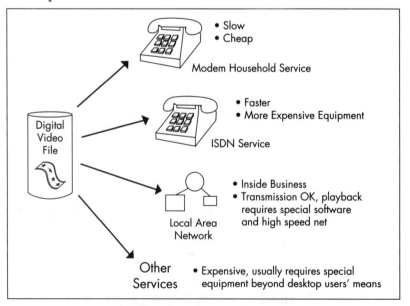

Overall, knowing that your carefully crafted productions might not find their way into general circulation directly from your desktop will probably greatly influence your concerns about portability. It is actually of much less concern if you plan to output your final productions back to video tape or are developing a game or training product that will be mass produced on CD-ROM from, say, your external hard disk.

But if you plan to produce standalone video files to share with large numbers of friends and colleagues, use in demos, play at trade shows, and generally disseminate through the quickly expanding electronic underground, you will immediately be faced with portability problems. For now, CD-ROM technology has the lock on the solution.

Industry Players

Many different companies and industries are getting involved in the overall field of digital video. The industry is becoming so broad, in fact, you usually have to interrupt and ask what *type* of digital video someone is talking about. In many cases, they will be at a loss to do this to your satisfaction unless they are an engineer or an ambitious marketing executive. Unless *you* are an engineer, a software developer, or a Hollywood producer, the answer will likely seem out of context anyway.

But the question is still a good one. The telecommunications industry is on the verge of making digital picture phone networks a reality. The cable TV companies are promising home delivery of interactive television. As mentioned earlier, motion picture production technicians are using digital video compositing techniques to create outrageous special effects. The list keeps growing.

What is interesting is that desktop video, as we have defined it, is arguably the most visible type of digital video. This is primarily because of its connection to the personal computer. Even outside of the software and entertainment industries, there is a ground swell of development activity by corporations that de-

Figure 3.9
Industrial Desktop Videos

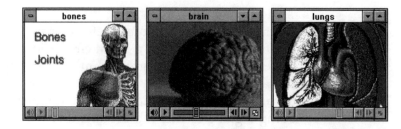

pend on the PC to deliver information to their customers and see desktop video as the most effective way to transfer this information.

Some of the non-computer industry sectors already marketing such products through trade shows and TV commercials are publishing, health care, travel, and heavy manufacturing. Figure 3.9 shows an example. An interesting report is circulating that the president, first lady, and vice president each have a Quadra 950 in their offices to view QuickTime clips of currently breaking crises over their first cups of decaf.

As most of us have seen, a tremendous amount of hype on this subject has appeared recently. Like with the Strategic Defense Initiative (Star Wars), people seem to want to believe this technology will make the world safe for democracy. Or at least rescue the American economy. Although the financial rewards *will* be enormous for the corporate players, the fact is that the same or comparable production tools will be available to the individual. This is where things are going get interesting.

Who's Going to Get Sued?

Something needs to be said here about copyright issues. They are real and becoming surreal. Even though the Video Police probably won't break in your door as you digitize *T2* or *The Little Mermaid* (just to make sure your gear is working properly), you are well advised to get permission—*in writing*—for capturing and distributing anything that is not completely original. This also includes any music you will use in your soundtracks. Figure 3.10 gives a graphic representation of these issues.

Who's Going to Get Sued?

Figure 3.10
The Fractional Distillation Approach to Multimedia Rights Licensing

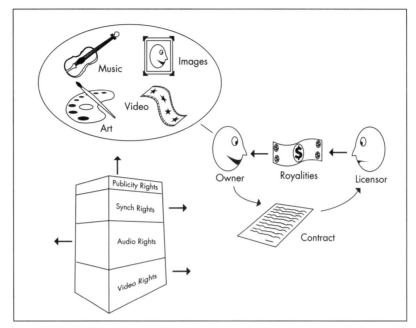

If you have the slightest feeling that you are infringing on someone's copyright, you probably are. If you think you can beat the system by morphing (using a PC to transform one image into another), recompositing, or otherwise altering a recognizable image owned by someone else, knock yourself out. There are going to be some interesting test cases in this area, which you might want to watch from the sidelines. See the suggested reading list appendix for more information on copyright laws.

Understanding the Meta System

POWERFUL HARDWARE SAVES TIME, AND YOU CAN EXPECT TO HAVE LESS TIME THAN MONEY.

In most dedicated personal computer systems, overall efficiency is limited by the power of the CPU and perhaps (to a lesser degree) one or two other pieces of specialized hardware. MIDI studios, desktop publishing stations, and electronic bulletin board services are examples of such operations, where data flow is well within manageable limits.

Computers dedicated to desktop video, however, are often hostage to the limitations of peripheral devices, not to mention their own internal data channels. As we saw in Chapter 2, this is due primarily to the monumental amount of data those peripherals must handle. This section of the book will concentrate on setting up and maintaining such systems—interconnected pieces of computer and video hardware—for effectively handling desktop video.

We should make an important distinction before we continue. The term *desktop video*, introduced in Chapter 2, is based on current limitations for movie *playback*. We did this to make you familiar with the term and the restrictions it carried, and the

Chapter 4 Understanding the Meta System

definition should remain in force. Movie *capture* does not have the same limitations. Moreover, the limitations it *does* have do not necessarily result from the same kind of hardware as those for movie playback.

In this chapter, you will learn:

- Some common bottlenecks in digitization (as opposed to playback)
- Why you can capture better movies than you can play back
- The four basic components for capturing desktop video

New and Improved Bottlenecks

The bottlenecks for movie capture depend on your *method* of digitization. For example, if you are capturing in real time, you may be limited by your CPU, hard drive, or capture card. If you plan to make multiple passes on your source video tape for frame-accurate capture, you may be restricted by your tape deck's transport mechanism. Ultimately, with the right combination of equipment and careful planning, you can surmount most of these limitations. Figure 4.1 shows the basic digitization bottlenecks.

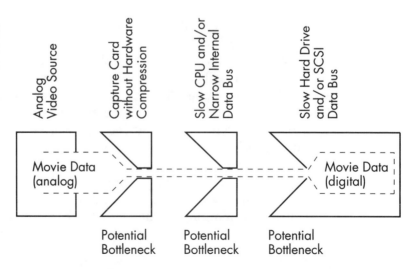

Figure 4.1
Overview of Digitization Bottlenecks

Because capture technology is changing faster than desktop video playback technology, we don't want to propose standards for it. What we would rather do is propose an abstract digitizing system capable of capturing desktop video movies and beyond—all the way up to full screen, full motion. Understanding how the components of this abstract system (CPU, capture card, mass storage medium, and video deck) function and work together will provide you with a key perspective for when we start cabling together real systems. We'll call this abstract model our *meta* system.

Visualize it: A finite set of components that can produce broadcast-quality digital video. We know it's an abstraction, but it shows what each piece is supposed to do, and exactly what components are required to get the job done. If you want to set up a digitizing suite, you can use our meta system as a reality check, knowing that it comprises the complete set of equipment necessary for video capture. All you have to do is substitute real equipment and calibrate it appropriately.

Whether you are troubleshooting a captured movie that plays badly or producing a video with unusual requirements, knowing where to expect performance problems based on an understanding of the meta system can save you a great deal of time and frustration. Our worst case scenario in Chapter 3 might have been avoided with even a brief review of such an abstract model.

We are not suggesting that you make a lot of movies for general consumption with attributes richer than our desktop video standard. But when playback standards improve as better hardware becomes available, the meta system will still be useful as a guide for assembling and coordinating equipment to improve capture standards.

Hidden Assets

To put it simply, you can *make* better movies than you can play back. (Better in this case means better performing, with more frames and greater clarity.) As shown in Figure 4.2, a movie digitized on System A with even a modest capture card often

Figure 4.2
Why You Can Capture Better Movies Than You Can Play Back

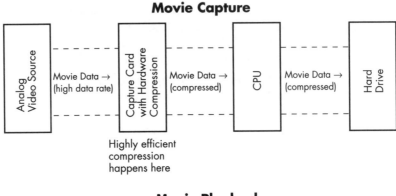

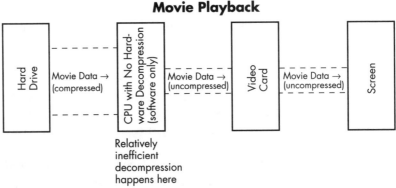

contains more movie data than can be played back on that same system or any other machine with System A's capabilities. The principal reason is that, in most capture cards, the circuitry used in digitization and compression is not used in playback. Although several of the high end digitizer boards *do* have this hardware assistance advantage, their target market expects richer playback performance.

This condition of having more data than needed is not always obvious when a movie is running (the movie may, in fact, perform well) and may not ultimately affect how you make movies. But it does contribute an overall sense of perspective to the digitization process. We'll cover this issue in greater detail in Part 3 of this book.

While it is tempting to construct separate meta systems for both Windows and Macintosh users (since not everybody has gone cross platform and many of the unreconstructed *jihad* warriors

are still flying the flannel), too much text would be duplicated. Instead, we will note platform differences where necessary.

We mentioned earlier that our meta system was by definition capable of creating broadcast-quality digital video. Let's now give this a more practical perspective. Whether you have a desk full of new computer and video gear, or just a basic 386 or 030 machine and a two-head VCR, it is possible that you don't really know your system's actual movie making potential.

If an ideal desktop production suite—our meta system—is defined with enough granularity, you can use it as a frame of reference to spot holes in your own system. In other words, if we calibrate our meta system to create a movie with particular attributes, you can compare this new configuration to your own system. You can then configure or upgrade your system to confidently produce movies with those desired attributes.

The Core System

Our meta system has four core components for digitizing video that cannot be reduced further:

1. *CPU:* The computer's central processing unit. Windows machines are assumed to have a sound card and speakers installed, though not required for video-only capture.
2. *Capture Card:* The hardware that converts an analog signal to digital video.
3. *Mass Storage Medium:* A big hard drive for holding freshly captured video sequences.
4. *Video Source:* A VCR, video camera, or laser disc player.

This meta system is shown in Figure 4.3.

Of course, the boxes in the diagram do not reflect the way real equipment is connected. In a physical system, the capture card would be inside the CPU. So might the hard drive used for storing captured sequences, but not necessarily. Again, these components are all you need to capture and store a video sequence—but you must have all of them.

Figure 4.3
The Core Meta System

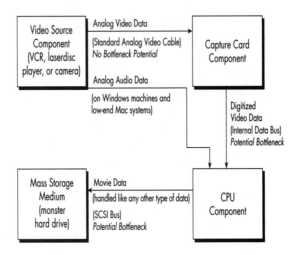

In a working production system, there will likely be some additional non-core equipment, such as a CD-ROM reader, a CD-ROM writer, an analog video monitor, and so forth. These elements are not as performance critical as the core pieces, but it may be helpful to show them as an overlay to the core system, as illustrated in Figure 4.4.

Equal in importance to the meta system components are the data pathways between them. This is a place where bottlenecks are often revealed. Figure 4.3 contains annotations at the component connection points where data rate efficiency may affect capture performance. Also shown is the direction of the data flow. Appreciating both the components and their connection

Figure 4.4
Peripheral Equipment Overlaid on the Core Meta System

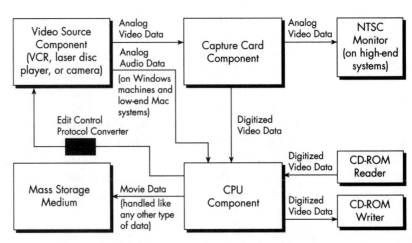

channels is essential to understanding the meta system as a whole.

As a quick example of how we will use this model, let's plug in some real equipment. We'll make our objective modest: a 10-second AVI/Indeo movie, 160 x 120 frame size, 12 frames per second, 16-bit color, 11.025 Khz sound. This is actually slightly below our standard for desktop video, but it is only a slam dunk illustration.

The *CPU* choice is easy, unless you are working in a production shop with a variety of platforms. In that case, any machine that the capture card will accept is appropriate. If your capture suite includes only a single PC, we assume you've got the desktop video habit bad enough to have scored a lean and mean CPU.

For the *capture card*, we'll select the Creative Labs Video Spigot board. We know that this card can adequately digitize movies that meet the above specifications. We also know that, unlike some high-end cards (mostly Mac-based), the audio signal from the VCR must go through the PC's sound card. This is true for most, if not all, Windows capture systems.

Normally, we would have to do some math in regard to the *Mass Storage Medium* component, but since this is a quick example we'll just provide the answer here. For a movie with the attributes mentioned earlier, approximately 1.1Mb of storage space is required. Capturing with the Indeo codec involves a relatively modest mass storage requirement.

If we were capturing in raw format for offline compression with, say, the CinePak compressor, a simple calculation would determine that the storage space required for the raw movie file had increased significantly and could exceed your current hard drive capacity. Recognizing this potential problem in advance can save you a world of aggravation.

We know that a consumer quality VHS machine can be employed in the *video source* role because the general movie attributes are modest enough for even the lowest of the low-end capture card to deliver when it is fed the video signal. Any

garden variety VCR will do, as long as it has jacks for audio out and video out.

Figure 4.5 shows what the meta system looks like with this real gear plugged in and the connection points more precisely annotated. As you make more and more movies, you will develop a feel for which components will cause you trouble and which ones won't. But whenever you take on an unusually ambitious production, it would be a good idea to map it out in advance using the meta system model.

You may have noticed that no aesthetic standards are addressed by our meta system. In other words, we can't use it to determine the feasibility of making a movie of X dimensions, Y frames per second, *and* of very high image quality with precision-tooled lip synching. The meta system is meant to be a quantitative modeling tool only. However, there are other ways to ensure that movies look and perform as well as possible, which we'll cover in Part 3.

The purpose of this example was to determine whether a proposed physical system could readily create a target movie before we ever even touched the record button. As noted earlier, we know the abstract meta system can produce any kind of movie we want. By replacing each of its generic parts with specific products of known capabilities, we can confidently make our determination.

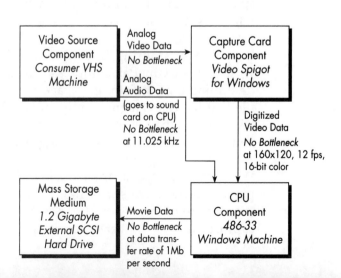

Figure 4.5 Meta System Template with Real Equipment and Connection Point Data

Before we get into actual product descriptions in the next several chapters, let's detail the function of each of the meta system's generic components. When we put the meta system to work later, each component type will receive a more detailed treatment as brand name examples are plugged in.

The CPU Component

In desktop video systems in general, we already know that the CPU controls a rather decentralized domain. Chapter 2 showed us how even the best machine will play good movies poorly if it is getting them off a slow CD-ROM drive. But now we are interested in the movie *making* side of things, where processor speed *is* important, especially in compression and data rate adjustment.

The CPU's role in the meta system is to encode movie data and keep the system in synch during the digitization process. A slower CPU will capture less data and produce fewer frames for your desktop movie. In this sense, it is a potential bottleneck. For serious desktop video production, a 486 or 040 class machine (or better) is the way to go. Figure 4.6 puts this component in complete perspective.

As a Windows producer, you are seriously encouraged to go all the way to a 486 DX2 66 with at least 16Mb of fast RAM and local bus video (based on current but quickly changing pricing trends as this book is written). In so doing, you will free your CPU from being a possible bottleneck in the meta system.

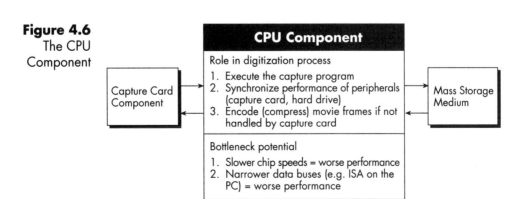

Figure 4.6
The CPU Component

This recommendation applies to desktop video (as we have defined it) and more. For the record, we believe that the premium *presently* commanded by a Pentium system is not worth it, although this could change. Stick with the 486 DX2 66. You will not regret it until the PowerPC is available or the Pentium loses its cachet.

Let your audience agonize over the hardware purchasing decisions. You know you *need* that extra processing power, and we're as cynical about this stuff as they come. The important thing to remember is that powerful hardware saves time, and you can expect to have less time than money once you really get into this.

As a Macintosh producer, the same arguments generally apply for the Quadra 800 or 840AV versus the high end Mac II and (now discontinued) Centris lines.

There are a couple of other things to consider in describing the function of this component group. For instance, the CPU is responsible for processing audio. Unlike on the Mac, this is uniformly handled on the PC by installing a third-party sound card such as the Sound Blaster or the ProAudio Spectrum. We'll assume all Windows CPUs used in our models have such boards installed.

Also unlike the Mac, there is very little software for Windows machines that will control a professional grade VTR for frame-accurate capture. On the Macintosh, this is a viable alternative to investing in a top-of-the-line capture card. For now, this will remain an issue addressed by the capture card component group.

The Capture Card Component

The capture card is the most conspicuous potential bottleneck in the meta system, and for good reason. It's sole function, at least on Windows machines, is to digitize the incoming video signal, as illustrated in Figure 4.7. Fortunately, capture card capabilities are usually well established and easy to verify with a few test captures. Also, they are relatively cheap on the Windows side (although some of high-end cards are now shipping).

Figure 4.7
The Capture Card Component

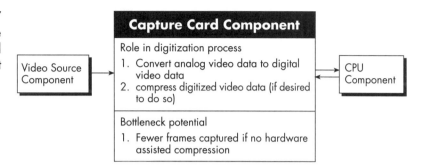

If you are just getting into desktop video, we recommend that you hold off spending big money on a capture card right away. A fast CPU and big hard drive should come first, especially if you are going to be making longer movies. Since the gulf between the low- and medium-priced PC cards is small (two to three hundred dollars), and the performance of the medium-level cards is more than adequate for our desktop video standard, we advise you to buy in the medium range. Wait until you absolutely need it before shelling out for the take-no-prisoners model.

Since the capture card component's only system interface is to the CPU, its role is very well defined. If it can't deliver the attributes required for a given movie, you should replace it or relax your requirements to match the capability of the card. If you start with a card such as the Intel Smart Video Recorder (for Windows) or the Sigma Designs Movie Movie (for the Mac), you can rescue this generic component from potential bottleneck status—at least for our desktop video standard.

The Mass Storage Medium Component

Like the capture card component, the mass storage medium component is fairly one dimensional, as shown in Figure 4.8. We are almost exclusively talking about good old fashioned hard disks here. Either your hard drive is big enough to hold gargantuan movie files or it isn't. In fulfilling its role, this component will not affect the quality of your movies—just their length. From a production standpoint, anything under one

Figure 4.8
The Mass Storage Medium Component

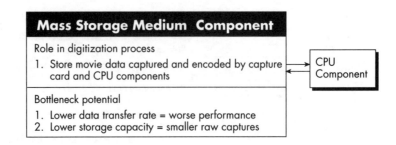

gigabyte in capacity will eventually become a bottleneck.

We suggest you save procuring a mass storage medium for last (assuming you have a few megabytes free on your current hard drive) unless you are jumping into a major project right off the bat (not advisable until you have your production suite completely tuned). Once you capture a few uncompressed movies and note their sizes, you will be in a better position to judge the relative importance of this component to your system.

The Video Source Component

From one perspective, the video source is the most uncomplicated part of our meta system. As seen in Figure 4.9, its role is simply to supply analog video to our capture card component. Whether it's from a VCR, a laser disc player, or a video camera, the signal coming through the cable from the video source will be digitized according to the movie attributes specified at the start of the capture session.

Within the context of the meta system, the sophistication of the video source component has no effect on the ability of the other components to physically create desktop video movies. In other words, it just supplies the analog signal and lets the rest of the system take it from there. As noted earlier, some high-end video decks can be controlled by the CPU via a serial connection, but so far this capability is more developed on the Mac.

From another perspective, the video source component can be the most bedeviling part of the meta system (if you let it). Although you can get the movies you ask for in terms of quantifiable attributes, you might never get the aesthetic quality you

Figure 4.9
The Video Source Component

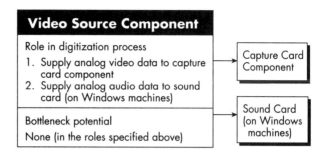

desire. High-quality source material on high-quality storage media is the key to great looking desktop video, and you can get progressively closer to your goal by climbing the analog video quality ladder (from VHS to Betacam SP).

Macintosh Systems

USING ANY MAC TO MAKE MOVIES INVOLVES MAKING SURE ALL SYSTEM AREAS ARE SET TO DELIVER PEAK PERFORMANCE.

If you come from the DOS/Windows world and are not familiar with the inner workings of the Macintosh, a few basics as they relate to Mac-based desktop video are presented for you in this chapter. Although Intel-based computers running Windows 3.1 are rapidly closing in on the Mac in terms of capability and ease of use, the Mac remains the top choice for making movies in many professional developers' minds.

As you put together a production suite, you should remember that the original digital video standard was QuickTime. It started out on the Macintosh and is still one of Apple's crown jewel technologies (at least for the time being). By the way, Macs crash just as often as Windows boxes, especially when running multimedia software.

In this chapter, we will look at:

- Macintosh hardware advantages
- The types of Macs suitable for handling desktop video
- The hype surrounding the new PowerPC Mac
- How to tune your Mac for efficient capturing

 Chapter 5 Macintosh Systems

Figure 5.1
A Quadra
840AV
(on the right)

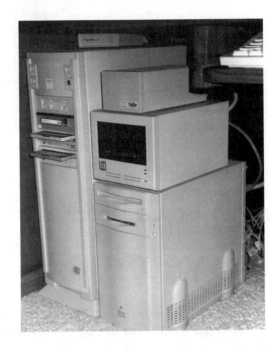

Technically, most Macs capture natively at either 11.127 Khz or 22.254 Khz. Since these values are commonly expressed as 11.025 Khz and 22.05 Khz by cross platform developers, we'll observe that convention throughout this book. Figure 5.1 shows a high-end Mac with a couple of hard-drives attached. The Mac's principal hardware advantages over Intel-based PCs are:

- The Mac's built-in 8-bit color adapter (256 colors) is mature and looks the same on all Macs. By contrast, most video card manufacturers for DOS machines supply their own Windows drivers. The 8-bit ones vary greatly in quality, and it's still an 8-bit world for the majority of Windows users who will be viewing your movies. 24-bit color (so-called *true color*) is also handled more consistently on the Mac.
- The Mac doesn't need a sound card or, necessarily, external speakers. Its internal sound chip can both record and play back at 8-bit, 11.025 Khz and 22.05 Khz audio quality (the higher-end Macs can even do stereo). Better yet, the recently released Sound Manager 3.0 gives the Macintosh 44.1 Khz (CD quality) audio capability. Also, sound control and editing software is currently much more advanced on the Mac (should you plan to labor over your soundtracks).

- The Mac has SCSI capability built in. This is extremely useful when attaching CD-ROM drives, monster external hard disks (for capturing raw movie data), and removable media drives such as Syquest devices (for backing up and transporting movie files). The Quadra 950 actually has two internal SCSI buses. Getting external SCSI devices to work on DOS machines is basically a crime against nature and not recommended for the faint of heart (due mainly to the myriad of jumpers needing adjustment on most SCSI adapter cards at installation time).

Fewer Bucks for the Bang

It is difficult to talk about meaningful price/performance ratios for Mac equipment when costs are not stable (as of this writing). Fortunately for the desktop movie producer, those numbers seem to keep coming down, recently within range of their DOS-based counterparts. As mentioned earlier, serious desktop producers will not be satisfied with anything less than a Quadra, *especially* at their new low prices. Dedicated amateurs may find the now-discontinued Centris line sufficient for their needs.

Once you could start with, say, a Mac IIci and achieve Quadra performance (in production areas like frame capture and effects processing) by adding in the right accelerator, for a lower total cost. Now you should just buy a Quadra, if you take the Apple road, and skip the workarounds.

Apple now seems to support seven Quadra models, having retired the numbers 700 and 900. Until recently, it also supported three Centris machines (they're now called Quadras). The capabilities of the main players are covered here:

- *The Quadra 610* Apple's bottom end of the 040 desktop line. The 610 is not recommended as a desktop video production machine due to its pizza box design, which makes it hard to handle third-party capture cards. Specs: 20 Mhz 040 processor, 68Mb maximum RAM capacity, one NuBus slot.
- *The Quadra 650* The 650 is perfectly acceptable as a low end CPU solution for a capture suite. Specs: 25 Mhz 040 processor, 132Mb maximum RAM capacity, three NuBus slots.

- *The Quadras 660AV* The 660AV (the AV is for *audio/visual*) is a hot machine enjoying most of the audio and video enhancements of the 840AV, but still hobbled by its packaging (same as the Quadra 610). It's a hard call to make, but we can't recommend this machine for video production if you want smooth 320-by-240 movies and above (since it can't accommodate a high-end capture card). Specs: 25 Mhz 040 processor, 68Mb maximum RAM capacity, one NuBus slot.
- *The Quadra 700* Discontinued. Still a formidable machine and probably available at a bargain price if you can find one for sale. Unfortunately, the 700 has no upgrade path. Specs: 25 Mhz 040 processor, 20Mb maximum RAM capacity, two NuBus slots.
- *The Quadra 900* Discontinued. Like the 700, the 900 is still a viable desktop video maker, and upgradeable to the 950. Specs: 25 Mhz 040 processor, 64Mb maximum RAM capacity, five NuBus slots.
- *The Quadra 950* The 950 is the only choice for some ultra high end digital video systems because of its five NuBus slots. Reported by real users in the trenches to be more stable than the 800 and 840AV. Specs: 33 Mhz 040 processor, 128Mb maximum RAM capacity, five NuBus slots.
- *The Quadra 800* The 800 is the original hot rod of the Quadra series, reportedly faster than the 950 (even though the CPU is rated the same), but with fewer NuBus slots. Specs: 33 Mhz 040 processor, 136Mb maximum RAM capacity, 3 NuBus slots.
- *The Quadra 840AV* Formerly code named the *Cyclone* (the Centris 660AV was called the *Tempest*), the 840AV is a completely redesigned Macintosh and the fastest desktop computer yet made by Apple. Connectors for both composite and S-video are built into the backplane, and you can even get D-2 video output (a type of high-quality, true digital video) with a special connector. In other words, you can now capture QuickTime movies without a third-party capture board (but only at 160-by-120 if you want acceptable frame rates). Another exciting feature is the use of an onboard AT&T 3210 DSP (*digital signal processing*) chip to handle audio digitization/compression and telephony. Unfortunately, this DSP chip causes conflicts with the audio digitizer chips on some third-party capture cards, such as the Radius Video Vision.

Your best bet is to call the card manufacturers before you buy their products. Also, the 840AV's single SCSI bus can be a problem when the machine is hooked up to a disk array (unlike the Quadra 950). And all third-party software will have to be rewritten to take full advantage of these new features. Specs: 40 Mhz 040 processor, 136Mb maximum RAM capacity, 3 NuBus slots.

Bring Out Your Dead

If you already have an older, sub-Quadra computer and are determined to upgrade, there are a few things you should know. For starters, the Radius Rocket accelerator board is incompatible with QuickTime—specifically QuickTime sound input. Version 1.5 of RocketWare does not fix all of the problems, despite claims to the contrary. This is unfortunate, because the Rocket 33 is otherwise a formidable and easy-to-install performance booster (it is actually functionally equivalent to a Quadra 950).

Also, any booster card, such as the DayStar FastCache or PowerCache, the Impulse Performance/040, and even Apple's logic board upgrades, can strain the power supply of the older members of the Mac II family. One configuration that we tested extensively with good results was a Mac IIci with the Radius Video Vision Studio and a DayStar 40Mhz Turbo 040. While it didn't achieve Quadra quality when full motion, full screen captures were attempted, lesser settings (240-by-480, 15 fps) produced satisfactory results. Also, the DayStar product was extremely useful in speeding up MovieShop when we optimized movies for CD-ROM playback.

For mere *playing* of movies, the Quadra 610 and the LC III are still adequate and nice to have around as test machines representing your mass audience. So are some of the now discontinued models such as the Mac IIci, Mac IIcx, and Mac IIfx, as well as the Performa 600 and the PowerBook Duos. (The Quadra 650 is actually an acceptable candidate for the CPU in a lower-end capture suite.)

If you buy a low-end capture card to use in these types of machines, you will not make *bad* movies, you will just feel dis-

appointed when you compare them to better looking sequences made faster on more powerful platforms. In other words, don't cut corners on something you will spend a lot of time with.

For the record, QuickTime movies will run on PowerBooks, but the best thing that can be said about them under these conditions is that they don't sound bad. To be fair, we have seen some movies running on the Mac PowerBook 165c (the color machine) that actually looked pretty good, considering.

Beyond Here Lie Monsters

Currently, the publicity mill is working at peak capacity on a new contender: the PowerPC. The PowerPC *chip*, co-developed by Apple, IBM, and Motorola, is the RISC-based, so-called *Pentium killer* that will allegedly drive both IBM and Apple desktop computers faster than Intel's top-of-the-line chip. The PowerPC Macintosh has been announced as Apple's initial foray into this arena.

The truly remarkable thing about this product is its price: reportedly $3,500 for the stripped-down version. Given Apple's new pricing policies and the reported low price of the chip, perhaps this is possible. Although the PowerPC Macintosh is supposed to be able to run Pink, NextStep, *and* System 7, the latter will have to be rewritten to run native. Some publications are discussing emulation layers but speculate that such a solution would force the machine to run at sub-Quadra speeds.

A lot of care is apparently being taken not to alienate the installed base of Macintosh users and developers by making their favorite software difficult to run on the PowerPC Mac. The promise is, of course, that the hardware will be powerful enough to provide a quantum leap in desktop video standards once the software matures.

System Tuning

Using any Mac to make movies involves making sure all system areas are set to deliver peak performance. Some of these settings may seem unnecessary if you are getting exactly the results you want, but knowing you have cleared the decks for action according to a proven checklist will free you to concentrate on other types of problems when they inevitably arise:

1. Install as much fast RAM as you can afford and use a RAM disk for short captures. The version of System 7.1 shipped with some Quadras has a memory control panel option that lets you do this. Otherwise, separate RAM disk software is very easy to come by.
2. Optimize your hard drive as often as possible with a product such as Norton Speed Disk.
3. Turn off all unnecessary extensions, especially network software, print spoolers, screen savers, and Apple Talk.
4. Unload all programs except your capture application.
5. In the memory control panel, turn virtual memory off. You don't want to be paging *and* trying to write out your movie data to contiguous sectors both at the same time.
6. Also in the memory control panel, give yourself as big a disk cache as the system will allow, especially for shorter captures. The 32-bit addressing switch is not as crucial as the first two, but you should turn it on if you want access to more than eight megs of RAM (assuming you have it available).

Mac Capture Cards

SCORING A DEATH STAR CAPTURE CARD FOR A DESKTOP VIDEO SYSTEM CAN COMPLICATE—RATHER THAN SIMPLIFY—YOUR LIFE.

For all its multimedia strengths, including shipping QuickTime with System 7.1, the Macintosh still requires dedicated add-on hardware to digitize video for all models except the recently introduced Quadra 840AV and Quadra 660AV. In the early days, few choices were available for capture cards. You either used SuperMac's Video Spigot or one of the several high end boards. The scene is changing now that these two extremes are converging and even more uptown and lower-end gear is becoming available.

It is now time for you to consider your needs. Whether you are an off-line editor converting to desktop video at work, or a desktop video producer bent on making and circulating cool QuickTime and AVI movies, you'll benefit from the capture technology presented in this chapter. It is exhilarating to aim for the high end and play 640-by-480, 30-fps productions on your system, but you should make sure you put a system together that really meets your needs and fits your budget.

In this chapter, you'll see:

- The differences between high-end and low-end Mac capture cards
- How the different cards conform to our desktop video standard
- Additional performance considerations for high-end cards

The reason we cover high-end capture cards for the desktop video producer is three-fold. First, the ones covered here are well-known, relatively mature products. Second, when used for making desktop video movies (as opposed to full-screen, full-motion movies) they perform their jobs without breaking a sweat; this is important to know if you're creating professional productions. Third, once you get your system tuned up, you are going to want one. You can justify this to yourself by putting it in an educational context: Experimenting with larger than desktop-sized captures exposes many of the limitations we've discussed so far.

By its nature, this book cannot hope to be an exhaustive hardware reference. This is especially true as new digitization gear hits the street almost monthly. Our focus is therefore on established equipment that has earned a good reputation. If you need to know about announced, but unreleased, hardware, we suggest you contact the manufacturer directly or pick up some of the magazines that cover this beat in detail, such as *New Media*, *Videography*, and *Digital Video*.

The Holy Trinity

From a consumer viewpoint, there are currently three recognized heavyweights: the Radius Video Vision Studio, SuperMac's Digital Film, and the RasterOps Editing Aces Suite. Also in the ring is the New Video EyeQ board, but it doesn't compete in the user market the same way as these other three products. Nevertheless, we'll give it the same level of coverage as the big three.

Aside from price constraints for our three heavyweights, there are other issues worth considering. For example, while all three will work on sub-Quadra computers, the Quadra 800, 840AV, and 950 are the true vehicles for such high-end capture boards. With lesser machines, you can try acceleration or other performance-boosting strategies, but when problems arise there are more suspects to interrogate. When the 840AV debuted, reports of conflicts with some third-party capture boards surfaced. We presume these were resolved, but you should contact the manufacturer of your chosen board prior to purchase just to make sure.

The point is that scoring a death star capture card for a desktop video system can easily complicate—rather than simplify—your life. Pretty soon you'll be thinking seriously about hard disk arrays and video stabilization equipment. Again, using the meta system described in Chapter 4 can reveal the implications of a significant component upgrade before you shell out for it. Knowing the potential bottlenecks in advance will help you to spend your money more wisely.

Even if you upgrade the rest of your system to keep up with a powerhouse digitizer, you should not expect flawless performance right out of the box. We have seen distorted images, garbled sound, and other quality busters on even the simplest configurations of high-end equipment striving for full-screen, full-motion performance. Most of these problems were eventually resolved, but only after intensive troubleshooting. It is easy to forget that this equipment, expensive as it may be, is still pushing the limits of personal computer technology.

Let's review our standards here, as we will again in the chapter on Windows capture cards. A Mac capture board must be able to digitize at least 10 frames per second, at a frame size of 240-by-180 pixels, with 24-bit color (true color), and 22.05Khz sound to create sequences that fit our *desktop video* profile, and thus be eligible for consideration in the digitization techniques section of this book. If a board meets these specifications, we will take it seriously as a candidate for inclusion in our base movie production suite for the Macintosh.

Before we begin, however, perhaps another jargon review is in order. Here are some terms we'll be using in the reviews that follow:

Breakout Box: An external device, connected to a digitizer card (usually by a single cable), to which *several* video and audio cables may be attached. Using a breakout box eliminates you having to plug the cables directly into the card itself. It can also be useful when you want to switch easily between video sources and mix multiple audio signals. Some breakout boxes have connectors for

	serial cables as well (for genlock and external device control).
Daughter Card:	An add-in circuit board that plugs into another card instead of the computer's motherboard. Daughter cards are usually designed so that they do not infringe on the space of adjacent boards, but sometimes things can get fairly snug.
Frames vs. Fields:	In analog video, a frame is broken down into two fields. One field contains the even scan lines of the frame, the other the odd lines. When the electron gun renders a frame, it does so in two passes, thus combining both fields. Some capture cards digitize only one of those fields—others do both. The difference can be dramatic when the movie is played.
SMPTE:	Society of Motion Picture and Television Experts. SMPTE (pronounced "*simp*tee") is a frame-accurate time code used by professional analog video editors. More recently, it has found its way into digital video, multimedia, and MIDI-based products. We cover SMPTE in greater detail in the chapter on video hardware standards.

SuperMac Digital Film

The SuperMac Digital Film solution is a NuBus board employing hardware-assisted JPEG compression and comes with an associated breakout box, as shown in Figure 6.1. Resurrected after a false start and a recall, the new Digital Film product carries a suggested retail price of $4,999, placing itself out of the budget for all but the most serious desktop digitizers. A special playback-only Digital Film card is also available from SuperMac for $2,499.

But you get what you pay for: high encoding quality at 640-by-480 pixels, 30 fps for both recording *and* playback (using Digital Film's proprietary codec) of QuickTime movies, output back to

Figure 6.1
The Digital Film Board (with Breakout Box)

video tape at these specs, XCMD control (for playback control from within authoring programs), and the DQ-TimeCoder from DiaQuest, which stamps SMPTE time code on each captured frame.

The features noted above are really of more value to people doing off-line (creating edit lists using copies of original footage, prior to assembling masters of commercial video productions) and industrial work, but they allow the Digital Film board to straddle both the desktop video and true digital video worlds. Unfortunately, the card only supports 8-bit sound. As of this writing, the product is bundled with Adobe's Premiere and Aldus' After Effects.

Unlike the Radius Video Vision card, the Digital Film board (and the RasterOps Editing Aces solution) only digitizes a single field of every frame it captures. This is significant because, as mentioned previously, an analog video frame is composed of two integrated fields. The result is a slightly fuzzy look, especially in action sequences and when outputting back to video tape, since both boards (Digital Film and Editing Aces) have to double the scan lines comprising the captured field (to fill out the 640-by-480 frame) prior to displaying it on the screen or printing it to tape.

Digital Film is actually slightly superior to MoviePak in this area because the RasterOps product only digitizes half of the horizontal data in a captured field (it is optimized to capture at 320-by-240) while Digital Film captures the complete horizontal dimension of the field. Remember, we are still talking about full screen desktop video here.

For further information, you can call SuperMac at: (408) 541-6100.

Radius Video Vision

The original and still-supported high-end movie capture board from Radius is the Video Vision, which now carries a price of $1,899. The deluxe version of this product includes a daughter card, and is called the Video Vision Studio ($4,495), shown in Figure 6.2. It delivers the de rigueur 640-by-480, 30 fps using JPEG compression technology. The daughter card upgrade to the original Video Vision is currently $1,999.

The Video Vision solution is a NuBus card that comes with a versatile breakout box sporting two input ports and one output port (for printing to video tape) for both composite and S-video (and audio), as well as one audio-only stereo input port for

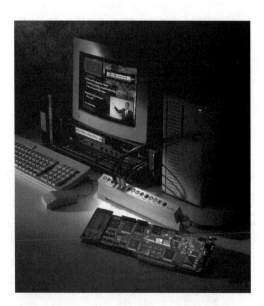

Figure 6.2
The Radius Video Vision Studio

sound mixing, and a serial connector for external hardware sources (for instance, genlock).

If installed in a Quadra, the Video Vision card can be upgraded with the daughter card attached to its H-Bus expansion connector to give it the same capability as the off-the-rack Video Vision Studio product. A Mac IIci equipped with the Radius Rocket and SCSI-2 Booster is reported by Radius to be similarly upgradeable to the same performance level, although the IIci will work with the basic Video Vision card to make excellent 240-by-180, 15-fps movies. Remember to contact Radius about possible conflicts between QuickTime and the Rocket.

Because it does true 640-by-480, 30-fps captures (with both fields captured for each frame), the Video Vision Studio delivers the best quality movies when it outputs to tape. The drawback is that the resulting files are much bigger than those of its peers (Digital Film and Editing Aces). In truth, the card is almost a wasted miracle at full-screen, full-motion settings unless you are using it with a hard disk array. The same applies for the Digital Film board and, to a lesser extent, the Editing Aces solution.

Some other attributes worth mentioning about the Radius product are:

- A convolution circuit to eliminate flicker
- An Adobe Photoshop plug-in for acquiring video still images
- An Adobe Premiere plug-in for playing movies via Video Vision Studio
- A standalone player application that also makes use of the card for hardware-assisted playback

Currently bundled with Adobe Premiere and Video Fusion, the Video Vision card is considered to be a real workhorse among its peers, and Radius has aggressively marketed and supported it. Even without the daughter card, it sets a performance standard in its class. We highly recommend this board.

For further information, you can call Radius at: (408) 434-1010.

RasterOps Editing Aces Suite

The RasterOps family of products—24STV, 24MxTV, 24XLTV, MovieTime, and MediaTime boards—take a different approach. The company maintains that a 320-by-240 movie size is the de facto standard for desktop video QuickTime because it provides the cleanest sizing algorithm and is most appropriate for CD-ROM distribution.

The RasterOps MoviePak daughter card ($999), when attached to any of the above cards, can capture 320-by-240 at 30 fps in 24-bit color using JPEG compression. What you get in return for reduced movie size is CD-quality audio digitizing (16-bit, 44.1Khz), a feature not shared with its peers (Digital Film and Video Vision, which only digitize 8-bit, 22.05Khz stereo sound).

The current flagship configuration from RasterOps, depicted in Figure 6.3, is called the Editing Aces Suite. It is a combination of the MediaTime board, MoviePak, and the Video Expander NTSC converter for printing to video tape. (You should note that the MediaTime product is the only card in the RasterOps capture board family that includes sound capture.) Also included in the package is a proprietary player program that uses MoviePak for hardware-assisted playback of movies encoded with the RasterOps propriety codec.

Figure 6.3
The Editing Aces Suite from RasterOps

The Editing Aces Suite comes bundled with Adobe Premiere. For some reason, the RasterOps boards have not found the same market as the SuperMac and Radius products, perhaps simply due to less aggressive marketing. In situations where full-screen output to video tape is not necessary, however, they are excellent choices for making high-quality desktop movies with superior sound.

For further information, you can call RasterOps at: (408) 562-4200.

New Video EyeQ 2.0

New Video EyeQ 2.0 differs from Digital Film, Video Vision, and the Editing Aces Suite in a number of significant ways. First, it is not composed of a single board. Second, it does not capture movies into the QuickTime format directly. Finally, it does not use JPEG compression. Price-wise, it is still in the same league: $4,495. A playback-only version is available for $2,495.

Although an outsider in some ways, the EyeQ solution is still a contender (see Figure 6.4). Like the RasterOps Editing Aces Suite,

Figure 6.4 The New Video EyeQ 2.0

its maximum capture size is 320-by-240, with audio capture going up to 16-bit stereo at 32Khz (near-CD quality). Another similarity is that the EyeQ board is not meant to be used for printing to videotape. It is much more suited to capturing desktop video for CD-ROM distribution.

Interestingly, the EyeQ is based on the Intel DVI (*Digital Video Interactive*) standard. The capture product consists of an Apple 8-bit video card (with some modifications) cabled to a separate board with an Intel i750 chip and a daughter card called the Capture Adapter. The playback product simply eliminates the Capture Adapter.

Both cards plug into adjacent slots on the Macintosh. The additional board is responsible for treating the 8-bit color from the modified Apple video card as 24-bit color for movie playback. S-video and composite video inputs are provided, as well as stereo ins for audio. Unlike the big three, you won't lust after a hard disk array quite so fast with this product.

Movie files are captured into the DVI format AVSS (Audio/Video Support System). They can be converted to QuickTime movies with a New Video application called EyeQ Movie Convert. The company has also released a Premiere plug-in to export QuickTime movies out to the AVSS format.

In general, EyeQ movies are smaller than average. This is because the product digitizes significantly less data when capturing a movie. While quality takes a hit, those captured movies can be played on Intel-based PCs without conversion. Also, New Video provides software-only versions of its hardware-imbedded codecs so that EyeQ movies can play on machines without the EyeQ boards (performance suffers accordingly).

The product currently ships with Premiere, VideoShop, and VideoFusion.

For further information, you can call New Video at: (310) 449-7000.

SuperMac Video Spigot

The Spigot for the Mac currently ships in no less than seven different flavors with suggested retail prices ranging from $279 for the LC version to $1,299 for the Spigot and Sound Pro NuBus. (Not all versions come with sound capability, but that is easy to work around with third-party products.) There are even special versions for the si and the LC. The Video Spigot for the Mac is shown in Figure 6.5.

What the Spigot does not do is digitize directly to the QuickTime movie format. It uses a program called ScreenPlay (included in the package) to capture movies in a *proprietary* format, then lets you bring those files into Adobe Premiere, which is bundled with the Spigot. You can play your sequences back using ScreenPlay, but not with the QuickTime Movie Player program—unless you save them specifically as QuickTime moves. The overall documentation is only fair.

To its credit, the Spigot is easy to install and use (like most Mac hardware), comes bundled with Adobe Premiere, and facilitates capture to a RAM disk—you can capture a 45-second sequence at 15 fps, 160-by-120, in a 16Mb RAM disk without dropping any frames using ScreenPlay.

Figure 6.5
The Video Spigot for the Mac

Chapter 6 Mac Capture Cards

Many of the early CD-ROM products that contained video were made using the Spigot, but most professional desktop video production houses have moved on to higher ground. It is interesting to note that SuperMac also produces the Windows version of the Video Spigot but then leaves the marketing to Creative Labs.

For further information, you can call SuperMac at: (408) 541-6100.

Sigma Designs Movie Movie

A new, lower-end solution (see Figure 6.6), the Sigma Movie Movie card has several strengths and weaknesses. Priced at $349, it is easy to install and operate. Because Movie Movie is not full length, it may be used on the pizza box Quadras (610 and 660AV) via an angle bracket NuBus adapter (available through Apple dealers at Apple peripheral prices). Although it has an RCA audio input connector, Movie Movie only accepts composite video (not S-video) which is displayed via analog passthrough by the Movie Movie software. The documentation highlights the fact that you can use the card to watch television.

On the software side, there are three drawbacks. The first is that the QuickTime Movie Recorder does not recognize the Movie

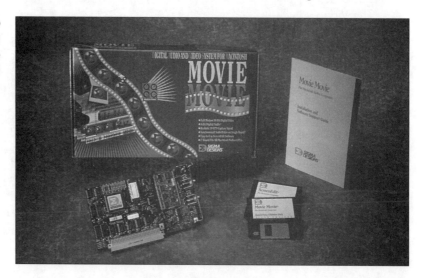

Figure 6.6
The Sigma Movie Movie Board

Movie card. A proprietary capture program is used instead, like with the Video Spigot. Second, the proprietary movie capture software used instead only allows for capture sizes of 320x240 and 160x120. This is notable because a common CinePak movie frame size is 240-by-180. Third, color depth support ends at 16-bit.

Although the Movie Movie card gives the Spigot some serious competition, the lack of 240-by-180 frame size support is a critical problem. Also, the documentation is misleading in spots. Overall, however, it is recommended as a viable low-end solution.

For further information, you can call Sigma Designs at: (510) 770-0100.

PC Systems

USING ACCELERATORS OR MAKING LOGIC BOARD UPGRADES TO A PC ISN'T THE SAME AS IT IS ON THE MAC.

Intel-based PCs are classified by their processor families and clock speeds (for example the 386/25Mhz versus the 486/33Mhz). Macs, on the other hand, are organized into dynasties wherein certain product lines can encompass different CPUs. In a way, this makes it easier to be specific when suggesting CPU standards for IBM-compatible, PC-based systems.

Unlike on the Mac, PCs have two popular standards of near-system software for playing movies: QuickTime for Windows and Video for Windows. Each places slightly different demands on a system's hardware. Like on the Mac, there is a difference between horse power requirements for simply watching movies as opposed to producing them (without losing your patience). As we are getting fond of saying, this book is aimed at people who want to *make* movies.

In this chapter, we will discuss:

- PC hardware advantages
- Types of PCs suitable for handling desktop video
- Differences between the PC data buses
- How to tune your PC for efficient capturing

Naming Your Poison

Let's reiterate what we said in Chapter 4: Your production machine should be at least a 486 DX, preferably a 486 DX2 66 for now, since this is currently the top of the line for non-price-gouging performance. Reputable clone makers such as ALR, Compaq, Dell, Gateway 2000, and Zeos all carry these boxes with prices close enough to make your decision a matter of loyalty or personal taste. No one particular vendor from this highly visible group is known for a bad product, and some offer specific benefits. Zeos, for example, offers machines optimized for performance under Windows and built-in SCSI support on the motherboard (for internal hard drives). Figure 7.1 presents an example of a high-end PC production station.

For best performance, you'll be better served by 16Mb of RAM rather than 8Mb (standard in most popular configurations), and local bus video. This brings up the somewhat complicated issue of bus performance in general: ISA (Industry Standard Architecture) versus EISA (Extended Industry Standard Architec-

Figure 7.1
A High-End PC Production Station

ture) versus MCA (Micro Channel Architecture). Because MCA is mostly the province of IBM hardware, we will concentrate on ISA vs. EISA, mentioning the Micro Channel where appropriate.

Rather than make a hard and fast recommendation, we will instead provide you with enough information so that you can make your own informed decision when choosing a bus type. It should boil down to an easy choice, but there are some trade-offs to be made and some apparent contradictions that come up the deeper you go. Because bus performance is one of the key factors affecting movie performance (in both playback and capture), it is worth exploring this subject in some detail.

Express, Local, and Magic Buses

In the era prior to graphical user interfaces, ISA was considered adequate for standalone PCs and workstations attached to networks. This was because there were very few PC applications that strained ISA bandwidth. When EISA and MCA came along, they became the buses of choice for network servers. They were also believed superior for graphics intensive CAD programs and emerging multimedia applications—and commanded a premium in terms of price. Life was simple then. Now there is desktop video and local bus technology. Figure 7.2 shows a generalized view of bus operation.

As time passed and GUIs began usurping the screens of standalone systems, the original wisdom began to change. Also, the technical issues began to sort themselves out. Specifically:

- You will not benefit from having an EISA bus system unless you have at least one EISA card to take advantage of it. In general, you can slot in as many ISA boards as you want on an EISA machine but you will never get better than ISA performance. The situation is less ambiguous with the Micro Channel, since MCA motherboards only accept MCA cards.
- Data throughput capability is not the only important discriminant when comparing ISA and EISA performance.

Figure 7.2
How Intel-Based
PC Buses
Transfer Data

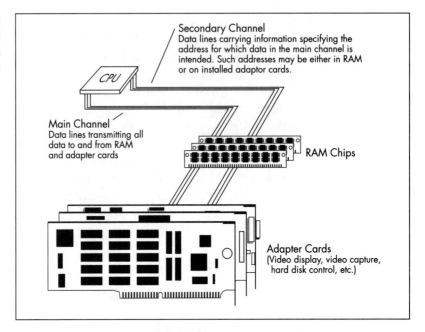

Equally significant is EISA's bus mastering ability. This is when an adapter card takes control of the bus to transfer data, as opposed to letting the CPU do the work. Freeing the CPU for other things (such as decompressing movie frames) while an EISA bus mastering card moves data (off the hard disk, for example) has obvious benefits. In fact, EISA's bus mastering ability can be more important than its increased bandwidth in some cases.

Now for some less sorted out issues. First, with local bus technology, most of the old bets are off. Local bus systems allow local bus peripheral devices, such as video cards, to communicate with the CPU through the same channel as system memory. Besides bypassing the normal expansion bus, peripherals that use the local bus get to talk to the CPU at the CPU's native speed, as opposed to the speed of the expansion bus.

The result is that EISA is no longer automatically superior to ISA. An ISA machine with local bus capability can now deliver similar or better performance than a standard EISA system, depending on the design of the local bus cards (and the operating system and driver software). For the desktop producer, this is an important consideration when putting together a capture suite.

Second, you would think that video capture cards would be ideal candidates for the EISA or local bus. Their manufacturers, however, appear to feel otherwise. All of the PC capture boards we review in the next chapter are ISA cards. Probably this was a marketing decision: board manufacturers want to be compatible with all the machines out there, both ISA and EISA. Making their boards EISA or local bus would mean that ISA machines couldn't use them.

On the other hand, maybe manufacturers realize that playing desktop movies (240-by-180, 12 fps, 16-bit color) will not hit the ISA throughput ceiling before they are limited by storage device throughput rates. If this is true, and ISA-compatible cards are cheaper to produce than EISA or MCA cards, it makes sense for them to be ISA—at least for the time being.

The most basic suggestion we can offer in this new and still changing environment is that ISA is not necessarily the wrong choice for a system that will be capturing and playing back desktop movies as we have defined them (240-by-180, 12 fps, 16-bit color). Just make sure to get local bus video. For movies with significantly larger frame sizes or higher frame rates, ISA will begin to limit system performance.

If you want to do the work to put together an EISA system that will make a significant performance difference, we suggest the following components as a foundation:

- VESA local bus video
- EISA bus mastering hard disk controller, with caching
- ISA cards for the rest of your peripherals, including your capture card, unless you can find compatible EISA alternatives; If your system is networked, make sure your network card is EISA

As this book is being written, the next bus standard is emerging: PCI (Peripheral Component Interconnect). Reportedly, this standard allows for huge amounts of data to be handled via local bus technology, and will be important for both the Apple and Intel-based PC environments. Since our policy is to comment only on hardware and software with which we have personal experience, it is hard to talk about PCI in any further detail. For

more information, we suggest you contact the PCI Local Bus Special Interest Group at (408) 496-0900.

While Pentium machines are now shipping, the premium you will pay at this early stage is much better put toward hard disk space or a better capture card. When Pentium chips are as cheap and plentiful as 486 chips, they will doubtless set a new movie performance standard for the PC-based CPU component, but until then we would like to reserve judgment.

Working on the SCSI Chain Gang

If your system will be your dedicated production station for a while, to which you'll be attaching external SCSI devices such as a CD-ROM drive and large-capacity hard drive (pretty much mandatory for movie production), you should consider an all-SCSI system. We'll discuss SCSI in greater detail in Chapter 9.

An all-SCSI system means your internal hard drive and floppy drives will run from either a SCSI adapter card (such as one of the Adaptec products) or an onboard SCSI adapter such as in the top-of-the-line Zeos PCs (See Figure 7.3). If an all-SCSI system makes you nervous and you want to keep your internal drives under the control of the regular system BIOS while controlling your SCSI gear with device drivers, you can do so, but be prepared for some lip curling at installation time.

For an internal hard disk, either SCSI or nonSCSI, get the largest you can afford. You never know when you might need to transport your system somewhere for a demo, and you'll be glad you set aside a movie staging area on drive C so you don't have to drag along your external drive or CD-ROM player. Just copy over the movies you'll need to your internal drive and you're at least somewhat portable. Anything over 300Mb is a good starting place.

The largest logical drive DOS currently supports is 1024 cylinders (roughly 1 gigabyte), so be prepared to partition anything physically larger. Certain third-party software, such as Adaptec's

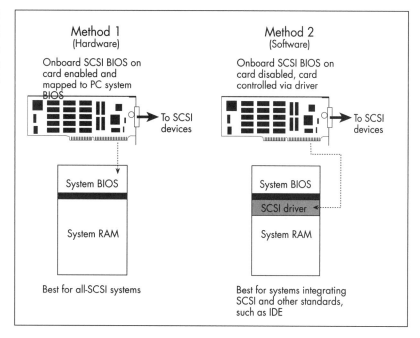

Figure 7.3
How SCSI Works with Normal System BIOS

AFDISK, allows you to work around this limit, but it is not guaranteed to work with all *other* third-party software.

Retrofitting Your PC

Using accelerators or making logic board upgrades to a PC isn't the same as it is on the Mac, either practically or philosophically. Outside of math co-processors and shadow RAM schemes, there is little available for the PC in terms of hardware acceleration. Some exceptions are video cards optimized for Windows, as well as 486 and Pentium upgrade sockets.

In fact, since QuickTime for Windows does not use floating point operations, installing a math co-processor for more efficient movie playing would have no effect on its performance. Unfortunately, we can't say the same thing about Video for Windows with absolute certainty, or about QuickTime on the Mac.

Most PC people upgrade by buying a new CPU and hanging on to their old monitors and peripherals. (Keeping your old machine around for fast-access movie storage can have hidden

benefits.) Putting a new motherboard in an old chassis is generally considered only slightly easier than installing a new transmission in your car. If you're at all serious about making movies, just buy the new system. And forget about getting anything with the letters *SX* attached.

Audio and Video Peripherals

As noted earlier, SVGA and higher graphics under Windows are a lot like national politics: There are many different cultures and interest groups, and some of the more populous are not necessarily the most visible. The key is buying a video card that is supported specifically by the desktop video technology you plan to use it with. For instance, QuickTime for Windows is currently optimized for specific video board chip sets, as shown in Figure 7.4. These chip sets are used in many of the brand name video cards, often in more than one brand.

As it turns out, there is a spate of lower-end cards with marginal 8-bit Windows video drivers (256 colors) that perform poorly enough to detract from the fun of watching a movie. This can be summed up as a palette issue. Later in this book, we will provide you with some solutions for improving the performance of applications that play movies in 8-bit environments. At the moment, the hands down over-achiever in the Windows video card marathon is the Diamond Viper. (For QuickTime for Windows, your current best bet is the ATI Mach 32 card.) Overall, our best advice is to spend a few extra dollars to get an

Figure 7.4
PC Video Card Chip Sets that Work Well with QuickTime for Windows

Adapter	Video Chip	Color Depth	Resolution
Diamond Viper	P9000	8, 16, 24	Up to 1280 x 1024
Diamond Speedster 24X	WD903Cx	8, 16, 24	Up to 1024 x 768
Orchid Farenheit	S3 series	8, 16, 24	Up to 1024 x 768
Orchid Pro-Designer IIGS	ET4000	8, 16	Up to 1024 x 768
ATI Graphics Ultra	Mach 32	8, 16, 24	1280 x 1024

Figure 7.5
The Media Vision Pro Audio Studio Card

assured fit.

The same goes for sound cards. The name players—Creative Labs' Sound Blaster Pro 16 and Media Vision's Pro Audio Spectrum 16—are well tested under both Video for Windows and QuickTime for Windows. Media Vision is reported to have a slight edge in reliability, and is now shipping its most advanced sound board yet, the Pro Audio Studio (See Figure 7.5). One of its features is separate ports for both line level out and headphone level out.

Tuning Your System

As we noted in Chapter 5, optimal movie digitization is not possible unless all system areas are set to deliver peak performance. You may be satisfied with the capture results under your Intel-based PC's current settings, but following a tried and true checklist to poise your machine for frame-grabbing greatness can only make things better. Here's what works for us:

1. Like on the Mac, install as much fast RAM as possible, and use a RAM disk if your captures are short enough. DOS provides a device driver called RAMDRIVE.SYS for this purpose. Make sure all your additional RAM plugs directly into the motherboard, as opposed to the kind that plugs into special ISA cards. Make sure all the new RAM that you add is extended rather than expanded. Windows has no use for expanded memory.

2. Use the latest versions of DOS and Windows.
3. Load DOS high. You can do this in DOS 5 and above. While you're at it, you might as well install DOS' high memory manager and extended memory manager. Assuming you have installed DOS in its own directory off the root of drive C, your CONFIG.SYS file should contain the lines:

DOS=HIGH,UMB
DEVICE=C:\DOS\HIMEM.SYS
DEVICE=C:\DOS\EMM386.EXE

 Loading DOS high gives any application (in this case, Windows) more room to run in *conventional* memory. HIMEM.SYS coordinates programs and device drivers that use extended memory. EMM386 permits you to load other resident programs (besides the DOS components) into memory outside of where applications run. Your DOS documentation provides instructions on how to do this. For even better performance, we recommend that you use a third-party memory manager such as QEMM from Quarterdeck or Qualitias' 386MAX.
4. Optimize your hard disk as often as possible. Norton Speed Disk does a good job of this, although other good products are also available.
5. Use a permanent swap file when you run Windows. This is accomplished with the *386 Enhanced/Virtual Memory* options in the Windows Control Panel. In the System Tuning section in Chapter 5, we recommended that you disable virtual memory prior to capturing movies. Windows works so much better overall with swapping enabled, that it makes sense to keep it on.
6. Close all applications except your capture program (and perhaps your sound mixer). Of course, make sure cycle-sapping software such as network drivers and screen savers are unloaded.
7. Don't capture to drives set up for disk compression.

PC Capture Cards

PC CAPTURE BOARDS CAN MAKE DESKTOP VIDEO MOVIES JUST AS COMPETENTLY AS SIMILARLY CLASSED MAC CARDS CAN.

Unlike on the Mac, Intel-based PC capture boards do not often double as deluxe video cards. They are standalone, dedicated boards that are generally less expensive, but must be carefully set up to work with the PC's DMA, interrupt, and I/O port mappings. Fortunately, their installation programs usually handle all of these issues, but not always. Expect some headaches at first.

In this chapter, you'll learn:

- Why Mac capture cards offer more performance than PC capture cards
- The differences between higher- and lower-end PC capture cards
- How the different cards conform to our desktop video standard

A Different World

You should be aware that since AVI has achieved nowhere near the respect of QuickTime in the professional video world, few of the PC capture cards on the market strive to be taken as dead seriously as their Mac counterparts (nor do they generally save

to the QuickTime for Windows format). This shows in their feature sets and in the advertising.

The high-end Mac boards offer breakout boxes, hardware assistance for playback, and video output ports for printing back to tape. They want to close the gap between desktop video and true digital video. In so doing, they will land a piece of the extremely lucrative post-production video market.

PC capture boards, on the other hand, don't generally acknowledge the standards set by high-end Macs (there are a couple of exceptions). But they can make desktop video movies just as competently as similarly classed Mac cards can. Put them in 486 DX2, 66Mhz environments and they'll do it faster than the flagship Macs. If you have been digitizing on the Mac for any length of time, it is a whole different feeling. On a sports car PC especially, the differences between desktop video, true digital video, and multimedia are all heavily accentuated.

We can begin setting standards here. A PC capture card needs to digitize at least 15 frames per second at 160-by-120 (240-by-180 is much preferred) with 16-bit color and 22.05Khz sound to create sequences that fit our profile for *desktop video* movies. If a board can do this, we'll take it seriously as a candidate for inclusion in our meta system. Two things should be noted:

1. Doing 240-by-180 or better at the rest of our desktop video standards will generally require hardware assistance, such as a special processor or a compressor embedded in the card's chips. Most of the upscale Mac cards have this, which you expect because of their higher prices.
2. Having such hardware available to assist in capture does not mean it will speed up playback, which can be misleading to the consumer.

Two relatively high-end cards sporting such features are being actively marketed to PC users: the Intel Smart Video Recorder (ISVR) and the Media Vision Pro MovieStudio. Brief descriptions of these two products are presented next, along with other boards we have tested.

Intel Smart Video Recorder

A 16-bit, full-length ISA card requiring a 486 CPU, the ISVR shown in Figure 8.1 is easy to install and comes with a daughter board attached that contains an i750 chip to handle compression (it only takes up one slot). This card is actually a descendant of the ActionMedia II, the vehicle for Intel's DVI video standard. Jacks are available for both composite and S-video.

Using the Indeo codec, the ISVR can easily capture 320-by-240 at 15 fps or 160-by-120 at 30 fps, with 24-bit color and 22.05kHz sound without dropping any frames and without frame distortion (if your signal is clean). It can also capture single frames at 640-by-480, but they tend to be a bit on the grainy side.

You should note that the ISVR is hardwired to capture in 24-bit color. If your system is set for 8-bit color, the ISVR automatically builds an optimized palette for better color handling. If you capture using the Indeo codec, the i750 chip provides real time compression capability. Unfortunately, the i750 is not utilized for playback.

Intel has confirmed that they will distribute a Windows application called SMARTCAP.EXE, beginning in February 1994, that will use the Smart Video Recorder to capture movies in either Video for Windows (AVI) or QuickTime for Windows formats.

Figure 8.1
The Intel Smart Video Recorder

The ISVR ships with Video for Windows and comes bundled with Asymetrix Compel, MediaBlitz!, and the GateKeeper CD-ROM. It currently lists for $699. As a workhorse PC capture card, this product comes highly recommended. For further information, you can call Intel at: (800) 538-3373.

Media Vision Pro MovieStudio

Also a 16-bit, half-length ISA card, the Pro MovieStudio shown in Figure 8.2 is the next generation of Media Vision's Pro MovieSpectrum product. Although the RS-422 serial port has been eliminated, the Pro MovieStudio improves capture performance significantly by embedding the Microsoft Video 1 compressor in silicon. You can enable or disable this option when running the Video for Windows program VidCap. Without it, a high percentage of frames will be dropped when shooting for movie sizes greater than 160-by-120 at 15 fps and 16-bit color (even on a fast 486).

While enabling hardware assistance ensures that no frames are dropped at settings as high as 240-by-180 / 30 fps / 16-bit color and 320-by-40 / 15 fps / 16-bit color, *playback* performance un-

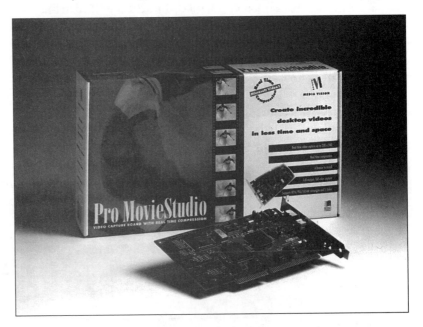

Figure 8.2
The Media Vision Pro MovieStudio

der Microsoft Video 1 of the resulting movies is not spectacular (an uneducated consumer might be disappointed). One way to improve performance is to convert them to Indeo with VidEdit following capture.

The Pro MovieStudio card uses a group of four I/O ports, one IRQ, and a frame buffer in high memory (all configurable). Installation is smooth. When you open the Video Source and Video Format dialogs in VidCap, the special Media Vision drivers give you many extra ways to configure your capture parameters. Though capture to the QuickTime for Windows format is not supported, this board fits our hardware profile nicely, and helps define the current high end of the PC capture card world.

The Pro MovieStudio carries a list price of $449, and comes with Media Vision's DOS-only movie player software and an AVI-to-Macintosh QuickTime converter (actually a Mac program). The card is currently bundled with Video for Windows and Macromedia's Authorware Star SE multimedia authoring product.

For further information, call Media Vision at: (800) 845-5870.

Creative Labs Video Spigot for Windows

Manufactured by SuperMac, the Video Spigot for Windows from Creative Labs targets essentially the same market as its Macintosh counterpart (the low to mid range). With a 16-bit, half-size ISA card, and both composite and S-video jacks, it is the most generic of the boards we tested (See Figure 8.3). Though acceptable, its picture quality does not match that of the Captivator, and it doesn't have a special capture interface beyond VidCap.

Adequate capture performance was delivered (no frames dropped at 160-by-120 / 30 fps or 240-by-180 / 15 fps with 16-bit color and 22.05 KHz, 8-bit mono sound—on a 486 DX2 66), but this was not due to onboard compression hardware. Instead, the Spigot for Windows use a proprietary real time *soft-*

Figure 8.3
The Creative Labs Video Spigot for Windows

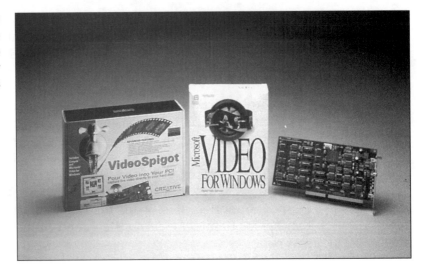

ware compressor called Spigot Compression. It is this feature that makes the board eligible for membership in our collection of desktop video digitizers.

With a list price of $399, it ships with a very good manual, Video for Windows, the Asymetrix Multimedia ToolBook, MediaBlitz! and Make your Point.

For further information, call Creative Labs at: (408) 428-6622.

Creative Labs Video Blaster

This card was one of the first available for the Windows market, and it shows (See Figure 8.4). If you have installed more than 15 megabytes of memory, it does not function properly and forces you to take memory off your system. Equally distressing is the fact that video is passed through the Video Blaster to the system's normal video adapter card for output on your monitor. Because of a short ribbon connector, it must be slotted in *next* to the video card.

Once you deal with these restrictions, you won't be surprised to find that the card does not have the credits to recommend itself to our special group, even though it might be suitable for some low-level types of development. Another deficiency is that the Windows drivers for certain cards (the Diamond

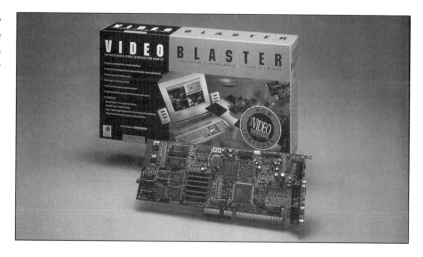

Figure 8.4
The Creative Labs Video Blaster

Speedstar 24x and Orchid ProDesigner IIs, for instance) are caused to function in 8-bit mode (256 colors) only. Installation is performed at the DOS level, not under Windows.

A 16-bit, full-length ISA card, the Video Blaster does permit full-screen analog viewing on your computer monitor, and it is good at capturing still video images. It currently ships with Video for Windows 1.0, Macromedia Action!, Tempra SE and Tempra Show. Its list price is $495.

For further information, call Creative Labs at: (408) 428-4622.

VideoLogic Captivator

The Captivator from VideoLogic (a British manufacturer) competes squarely with the Intel Smart Video Recorder and Pro MovieStudio in its ability to make 240-by-180, 12 to 15 fps, 16-bit color movies using proprietary software assiststance (like the Video Spigot). When tested at higher frame rates and frame sizes, however, the product began dropping frames in substantial numbers.

The Captivator as shown in Figure 8.5, is a 16-bit ISA board with both composite and S-video connectors. It installed on our test machine, a major brand 486 DX2 66 clone, with no trouble. In fact, when we ran the install program before seating the card (as directed in the manual), we were informed which I/O port

Figure 8.5
The VideoLogic Captivator

jumper to cover based on a system interrogation. If there are other conflicts, the user is notified about them as well prior to inserting the card. When the board is in use, it autosenses between composite and S-video, and between NTSC and PAL.

What the Captivator does extremely well is preserve image quality. VideoLogic's promotional literature stresses this attribute, and it held up in the tests we performed. When we used VidEdit to save a raw Captivator capture in the Indeo format with a data rate of 80 kbs, the resulting movie was much crisper than the same movie captured on the ISVR or Pro MovieStudio and re-encoded with the same settings as the Captivator movie. This improvement is due to the high-quality resolution produced by the Captivator in the original capture.

The frustrating thing about using this board is that it makes VidCap perform sluggishly. Clicking on VidCap's buttons when setting up for a capture often didn't register the first time, and mouse pointer movements became jumpy and erratic. After a while, this becomes quite distracting, which is unfortunate since the captured images were so clear. For the record, this card does not capture to the QuickTime for Windows format.

A Different World

Currently priced at $349, the Captivator is bundled with Video for Windows and MacroMedia's Action. It also includes an application called Video Snap for easily capturing high quality stills (especially at 640 x 480). For further information, contact VideoLogic at (617) 494-0534. The package is priced at $399.

Sigma Designs WinMovie

The thing that sets the WinMovie card from Sigma Designs apart from the others in its class (the Captivator and, to some extent, the Spigot) is its proprietary capture interface, called WMTV (See Figure 8.6). Using an onscreen representation of a television and VCR, WMTV is an interesting alternative to VidCap, although VidCap can be used just as easily.

Other than that, the WinMovie card offers roughly the same level of capture performance as its peers: no frames dropped at 160-by-120 / 30 fps or 240-by-180 / 15 fps with 16-bit color and 22.05kHz, 8-bit mono sound. Approximately 50 percent of frames were dropped capturing at 240-by-180 / 30 fps, and about 40 percent were dropped at 320-by-240 / 15 fps. Nevertheless, these figures support the board's inclusion on our short list.

Figure 8.6 The Sigma Designs WinMovie

To complete the picture, the WinMovie board is 16-bit ISA with both composite and S-video connectors, and is configurable at installation time in terms of IRQ, base address, and high memory exclusion range parameters. Installation on our system was smooth, and a utility is provided for changing the original parameters on the fly (in case other conflicting equipment is installed later).

On the down side, software crashes occurred frequently when setting up for captures (this happened more when using VidCap than with WMTV). Also, the WinMovie's overall digitization quality seemed merely adequate when compared to that of the Captivator. Still, it does the job and—aside from the crashes—has a fairly stable feel when running each of its two interfaces. Interestingly, there is an uninstall feature included with the setup program. (Windows developers, please take note.)

Along with the WMTV movie capture interface, a media catalog manager called Picture Prowler is also included. This program lets you create libraries of compressed still images and movie files. Currently, the WinMovie card is only bundled with Video for Windows. Its list price is $299.

For further information, you can call Sigma Designs at: (510) 770-0100.

Mass Storage Devices

YOU WILL NEED LOTS OF ROOM TO STORE BOTH YOUR WORKING CLIP LIBRARIES AND FINAL, READY-FOR-PRIME-TIME MOVIES.

One of the clear advantages of using the Mac as your desktop video platform is its implementation of SCSI (Small Computer System Interface). On the Mac, SCSI is built in. Getting a SCSI device to work on an Intel-based PC often involves a deal with the devil. This is unfortunate, since being able to easily plug and play more (and more) SCSI devices should be the least of your worries when making movies.

To ground you as solidly as we can in the ways of SCSI, especially in how it co-exists with DOS, we'll begin with a practical guide to the subject. Once we have laid the groundwork, we'll discuss the various types of SCSI mass storage devices and what roles they can play in capturing and storing movies.

In this chapter, you'll learn about:

- Hard drives and hard disk arrays
- Removable storage media such as SyQuest drives, Bernoulli boxes, flopticals, and magneto-optical devices
- CD-ROM readers and writers
- Storage compression technology
- Networks

Hitting the Big Time

The big question that comes up when discussing desktop video storage issues is, how much is enough? The answer depends on your approach to digitization. The issue is not one simply of traditional storage capacity, but also of temporary buffering of raw, freshly captured sequences prior to compression and editing. Finished movies are big. Unfinished movies are *gigantic*. Figure 9.1 shows these relative disk space requirements.

If you plan to capture short sequences (under 30 seconds) and then lace them together with an editing workbench like Premiere, you *may* want to consider buying enough memory to do all your capturing to a RAM disk. On the other hand, if you are going to digitize, say, three-minute music videos at 240-by-180,

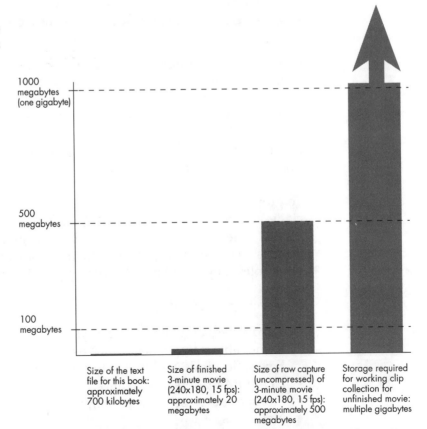

Figure 9.1
Movie Storage Requirements

10 fps with 22.05kHz sound, you will need at least 500 to 600Mb of fast hard-drive storage to hold the resultant raw movie file. We will cover these and other techniques in greater detail in the third part of this book.

SCSI Standards

As the name says, SCSI—Small Computer System Interface—is just that, an interface. Specifically, it is an ANSI (American National Standards Institute) specification for an I/O subsystem that is both intelligent and bi-directional. Devices conforming to the original SCSI specification, however, often get a bad rap when attached to Intel-based PCs.

The original SCSI specification, officially adopted in 1986, is now dubbed SCSI-1. For the record, SCSI was also designed to efficiently support multi-threading and true multitasking operating systems like OS/2 and UNIX. It is widely used in connecting peripherals to minicomputers, and is believed to be uniquely positioned for exploitation by PowerPC machines.

The problems are due in large part to SCSI-1's poor integration with DOS, and also to incompatibilities with third-party, DOS-based hardware and software. (For instance, DOS transfers data in sectors while SCSI does it in blocks.) On other types of systems, such as Macs and various types of UNIX-based workstations, SCSI is written into the operating system—thus avoiding assimilation conflicts.

The latest SCSI specification, SCSI-2, is beginning to clean up the mess. Recently made official by the standards regulators, SCSI-2 embodies a much tighter command set and allows for much higher data throughput rates than the original. SCSI-2-compatible adapters and devices also cause fewer headaches at installation time. As of this writing, SCSI-3 standards are already being hammered out.

Actually, SCSI-2 comes in four flavors: basic SCSI-2, Fast SCSI (up to 10Mb per second), Wide SCSI (up to 20Mb per second over a 16- or 32-bit data path), and Fast-Wide SCSI (up to 40Mb

per second with a 32-bit data path). SCSI-1 only permitted a maximum of 5Mb per second along an 8-bit data path.

Of course, the proper hardware must be engaged to handle these new performance levels. PCs without EISA, MCA, or local buses will generally be unable to take advantage of all the new data SCSI-2 can provide. The same applies for the Mac in general, although EISA and NuBus standards are considered roughly equal.

A few of the new hard disks and disk arrays currently on the market are already Fast-Wide compatible. Because of their new speed limits, SCSI-2 hard drives are now leaving their IDE and ESDI competitors in the dust. This was not the case with SCSI-1. The advantage is being pressed with SCSI's greater storage capacity (up to 3 gigabytes). As usual, these are benefits you can expect to pay for, but as a desktop movie producer, you are already going for broke—aren't you?

Adapting to SCSI

Let's get to some practical details. For the most part, Intel-based PCs implement SCSI with an adapter card. As noted earlier, some upscale PC clones now come with a SCSI port on the motherboard, but this is still an adapter per se and is used mainly for connecting internal SCSI devices—not the external equipment we are primarily interested in.

The reason an adapter board is necessary is that no commercial PC-based operating system or BIOS natively supports SCSI. This capability must be added through the use of drivers, which are loaded into memory along with DOS at system startup time. These drivers allow the PC to communicate with the adapter and, through the adapter, with any attached SCSI devices.

You can attach up to seven SCSI devices to your system with a single adapter card, and more than one such adapter card can be installed in your computer. All of the devices connected to a single adapter are referred to as being on that particular *SCSI chain*.

A SCSI chain can accommodate many different types of SCSI devices: hard drives, CD-ROM drives, tape backup units, scanners, printers, DAT boxes, and so on. Each device must be uniquely identified on the chain with a SCSI ID number from 0 to 7. On Macs, where SCSI is built in, the principal internal hard drive normally has a SCSI ID of 0, while the system itself is traditionally SCSI ID 7.

Promises, Promises

SCSI's original promise was to allow plugging and playing of external devices as easily as the preceding conceptualization. As most SCSI pioneers know, it didn't start out that way in the DOS world. To be honest, things were never perfect on the Mac either, although they were certainly better. Fortunately for everyone, the SCSI skies are now beginning to clear. In fact, the final outcome may be very nice indeed—if manufacturers follow the new specifications rigorously.

Speaking of SCSI's promise, it is interesting to remember that slot saving was among the touted advantages. For non-multimedia PC users, this might not be such a big deal, but for multimedia people and desktop movie makers whose available slots are getting filled up with sound cards, capture boards, and other essential equipment, slot-saving takes on a special significance.

In the same way that an Intel-based PC uses an expansion bus to communicate with its peripherals, a SCSI host adapter treats its attached devices as peripherals on a private expansion bus. Data coming from the CPU to the adapter is circulated to the appropriate SCSI devices, which in turn route data targeted for the CPU back to the host adapter first. Figure 9.2 illustrates this process.

Under SCSI-2, if you have multiple host adapters on a system, each one can be in control of its own separate bus, or you can nest one adapter in the bus of another and still keep the respective devices under the command of the nested controller. Things can get a little hairy when you get to this point (special software is required), but the new specification is robust enough to keep it all sorted out.

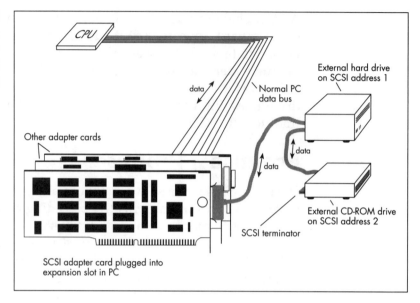

Figure 9.2
How a Host Adapter Handles SCSI Traffic

Each SCSI-legal device has its own onboard controller, and is able to process data internally however it chooses. The catch is that the device must talk to the host adapter using SCSI protocol. This flexibility is another strength of the SCSI design specification, and one of the main reasons it is expected to go the distance.

In effect, any new device or *type* of device that comes along can be placed on a SCSI chain as long as the host adapter can manipulate it with SCSI control protocol. This is especially significant when you consider the rate at which new high-end digital video devices, and the associated storage media, are being developed. Remember when SCSI meant (to PC geeks) just another variety of hard drive?

Termination with Cause

All SCSI chains must be terminated correctly in order to function properly. Technically speaking, *each end* of the SCSI chain must be terminated. In most cases, the SCSI adapter card will be at one end of the chain and will be terminated properly by the manufacturer. All you have to do is make sure the last physical device (not necessarily the one with the highest SCSI ID number) wears the SCSI terminator cap.

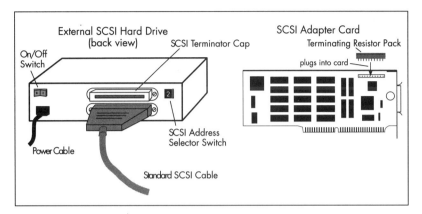

Figure 9.3
Both Types of SCSI Termination

If you have both internal and external SCSI devices, the host adapter card should generally *not* be terminated. Since it will probably arrive terminated from the vendor, you will have to remove the terminating resistor pack to make your internal SCSI devices operational. This type of internal terminator is different from the external terminator that goes on the back of an external SCSI device. Figure 9.3 shows both types of SCSI terminators.

We suggest you read your documentation carefully before removing any internal SCSI terminators or changing any of the adapter's jumpers. Better yet, call the vendor's technical support line and have them walk you through it. Chances are they will have a lot of experience in this area. Getting the gear on an external SCSI chain to work together under DOS is hard enough—getting an internal drive to participate in the total scenario can be even grimmer.

Cables, Connectors, and Drivers

Depending on what kind of adapter your are plugging your SCSI cable into, SCSI-1 ports take one of two forms. If you are attaching to, say, an Adaptec 1542B PC adapter board, the port will look like the one for Centronics printer connector, as shown in Figure 9.4. If you are plugging into the back of a Mac, the connector can look like the 25-pin end of an RS-232 cable, also shown in Figure 9.4.

Basic SCSI-2 and Fast SCSI-2 employ 50-pin connectors. Wide SCSI-2 uses a 68-pin P-connector for the time being, but this will probably change under SCSI-3. Currently, there is no stan-

Figure 9.4
SCSI Connectors

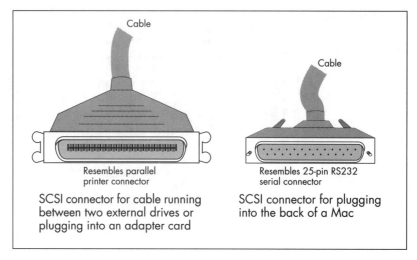

dardized way to mix devices using these different types of connectors on the same SCSI chain. As for termination under SCSI-2, terminators are still required but they have been upgraded to reduce line noise.

As we noted before, it all comes down to drivers when dealing with SCSI devices on Intel-based PCs. One of the big problems in the early days of SCSI-1 was that manufacturers of SCSI devices (such as hard drives and adapter cards) often did not *supply* the drivers for their equipment, leaving that chore to third-party software developers.

Unfortunately, the original SCSI-1 specification was vague in spots—especially where it dictated which elements in the SCSI command set a device had to support to be recognized as SCSI compliant. As you can imagine, driver developers were forced to make their own decisions. In many cases, they often wound up writing drivers for adapter boards that worked with some peripheral devices but not with others.

As we keep saying, the SCSI-2 specification does it better. Drivers for host adapters must now conform to a much stricter command set, thus ensuring that devices that also adhere to the tightened up SCSI language will get much better service. Also, various command extensions that try to anticipate and allow for new types of SCSI devices have been added, as has the

SCSI Standards

capability to support the much greater throughput speeds (provided you have the hardware to play along) that we noted earlier.

One exception to the driver rule worth mentioning concerns hard drives only. Many host adapters will recognize hard disks assigned to SCSI ID 1 or 0 without the assistance of a driver. Check your adapter documentation to find out if your board can do this. The exception to *this* exception are hard drives over 1 gigabyte, which must be controlled by an adapter *and* a driver.

The Layered Effect

SCSI drivers work in layers. The primary driver allows the host adapter card to talk to the PC's operating system. Secondary drivers allow individual SCSI devices to talk to the host adapter. The primary driver normally comes in the box with the adapter card. Sometimes secondary drivers are also included (for popular SCSI devices such as CD-ROM drives) but any self-respecting SCSI device manufacturer will include a secondary driver in the package for *their* equipment. Figure 9.5 details this scenario.

The following sample lines from a DOS machine's CONFIG.SYS and AUTOEXEC.BAT files show how a primary driver and secondary drivers for an external hard drive and CD-ROM player are implemented. The AUTOEXEC.BAT statement is required to make the CD-ROM drive recognizable under Windows.

Figure 9.5
How SCSI Drivers Work in Layers

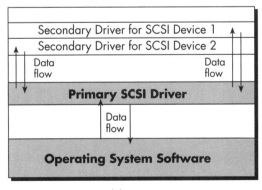

In the CONFIG.SYS file:

```
REM INSTALL THE PRIMARY HOST ADAPTER DRIVER
DEVICE=C:\...\ASPI4DOS.SYS /D
REM INSTALL THE SECONDAY EXTERNAL HARD DISK DRIVER
DEVICE=C:\...\ASPIDISK.SYS /D
REM INSTALL THE SECONDARY CD-ROM DRIVER
DEVICE=C:\...\ASWCDTSH.SYS /D:ASPICD0
```

In the AUTOEXEC.BAT file:

```
C:\...\MSCDEX /D:ASPICD0 /L:e /M:12 /v
```

Note that the primary driver must always be loaded before any secondary drivers. You can try loading these drivers high (see the Tuning Your System section in Chapter 7), but some of them may not work in that configuration. It is worth a try, however, in the interest of keeping as much conventional memory available as possible.

If you plan on moving your CD-ROM drive (or any other cross-platform SCSI device) back and forth between your PC and your Mac, you will have to get a different driver for it on each platform. Many forward-looking OEMs already make a practice of supplying both, although you should always check to be sure, especially when buying new gear.

SCSI System Tuning

As we did in the earlier chapters on Mac and PC systems, we'd now like to offer a checklist for making your SCSI devices perform as designed. Once again, the main audience for this is expected to be Intel-based PC users, although some of it generally applies for Macintosh users as well.

1. Attach a Post-it note to the edge of your monitor for quick reference to the SCSI ID numbers you will assign to your devices. Also include the configuration parameters of your adapter card (IRQ level, DMA channel, I/O port, and high memory exclusion range). Better yet, make a grid containing this information for all your cards to keep this data sorted out as you add any new equipment, as shown in Table 9.1.

SCSI System Tuning

Table 9.1 Micromanaging Your Peripheral Parameters

Card Type	IRQ	DMA	I/O Port	Exclusion Range
SCSI Card	12	7	330	DC00-DFFF
Sound Card	7	6	N/A	N/A
Capture Card	9	N/A	310	N/A

2. For best overall performance, prioritize your devices. Your external hard drives should have low numbers, starting with 0 (on the PC). The host adapter itself is usually set to 7 by the manufacturer. Removable hard drives, such as Bernoulli and SyQuest gear, should be next. CD-ROM players should be highest. Your devices should be attached in this order physically as well.
3. If you have internal SCSI devices, install them first. Remember to start with your hard disks, and do them one at a time. Also remember that you will probably have to pull a terminating resistor pack off your adapter card if your are running *both* internal and external SCSI devices off it.
4. If you are installing an adapter card and external SCSI devices for the first time, do it in stages. First get the adapter card itself working. Turn on the diagnostics (if they exist), and make sure the details are reported in a way that makes sense. Install the devices on your chain one at a time after that. In other words, don't hook everything up, turn it on, and expect it to be Christmas morning. It won't be.
5. Make sure the last device on your external chain wears a terminator cap. If you are only operating external SCSI devices, make sure your host adapter is terminated. Use the highest-quality (shielded) SCSI cables you can get, and keep them short (three feet is a good length). If you are going to use SCSI-2 devices that accept 50-pin cables, plot out your connection strategy in advance.
6. If an external device will not be in constant use, you will have to turn it on and then restart your CPU to get access to it. On the Mac, getting access to newly powered-on SCSI equipment usually involves just manually mounting the device (as opposed to rebooting the computer). Always power off all equipment when connecting or disconnecting SCSI

gear. Don't listen to people who tell you otherwise—your data is too important.

7. At the first sign of trouble, call technical support. Naturally, there is some satisfaction in getting everything done yourself, but wouldn't you rather be making movies? If you must do your own troubleshooting, you can start by changing the SCSI ID numbers of your devices and repositioning them physically in the chain. If you have built your working chain up one device at a time, you should be able to isolate a dysfunctional device fairly easily. If you are having trouble with the host adapter, definitely call technical support right off the bat.

Inter-Platform Benefits

One of the benefits of most SCSI devices (at least hard drives and CD-ROM readers) is that you can swap them between Macs and PCs. From a hardware perspective, the cabling and termination is essentially the same, but you *will* have to reformat a hard drive whenever you move it from one platform to the other. On the Mac, this is a Texas two-step. Formatting a SCSI hard drive under DOS is a sharp stick in the eye until you've done it enough times.

If you are not an experienced Mac user, you may find it confusing when the icon for the hard drive you just connected to your SCSI chain does not show up on your desktop. The process by which your system gets to know a new device is called *mounting*, and there are several SCSI probe applications (such as Drive 7 by Alysis, and SCSI Director from Transoft) that can be used to identify the SCSI devices on your chain and mount them if necessary.

The issues surrounding cross-platform CD-ROMs are slightly different. While you can swap the *drive* back and forth between your Mac and your Windows boxes without reformatting anything (as long as you have the appropriate drivers loaded), a CD-ROM disk itself is usable on both platforms only if it was specifically formatted that way, as illustrated in Figure 9.6. The format readable by both platforms is called ISO 9660, and is discussed in greater detail in Chapter 28.

Figure 9.6
Cross-Platform
CD-ROM Issues

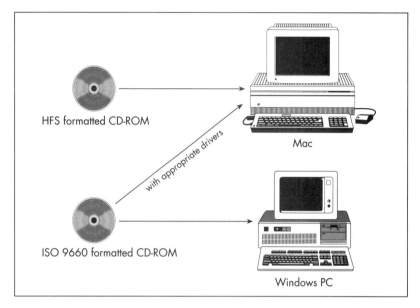

Otherwise, a DOS formatted CD-ROM disk will be playable just on DOS systems, and a Mac CD-ROM disk just on Macs. As cross-platform issues are heating up in the emerging CD-ROM industry, it is worth discussing them in some detail. We'll get into this further when we talk about CD-ROM writers later in this chapter, and also in Part Three when we discuss mastering a commercial CD-ROM product.

Hard Drives

Here are a few criteria for selecting hard drives for movie capture:

- *Capacity* Realistically, there is no getting around 1.2 gigabytes as a bottom limit. Working with less will prove too frustrating, and then you will have the extra expense of upgrading when you finally do. A three-minute, 240-by-180, 12 fps, 24-bit color movie with 22.05kHz sound will use up to half of such a drive during digitization. On the Mac, hard disks with a physical capacity of over two gigabytes will have to be partitioned into logical drives that do not exceed 2 gigabytes each—a requirement of the System 7 Finder. (Earlier versions of the Finder were even more restrictive.) On Intel-based PCs, this limitation is roughly 1 gigabyte (technically, 1024 cylinders).

- *Speed* Since your hard drive is going to be your fastest deliverer of movie data (as opposed to SyQuest and CD-ROM drives), you will want to give it an edge for movie performance testing among your different types of drives. The minimum sustained throughput you should accept is 600 kbs, although the newer IDE (on non-SCSI PC systems) drives often do better than 1000 kbs. If you do not plan to optimize your hard drive as a religious activity, access time will also be important (ten milliseconds or faster is a good benchmark).
- *SCSI level* While high-end Quadras now come with SCSI-2 built in, SCSI-1 is still the boss in most Macs and PCs. For desktop movies (as we have defined them), SCSI-1 will be adequate. If you otherwise have the capture power for full-motion, full-screen digitization, let your wallet be your guide.
- *Footprint* These days, it's not surprising to see serious wireheads carrying around 2.4-gigabyte hard drives in their fanny packs. External hard drives come in sizes based on at least two dimensions. In general, you have the choice between half height versus full height, and 3.5-inch versus 5.25-inch widths. The half height, 3.5-inch models are the coolest, but cost more.

Hard Disk Arrays

While still prohibitively expensive for the average desktop producer, hard disk array products are proliferating. Starting between $6,000 and $7,000 (including hidden costs for additional hardware and software), disk arrays are not simply a collection of drives under the same roof. They are engineered to deliver superlative performance by banding an incoming data stream across mul-

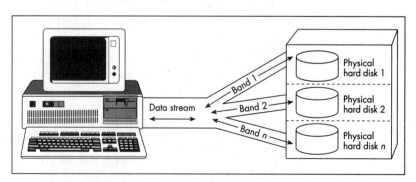

Figure 9.7 One of the Ways a Disk Array Can Work

tiple drives, as shown in Figure 9.7. In most cases, additional SCSI hardware is necessary to get them up and running.

We mention hard disk arrays for completeness only. While they are exciting acquisitions for people doing full-motion, full-screen capture and play back (and generally outputting back to video tape), they are unnecessary for producers of desktop video clips. If you need more information on this subject, we suggest you check the advertisements in the magazines devoted to high-end digital video.

Virtual Luggage Racks

Ultimately, you will need lots of room to store both your working clip libraries and your final, ready-for-prime-time movies. A removable media drive such as the SyQuest or Bernoulli is recommended for archiving finished productions, while a monster hard drive is best for keeping all your work-in-progress files organized.

Of course, it would be nice (and much more comforting) if all finished movies could be saved off to multisession CD-ROMs, but this is not cost effective just yet (actually it *is* cost effective in the long term view, but not as an incremental short term solution). For the time being, we are pretty much stuck with magnetic and magnetic/optical media. Brief discussions of the basic types are presented in the following sections.

SyQuest Drives

Probably the most common form of removable storage is the SyQuest drive. Unlike Bernoulli technology, SyQuest drives treat their cartridges just like real hard disk platters—which they essentially are. The cartridges come in four sizes: 44Mb, 88Mb, 105Mb and (just shipping as of this writing) 270Mb. The first two have a 5.25-inch form factor, while the 105Mb and 270Mb units have a 3.5-inch footprint.

You can play movies from SyQuest drives if you have to, but performance falls significantly short of a decent hard drive (but much better than a CD-ROM). As mentioned previously, they

are only a fair solution for archiving finished movies. What they are best at is fitting inside a Federal Express mailer padded with bubble wrap. Drive prices range from $300, for the 44Mb models to $650-$700 for the 270s. Cartridges average about $65 each. Note: You cannot format a 44Mb cartridge in an 88Mb drive.

Bernoulli Drives

Bernoulli drives, much more common in the DOS world, approach removable storage technology from a different direction. Basically, a Bernoulli cartridge is an extra large capacity diskette in a vacuum packed hard-shell case. Consequently, it is much more durable (and more transportable) than a SyQuest cartridge. It can also play movies just as well.

Although they come in two sizes and can hold as much data as their SyQuest counterparts (slightly more, really), Bernoulli drives are more expensive. The 150Mb drive comes in around $900 with cartridges going for about $150 each. Because of the hardiness of the storage media, it is unfortunate that Bernoulli boxes are not as widespread on the Mac as they are on the PC.

Flopticals

Floptical technology is at the low end of the removable storage spectrum for two reasons. First, since the data transfer rate is comparable to that of regular floppy diskettes, you can't reasonably play movies off of them. Second, their capacity is only about 21Mb—not really enough for a three-minute plus music video. The drives that play them (which can also read and write to regular diskettes) cost in the neighborhood of $500. The disks cost around $20 apiece. Many people feel that flopticals are fading out as a useful storage medium.

Magneto-Optical Drives

Before we tackle CD-ROM writers, there is one more disk-based technology for you to consider: the magneto optical drive. The MO recording mechanism is actually similar to that of the CD-ROM burner, as is its high-end storage capacity. There are several gauges of disks, providing from 120Mb to 650Mb (and beyond) of storage in 3.5-inch and 5.25-inch diskettes. More

resilient to shock than any of the other mass storage vehicles, an MO disk is also unaffected by magnetic fields—the bane of floppy diskettes and hard drives.

The downside is three-fold:

- Some MO disks store their data on both sides (eventually you have to flip them over).
- They are generally slow enough (sub CD-ROM speeds) to make them viable for storage only—not for playback, although this is starting to change.
- They are expensive—around $2,000 for the small size. Since the slant of this book is to treat movies as just another type of data, it makes sense to discuss this final removable storage alternative in an archival sense only.

If you are using SyQuest or MO cartridges just for backing up your own system, you can expect few compatibility problems. If you swap cartridges with friends or clients, make sure they can read the cartridges first (especially MO cartridges).

CD-ROM Writers

Pioneering the downsizing movement (whether it knows it or not) is the CD-ROM writer (CDW). In an abstract sense, a CDW is one disproportionate half of a removable mass storage device. The other half, of course, is the CD-ROM reader (CDR). In this context, it make sense to talk about both of these devices here.

It seems fitting that the most efficient way to transport large quantities of data (once the CD-ROM has been created) is also the most expensive. CDWs currently range from between $3,000 and $4,000 to around $7,000, but these prices are changing as fast as other prices in this field. The range of these prices reflects significant levels of quality and capability in both the hardware and accompanying software. Maximum capacity of a CD-ROM disk is roughly 660Mb.

Another important difference between CDWs and other types of mass storage devices is the time that CD-ROMs take to master, which depends on the amount of data you want to record. A full 660Mb worth of multimedia flora and fauna can take up to an hour, while a single 50Mb movie takes a fraction of that.

Some CD-ROM-burning software allows for double speed mastering, depending on how the source data is organized.

And it is just that—a mastering process, even for a one-off copy. It is not the same type of data copying process as, say, moving a movie from a hard disk to a SyQuest cartridge. Special software is required to manage the burn, and some CDWs can even do separate burn sessions on the same CD-ROM. This is called *multisession* capability.

What is produced by the CD-ROM mastering process is usually a disk that can be mass-replicated (after a few interim steps) like a phonograph record master. This is where CD-ROM technology seriously departs from that of general mass storage. As CDWs proliferate and come down in price, however, they will be used more and more like traditional backup devices, and one-off CD-ROMs will become a common means of transferring all kinds of data (not just movies).

Which brings us to cross-platform CD-ROMs. In our current context, this issue has much more to do with mass commerce than with mass storage. Just as the other monster backup devices discussed above need to be reformatted to work under a different platform, a CDW attached to, say, a Mac for burning Mac-only one-offs seems perfectly acceptable. Our position here is slightly simplified, but we'll be covering cross-platform CD-ROM issues much more comprehensively in Part Three.

We only mention CD-ROM readers (CDRs) at this point because they are the conceptual complements to CDWs—not standalone mass storage devices. There are, however, two important things worth considering. First, after normal and removable hard disks, CDRs provide the next most efficient way to play movies. Second, you will need one on your system if you want to run most of the current big time multimedia products, as well as those in the works.

As noted earlier, a CDR can be used with either a Mac or a Windows machine, provided you have the appropriate drivers installed on your system to handle it. The most popular ones currently are the so-called doublespeed models that boast a data transfer rate of 300 kbs. The actual *sustained* data transfer

rate is significantly less than this, depending on the device. As of this writing, triple-speed drives have already begun shipping.

Tape and DAT Backup

From the broadest perspective, traditional tape backup should not be considered an optimal means of backing up desktop video productions. There are just too many alternatives that can do it faster. For backing up PCs exclusive of movie data, tape archival solutions are fine—many have enough options to make unattended backups quite convenient—but the resultant tapes are nowhere near as universal a medium as, say, SyQuest platters or even Bernoulli cartridges. (We're assuming here that you are not (yet) servicing clients, who have much heavier archiving requirements.)

Besides, dedicated SCSI tape backup devices are disproportionately expensive. For Intel-based PCs, there are cheaper solutions such as the popular Colorado Memory Systems tape drives, but the basic issues are still the same: it takes a while, it is not completely universal, and you are basically restoring files to a hard drive from a sequential access medium.

A tape-based technology that *is* completely viable for backing up a desktop video system is DAT (Digital Audio Tape). DAT backup units that take 1.2 Gbyte tapes cost under $1,000 and the tapes themselves will only set you back $12 each. If you service clients on a professional basis, you will need vast amounts of archival storage. DAT may well be your best solution.

Soon They Will Be Folding Space

An emerging technology worth mentioning here is driver-level data compression for hard disk drives. Programs such as Stacker (available for both the Mac and PC) are becoming increasingly accepted as ways to expand disk capacity by up to a factor of two. While some people still seem to get nervous about these programs, it is for no good reason. They may as well get nervous about all their software.

While we have found Stacker to be a generally reliable product, we cannot recommend it (or similar products) for compressing movies. The reason is that movies tend to be already compressed as much as possible. It is unlikely that a program such as Stacker could achieve additional compresssion.

You should note a few other things about Stacker (and other driver-level compressors):

- Don't install it on drives used for virtual memory
- Don't install it on nearly full drives
- Don't use it in combination with driver-level security software

Networks

While not storage *devices* per se, networks do offer a way to archive movie files or simply move them off a local system to make more room. In a pinch, you can even *play* movies over a network (to see what they are) with performance levels close to those of the slower disk-based devices mentioned above (depending on network traffic at the time).

Actually, network video server technology is a fairly heady development area as of this writing. Since movies consume so much disk space, it doesn't make sense for everyone in a large organization to have copies of, for example, weekly memos from the president that include video. If a dedicated server could be employed to stream video data on demand for its attached clients, you could have the best of both worlds (depending on what you think of desktop video as a means of business communication).

For real effectiveness, a network must be able to link both Macintoshes and Intel-based PCs. Of those that can, Novell systems are especially useful since their servers preserve the Mac name space. In other words, a self contained QuickTime for Windows movie named, for example, MySummerVacation can be copied from a Mac to a PC-based Novell server, then copied back to the Mac with its full name intact.

Using Desktop Video Software

IN PUTTING TOGETHER A MAC- OR PC-BASED VIDEO DEVELOPMENT SYSTEM, YOU'LL NEED TO SELECT THE RIGHT SOFTWARE FOR YOUR PROJECTS.

This chapter is comprised almost entirely of desktop video software reviews, though it is by no means comprehensive. Instead, we've attempted to give you overviews of the principal applications you will need to create, edit, and present desktop movies. No rating system is employed, but we don't cover any applications that we feel are not useful.

Naturally, we have some favorites. If a product is not included here, however, it doesn't mean we necessarily have a low opinion of it. It simply means we use something else or haven't used the product extensively. Also, unless an application clearly contributes to the movie-making process, we don't cover it.

If you are interested, we have provided some of the development tools from our own product, the *Canyon Movie Toolkit*, on the CD-ROM companion to this book. One of them, TRMOOV.EXE, converts quickly between QuickTime for Windows (QTW) and AVI movies, provided they use the same codec.

In this chapter, you will learn about:

- Standard Windows-based software for making and editing movies
- Third-party Windows programs for editing and presenting movies
- Standard Mac-based software for making and editing movies
- Third-party Mac programs for editing and presenting movies

Windows-Based Software

In this section we'll explore the key video development software for Windows including standard video applications, QuickTime applications, editing workbenches, special effects packages, authoring software, and software for controlling analog video equipment.

Standard Video for Windows Applications

The applications listed in this section ship with the retail version of Video for Windows (VfW). The workhorse capture and edit programs—VidCap and VidEdit—are highlighted, but other important tools are also featured. Some applications are not covered here, either because they are buggy or we don't use them enough to comment on their full potential.

VidCap

VIDCAP.EXE is the reigning application for digitizing video under Windows. The current version ships standard with VfW, thus making VidCap easily available to end users. (Perhaps it and the other VfW software will all be folded into Windows 4.0.) VidCap's main user interface is shown in Figure 10.1.

As we noted in other chapters, Intel has released a similar capture application, SMARTCAP.EXE, that will likely ship with its Smart Video Recorder board. Currently, SmartCap is available via CompuServe and Intel's BBS. The program allows for capture into the QuickTime file format as well as the AVI format. Even though Microsoft has published tools capable of crafting so-

Figure 10.1
VidCap's Main User Interface

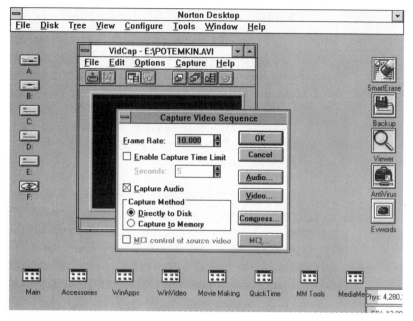

phisticated movie capture applications, we know of no other dedicated digitizing programs beside SmartCap that are near shipping or in the pipeline (although, there may be some by the time you read this).

VIDCAP.EXE provides an adequate way for you to capture movies, but the current version lacks some of the capabilities of its dedicated Mac counterparts MovieRecorder and GrabGuy. Also, its window capture dimensions are limited to a few standard sizes, depending on the compressor enlisted, as opposed to letting you drag the capture window to a desired size.

Some other notable things about Vidcap are:

- While it can't compress sound, VidCap can capture WAV files; unfortunately, there is no concept of a sound-only movie under VfW (although there is under QTW)
- It can capture still movie frames
- It can't capture QTW movies—only SmartCap can
- Codecs are selectable at capture time—new codecs are installed via the Control Panel

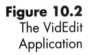 Chapter 10 Using Desktop Video Software

VidEdit

VIDEDIT.EXE is the movie *editing* companion to VidCap, and also ships standard with VfW. Shown in Figure 10.2, VidEdit is a relatively easy-to-use application. You can cut, copy, and paste movie frames and their related audio data into different places in the same movie or into new or different movies just as if you were dealing with text or graphics. You can also simply play the movie, step through it frame by frame, or advance to a specified frame.

In addition, VidEdit can change the physical attributes of a movie or the way it performs. You can specify different frame sizes, frame rates, audio qualities, and other attributes, which will show up when you save the movie. Likewise, you can change a movie's compressor type, data rate, picture quality, and audio/video interleave ratio when you save it.

You can do some less obvious things as well, such as synchronize a movie's sound track with its video track if they've slipped (this says something about the robustness of the AVI standard, but we won't belabor the point here) and display statistics on

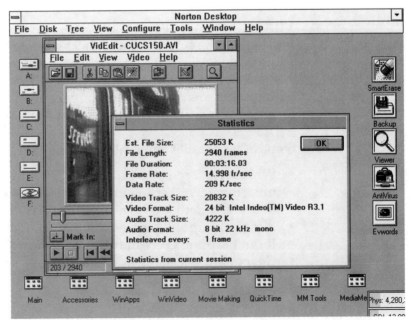

Figure 10.2
The VidEdit Application

the movie, such as file size, frame count, and current data rate. Also, you can disable either the audio or video track when playing the movie.

Some other things you can do in VidEdit are:

- Paste bitmaps *into* movies
- Convert Animator FLI and FLC files into AVI movies
- Add sound to otherwise silent movies
- Specify key frames from which to build palettes

Media Player

MPLAYER.EXE is the quick and dirty way to just play a VfW movie. Actually, by double-clicking on its file name, you can play any Windows media file this way (QTW movies, .WAV files, and so on) as long as the appropriate MCI driver is loaded. Media Player's user interface gives you far less control over the attributes of the movie than VidEdit, but presumably you don't care.

You can do several useful things to a movie with Media Player besides just playing it, such as putting it in continuous loop mode, playing it in reverse, and doubling its frame size. You can also select the appropriate MCI driver for the movie (or other media file) you want to play. This comes in handy when you want to play both AVI and QTW (if you have installed QTW 1.1) movies.

In general, you can distribute Media Player with your movie files royalty free—as long as you are not including it in a retail product.

Standard QuickTime for Windows Applications

The programs in this section are included with the retail version of QTW 1.1. Currently, QTW is a playback technology only, so no capture or editing applications are listed. Only two executables are actually included on the Apple retail developer's CD for QTW: Player and Viewer. There is currently no retail *runtime* version of QTW available from Apple, but the compan-

ion CD-ROM for this book provides one. You can install it by running the Setup program in the QTW directory.

Movie Player

PLAYER.EXE is the dedicated vehicle for playing QTW movies on the Windows desktop. It was designed and implemented to operate as closely as possible to its evil twin on the Macintosh (MoviePlayer), right down to its movie controller, volume control, and keyboard interface. Figure 10.3 shows its user interface.

Because QTW is currently playback only, Player does not have cut, copy, or paste features (though you *can* copy a single frame to the Windows Clipboard). QTW 1.1 does, however, have a matching decompressor for each compressor in QuickTime 1.6.1 for the Mac. In other words, any QuickTime movie encoded on the Macintosh with a standard codec can be played under QTW (multiple tracks in the same movie won't all get played under Windows).

In terms of controlling movie play, you have more leeway. You can loop a movie, play it backward, set a selection to play, loop, or play in reverse. You can also play multiple movies in a single

Figure 10.3
The QTW Movie Player

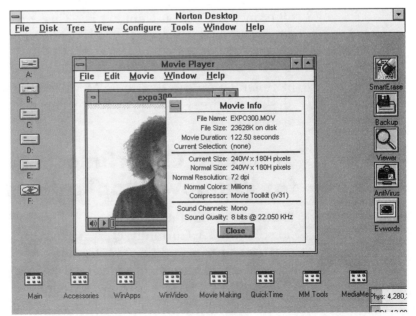

instance of the Player program. You can also get the movie's vital statistics and scale its size by factors of 2x and 1/2x from the program's menu.

Like on the Mac, you can also drag the grow box at the bottom-right corner of a movie window to change its size. If you have QTW 1.1, a special pixel-doubling algorithm kicks in when you resize the movie to exactly two times normal. This can enhance the overall performance of some movies significantly.

Since QuickTime was developed by Apple to be a cross-platform technology, QuickTime movies created on the Mac should be easily playable under Windows—and so they are. If you plan on doing your movie captures on the Macintosh but wish to have them play under Windows or on both platforms, you should read Chapter 28, in which we discuss cross-platform strategies and give a recipe for making Mac QuickTime movies playable under Windows.

Picture Viewer

Similar to the QTW Movie Player, the QTW Picture Viewer (VIEWER.EXE) was developed to work just like PictureCompressor on the Mac, and it does so as much as possible. If you bring still images over to your Windows desktop that were saved with the Mac QuickTime PictureCompressor, you can easily view them, copy them to the Windows Clipboard, or print them. You can also scale them and get their statistics. You just can't save or compress anything with it.

Editing Workbenches

The programs listed in this section are designed to help you edit your videos. In this category, we note two contenders—Premiere for Windows and MediaMerge.

Premiere for Windows

Adobe's Premiere for the Macintosh is the top-of-the-line movie editing tool for QuickTime movies in the Apple realm. Just released as of this writing, Premiere for Windows 1.1 works with both AVI and QTW files, but is not nearly as feature-rich as its Mac cousin. Still, the user interface works essentially the same way for both platforms.

Chapter 10 Using Desktop Video Software

If you would like to know how Premiere for Windows works at a basic level, see our review of the Mac version later in this chapter. We can say here that it is an exciting product, and one that most desktop producers won't want to be without (though you should expect problems when playing QuickTime movies created by Premiere for Windows back on the Mac). Currently, the only serious competition the program has for editing desktop video is ATI's Media Merge (in our opinion).

Available from Adobe Systems, (415) 961-4400, $395.

Media Merge

ATI's Media Merge has its work cut out for it when going up against Adobe's Premiere for Windows, but it meets the challenge head on—even though Premiere has a significant head start with so many people already trained on (and swearing by) its Mac version. Currently, these are the only two full-fledged AVI movie editors for Windows that we have experience with.

Like Premiere, Media Merge uses the parallel film strip metaphor as its main editing environment (called the Scene Editor), but it also includes another interface called the Storyboard Editor (which will have a familiar feel to Mac-based Video Fusion users). The Storyboard Editor lets you combine edited scenes into finished movies.

The media types that you can merge in the Scene Editor include AVI and QTW movies, Autodesk FLI and FLC sequences, WAV audio clips, and bitmaps in the GIF, BMP, and PCX formats. It would be nice to see more sound and bitmap formats supported (such as AIFF audio files and Targa bitmaps), but the types you *can* use are more than adequate. It is especially good to see QTW support.

Unlike Premiere, the Scene Editor interface allows for more than just three tracks—up to 16, in fact. When you place a media clip into any of the tracks, you can drag it left or right to change its start time, alter its duration by dragging on one of its edges, or click on it to bring it into a separate editor. Also, you can use the Overlay feature to set the transparency of movies and still pictures. This feature will be fun for Premiere users already used to the feel of the rest of the interface.

If you wish, you can output AVI movies directly from the Scene Editor. Or you can take your scenes over to the Storyboard Editor to add transitions or, perhaps, additional sound. This interface represents clips as single frame icons in a two-dimensional grid separated by buttons representing transitions. You click on a button to set the desired effect, then drag over adjacent icons to set the scope of your finished production. Finally, you tell Media Merge to *produce* a finished movie.

Other interesting features include:

- A composite track in the Scene Editor that shows the cumulative effect of all the tracks at a given point on the timeline
- A very powerful audio editor

Media Merge's shortcoming list, while brief, does have a few significant entries:

- Occasional crashes (not unlike Premiere for Windows)
- Long waits for previews
- No built-in saving at the 240-by-180 frame size

Media Merge ships with a CD-ROM called *MediaMontage*, which provides a large selection of clips for you to practice editing with. A lot of them are boring, but some have a particular sense of humor, particularly the animation and audio clips.

Available from ATI Technologies, (416) 756-0718, $299.

Effects Packages

As of this writing, there are more and better effects packages for the Mac. Until this situation changes, we only have a single recommendation in this area. Fortunately, both Premiere for Windows and Media Merge provide their own internal special effects.

Morph

Like it does on the Mac, Morph performs very well under Windows, turning one image into another over a specified period of time. How graceful that process looks when the finished

sequence runs depends on how well you set up the transformation. In the hands of an experienced user, some inventive and creative morphs can be pulled off. In the hands of Beavis and Butthead...well, you get the idea.

There are several other Windows morphing packages currently shipping, but this one was easy to learn and has filled our needs to date. Unfortunately, there is no support for QTW.

Available from Gryphon Software, (619) 536-8815, $149.

Authoring Software

Creating multimedia applications can be a real challenge—especially if you aren't using the right development software for a particular project. In this section we profile some of the more popular multimedia authoring software tools for Windows.

IconAuthor

IconAuthor, a highly respected product, has been around for a while, and it shows. How else could you explain its ability to blend both immense power and extreme ease of use? Fortunately for the desktop producer, IconAuthor strongly supports video (VfW, that is, but not QTW). Unfortunately for everybody, it has a price tag ($5,000) to send the dilettantes packing. Nevertheless, you couldn't ask for a better model of visual programming.

The main user interface works on a building block principle, with placeholder icons as the blocks. When your presentation structure is established, you deposit specific media files into the building block icons, then add transitions between them. It is this sort of approach that makes it possible to jump right in and create decent looking presentations the same day you open the package.

Other benefits of IconAuthor's visual programming environment are:

- Easy cutting and pasting of sections, even into other IconAuthor applications
- Fast preview of applications in development
- Built-in animation and painting modules

The downsides has less to do with product performance than with product management policy:

- To distribute your application to more than six people, you have to pay extra (contact AimTech for details)
- Free technical support only lasts for one year

Available from AimTech Corporation, (603) 883-0220, $5,000.

ToolBook

Many people find Asymetrix ToolBook Sphinx-like. They sense it has a lot of power to offer, but they have trouble unlocking it for some reason. This doesn't mean they don't buy the product; rather, it sits on the bench while the leaner, meaner applications take care of business.

This is unfortunate since ToolBook really does have power to spare. Much like Hypercard on the Macintosh, ToolBook lets you build *pages* (screens) into a *book* the way the Mac product uses cards to make a stack. Extra functionality is implemented through ToolBook's OpenScript, a high-level programming language.

Like in Visual Basic, ToolBook pages are actually forms to be painted with user controls and appropriate graphic design elements. Such controls are objects that have properties and behaviors. You can create graphic elements, such as bitmaps, within the application or import them from the outside world. Behaviors not predefined for given objects can be OpenScripted.

If you want to do video in ToolBook, you pretty much have to buy the Multimedia version (as opposed to the regular version). Included in the Multimedia edition are *widgets*, pre-scripted objects that you can use for, among other things, controlling both QTW and VfW movies. The movie control widgets look like the standard control buttons for consumer electronics devices such as VCRs.

ToolBook has a reputation for being a heavyweight as an application development tool. But because multimedia developers incorporating video are going to need lots of clear cut ways to add interactivity, ToolBook faces significant competition from

lighter weights. The regular version lists for $395, while the multimedia version is priced at $595.

Available from Asymetrix Corporation, (206) 462-0501.

Visual Basic

Unlike ToolBook and IconAuthor, Microsoft's Visual Basic is not a traditional authoring tool. It is an application builder. Originally targeted for developers needing to build demo programs under Windows, Visual Basic quickly charted its own course once people got their hands on it. As it turns out, Visual Basic is an ideal development environment for multimedia applications—particularly those applications that play movies.

Many of the Windows CD-ROM products currently shipping were developed using Visual Basic with the special QTW interface provided in QTW 1.1. This interface provides VBX controls for both QuickTime movies and pictures. In terms of performance, many people claim there is no discernible difference from programs written in native C.

If you are already working in Visual Basic, you'll have blue skies ahead when it comes to desktop video. If you are looking for a powerful and easy-to-learn development tool not only for multimedia (and are not intimidated by the Basic programming language), we highly recommend it.

Available from Microsoft, Inc., (800) 426-9400 (or most full service software outlets), $495.

Software for Controlling Analog Video Equipment

This section presents two very useful development tools for controlling analog video equipment—Personal Producer and Video Director.

Personal Producer

While Personal Producer has little to do with *digital* video per se, it handles what some people feel is the true desktop video. We cover it because it is an interesting and powerful applica-

tion that has significant parallels to products that manipulate the type of desktop video *we* have defined.

Essentially, Personal Producer brings linear, analog videotape editing to the Windows desktop. When combined with Matrox's Illuminator-16 video card, some additional titling and graphics software, an NTSC monitor, and a couple of tape decks that respond to one of several broadcast or industrial control configurations, Personal Producer can tie together a system capable of cutting and assembling industrial video productions back to tape (as opposed to digitizing them).

The main user interface resembles the Adobe Premiere model up to a point—complete with parallel video, audio, graphics, and effects tracks—but once you get into it, the similarity begins to fade. It's a fine product for what it does, but is not of much value to the *digital* desktop video producer. Perhaps one day there will be a digitization option included somewhere in the interface. If you want more information, Matrox distributes a VHS video that demonstrates the product's capabilities.

Available from Matrox, (800) 361-4903, $1,999.

Video Director

In a sense, Video Director is Personal Producer Lite. Also using the analog in/analog out approach, Video Director requires only a LANC-compatible source deck (or camera) and normal consumer grade VCR. It also costs significantly less. Unlike Personal Producer (and Premiere), its Windows interface does not display the audio and video tracks as parallel icon-like bars across the desktop. Instead, it uses onscreen VCR-like controls.

Video Director controls the source deck and VCR with a proprietary cable. One end connects to the PC's serial port. The other end splits into two separate cables: one with a mini phone plug for the source deck, the other with a special terminating wand that sends signals to the VCR's remote infrared receptor. Sounds marginal, but it works.

If you need to put together consumer grade video presentations with consumer grade equipment, Video Director can help

you. Again, programs that do not actually digitize video are pretty much out of our jurisdiction, but they are fun to use and can be very useful in putting together certain kinds of analog video productions.

Available from Gold Disk, (416) 828-0913.

Mac-Based Software

Most of the applications listed in this section ship with the retail version of QuickTime 1.0, although a few are only available on the 1.5 Developer CD-ROM. As in the Windows software section, the workhorse capture and edit programs get the most attention, but other tools are featured as well. If an application is not covered here, we haven't used it enough to provide a qualified review.

Standard QuickTime Applications

The programs profiled in this section are designed to work with QuickTime. Here you'll find an assortment of tools for performing tasks from capturing movies to converting and compressing them.

MovieRecorder

Still the easiest and most direct way to capture movies on the Macintosh, the venerable MovieRecorder hasn't changed much from its original incarnation in the QuickTime 1.0 Starter Kit. QuickTime itself, in version 1.6.1 as this book is written, has improved significantly in performance since that time. Figure 10.4 shows MovieRecorder's main user interface.

You can set all essential movie attributes from the application's various control panels, including frame size, frame rate, color depth, image quality, audio attributes, and compressor type. Depending on the capture card you have installed, various video sources can be selected, as well as various image attributes such as hue, brightness, contrast, and saturation.

Again, since QuickTime is cross platform, movies created on the Mac are playable under Windows. If you plan to capture on

Figure 10.4
The Mac
MovieRecorder
Application

the Mac but play your movies under Windows or on both platforms, you should read Chapter 28, in which we discuss cross-platform strategies and give a recipe for making Mac QuickTime movies playable on both platforms.

Although (as we all know) the Mac makes things easier, MovieRecorder is no less difficult to calibrate or digitize with than VIDCAP.EXE under Windows. Granted, they are both simple applications, but once you use them for a while you will appreciate how similar desktop video capture is on both platforms. We will uncover some of the disparities that *do* exist in the third part of this book, but basic capture is pretty much the same in either world.

MoviePlayer

MoviePlayer is the dedicated movie-playing utility on the Macintosh. It is the program that is invoked when you double-click on a standard Mac movie file. You can cut, copy, and paste movie frames (along with their audio) either within a single movie or among separate new or existing movie files. Figure 10.5 shows the user interface.

Figure 10.5
The Mac MoviePlayer Application

Movie play is directed with the *Movie Controller*, an interface common in look and feel to standalone QuickTime movies playing on both Mac and Windows desktops. It consists, essentially, of start and stop buttons, a volume control, and a scroll bar with a slider that permits you to scrub back and forth through a movie.

You can loop a movie, play it backward, set a selection to play, loop, or play in reverse. You can also play multiple movies in multiple instances of MoviePlayer on the Mac desktop. You can also get the movie's vital statistics and scale its size by factors of 2X - 1/2X, and full screen from the menu. Dragging the grow box at the bottom right corner of a movie window can also change its size.

MovieConverter

MovieConverter is the Casey Jones of QuickTime. Included in version 1.0, it was and still is (in our opinion) the most reliable way to make Macintosh QuickTime movies playable on both platforms. For some bizarre reason, however, Apple decided to drop it from subsequent QuickTime releases. Nice going, dudes.

As of this writing, everybody is running around trying to get a copy of MovieConverter or using less reliable ways to convert their movies, with predictable results. It seemed at first that MovieConverter's successor was ConvertToMovie but all this program really does is convert collections of pictures into movies. Useful in its way, but not really essential for our purposes. ComboWalker (which can batch movie conversion) seems to work in most cases, but we have not tested it as thoroughly as MovieConverter.

The other chore MovieConverter can do for you, if you can find it, is change the attributes of a given movie. You have to save it with the new properties, or under a new name, to realize them. Frame rate, frame size, compressor type, color depth, and image quality are the basic attributes available for change with MovieConverter.

MovieAnalyzer

See Chapter 24 for an in-depth look at this application.

MovieShop

See Chapter 24 for an in-depth look at this application.

GrabGuy

Technically unsupported by Apple, GrabGuy is dedicated to frame-accurate captures (from compatible video decks) by controlling the motion of their tape transport mechanisms via a serial port connection. Its main user interface is shown in Figure 10.6. In the early days of QuickTime, GrabGuy was the most popular way to get one-for-one frame grabs of longer movies.

Unfortunately, running GrabGuy requires that you have an industrial-quality (or higher) video deck, which can be expensive—at least several thousand dollars. It can be a tough choice: spend the money on video hardware *or* a more powerful Mac. Early on, we chose to get the video hardware since it gave us a lot more flexibility in that area. Also, Mac hardware was changing so fast we weren't sure what would be discontinued a week after we drove it off the lot.

Figure 10.6
GrabGuy's Main User Interface

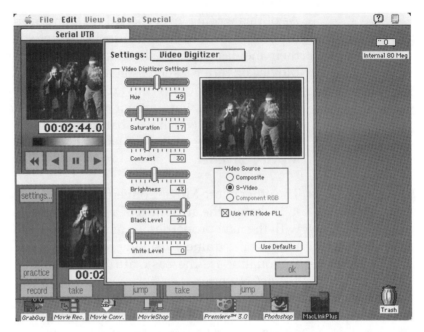

We have found GrabGuy to be reliable and efficient. The problems in using it happen on the video side—with Hi-8 tape delicacy, time base correction, and so forth. Also, you will want to capture your longer movies uncompressed, so you will need huge amounts of hard disk space (up to 1.2 gigabytes for five-minute movies).

The reason you'll need to capture raw is that simultaneously capturing and compressing with codecs like JPEG or CinePak almost always leads to damaged frames. Since GrabGuy makes multiple passes over a tape, picking up as many frames as it can in each pass, more time spent compressing means less time spent capturing. Thus, many more passes are needed, which over-stresses the tape.

Captioned Pioneer Movie Maker

The Captioned Pioneer Movie Maker application does the same thing as GrabGuy but works with the Pioneer line of laser disc players—the ones that can be serially controlled. One advantage it has over GrabGuy is that capturing with compression is possible, since the disc is only advanced one frame at a time during digitization (as opposed to multiple passes). This means you can get by with a lot less hard disk space if you simultaneously capture and compress with, say, CinePak.

Another benefit is that industrial laser disc players are cheaper than industrial VTRs. The big disadvantage, of course, is that most people can't afford the equipment to *record* onto the discs. A specialized service bureau can do this for you, but it costs about $300 per disc. We don't have a lot of experience in this particular area, but people we know have used this method successfully for commercial products.

PictureCompressor

What MoviePlayer does for QuickTime movies, PictureCompressor does for QuickTime pictures. In fact, you can clipboard an individual frame from a movie to the PictureCompressor and recompress it using any of the available QuickTime codecs.

PictureCompressor handles images in the PICT format. While its most obvious function is as a means to view still images, you can also use PictureCompressor to bring single frames into QuickTime movies. If you save an image to the PICT format from a program like Photoshop or DeBabelizer, you can open it with PictureCompressor and clipboard it into a movie.

Editing Workbenches

This section presents the three best Mac-based video and image editing packages that we know of—Adobe Premiere, Avid VideoShop, and Adobe Photoshop.

Adobe Premiere

It is fair to say that, as of this writing, Premiere rules the world of QuickTime movie editing on the Macintosh desktop. People who have been using Premiere all along have been impressed with version 3.0's substantial new features, while those learning it for the first time—even cynical video tape cutters—are likely finding little not to like.

Premiere's main user interface consists of parallel horizontal tracks in which you lay your video clips end to end. Separate tracks are provided for video, audio, and transitions and special effects. In version 2.0 of Premiere, only two working audio and video tracks were available (with a third for superimposed clips). In the new version 99 tracks are available—the original 2 plus 97 for superimpositions.

You can zoom in or out on any of your tracks, from the 30,000-foot view to the single frame. Clicking on any of the clips in a track brings up the clip in a separate window where you can set specific in and out points for that clip. Fast previews of marked sections of your overall movie are easily effected, and you can capture both video and standalone audio directly from within Premiere. Several add-ins are available that give you onscreen device control over your video deck.

It is hard to give a thorough review of all Premiere's features in a capsule of this type. For serious desktop producers, the program could hardly be better: flexible, solid, and professional in scope. If you are sure you need an editing workbench of this caliber, and are willing to pay the price, this is the one to get. Premiere is also now available for Windows, but with a feature set not even as robust as version 2.0 for the Mac.

Available from Adobe Systems, (415) 961-4400, $695.

Avid VideoShop

Originally called DiVA VideoShop before Avid acquired the company, VideoShop looks similar to Premiere at first, but once you start using it, you'll see that the user interface is significantly different. The original version of the program was HyperCard-based, but the new 2.0 edition is not. Parallel tracks (into which you can place video and audio clips) form the basis of the user environment in VideoShop, but there are other areas of the program that depart from this metaphor.

In the early days of QuickTime, Premiere and VideoShop seemed evenly matched and equally poised for greatness. In fact, VideoShop seemed to have an inside track because it used the QuickTime toolbox to manipulate movies while Premiere sucked movies in whole to do its magic. Somewhere along the line, however, Premiere pulled ahead in both market share and overall usability. VideoShop remains a fine product, but it may not catch up to Premiere in the public eye. We suggest you evaluate it for yourself to get an idea of its power.

Available from Avid Technology, Inc., (800) 394-3482, $499.

Adobe Photoshop

A recognized powerhouse in the world of Macintosh graphics processing, Photoshop can also be used to manipulate individual frames in a QuickTime movie if you output them in the *filmstrip* format from an application like Adobe Premiere. Once such multi-frame filmstrips are imported into Photoshop, you can do all kinds of cool things with them, not the least of which are compositing and rotoscoping.

Like with Premiere, covering Photoshop in detail would take up too much space here. It is, however, the best tool of its kind for doing the kinds of work we've mentioned. Additional capabilities for manipulation of movie frames can be added through Photoshop plug-ins. The product has recently been ported to the Windows platform.

Available from Adobe Systems, (415) 961-4400, $895.

Effects Packages and Utilities

As compared to PC tools, many more special effect packages and utilities are available for the Mac at the time of this writing. In this section we present the more widely used tools.

VideoFusion

Despite the fact that some people think VideoFusion plays second fiddle to After Effects, this product is an easy-to-learn workhorse for getting things done at a much lower price. Recently released in version 1.5, VideoFusion now supports field manipulation for broadcast-quality video (60 fields per second). Also, it can now import and export filmstrip files for desktop editors who want to work on individual frames in Adobe Photoshop.

Other enhancements include:

- Titling capability
- Capturing movies from within VideoFusion
- New *Save As* options for CD-ROM playback and variously powered CPUs

The real strength of VideoFusion is its complete battery of effects. None are arbitrary, and few (if any) important ones have been left out. After using them for a while, you may even find that its transitions are superior to Premiere's—although experimenting with basic transitions in Premiere can save time in the long run.

Of particular note in terms of usefulness are the effects PZR (Pan/Zoom/Rotate), morphing, compositing, and color channel manipulation. This is where skilled effects people will have the most fun and get the most professional, pricey-looking output. And even if you are new to these categories of effects, some patient exploration will pay off big time.

On the downside, VideoFusion's main user interface can be frustrating at times. Although at first it seems straightforward verging on intuitive, delays crop up when you try to combine movies with different attributes. For instance, trying to combine a 240-by-180 movie with a 320-by-240 clip involves first resizing one of the clips, which forces you to make some extra decisions and wait until the resizing is complete before proceeding.

Also, while most of the effects are quite powerful, some of the controls in the dialogs that calibrate them are nonstandard and confusing at first. When all you want to do is, say, rotate a movie around the Y axis, you wind up trying out all the knobs and barber poles to see what they do. Ultimately, you'll get the hang of it and can start cranking, but your patience can be drained until you do.

If you feel it justifies the price, you can purchase hardware acceleration gear (such as the YARC Nusprint card), which VideoFusion can utilize to drastically speed up the time it takes to do its rendering work. Like most real time savers, boards like this are expensive, but some larger production facilities may feel it is worth it.

On balance, VideoFusion is nevertheless an extremely useful jackknife of an application. People new to desktop video without a background in analog video do not seem to sense its potential at first, but once they start producing interesting

projects, they come to swear by it. You'll see why once you've used it for a while.

Available from Video Fusion Ltd. Partnership, (800) 638-5253, $649.

After Effects

Recently upgraded to version 1.1, Aldus' After Effects is considered the Rolls Royce of QuickTime special effects packages. It has a price tag to prove it, too: $1,295. Because it offers features completely lacking in its closest competitors (for example, editable transitions and mixing of unlimited video and audio tracks simultaneously), After Effects is the clear choice for desktop videographers needing access to professional-level image control.

Unlike VideoFusion and Premiere, After Effects' editing paradigm is based on layering. You add the effects you want one layer at a time, beginning at precise frame locations in the movie's time line. As with most extremely powerful and versatile software, the learning curve can feel mighty steep at times, but the results are worth the efforts (a few people we know had no trouble mastering it in a few hours (rendering time not included).

Among the other valuable features After Effects offers are:

- Outputting in frame sizes up to 4,000 x 4,000 pixels
- Outputting at frame rates up to 60 *fields* per second
- Cropping images in irregular shaped fields
- Frame-accurate control over almost every editing option

Aside from its unusual approach to movie editing, After Effects suffers from a small number of drawbacks:

- No zooming in on the time line; this can be tedious when microtuning longer movies
- No standard issue effects—all of them must be configured
- No real time movie preview—there is too much going on at the image processing level to allow good performance of the preview movie

Available from Aldus Corporation, (206) 622-5500, $1,295.

DeBabelizer

The Swiss army knife of bitmapped graphics converters, DeBabelizer can perform an extremely important function for desktop animators: batch conversion of a collection of graphics files to a format suitable for stringing them together into a movie. If you have ever attempted this laborious process by hand, you will appreciate the power DeBabelizer has to offer.

As a straight ahead graphics manipulation application, DeBabelizer features tools for editing images (though not as powerful as Photoshop's), adjusting tonal values, and converting bit depths. It also has the ability to dither images and remap and optimize color palettes. Although DeBabelizer can be controlled with an AppleScript, its own scripting language offers even greater control. We highly recommend this product.

Available from Equilibrium Technologies, (415) 332-4343, $299.

Authoring Software

In this section we present the three widely used multimedia development tools—Macromedia Director, Passport Producer Pro, and the HyperCard Development Kit.

Macromedia Director

Director is the multimedia development tool that keeps on giving. Unfortunately, for serious interactive productions, you'll need a level of intimacy with the application that is often required for programming itself. Many impressive works have been forged with Director over its various product cycles, however, so persistence pays off.

As of this writing, Director is the best suited tool among its peers for cross-platform development. Software is already shipping that converts Mac Director files into formats suitable for the royalty-free Windows Player and its counterpart on Silicon Graphics Workstations running IRIX 4.0.1 or higher. (For the record, some reports of bad performance under Windows have surfaced.)

Although Director is essentially a forms painter, it is less object oriented than most of its competitors, relying instead on a coding approach embodied in its script language, called Lingo. Classes of objects do exist (movies in particular) but the difference lies in how they are pressed into service at design time. If you are looking for analogies, HyperCard and HyperTalk come to mind, but similarities end when you expect quick and easy assembly of the finished pieces. Again, persistence will pay off.

Director currently has a list price of $1,195. Its big brother, Authorware Professional (also available for Windows) costs $4,994 but offers a staggering level of sophistication and control in developing multimedia applications.

Available from Macromedia, Inc., (415) 442-0200.

Passport Producer Pro

Producer Pro is an extraordinary product. Like QuickTime itself, Producer Pro is *time based*. This means that when a production is running, it will remain synchronized to the passage of real time—as opposed to falling apart if it tries to do too much work (like Director). The overall effect is a production that never feels sluggish, no matter how complex. Of course, embedded movies may drop frames, and text crawls may appear jerky, but on more powerful machines (and with well designed Producer Pro productions) this is a negligible problem.

Producer Pro uses a multiple track paradigm for its main user interface, laid out in parallel vertical columns. Time increases down the Y axis at the left edge of the construction area. The user drags various types of media to desired tracks, selects specific files of that media type, and then fine tunes them for playing, entering appropriate editing screens by clicking specific controls on the faces of the media elements, called *cues*. When you run your creation, all the tracks play their cues simultaneously. For testing purposes, tracks can be muted or soloed.

Placing a cue on a track effectively assigns it a start time, based on where in the track you drop it. You can bump it up against an existing cue on a particular track for an instant segue, or

slide it away and let cues on other tracks play during the vacant interval. Whenever you want, you can set exact start and end times for your cues via controls on their faces. Preview mode is available at the touch of the space bar. This is visual programming as it was meant to be.

Among the media types supported are: QuickTime movies, PICT and TIFF images, PICS animations, digitized sound files, slides with titles, audio CD tracks, AIFF files, and MIDI data. There are also extensive text handling capabilities and support for AppleScript and SMPTE time code. All visual media types may be animated to move around the screen while they are playing.

Other useful features include:

- Making an image (or part of an image) an invisible button for triggering a specific program branch
- Device control for VISCA, VLAN, ARTI, and Pioneer laser disc equipment
- A gradient background generator
- Over 40 Transitions for segueing between media (dissolves, zooms, and so on)

Of course, there are a couple of minor chords, but only for the record:

- A little too much reliance on command keys, although Passport has listened to customers and improved this significantly since the previous version of Producer
- Although many enhancements have been added to Producer Pro to make it capable of producing interactive applications (the original version was noninteractive), the overall feel is that you are still building passive presentations—this is, however, just a matter of opinion and not quantifiable

When your project is complete, you can compile it into a Player file. To run a player file, you need the Producer Player program, available from Passport on a sliding fee scale, depending on how many copies you plan to distribute. Details on this pricing program can be obtained from Passport.

Currently priced at $1,495, Producer Pro is also available on an upgrade path for owners of the original product. If you are

unconvinced, a video is available from the company that demonstrates its power and ease of use.

Available from Passport Designs, (415) 726-0280.

HyperCard Development Kit 2.1

Hypercard is either a capable survivor or dead technology, depending on who you listen to. The truth is, people who have invested time learning how to program in HyperCard—and they are legion—can pull movies into interactive stacks and build impressive multimedia applications without breaking much of a sweat. The original version of DiVA (now Avid) Video Shop was a HyperCard application.

This latest edition of the HyperCard Development Kit offers some important new features:

- Multiple, resizable windows (as opposed to the 6-inch x 9-inch windows of yore)
- Support for Apple Events
- Improved script support

As with previous versions, there are still a few irritations:

- Sluggishness in large stacks, especially on slower machines and in interactive creations where precisely timed user response is required
- No clear way to view the overall structure of your production
- The requirement that the end user have HyperCard installed (Claris provides a separate HyperCard Player for $349)

Still, compared to its peers (on an admittedly unlevel playing field), Hypercard is a terrific bargain. Also, for beginning multimedia developers, the existing code base is enormous. You can get royalty-free stacks almost anywhere these days (from online services, user groups, and so on) that you can both learn from and incorporate into your own productions. Now that Apple has reclaimed HyperCard from Claris, perhaps the best is yet to come.

Available from Claris Corporation, (408) 987-7480, $199.

Software for Controlling Analog Video Equipment

We'll close out this chapter by profiling a useful tollkit for controlling your Mac's analog video equipment.

Abbate Video Toolkit

In concept, the Abbate Video Toolkit falls somewhere between the PC programs Personal Producer (Matrox) and Video Director (Gold Disk), except that it also captures QuickTime movies. This Hypercard-based program's main purpose is to allow video producers to do logging and offline editing on a wide range of Apple systems, from Quadras to Mac Pluses, including Powerbooks.

The Toolkit can control a number of prosumer and industrial decks (including cameras) with near-frame accuracy, but the only capture boards currently supported are RasterOps products, specifically the 364, 24STV, 24MXTV, 24XLTV, VideoTime, and MediaTime. When no capture card is installed, you can still use the product for logging but you can't digitize QuickTime movies. This is not meant to downplay the logging capability—it offers power and flexibility in annotating and cross-referencing that most video people who have used the product say is worth the price tag all by itself.

Using a cable that comes with the Toolkit, you connect your Mac to any LANC compatible deck and control it via a VCR-like onscreen interface panel. Response can be somewhat sluggish. If you are using a capture card, a small movie window opens to display the output from the deck you are currently controlling. Custom Hypercard stacks are created that contain the results of your work.

Unfortunately, Hypercard's performance drag may frustrate some users. The Toolkit's basic list price is $279. Separate kits are available for equipment that supports other edit control protocols, such as Control L, Control S, and Control P.

Available from Abbate Video, (508) 376-3712.

Video Hardware Standards

HAVING AN UNDERSTANDING OF VIDEO HARDWARE STANDARDS WILL HELP YOU APPRECIATE THE CAPABILITIES OF THE EQUIPMENT YOU'LL BE USING FOR DIGITIZING VIDEO.

As far as the desktop video producer is concerned, real video standards are already set. Real videographers have been dealing with them since before VGA. The video world is lousy with acronyms and coined words, almost as bad as the personal computer industry. Fortunately, the analog video world is not changing quite as fast as the PC industry where Macs and Intel-based PCs constantly struggle to outdo each other.

While we will not speculate on the future of commercial video or presume to dictate its behavior, we will, however, attempt to explain the existing standards and identify the equipment that will best facilitate your digitization efforts. (An excellent reference for more detailed information on the technical aspects of analog video and how it is converging with digital video is *Video Demystified* by Keith Jack, HighText Publications, Inc.)

In this chapter, we will discuss:

- Video tape standards
- Video signal standards

- Broadcast standards
- Time codes
- Edit control protocols
- Hi-8 and 8mm tape management

Getting the Right Perspective

Let's digress for a moment to establish a working perspective on analog video. As a desktop movie maker, you'll need to have a consistent way to conceptualize and deal with it so that, when problems come up, you do not waste time going down blind alleys or spend money on temporary solutions to permanent dilemmas.

Within the scope of this book, we will regard analog video as a signal that arrives at a PC over a standard cable. The first thing we do with this signal is use our capture card to turn it into a series of digital images. From that point on, it is no longer video in the traditional sense, but we really don't care as long as it looks as good as possible on our monitor while we digitize it. We are talking about stability, clarity, and color values here—not the nature of the video content.

If we have reasonable expectations (based on earlier chapters) and do a decent capture job, our digitized clips will constitute a viable media type all on their own. They will be merely based on, not *dependent* upon, the original analog video. We don't have to know anything deeply technical about the analog video signal to handle it in this manner, just that it adheres to some type of recognized standards. We'll cover these standards in a moment.

A useful analogy is what happens when images are recorded by a video camera. Light from a subject enters the camera and strikes a sensitive surface. That surface, which holds a constantly changing facsimile of the subject, is scanned (sampled) many times per second by an electron beam. Each successive scan is encoded as a series of changing voltages, which together comprise a continuous video signal. That signal is *based* on the original incoming light, but is ultimately only a representation of it, just like our digitized clip is a representation of the generated video signal.

It is interesting to consider most desktop movies as *twice* removed from what their original subjects looked like. For the time being, desktop video (unless it is assembled from collections of still images) will piggyback on analog video for efficient production. One day soon, perhaps, we'll carry around powerful laptops with huge hard disks onto which we can digitize directly from our camcorders without first recording onto videotape. Digital *still* photography for the PC is already available to the consumer.

Simplifying the Issues

The point of the above digression was to reduce analog video issues to simply a matter of differentiating among several sets of standards (NTSC, PAL, SECAM, Composite, S-Video, VHS, Hi-8, Betacam SP, and so forth). As we stated in the overview to this book, digitizing professional-looking desktop movies shouldn't involve a course in video engineering (contrary to some popular opinion). Such a background would lend an extremely interesting perspective, but won't necessarily help you make better movies.

All you should need to know is how to hook up your equipment and the basic differences between the standards, especially how they differ in quality. For example, if you want to digitize from the highest-quality video source available from a particular taping session, you should know how to ask for it by name (Betacam SP, please, if possible).

Some other books on desktop video spend a chapter or two explaining how video works, but this generally raises more questions than it answers. Again, it is a fascinating subject, but a rat hole you don't need to go down if you wish to get started making movies. For full-on digital video, such an understanding is essential. Not so for desktop video as we have defined it.

Once we have examined the pertinent standards, we will cover as thoroughly as possible the currently available video input sources and low end video processing equipment. This will include VCRs, VTRs, laser disc players, video cameras, and more esoteric gear such as time base correctors.

Tape Standards

The first series of acronyms and diminutives we'll try to put in perspective are the tape quality standards. The formats the desktop producer needs to be aware of are: VHS, Beta, S-VHS, 8mm, Hi-8, 3/4 Betacam, and Betacam SP. There are even higher-quality grades, which we will mention for completeness once we cover the basics.

VHS, Beta, and 8mm are considered consumer standards. S-VHS and Hi-8 are the industrial grades. The term *industrial* is basically a catch-all that covers tape and other production standards between consumer and broadcast quality. While industrial productions may include professional education and training videos, they would rarely if ever show up on broadcast TV. Betacam and above formats are used for broadcast-quality productions. Next, we'll show you a detailed breakdown of the video tape continuum.

VHS

VHS is the most commonly used type of video tape in the universe, even though it was not the first kind available to the consumer (Beta was). Standard cassettes like the ones you rent at Blockbuster can hold roughly two hours of content recorded in the SP (Standard Play) mode. VHS uses a half-inch tape width and stores video in the composite format (covered in a moment).

For many desktop video productions VHS will suffice, but you should always try for better. Some of the older camcorders use tapes in this format, but it is principally a VCR format. A new variant of VHS, called VHS-C, comes in a more compact videocassette (for camcorders) and offers essentially the same quality as regular VHS.

Beta

Sony's original VCR format, Beta, lost the consumer standard war to the VHS format developed by JVC. Although technically superior, Beta machines have all but disappeared from the landscape. A consumer standard called Super Beta appeared briefly, but it too fell by the wayside after a time.

An even newer format that is now available, Beta-ED, gives even more improved picture resolution. Like VHS, Beta tapes are half-inch composite but deliver a better signal. Beta cassettes are smaller than VHS cassettes but still hold up to two hours of content in standard mode.

8 Millimeter

The new consumer standard for composite tape is Sony's 8mm. Able to record for two hours in SP mode, these compact tape cartridges have helped make possible the bantam weight camcorders that have become so popular. Unfortunately, you need to get a new deck to play these tapes back on if you want to digitize from them. In a pinch, you can use your camcorder itself as an 8mm deck (until that third mortgage comes through and you can pick up a dedicated EVO-9800A or two).

S-VHS

S-VHS, shown in Figure 11.1, is the most prevalent tape format in the industrial arena, such as it is. S-VHS tapes are made to be used in decks that support the S-video standard—as opposed to composite video. Based on the same half-inch tape standard as regular VHS, S-VHS tapes nevertheless deliver a much sharper image than their cousins. They also sound a lot better, by design. Unfortunately, you can't play them in a normal VHS machine (although you can do the reverse).

Figure 11.1 An S-VHS Tape

Hi-8

While S-VHS rules the industrial class, Hi-8 is the king of camcorders (and an example of the emerging *prosumer* quality standard). With one of its feet still rooted in *con*sumer land, Hi-8 is nevertheless also the tape format of choice for many of Sony's professional video tape decks, such as the EVO-9800 series. Like S-VHS, Hi-8 tapes store video in the S-video format and impart high fidelity sound. If you are a serious desktop movie producer, you will probably settle on this format in the long run (see Figure 11.2). Unfortunately, you will have to deal with Hi-8's much greater fragility (compared to S-VHS).

Betacam

We are now at the bottom rung of the true professional world (not including the 3/4 standard). How's your credit rating? While still using a half-inch tape format, Betacam cartridges are bigger and more durable than the other formats we have discussed. The Betacam standard also ups the visual ante by separating each of the colors in the signal. S-video just separates color and brightness channels.

Betacam SP

Essentially, Betacam SP delivers even better audio and video quality than the already high Betacam standard. Both have the ability to be played and copied many times before wear and tear is noticeable. Betacam and Betacam SP tapes are the workhorses of the existing base of professional videographers (see Figure 11.3).

Figure 11.2
A Hi-8 Tape Cartridge

Figure 11.3
A Betacam SP Tape

The typical desktop producer will not be able to make use of this format unless he or she rents a Betacam deck at an outrageous daily or weekly rate. Don't even think about buying one. For all but the most critical productions, you would be wise to consider Hi-8 your target tape format for making your own desktop videos.

Other Formats

A couple of other formats are worth mentioning here to complete our tour of tape standards. Even higher on the quality scale than Betacam SP are the digital tape standards: D1, D2, and D3. The differences between these standards are not worth going into here, but they are basically different and incompatible formats—not related versions on a sliding quality scale.

The cool thing about them, of course, is that these tapes don't lose a generation when duplicated. Like DAT audio tape, they are digitally encoded. Also, they have CD-quality audio standards. Unfortunately, only the most well-heeled production and postproduction facilities can afford them. And, because they are incompatible, they are strongly competitive and serve to fragment the industry. Live television broadcasts are generally stored on this type of tape for rebroadcast later.

Perhaps the most venerable of the broadcast standards is the three-quarter-inch Umatic format, shown in Figure 11.4. Though

Figure 11.4
A Umatic Tape Cartridge

only able to contain about an hour's worth of taped material, Umatic machines refuse to go quietly from the video trenches. They do have high image and audio quality from a desktop producer's perspective, but are only worth mentioning as a form of lifetime achievement recognition.

A final word: There are more tape formats on the way; all digital (of course), all from major corporate contestants, and all different. Like with the emerging digital video standards on the personal computer, there is a poker game in progress among players with deep pockets who are convinced they can make them deeper by digging in instead of cooperating.

Getting back to our desktop, it makes no difference to a capture card what kind of tape the analog video is coming from. But sequences based on the same content digitized from different quality tape media can be very different in terms of image quality. We can't say this enough: Make sure not only that your source is clean, but that it is one of the highest standard of tape possible, especially if you're going for a real video look. If you compare the movies VHS.MOV and BETACAM.MOV on the companion CD-ROM, you will be able to see the difference clearly.

Video Signal Standards

The second group of video standards involves the degree of separation of the video signal components. The cables that carry

these separate signals are physically different, and correspond to the type of video deck and tape format they are being used with. In order of quality, lowest first, there are composite, S-video (also referred to as component video or Y/C) and, in a related way, RGB.

Composite Video

Composite video is the standard that connects almost all consumer video equipment—television sets, VCRs, laser disc players and camcorders. Normally it is transmitted over basic patch cables with male RCA plugs on each end, as shown in Figure 11.5. Often these cables are joined strands with red and white (or red and black) connectors that carry video and mono audio signals side by side. With higher end prosumer gear, the composite video cables are often three-ply, with two wires for stereo audio and a thicker, shielded strand for the video signal.

As we saw in the previous section on video tape standards, composite video is the format used in standard VHS and 8mm cassettes. Technically speaking, it combines the three basic elements of a video picture (color, brightness, and synchronization data) into a single, composite channel. As a beginning desktop video producer, you will often work with composite video. As you become more seasoned, however, you will probably begin insisting on S-video (or higher).

Figure 11.5 Composite, S-video, and RGB Cables

S-Video

S-Video (Y/C or component video) is carried on cables that end with four-pin DIN connectors, as shown in Figure 11.5. A video signal transmitted according to this standard separates color and brightness into two separate channels. This makes for a better looking, less granular picture on the receiving end. Higher formats, such as Betacam, break down the video signal into even more channels for better picture quality.

Since digitized granularity looks worse than analog granularity, you are strongly advised to use S-video over composite whenever possible, especially when striving for close fidelity to the original. Also, by using the S-video standard, you will not have to worry so much about *dropout*, a problem that occurs more in the VHS/composite video world. We'll cover this in more detail in Chapter 14. The tape formats that correspond to the S-video standard are S-VHS and Hi-8.

For some bizarre reason, more than a few people getting into desktop video think that S-video incorporates audio. We've seen cases where content is captured with just the S-video cable connected, and the capturer wonders why the movie has no sound. Here's the deal: Always connect the audio cables, regardless of what video standard you are using.

RGB

RGB is not a video standard per se, but is worth mentioning to provide an overall perspective. It is rather a standard for computer monitors, and requires a special four-strand cable for connecting the monitor to the CPU (see Figure 11.5). In concept, it is a component format more like Betacam than S-Video. Three of the strands carry color information for the red, green, and blue (RGB) components of the image, while the fourth strand carries timing information.

Broadcast Standards

The third group of standards—NTSC, PAL, and SECAM—combine technical and *legal* definitions. These are the broadcast

standards, and countries worldwide adhere to one of the three. NTSC and PAL are based on other standards (basically, alternating current frequency). SECAM is essentially political.

NTSC

NTSC stands for National Television Standards Committee (or Never The Same Color). It is the video standard for North and Central America (including Canada and Mexico) and Japan. Its technical format is 525 lines per frame with roughly 30-fps refresh rate, as shown in Figure 11.6. It is pretty much synonymous with composite video when talking about a video signal, but is not necessarily equivalent to the output from a video capture card that a manufacturer's rep may claim is *NTSC-legal*.

PAL

PAL (Phase Alteration Line) is the European counterpart to the NTSC standard. It has a higher vertical resolution (625 lines) but a lower frame rate (25 fps) that can cause flickering. It is the standard in the UK, Western Europe, the Middle East, and parts of Africa and South America.

SECAM

SECAM (Systéme Électronic Pour Couleur Avec Mémoire) is very similar to PAL. It specifies the same number of scan lines and frames per second, but differs in that chrominance (color) is FM modulated. It is the broadcast standard for France, Russia, and parts of Eastern Europe and Africa. SECAM exists in France because the French government was looking for new things on which to levy an import tax.

Figure 11.6
Traditional NTSC Video Output vs. That from a Computer Video Card

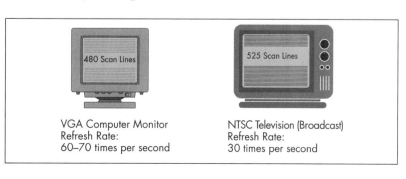

While people may tell you there is inexpensive hardware available at video supply stores and Radio Shack franchises that will convert between these three standards, don't believe them. Some industrial video decks handle tapes in multiple formats, but they are not cheap.

If you need translation of, for example, a two hour PAL VHS tape to NTSC, a conversion house will likely do it for under a hundred dollars. Fortunately, your day-to-day digitization activities will rarely include dealing with mismatches among these standards.

What is more interesting is the evolving debate centering on whether the hot rod video capture cards can produce NTSC signals suitable for legal broadcast. Even though output from these cards can exceed the number of scan lines required per frame, it is the *number* of frames (fields, actually) per second that is in question, as well as issues having to do with such things as pixel shape. This issue is going to heat up substantially in the near future.

The Evolving HDTV Standard

The standard for High Definition Television (HDTV) will probably turn out to be digital. But who's really winning this race? Every few months, an article appears in *The Wall Street Journal* saying that either the United States or Japan has the technological lead, but that commercial penetration is several years away. The current wisdom is that, if Japan wins, the standard will become analog. If the U.S. wins, it will stay digital. Reportedly, the FCC is deciding *which* digital standard to adopt for the U.S. Several are being developed.

While it is exciting to imagine the promised improvements in clarity and screen size for the home theater, the implications for the desktop video producer are not troubling at this point. It is likely that by the time really big, crystal clear TVs are part of the culture, advanced computer technology will have enabled desktop video to merge with or replace true digital video.

Time Code Standards

But wait, there's more! Time codes are the standards that provide synchronization among video decks, video cameras, DAT machines, edit controllers, and desktop video (up to a point). SMPTE time code is used at the broadcast level and is completely frame-accurate. Hi-8 time code, a more industrial standard, also provides frame accuracy but lacks SMPTE's ability to include extra information with each frame. RC is a time code used on consumer grade products.

SMPTE Time Code

On analog video tape striped with SMPTE time code, frames are stamped with the hour, minute, second, and frame numbers (for example, 04:22:17:05) which can be read by SMPTE-enabled decks. Betacam decks and most high-end video cameras stripe tape automatically. Industrial video decks often need to be instructed to do so.

Technically, SMPTE time code can be split into two subtypes: drop and nondrop. The drop variety skips two frames per minute to compensate for the true frame rate of NTSC video (29.97 frames per second). To get even closer, every ten minutes those two frames are *not* dropped.

SMPTE nondrop time code assigns a time stamp to *every* frame on a tape. The result is a discrepancy between the actual runtime of a video clip and an estimate based on 30 fps. Because this discrepancy can become significant over the course of an hour, the broadcast video industry adopted the SMPTE drop standard.

When broadcast-quality productions are being assembled, SMPTE time code is essential for frame-accurate edits and effects. First, copies of the original video footage are made that contain the same time codes as the original. Then, when *offline* edits are performed on the copies, an edit decision list (EDL) is generated that contains time code references to where the edits were made (and what type they were) on the tapes.

In the final *online* editing session, that EDL is used to orchestrate copying of the desired portions of the original footage onto the final master tape for the production. Since SMPTE provides for including an optional eight characters worth of *user bits* in each frame (along with the time code), information such as cassette number can be included on all copies of the footage, including the final master tape.

You should also know that SMPTE time code can be broken down into two *other* subcomponents: Longitudinal Time Code (LTC) and Vertical Interval Time Code (VITC). For the desktop producer, an important difference is that VITC can be read when a video deck is paused (when you are looking at a still frame). LTC does not provide this facility. Remember that SMPTE is not meant for telling time. It is simply a frame numbering strategy, a way to match frames on one medium with frames on another.

Hi-8 Time Code

Hi-8 time code is just as accurate as SMPTE nondrop time code, but doesn't include the user bits. Its advantage is that the area of the tape on which it is striped is separate from the audio and video data. In other words, Hi-8 time code can be written onto a tape after footage has been recorded without damaging the existing footage.

Hi-8 time code is important for desktop video producers doing frame-accurate captures with applications like the Mac-based GrabGuy, which can control an industrial video deck through a serial port connection. We cover this and similar programs in Chapter 10, and also the third part of this book.

One of the inevitable analog/digital mismatches crops up here. This one casts into high relief how desktop video is merely *based on* analog video, not an undiminished digital copy of it. Since NTSC analog video is always 29.97 fps and desktop video is substantially less (depending on the frame rate set at capture time), there are going to be apparent inconsistencies when ascribing time code to desktop video clips.

Edit Control Protocols 173

For example, the GrabGuy program has an option for stamping time code on each of the frames it captures. (This is akin to a *window dub* in analog video.) If you tell GrabGuy to capture at a rate of 12 fps, you will see that the resulting clip contains frames that are not evenly spaced (that is, frames 2, 4, 7, 9, 12, 14, 17, 19, 22, 24, 27, 29). This is, of course, because 30 is not evenly divisible by 12. Figure 11.7 shows a frame from such a window dub.

What this example demonstrates is that time coding has a significantly different context in the desktop video world, even though an increasing number of programs (authoring and movie editing programs in particular) take a time code-like approach to placing video clips in a time-based continuum. In the long run, it probably makes sense to do it this way as opposed to creating a whole new synchronization system, but you should realize you are dealing with approximations when using such programs.

Figure 11.7
A Movie Frame with SMPTE Time Code Stamped on It

Edit Control Protocols

The last set of video hardware standards we will discuss in this chapter is the most esoteric: edit control protocols. It is important to cover these standards in some detail, however, because editing programs like Adobe Premiere are now using them to control prosumer-quality video decks, cameras, and external edit controllers for movie capture and assembly.

With the exception of specialized applications that use edit control protocols to manipulate tape decks for output *back to tape*, the Windows world trails the Mac world in exploiting these standards. But it is catching up quickly, as witnessed by the inclusion of an MCI-based device control API in Video for Windows 1.1.

To give you a better idea of what we are talking about here, let's use a quick example. When you select *Preferences* from the Premiere 3.0 *File* menu, a submenu is displayed that contains an item called *Device Control*. Selecting this item brings up a dialog, shown in Figure 11.8, from which you can choose among several different device control methods. Included by default are ARTI, DQ-Animaq, V-LAN and VISCA.

Figure 11.8 The Premiere Device Control Dialog

Figure 11.9
Premiere's Capture Dialog with a Device Control Interface Attached

If you have the software and, in some cases, the hardware installed that support one or more of these device control methods—and you select it—you will generally receive additional instructions. In the case of the VISCA option, a VCR-like control bar interface appears below Premiere's capture dialog when you invoke it from the *File* menu. Figure 11.9 shows what this interface looks like on your desktop.

Using the interface provided by the VISCA driver, you can put a VISCA-compatible video source through all of its basic paces (start, stop, pause, rewind, and so on) just as if you were punching the buttons on the actual equipment. When you have the tape cued to the appropriate spot, you can click the *Record* button inside the dialog, then roll the tape using the interface's start button. When you have recorded what you want, use the interface to stop the tape. No muss, no fuss.

Each selectable device control method uses a particular edit control protocol to govern the attached equipment. Instructions are sent to the video source through a separate cable generally attached to a Mac serial port. Currently, the hardware and software that works with each device control method must be purchased separately. If you want to install one of these options

right away on your Mac, here are the latest numbers we have on file:

- ARTI, from ARTI, Inc., (408) 374-9044
- DQ-Animaq, from Diaquest, (510) 526-7167
- V-LAN, from Video Media, (408) 745-1700
- VISCA, from Sony, (408) 944-4357

As mentioned earlier, similar device control has not been implemented under Windows for applications that digitize video. Premiere for Windows 1.0 specifically doesn't have it, but then it doesn't have a movie capture function either. Again, this situation in general appears to be on the verge of changing, based on the device control API included with VfW 1.1.

What *has* been implemented under Windows in terms of device control is a group of products that control video decks for output back to tape (as opposed to digitization). Among these applications are Gold Disk's Video Director and Matrox's Personal Producer. These and other products are covered in detail in Chapter 10.

Hopefully, the example we provided earlier will help you to put device control into a sensible context. The main thing to remember is that, in general, device control relies on an edit control protocol for communication with a given device. Let's now return to our discussion of edit control protocols as video hardware standards.

On the analog video side, a device that synchronizes subprofessional video gear in an editing suite is called an *edit controller* (sub-professional, as used here, includes both prosumer and industrial equipment). There are a number of products—implemented as either dedicated hardware solutions or PC applications—that fill this roll, with varying degrees of sophistication.

Some interesting onscreen products are:

- Soft VTR, from Moonlight Computer Products, (619) 625-0300, for $999
- The Animation Commander, from Drastic Technologies, (416) 636-4444, for $599.00

Edit Control Protocols

The lexicon of commands that flows between an edit controller and the devices being controlled (video decks and cameras) is the edit control protocol. Almost all edit control protocols currently in use were created by hardware manufacturers to manipulate their own equipment. They are generally transmitted serially.

Not only do these protocols differ between OEMs, but most manufacturers also have different protocols for their consumer and industrial equipment. Fortunately for desktop video producers, such incompatibilities are not much of a problem, since all you need is one deck or camera to control when you are capturing a clip.

The following sections show the edit control protocols currently in use.

Control-S

One of the simplest of the protocols, Control-S consists of basic start, stop, record, and pause commands corresponding to functions available on a VCR remote control bar. Created by Sony, this command set has little relevance to PC-based edit controllers. A subset of Control-S, called Control-P, provides just start and stop commands.

GPI

An uncommonly ubiquitous protocol, GPI (General Purpose Interface) is an industrial standard that uses short pulses to communicate action requests. Like Control-S, GPI is not of much use to desktop video producers.

Control-L

Also known as LANC (Local Application Network Control), Control-L is implemented on all Sony consumer video cameras. This Sony protocol is also found on Canon camcorders and those of a few other companies OEM'd to by Sony. Although prevalent, Control-L is considered somewhat clumsy and inefficient. It also employs different types of connectors for video decks (a 5-pin DIN plug) and video cameras (a mini stereo plug).

Many of the existing noncomputer-based edit controllers use Control-L, as do most of the Windows and Mac applications that control tape decks for output back to tape (for now).

Control-M

Control-M is a standard developed by Matsushita that, while employing a similar 5-pin connector, is incompatible with Control-L. The Panasonic AG-1960 and AG-1970 decks both support Control-M, as does Panasonic's AG-460 camcorder. Like Control-L, Control-M is nonframe accurate but supported by both standalone edit controllers and software applications.

RS-232 and RS-422

Both the RS-232 and RS-422 protocols are existing microcomputer standards. On Macs, RS-422 rules. For Intel-based PCs, RS-232 is king (and is used for such things as connecting computers to modems and laser printers). Because of a slightly different wiring scheme, RS-422 cables can transmit data over longer distances. They are also less sensitive to noise and support both SMPTE and Hi-8 time code.

Actually, RS-422 is much more prevalent. It is implemented across gear from almost all manufacturers, from the industrial level on up. Bold pioneers who used the venerable GrabGuy program to control an industrial Sony VTR such as the EVO-9800A often became intimately involved with RS-422, especially as they called around looking for someone to build them a proper cable.

VISCA

VISCA is an acronym of Video System Control Architecture. It is a networking protocol designed to interface a wide variety of video equipment to a computer. Although the word video appears in the name, VISCA is not limited to the control of video devices. The protocol is very flexible and can be extended for a wide variety of equipment.

The primary purpose of VISCA is the control of devices on a single network. VISCA utilizes messages to exchange data be-

tween network devices. The computer serves as a network master, doing all the necessary tasks to initialize and maintain the network.

Communication is accomplished using message dialogues. One device, the controller, initiates a dialogue with another device, the peripheral. Any device on the network is permitted to assume the role of controller and initiate dialogues with another device on the network.

One of the principal advantages of VISCA is that you can daisy chain devices—up to seven of them. Because of Sony's backing, VISCA seems to be the protocol with the most promising future in computers. As we have seen, it is already supported by Premiere on the Mac, and we expect to see it implemented on Intel-based PCs in the very near future.

The reason we have run down the various edit control protocols is that they are probably somewhere in your future. While they can seem peripheral to the larger standards issues involved in desktop video, the fact that they are aggressively supported by major hardware vendors makes them well worth paying attention to.

The Ten Commandments of Hi-8 Videotape Management

If you have chosen Hi-8 as your videotape medium and you do not come from the analog video world, you may have already had some ugly experiences with this format (and regular 8 mm tape as well). There are few things worse than thinking you have shot terrific footage, then finding out it is full of inexplicable distortion when you sit down to digitize it.

You'd think the word would be out about the sunken coral reefs waiting to rip through your carefully recorded clips, but for some reason appropriate warnings have been left off the tape packaging. The main reason for the problem, of course, is that the smaller cartridges and lighter tape stock are much more delicate and subject to wear, tear and temperature than their VHS and Betacam counterparts.

To help you navigate the land mines, we present a list of recommendations for dealing with both Hi-8 and 8 mm tape cartridges. These are not casual tips meant for perfectionists. Failure to abide by most of them can make the difference between usable and unusable footage. We are grateful to Paul Lundahl at Practical Productions for letting us expand on his original list.

1. Never use 120-minute tapes. The tape stock used in these cassettes is only 9 microns thick, as opposed to 60-minute or less tapes which are 12 microns thick.
2. Never do your takes on the first several minutes of tape (starting anywhere past the five minute mark is a good rule of thumb). The first few minutes is where most of the stretching and crud build-up are likely to occur. You can expect to suffer greatly for ignoring this point.
3. Always fast forward a new tape to the end then rewind it. This is know as *packing* a tape. Many professionals also recommend *blackstriping* your new tapes—recording from start to finish in one pass, then rewinding. Both processes remove stray particles from the tape coating and also even out tape tension across the entire cassette. If you record onto loose particles and they fall off, you will lose the corresponding parts of your picture. You can expect to pay dearly for ignoring this point also.
 Also, don't reuse 8 mm and Hi-8 tapes like you would VHS tapes. Obviously, there is a happy medium here. To put it as succinctly as possible, expect to make an investment in Hi-8 (or 8 mm) tapes. You must condition them for your recording sessions, but re-using them more than a few times invites disaster. (Recycling is a good way to pile crud onto your tape heads.)
4. Always take head cleaning seriously. This is an area in which opinion varies greatly. One strategy we endorse is to use dry abrasive cleaning tapes until your heads wear out, then get new heads. This ensures that only the heads are at risk during the cleaning process. If you must clean your heads by hand, be sure to get the advice of a trained video professional.
5. Always test your tape cartridge when preparing to shoot anything crucial. Also, always test your tapes on different

machines after your shooting sessions. Some decks can have tracking problems that can make your tapes look bad when they are actually okay.

6. Always do logging and cutting for complicated productions on copies of your masters. If you are digitizing your raw masters immediately (so that you can edit the captured digital versions), always make copies of your masters anyway, just like you would back up your computer files.
7. Always make sure to store your tapes well out of sunlight. Cases should be stored on edge with the packed spool at the bottom.
8. Always consider humidity and temperature. When storing or transporting your equipment, pack it in a sealed case or ziplock back with a dehumidifier such as Desacant. If your equipment undergoes drastic heating or cooling changes, be aware that condensation can result which must be eliminated prior to using the equipment.
9. Always carry on your tape stock when flying. Airplane cargo compartments are not kept anywhere near room temperature.
10. Always use transcoding time base correction when bumping up from Hi-8 to Betacam format. This allows for precise RGB transferring.

In this chapter, we've attempted to cover all of the video hardware standards that will be important to you as a desktop producer. With this information now (hopefully) clear to you, you can better appreciate the capabilities of the various types of equipment available for video digitization. As a practical matter, once you get past consumer grade VCRs, laser disc players, and camcorders, prices take an ugly upturn. For now, your best strategy is to examine each potential addition to your digitization studio on its own merits.

VCRs, Cameras, and Laser Disc Players

BEFORE JUMPING INTO THE EXCITING WORLD OF CONSUMER ELECTRONICS AND INDUSTRIAL VIDEO EQUIPMENT, YOU'LL WANT TO CONSIDER ALL OF THE AVAILABLE OPTIONS.

When you install your first video capture card, you'll probably connect it your home entertainment center VCR right away (assuming you're not immediately setting up a complete capture suite). After moving it between your television and your computer a few times, you will probably consider buying a new VCR. Before you head out to the mall, we'd like to offer you a few things to consider before you spend money on just another VHS machine.

If you plan on becoming a dedicated desktop video producer, you will want to invest in equipment you can get as much use and performance out of as possible. For instance, if you were planning to buy a camcorder anyway, why not spend a little extra to get a prosumer Hi-8 model and let that serve as your

new *deck* as well? (We can't recommend this exact strategy for the long term, but it does serve to illustrate a particular way of thinking.)

Or maybe you're already working in the desktop video industry and have received an assignment to digitize into Macintosh CinePak format a series of high-quality tapes. The problem is, you don't yet have a Quadra class computer or the necessary hard disk space to capture raw, 15-fps, 240-by-180 movies for subsequent compression.

For this particular assignment, you might want to think about having the tapes transferred to laser disc first. Then, using the Apple Pioneer laser disc player control program, you can simultaneously capture and compress the laser disc output with complete frame accuracy and without the need for a new computer, acres of extra hard disk storage, or a fancy new VTR. (Of course, who wouldn't want to justify an equipment upgrade with just such a project?)

Trying to anticipate these types of issues is highly recommended before jumping into the exciting world of consumer electronics (fast becoming *pro*sumer) and industrial video equipment. You can make this stuff work for you, but you will likely have to get your hands dirty in the process. Again, we hope you will be able to profit from our mistakes.

In this chapter, you will learn about the three main input sources for capturing video:

- Video tape decks
- Video cameras
- Laser disc players

Video Tape Decks

Depending on how familiar you are with video hardware and production details, shopping for a deck can be either fun or painful. If you've had your eye on a particular unit, read reviews of it, or perhaps talked to people that use it in the trenches, you might not need to read this section. However, if you have

followed the VTR market less carefully but still want a deck that will keep on giving, we recommend that you first try to establish exactly what you need.

Of all the video gear you will acquire, your VTR is the most crucial for real production chores. For this level of work, you will probably need an industrial deck—that's why we give them so much attention. If you're not familiar with this world, it can be a strange realm at first, full of what look like regular VCRs on steroids. But don't let it throw you for too long. VTRs may look strange, but they have some very useful features.

Feature Checklist

The following breakdown of VTR standards and internals provides a basic list of issues for you to consider when shopping for a workhorse deck. You probably don't want to breeze into some store and start spouting all this jargon, but it can be useful to know when someone is trying to sell you a machine that you have not researched beforehand.

The Transport Mechanism

From a performance perspective, the heart of any video deck is the tape transport system. The more precise the transport's range of movements, the more control it will have over the tape you are playing. It's an extremely delicate assembly, especially in the newer Hi-8 and regular 8mm equipment.

The device that drives the transport mechanism is called the *servo motor*. The servo motor propels the delicate apparatus that pulls the tape through the transport mechanism. As the tape passes through, it rubs lightly across the play and record heads, imparting or receiving encoded video information (depending on whether the deck is in playback or record mode, respectively).

Not all servo motors operate at the same level of precision. The traditional way of rating them is by ascertaining how many separate steps they are capable of in one complete rotation. Since the servo motor turns the drive capstan (the roller that turns the big cylinder that moves the tape), more separate steps means greater accuracy in positioning the tape.

In theory, the tape travels through the transport assembly at a constant speed. This ensures that the resultant video signal remains synchronized, or that the resultant encodings on the tape (if in record mode) are evenly spaced. As you will see in Chapter 14, things get ugly when the tape speed fluctuates.

If you are looking for frame accuracy in a VTR (and who isn't?), you should make sure the deck comes with capstan override capability. Without such circuitry built in, you cannot be assured of absolute frame-accurate control. Actually, you will need some sort of frame code reference capability as well—such as SMPTE, which we covered in Chapter 11. Your video hardware salesperson will certainly enjoy talking to you about these technical issues.

This brings us to tape heads. A useful distinction between consumer and industrial machines is that most of the gear in the latter category has heads that record both video and audio at the same time. They also generally have a so-called *flying erase head* on the drum that erases the tape just before it is recorded.

In industrial equipment, tape heads are usually clustered in groups of two or three. For Hi-8 and regular 8mm machines, however, the quantity of heads is not as crucial as how wide they are. It's like explosives: the more surface area covered, the better the performance. If your tape heads rub against as much of the tape surface as possible, the quality of the recorded video signal will be that much better.

One final transport issue: *full-load* capability. In most VTRs and VCRs, when the machine is at rest (not playing or recording), the tape is in an unretracted state. In other words, it is not snaked through the transport mechanism. When you push the play or record button, the transport assembly swings into action, extracting the tape from the cassette and wrapping it around the tape cylinder prior to actually playing or recording.

As anyone who uses a consumer VCR has probably noticed, this process can take a second or two (or longer) and accounts for all the whirring noises you sometimes hear, especially when you first insert a tape and your machine makes sure it is play-

able. If you have ever removed the cover of a VCR and watched this process, you no doubt gained new respect for Japanese engineering (and probably voided your warranty, as well).

With a full-load VTR, the tape is kept in a retracted position between transport events (such as play or record). For the desktop video producer, the advantages of full-loading capability are quicker response time when transport events are initiated and greater stability of the video image from the time you push the button until the tape is running freely (the pre-roll period).

Video Features

Of the various criteria for judging a VTR's electronic sophistication, several in particular are significant for the desktop video maker. If you drop in after lunch on a weekday and ask nicely, your video deck salesperson might agree to induce and correct some of the problems that can be handled with the right feature set. Here are four good things to ask about:

- Signal to noise (S/N) ratio
- Chroma noise reduction (CNR) capability
- Time base correction capability
- Color correction capability

As you may have guessed, the S/N ratio gets better as it gets higher. Video with a low S/N ratio is at least poorly resolved, and might also exhibit other defects. While not easy for the average consumer to determine with a standard tricorder, S/N ratings for almost every available VTR are listed in its manual. Acceptable numbers for industrial gear start around 40db. For broadcast equipment, the rating should not be below 55db.

Chroma noise causes wear and tear on a video signal as it winds its way through your system. Like video suffering from a low S/N ratio, chroma noise-tainted images also appear degraded, but in a more ragged way. Though most industrial grade and above VTRs have built-in CNR circuitry, you can only turn it on and off, and there is a fairly wide implementation path. Some degree of chroma noise will always be present—the trick is reducing it effectively. Some manufacturers do, some don't.

Time base correction (TBC) is an issue we will cover in Chapter 14. For now, you should note that few Hi-8 or 8mm decks incorporate TBC circuitry. For the desktop producer, we recommend either a TBC *board* to put in your PC or a standalone unit that you can mix and match with new gear as your capture suite evolves. You will have to be the judge, however, since TBC capability built into a VTR is cheaper than either of our recommendations. Perhaps one day soon we'll see TBC circuitry on video capture cards.

Color correction capability is more of an issue in the analog world, but it *is* nice to have if you can get it. The level of control you should look for includes saturation, tint, brightness, and contrast, although you will probably be able to set these values with the user interface of your digitizing software.

Audio Amenities

There is a fair amount of design difference among the different brands of prosumer and industrial VTRs when it comes to recording audio. The most significant fork in the road separates linear and nonlinear methods of handling audio channels. Linear decks permit new audio tracks to be laid on without disrupting existing audio (and video) tracks. Nonlinear audio decks allow existing tracks to be overwritten. Also, you should be aware that VTRs without a dedicated channel for time code (such as SMPTE) will use one of the audio tracks for this purpose.

While it can be useful to understand this distinction, the bottom line is that audio handling issues on prosumer and industrial decks—the class of VTR you are likely to purchase—are inherently simplified for the desktop video producer (as opposed to analog in/analog out producers). You will generally be capturing clips with 8-bit, 22.05kHz monaural sound. If you want to add additional audio tracks to your AVI or QuickTime movies, you will likely do it in a movie editing program such as Adobe Premiere.

In other words, make sure the sound is as clean as possible on your source video tapes, but you can safely give audio a lower priority than video when evaluating the features on a VTR you are considering. Downplaying sound anywhere is, of course, a bad idea, but here we are only saying don't go nuts over it.

External Control Compatibility

In Chapter 11, we discussed edit control protocols in some detail. In this section, we'll talk about how these protocols and other types of PC-to-VTR communication are implemented on various types of video decks. This area of desktop video production has been fairly confusing in the past, due mainly to the lack of specialized software that is capable of generating the various external control commands. Again, based on the API for issuing such commands contained in Video for Windows 1.1, it appears this is about to change for the PC world. On the Mac, it is already somewhat mature.

On high-end industrial equipment, a connection to a Mac or PC is normally made with a serial cable connected directly to the VTR's serial port, which is in turn connected to its onboard microprocessor. On prosumer machines, the connection usually involves an intermediate piece of hardware (such as Sony's Vbox) that can translate between data sent by the PC and, say, the VISCA commands understood by the VTR. When shopping for a deck, this is an area to ask lots of questions about.

VTRs keep track of where they are on a tape in various ways. All decks—from consumer models on up—use a basic system. Higher-end machines employ a couple of more sophisticated methods. The basic system, usually referred to as *control track indexing*, counts pulses embedded in a tape when it was recorded. The pulses are contained in a special region of the tape: the control track.

Granularity in control track indexing is not all that fine—usually one second for both consumer VCRs and industrial boxes. (On consumer VCRs, the standard front panel display showing hours, minutes, and seconds is updated using control track index data.) This is one reason why consumer VCRs are not used in most professional production environments, even if there were a way to control their tape transport mechanisms externally.

The next level up in tape positioning technology is called *frame code addressing*. The good news is that individual frames are tracked. The bad news is that there are a few different stan-

dards. Each deck manufacturer is free to run with their own protocol, and a number of them have. The original (now discontinued) PC-VCR from NEC used a proprietary type of frame code addressing that drove many software developers crazy.

The ninjas of the external control kingdom, of course, are machines whose tape transport mechanisms can be controlled by SMPTE time code. Most of these VTRs, from high-end industrial decks to Betacam machines, can also write SMPTE—either while footage is being recorded or afterward. SMPTE time code is normally transmitted from a Mac or PC over an RS-422 or RS-232 serial cable.

Consumer Decks

Clearly, there are far fewer discriminants involved when purchasing a new consumer-grade VCR than when evaluating prosumer and industrial boxes. If you have either exceptional self control or relaxed production requirements (and you call yourself a desktop video producer), you may be able to put off getting that more sophisticated gear for a while. If this is indeed the case, here are some points to consider when shopping for an off-the-rack, consumer-level VCR:

- Picture quality. This is often determined by the number of heads in the tape transport assembly. Four-head machines deliver markedly better performance than two-head VCRs.
- Stereo versus monaural sound. Few if any of your desktop productions will need stereo audio. Don't pay extra for it unless you want to use the VCR for your home theater in the future.
- Audio/Video in and out. Some rock bottom VCRs don't have this capability—just the straight coaxial cable connector. Make sure to look for the color-coded RCA jacks (usually red and white or yellow and white) on the back panel.

If you can't decide among brand names offering comparable features for the same price, you could do worse than consult a publication such as *Consumer Reports*. Or you could log on to one of the special interest forums in a major BBS like CompuServe or America Online and ask for recommendations there.

Prosumer and Industrial Decks

As a *serious* desktop producer, you will most likely be interested in the prosumer and industrial class of equipment. The Sony gear is the most expensive, but offers the greatest levels of control. We recommend that, once you are pretty sure which machine you want, you rent it for a few days to make sure you can get what you expect. The hundred dollars or so you might pay in rental fees beats getting stuck with a wasted miracle (unless your video supplier has a liberal return policy). This section describes some boxes we have had experience with.

Sony CI-1000 Vbox

The Sony CI-1000 Vbox, pictured in Figure 12.1, represents Sony's latest rapid deployment move to capture the market for video device control from the desktop. Its purpose is to bring VISCA (Video System Control Architecture) to the masses. Up to seven VISCA devices can be daisy-chained off the Vbox, which itself is controlled via an RS-232 connection to a PC. See Chapter 11 for more information about the VISCA edit control protocol. Also, you can call Sony at (201) 368-9272. External control connectors: VISCA In, VISCA Out, LANC, Control-S. List price: $299.

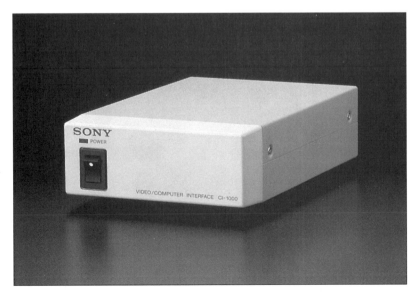

Figure 12.1
The Sony CI-1000 Vbox

Sony CDV-1000 Vdeck

Especially designed for control from a PC (according to Sony), the Sony CDV-1000 Vdeck is a VISCA-controlled VTR targeted deck for multimedia production (see Figure 12.2). For the record, it can also handle Sony's new proprietary frame accurate time code, RC (Rewritable Consumer). Offering 400 scan lines of video resolution, the Vdeck also has both AFM and PFM audio channels. S/N ratio: 45db. External control connectors: VISCA In, VISCA Out. List price: $2,295.

Sony EVO-9800 and EVO-9800A

A high-end industrial VTR that uses Hi-8 and standard 8mm cassettes, the Sony EVO 9800 supports composite video only, while the 9800A also supports S-video. Although small-format tape is subject to more problems (due to its greater delicacy), the EVO-9800A in Hi-8 mode, as shown in Figure 12.3, is a good choice for desktop video producers looking for very high-quality video output in the industrial class.

Equipped with a jog shuttle control, chroma noise reduction, and a generous selection of video and audio in, out, and monitor connectors on the back panel, the EVO-9800A can either record SMPTE time code along with video content or stripe it on later. As such, it is a popular deck for using with the Macintosh

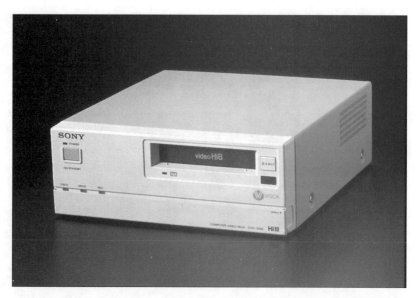

Figure 12.2
The Sony CDV-1000 Vdeck

Figure 12.3
The Sony
EVO-9800A
VTR

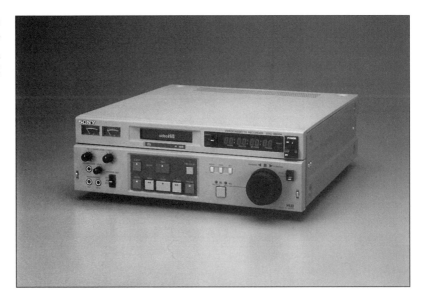

GrabGuy application to digitize with complete frame accuracy. (You will have to have a special cable made to use this configuration.) S/N ratio: 45db. External control connectors: 9-pin RS-422. List price: $5,865.

Sony EVO-9650

Strange as it may seem, the EVO-9650 is targeted for the computer graphics/animation market. In this capacity, it has a lot to offer: digital effects and special buffering for short clips (animation or video). As a workhorse S-VHS VTR for capturing just video, however, we feel the machine is eclipsed by the EVO-9800A. S/N ratio: 45db+. External control connectors: RS-232, Control-S. List price: $5,770.

Panasonic AG-1970

The Panasonic AG-1970, shown in Figure 12.4, effectively replaces the venerable AG-1960 as the tool of choice for producers of corporate and so-called *event* presentations, such as professional-quality wedding videos. For the desktop digitizer, it offers a jog shuttle controller, fast tape transport, built-in color correction, primitive TBC, and an auxiliary S-VHS In connector.

For external control, you can use an outboard interface like the VuPort from Selectra Corporation, located in Walnut Creek, CA, (510) 284-3320. This device performs the essential function of

Figure 12.4
The Panasonic AG-1970 VTR

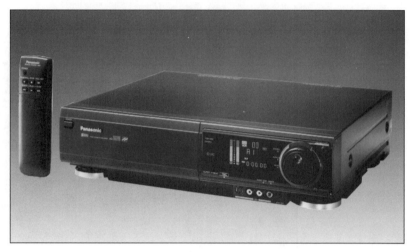

translating commands from a PC video editing program into protocol understood by the AG-1970. The VuPort can control up to two decks at a time, but up to eight VuPorts can be daisy-chained together. Currently, there are no Intel-based PC applications that can directly control the AG-1970 or the other members of the Panasonic AG family. However, Mac products such as the Abbate Video Toolkit *are* capable of doing this.

While this machine delivers a high-quality video signal (for desktop *digital* video makers) and offers an extra level of manual control via its jog shuttle dial, it is mainly targeted for desktop analog producers using software such as Matrox's Personal Producer, Gold Disk's Video Director, and Macromedia's MediaMaker. For more information, you can call Panasonic at (714) 373-7840. S/N ratio: 43db. External control connectors: 5-pin mini-DIN. List price: $1,650.

Panasonic AG-5700

One of the few transportable (no battery pack option) industrial boxes, the 5700 nevertheless offers external control via an RS-232 port. An interesting feature of this deck is auto-sensing of an incoming video: It can be triggered to record when a video signal is detected, then stops recording when the signal stops. Because of its luggability, the AG-5700 is an especially viable product for field and classroom work. S/N ratio: 45db. External control connectors: RS-232. List price: $1,700.

Panasonic AG-7750

The Panasonic AG-7750 is the heavyweight of the Panasonic AG line, and is priced to prove it. Cutting a swath in broadcast production suites, the 7750 includes onboard TBC and noise reduction, a separate time code channel, and both serial and parallel connectors for external control. If you wish, you can even add in a SMPTE reader/generator card.

There are some other nice features about this machine as well, such as its implementation of Dolby noise reduction on two linear audio channels. But, as with some of the other higher-priced decks, they may be too much of a good thing as far as the strictly desktop digital video producer is concerned. S/N ratio: 46db. External control connectors: 9-pin RS-422A, 34-pin parallel. List price: $6,800.

JVC BR-S605U

Combining some of the better design concepts of the industrial class Sony and Panasonic products, this JVC deck features chroma noise reduction, video dropout compensation, and a special luminance enhancer (to make up for bad-quality source video). Also, it makes room for several add-in boards, including an SMPTE card and a TBC module. Desktop producers will be interested in the broadcast VTR-style video pre-recording amplifier. For more information, you can call JVC at (800) 882-2345. S/N ratio: 47. External control connectors: RS-232, 45-pin parallel. List price: $2,395.

Professional Decks

Since few if any desktop video producers will be shopping for a professional deck of the Betacam SP class (or higher), it is not really practical to compare features on this equipment. If you need to rent one, and many title developers are starting to do this now, you should rely on the wisdom of the rental store personnel when it comes to specific performance questions.

Video Cameras

If you thought selecting a videotape deck was painful, try weeding through the camcorder jungle. Actually, there is so much new equipment coming on the market, especially in the prosumer area, that even most *professionals* have a difficult time keeping current. Even the publications that cater to the camcorder market seem to be multiplying—probably because there are so many test drives and product shoot-outs to conduct.

As a desktop producer shooting raw footage, you will fast learn the language of the industrial video camera operator. It's a much different experience than taking your camcorder along on vacation to point and shoot at what amuses you (although this remains an essentially righteous activity) but you can still pretty much learn as you go. Just don't make too many commitments early on.

Feature Checklist

Like we did for video tape decks, we would like to present you with a working list of criteria for selecting a video camera. Not all of these features are absolutely essential, but it is always good to err on the side of completeness when giving advice to people who are going to be putting their money where *your* mouth is.

One good thing to remember is that a video camera is both a camera *and* a video tape recorder. We'll talk about the camera-related issues first, then discuss the tape and VTR matters since we have covered them to some extent already. As noted earlier, for many projects you may even want to use your camera *as* your videotape deck.

Image Stabilization

Image stabilization is a feature generally implemented on S-video quality and above cameras. Essentially, it tries to compensate for the shakiness that can be produced by the hand-held approach or by mounting your camera on a moving platform (such as a car). There are two main types of image stabilization: optical and electronic.

Optical stabilization tries to correct the incoming image before it even strikes the camera's light sensitive pickup tube. Some high-end gear made by Sony and Canon employs the optical method, which is generally considered superior to the electronic approach because there is no (or very little) degradation of the original image.

Electronic stabilization, implemented on various Hitachi and Panasonic cameras, attempts to do its magic with special circuitry. Unfortunately, image quality often suffers noticeably under this method. Especially apparent can be ill effects due to rapid panning. This is an important consideration, since digitized blurring looks worse than its analog counterpart.

Manual Control of Exposure and Focus

With personal control over your camera's iris, you can record certain scenes better than when automatic exposure is engaged. A classic example of miscalculation by the automatic mechanism is when it overcompensates for backlight—resulting in darkened details in the foreground (a classic problem in still photography). Most Hi-8 cameras allow for manual control of the iris.

Backlighting should be another area of special concern to the desktop producer, since compression algorithms can seriously mangle blurry images. A feature in some Hi-8 cameras called BLC (backlight compensation) can be somewhat helpful, but it is no substitute for full manual control over your exposure settings. A few models offer light amplification for shooting in low light conditions.

As for auto-focus, make sure it works well close up. You can try this at the store. Get in close with a nearby subject and then pull back and move forward again quickly. See how long it takes the picture in the viewfinder to clear up, and if it stays sharp in an extreme close-up. Good desktop video depends on close-ups, especially of people, so you need to know that your camcorder is up for the job.

White Balance

White balance is an interesting feature that tries to match the camera's color values with the quality of light you are recording

in. Many top-of-the-line models have individual settings such as sunlight, indoor light, and automatic white balancing. If you are moving between different lighting environments during the same shot, you might want the ability to control your white balancing.

Color Sensing

Of the camera-related issues, color sensing is possibly the *least* crucial for desktop producers. What it is concerned with is the number of chips a camera uses to sense color. Even such star performers as the Sony TR101 and Canon UC-S5 use only one such color-sensing chip. When three chips are used, as in broadcast level equipment, each chip senses a different color: red, green, or blue. The only three-chip prosumer camera currently available is the Sony CCD-VX3 ($3,800 list price).

Title Creation

Another Hi-8 feature—titling—is handled in two ways, depending on the camera. Truthfully, this feature is not all that valuable to the desktop producer—except as a crude form of logging. If you really want to put titles on your clips, especially good-looking titles, you'll do it with an editing workbench or special effects program.

The first type of titling is done with an onboard character generator. After successively scrolling through the alphabet to hammer out a few geeky looking words, you might not use this titling method much. The other titling approach involves actually writing out (or printing) a title, then storing it in the camera's memory by recording to memory instead of to tape. When you are ready to put your title on a captured clip, the camera lets you digitally superimpose it. Again, it is hard to see the value in this for the desktop producer unless it's done very creatively—for example, using it as a positioning guide for composite work.

Zooming Levels

Zooming capability is usually expressed in zoom lens ratios. These ratios express the range between a lens' extremes in optical focal lengths. For instance, a 10:1 lens ranges from 64mm to 6.4mm. This feature may or may not be important to you, and we suggest you get sales advice on this one if you need addi-

tional information. What is importnat is the maximum wide angle you can get.

Video Effects

Video effects include things like freeze frame, strobing, and digital zooming. While fun at first, the novelty of these effects soon wears off, and you find that you can get the same effects only better if you apply them in software later. Since not all cameras have these features, you'd eventually feel ripped off if you were paying extra for them.

Image Resolution

One good reason to select Hi-8 as your personal standard (if you can put up with its quirks) is the amount of resolution it provides: 400 scan lines, as opposed to the VHS and regular 8mm standards of approximately 250 lines. Actually, it is probably worth getting used to Hi-8's quirks since the ante for acceptable desktop video quality is continuing to rise.

As we noted in Chapter 11, 400 scan-line resolution is also supported by S-VHS, but the cameras are much bulkier. You don't see too many desktop producers lugging around these units unless they are ex-analog video people or got them cheap. Most title developers either go small format or spend a bundle on rented broadcast-quality cameras. Remember that all cameras can see much more than they can record. (You can test the extent of the disparity by recording some footage and immediately playing it back—with what you saw in the eyepiece still fresh in your mind.)

Hi-8 and S-VHS cameras only account for a small fraction of the camcorder installed base, while over half of all camcorder sales belong to the regular 8mm family. Don't be fooled by the size of the cartridge or the futuristic packaging—straight 8mm image quality is no better than that of garden variety VHS. Remember that both Hi-8 and 8mm tapes can record up to two hours. S-VHS-C and VHS-C are only good for 20 minutes in standard mode.

Remote Control

Although we covered edit control protocols in detail in Chapter 11, we'll touch on them again here as they relate to camcorders.

You will only need to be concerned with this capability on a prospective camcorder if you intend to make it do double duty as a VTR in your capture lab (not recommended for the long haul).

As we also noted in Chapter 11, the most prevalent form of remote control for prosumer video cameras is handled with LANC (local application network control) edit control protocol. Most Sony equipment supports this command language. While prevalent, LANC is now considered somewhat clumsy and inefficient.

Closing on the inside track is Sony's newest favored edit control protocol, VISCA. This protocol provides for control of industrial and prosumer cameras and VTRs, not only by dedicated edit controllers, but also by Macs and PCs running VISCA-compatible applications to control video equipment at a near frame-accurate level.

Time Code

We also discussed time codes in Chapter 11, but there are some separate issues for camcorders. The most important thing to remember is that sub-prosumer models generally don't record time code. While Hi-8 cameras generally do, this is not an important issue if your VTR has the ability to stripe it on later.

The reason we're hedging a little here is that there is a lot of new equipment out there, and speaking in absolutes can be somewhat risky. Also, although you might be hearing about the new Sony RC (Rewritable Consumer) time code, you may want to stick with SMPTE for compatibility with desktop video editing programs.

Sound Standards

Audio is handled differently among the various families of cameras. On VHS gear, you can get either hi-fi audio (stereo) or linear track audio, which is considered inferior (and horrible in EP mode). Only a few VHS units handle hi-fi, however, and they must be recorded at the same time as the video track. Linear track audio can be dubbed later.

On 8mm cameras, the standard is AFM (audio frequency modulation) stereo. Although AFM produces high-quality sound, the stereo channels often bleed into one another. Unlike VHS hi-fi audio, AFM tracks have to be recorded simultaneously with the video track. Dubbing either audio or video tracks later is impossible.

Top-of-the-line Hi-8 camcorders use digital PCM (Pulse Code Modulation) audio. Although (analog) AFM is supposed to sound better (here come the CD/vinyl wars again), this is not an issue for desktop video producers. Like AFM, the PCM standard involves stereo audio channels that must be laid down simultaneously. Unlike AFM, however, PCM audio tracks can be added later (but not *before* the video track) and have excellent separation.

While you may find all this information interesting, it may not have much practical value to you unless you are developing commercial titles. Then again, if you are recording, say, live music, you might want to get your audio signal off the house mixing board. In general, most Hi-8 class cameras will serve your overall audio needs well.

Headphone and Microphone Jacks

Most top-of-the-line camcorders have both headphone and microphone jacks. Headphones are highly recommended for monitoring your subject while you shoot. In fact, you are inviting disaster if you don't use them. Being able to manually adjust the recording and headphone levels is also quite handy. Obviously, these are perks—not standard features.

If you are recording, for example, a speaker at a business gathering, you will want to put a microphone in front of him or her that feeds directly into your camera. Do not use the camera's built-in microphone no matter how quiet the room or how close you can get. Always try to set your levels beforehand and anticipate possible spikes.

Accessories

Like with computers, it is easy to forget the accessories—especially when putting together a budget. Here is a short list of essentials:

- Headphones
- Carrying case
- Extra tape stock
- Extra batteries
- Tripod
- Lens and head cleaners
- Lighting equipment
- Wireless microphone (you'll soon wonder how you lived without one)

Are We Rolling?

One last thing. It sounds silly until you get bitten by it, but knowing whether your camera is paused or recording can be very valuable—especially when an important scene is in progress and you get that infamous sinking feeling. Look for a camcorder that has indicators both within the viewfinder and on its outside surface (such as the standard red LCD). Also, try to get a camera that shows you the status of the battery from within the viewfinder.

Consumer Video Cameras

Many of the issues that confront the consumer camcorder buyer also confront the consumer VCR customer: picture quality (based on head count), stereo versus mono sound, and so on. We suggest you read the section on consumer VCRs earlier in this chapter, establish some criteria, then work your way through dedicated video magazines until you find a match. For serious desktop producers, the real action is in prosumer and industrial cameras.

Prosumer and Industrial Video Cameras

The first thing you might notice in this mini product roundup are the prices. The good news is they are list. As any consumer electronics junkie will tell you, manufacturers' list prices were made to be slashed, especially by the likes of Circuit City and The Good Guys. The other good news is that they nevertheless provide a proportional value scale.

The list we provide next is not supposed to be arbitrary. All of the cameras we mention have either been used by us, have extraordinary features to recommend them, or are considered reliable workhorses. As with VTRs, our advice is to rent them first, if possible, and see in advance if they are going to work for you.

Sony CCD-VX3

Famous for its color fidelity, the Sony CCD-VX3 is currently the only non-professional camera to use three CCD (charge coupled device) chips. The VX3 also supports RC (Rewritable Consumer) time code, Sony's new format for frame-accurate editing on industrial (they say *consumer*) equipment. If you are doing a major production with a budget for high quality in the taping phase, we encourage you to check this camera out. Price: $3,800. Important features: Hi-8 compatible; 12x zoom ratio; LANC edit control. For additional information, call Sony at (201) 368-9272.

Sony CCD-TR101

Famous for its Steady Shot image stabilization, the Sony CCD-TR101 is the workhorse camera for many desktop video producers (see Figure 12.5), as is its little brother, the TR81 (currently out of production and without steady shot). We have used both of these models extensively, and recommend them highly, especially

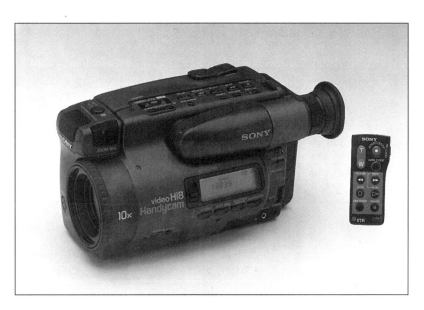

Figure 12.5
The Sony CCD-TR101 Camcorder

when used with the wide angle attachment. Just make sure to follow the Ten Commandments of Hi-8 Tape Management presented at the end of Chapter 11. Price: $1,800. Important features: Hi-8 compatible; 10x zoom ratio; LANC edit control.

Canon L1

The Canon L1 is a staple for wedding and special events videographers, and has a couple of unusual features worth noting: interchangeable lenses (including the ability, with an adapter, to accept ESO lenses from 35mm Canon still cameras) and overlapping (a type of dissolve). This camera is kind of expensive for the desktop producer, but worth considering if you can get it second hand. Price: $2,999. Important features: Hi-8 compatible; 15x zoom ratio; LANC edit control. Call Canon at (800) 828-4040 for additional information.

Sharp VL-HL100U ViewCam

Featuring a four-inch color LCD screen instead of a viewfinder, the Sharp VL-HL 100U ViewCam, shown in Figure 12.6, also has digital effects such as freeze frame and strobing. Unfortunately, it uses electronic image stabilization, but you may not care in the long run. Because the ViewCam has a built-in speaker, you can even use it as a miniature TV/VCR combination. Price: $2,199. Important features: Hi-8 compatible; 8x zoom ratio; no edit control. For additional information, call Sharp at (201) 529-9731.

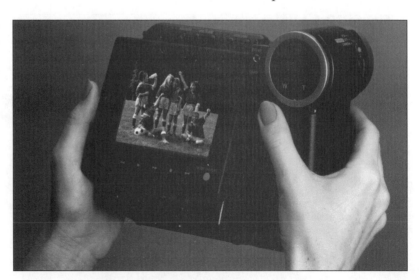

Figure 12.6
Sharp VL-HL 100U Camcorder

Laser Disc Players

Of the equipment available for streaming in video data to your capture card, the laser disc player is perhaps the most efficient. Unfortunately, it suffers from the same limitation as a CD-ROM player: To record *onto* a laser disc, you need an expensive laser disc writer. Unlike for CD-ROM writers, there is no real pressure for manufacturers of laser disc writers to bring down prices in the foreseeable future, and they generally cost even more than CD-ROM cutters.

With this drawback in mind, we need to say right up front that the laser disc player is a real niche solution for most desktop video producers. Assuming you are capturing original or licensed content (as opposed to commercial laser disc releases), the only reason you would want a laser disc player is to do high-quality, frame-accurate digitization.

If this is indeed your goal, you will then have to pay up to $300 to press your video footage with a laser disc writer so you can turn around and capture it. We know people who do this on a regular basis, but only because they can make it cost effective in their business model. The resultant movies do look great, however.

High Production Values

Image resolution provided by laser disc players is on the order of Hi-8 VTRs and camcorders—around 400 scan lines (VHS machines do about 250 scan lines). This is why they have such good reputations for picture quality. Another nice feature is their ability to pause on a completely stable frame, as opposed to seeing the paused image start to waver like on most tape decks.

As noted earlier, the most important property of the laser disc player for the desktop producer is its smooth, frame-accurate captures. Tape decks that support frame-accurate time codes such as SMPTE can do this in theory, but it is not uncommon for some frames to be distorted after a long offline capture. This distortion is principally due to tape stress as the tape is repeatedly played and rewound.

Chapter 12 VCRs, Cameras, and Laser Disc Players

The reason laser disc players can provide completely stable images is because of the way data is read off the disc. Like CD-ROM players, they use an optical process instead of a mechanical one. In other words, the reading mechanism does not physically touch the storage medium (like in a tape deck), and therefore cannot send a distorted video signal based on even minuscule mechanical aberrations.

When a read is in progress, a small laser beam scans the frame data stored on the disk and sends a digital representation of that data to a converter. The converter changes the digital data to analog video data and outputs it to your monitor (or your capture card—where it is re-digitized). Obviously, there is a fair degree of irony here when you think about it.

At any rate, if you are seriously considering a laser disc player as your input source, our best recommendation is the Pioneer LD-V8000 (current list price $2,495), shown in Figure 12.7. We can also recommend the Pioneer LD-V4400 ($1,350 list) and its predecessor, the 4200 (officially discontinued but still available from some dealers).

These machines have RS-232 ports for external control by a personal computer, as well as sophisticated audio handling and

Figure 12.7
Pioneer
LD-V8000
Laserdisc

extras such as text overlay and external synch ability. Clearly, we are talking about industrial class devices here. Because of the laser disc player's very specific use in desktop video, consumer class models need not be considered.

In terms of PC compatibility, the Pioneer boxes are the specific machines supported by the famous Mac software for controlling laser disc players. Also, they now appear to be supported under Video for Windows, as evidenced by the MCI driver (MCIPIONR.DRV) for Pioneer laser disc players in the Developer's Kit for VfW 1.1. (An MCI drive for Panasonic laser disc players is included there also.) For additional information, call Pioneer at (800) 527-3766.

If you are determined to shop around a little more, or will be using the laser disc player for other purposes besides video capture, ask the following questions:

- Is the machine you are considering a CAV (Constant Angular Velocity) or CLV (Constant Linear Velocity) device? This distinction has to do with how fast the player is able to seek to different tracks, and may not be an issue if you are capturing video recorded on the disc contiguously. It will make a difference if you use the machine in, say, an interactive information delivery system.
- Is the unit capable of keeping the last frame read in a display buffer while searching for the next clip? Make sure the answer is yes. Otherwise, your monitor will turn blue for the duration of the search.

Audio Hardware Standards

YOU DON'T HAVE TO BE A SOUND ENGINEER TO MAKE YOUR MOVIES SOUND GOOD, JUST BE CAREFUL AND CONSISTENT.

In many ways, working with audio—in both analog and digital form—is just as complex a task as working with video. While analog and digital audio are ultimately just data types to the computer, each one requires careful management on its way to the capture card. Fortunately, users are growing more aware that relative audio quality can make or break a desktop video production, especially in more ambitious projects.

Getting good audio into your desktop movies (or any digital format) means starting with good analog equipment. Unfortunately, your most often-used analog equipment will probably be your video deck. With this in mind, you'll have a basic decision to make for each movie you capture: Will you process your analog audio signal on its way from the video deck to the computer, or will you digitize a separate copy of the sound track, fix it up, then add it back in with a movie editing tool?

Desktop producers we've talked to take both approaches. Usually their decisions are based on their target audiences. For CD-ROM-based games or educational programs that drive the market, it

is worth doing the latter. For less ambitious projects, you can save a lot of time by processing your audio track with analog equipment during the capture. Even if you do this well, however, you may be the only one who notices.

We'll discuss the second method in detail in Chapter 25. For now, let's concentrate on the first approach. In this chapter, you will learn:

- How sound is stored on video tape
- What devices are available to process analog sound
- How incoming analog sound is handled on the Mac
- How incoming analog sound is handled on the PC

Audio Standards on Video Equipment

The best thing that can be said about audio output from consumer VHS decks and 8mm camcorders is that it is generally stereo. Unfortunately, given the current data rate restrictions for most Macs and PCs, desktop movies have little use for stereo sound. Industrial decks and cameras have better sound capability because (presumably) they are used to create productions for public consumption.

Remember, there is a big difference between the soundtrack of a Hollywood movie on a VHS cassette and the audio you will capture with your camcorder. The Hollywood movie sound was labored over by professionals in a state-of-the-art studio. It was sweetened, remixed, equalized, and basically distilled down to a format that will sound good across a wide range of playback devices and speaker systems.

The audio captured by your camera's built-in microphone, however, could not be used in a professional production without some sort of additional processing. Depending on the aural environment you recorded in, it is probably full of ambient noise and lacks the right definition for mixing with other audio tracks. We're flirting with professional standards here, but it's important to put these things in perspective.

Typically, working with video (unless you have a serious background in it) has more of a "Who's in charge?" feel than audio. Sound qualities feel more manageable—there are finite ways to adjust volume, treble, bass, and stereo balance. Even EQ can be tamed fairly quickly. While there are a few extra hurdles when jumping from analog to digital, we hope you will come to view audio as a reducible adversary.

Fewer Quality Levels

Sound is not as granular as video in terms of recognized standards (composite, S-video, Betacam, component, and so on). There are, however, a couple of quality levels worth discussing. As we noted in Chapter 12, off-the-rack VHS machines use linear track audio. Some of the more uptown models come with hi-fi audio, which is significantly better. Besides this quality distinction, hi-fi sound tracks must be recorded simultaneously with the video, while linear track audio can be added to an existing video track later.

The standard for 8mm camcorders is AFM (audio frequency modulation) stereo. The problem is the stereo channels often bleed together—even though the overall sound quality is comparatively high. Top drawer Hi-8 equipment uses the digital PCM (pulse code modulation) standard to handle audio, which has very good stereo separation.

This being said, analog sound is still just analog sound. Unlike analog video, it has no components—like color, brightness, and synchronization data—that can be separated out and transmitted on different channels. (Of course, stereo sound has right and left channels, but it does not involve the same type of separation.) Distinctions like *22.05kHz* and *16-bit* don't apply until the audio is sampled and digitized for storage.

Thinking Outside the Box

Which brings us to the ways in which audio *can* be handled. Basically, it comes down to boxes. The audio signal that leaves your consumer VCR, for instance, is effectively coming from a black box. Because the cable it is traveling on is connected to a

Chapter 13 Audio Hardware Standards

line level output jack, you can't change its inherent volume. When the signal gets to another box, such as a television set, you can then amplify it by turning up the TV's volume.

The audio signal that comes out of the same VCR's headphone jack (if it has one) is equally unchangeable in terms of volume. It is, however, a much *hotter* signal, which you probably know if you have ever cabled it to the line in of your sound system. The difference is that line-level equipment like VCRs, audio tape decks, and rack-mounted CD players are meant to be amplified. Headphone outs (on portable CD players and camcorders, for example) are *already* amplified.

Even industrial grade VTRs are black boxes in this sense. Certain models, such as the venerable Sony EVO-9800A, have adjustable audio levels for signals coming in (and the ability to switch between PCM and AFM for output), but their output volume reflects the level recorded on the tape itself.

Consequently, if you want to do something to the sound before it gets to your computer (another box), you have to route it through an interim box first. If you are using an outboard TBC device to process your video signal before it gets to your capture card, you are already doing something analogous. An interim box for your audio signal can take various forms, as shown in Figure 13.1. Let's now look at each of these interim components individually.

Figure 13.1
Using an Interim Box to Process an Audio Signal

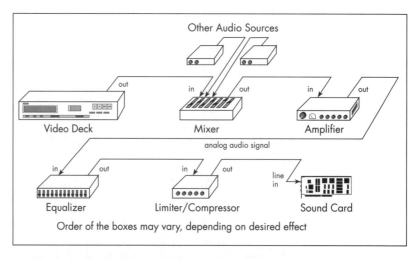

Amplifiers

Amplifiers boost audio signals. In consumer electronic equipment, such as television sets and AM/FM receivers, built-in amplifiers drive speakers. (The new compact component style audio systems generally have standalone amplifiers.) The word *powered* in *powered speakers* (the ones people are hooking up to their multimedia PCs) generally means *amplified*.

When you run a line-level audio cable between your consumer VCR and your computer's capture equipment, you will probably not need any additional amplification. We have found a discrepancy, however, in connecting the audio outs of industrial VTRs to certain digitizers. Industrial audio line levels are not necessarily the same as consumer audio line levels.

At first, we compensated by running the audio signal through a solid state 10-watt amplifier from Radio Shack (another box). Later on, we tweaked the software volume controls for our capture card (the Radius Video Vision) to the point where we didn't need the amp any longer, but it was useful for a while and worth the price to get the problem solved. Figure 13.2 shows an example of an inexpensive outboard stereo amplifier.

Figure 13.2
An Inexpensive Amplifier

Equalizers

Next to an amplifier, an *equalizer* (often referred to as a *graphic EQ* box) is the most prevalent type of audio signal processor. With it, you can partition the total human audio spectrum—roughly 20Hz to 20,000Hz—into separate bands that you can modulate separately. The object of this level of control can range from reducing noise to eliminating certain frequencies altogether. Figure 13.3 shows an inexpensive, but capable, equalizer.

If you don't have a background in audio, one way to picture an equalizer is as a highly sophisticated bass and treble control. They're easy to get hooked on—fortunately, they teach you a lot about sound. For instance, since certain types of music always sound better with specific fader configurations, it makes you stop to think about how that music may have been recorded. After a while, you'll want one for your car stereo.

Limiters and Compressors

Limiters and *compressors* can be key components in processing analog audio for your desktop movies. Essentially, they both process audio in the same manner, although compressors do it

Figure 13.3
An Inexpensive 20-Frequency EQ Box

with more care and subtlety. The problem is high-end peaking from, say, a Joe Satriani guitar solo or a flight deck recording of an F-14 takeoff. The solution is keeping the signal from going over (or even very near) the top.

Limiting (also known as *gating*) takes a direct approach: It simply lops off as much of the top of the signal as you tell it to. Everything under that point is retained. Compressors *scale down* the high-end portion of the signal so that its dynamics are preserved but not distorted as the signal pushes the envelope. Producers of rock bands do this (and get grief for it by purists) so that the music can get commercial airplay.

Generally speaking, the best use of a compressor in the desktop video world is to amplify dialog without distortion. If your movies include a lot of talking heads, you should look for a compressor designed to work specifically with voice—not just guitars.

If you score one of these boxes, you should exploit it to its full potential. Outside of working on the digitized version of the audio signal with a software tool (which we cover later), a compressor is just what the spin doctor ordered for fattening up your sound where it needs it most. Even a limiter can make a crucial difference if you use it judiciously.

Noise Reduction

The premise of using *noise reduction* equipment (like Dolby) when you record audio is that you will have complementary equipment on your playback machine to un-reduce the signal. Clearly, this idea falls apart when it comes to digitization. The bottom line is, don't let anyone sell you noise reduction equipment (the kind that needs a decoder, that is) to make desktop movies. A noise *gate* is a whole different type of device, more like a limiter. This kind of box *could* come in handy—depending on your needs.

Reverb

Reverb (echo) is a property of sound that makes it sound full. It is also an important factor in making a recording sound live. The trick is to apply reverb correctly. Too little, and the audio

Chapter 13 Audio Hardware Standards

will sound in your face—especially the deeper tones. Too much makes the whole mix sound muddy. Again, you'll have to experiment to find the right levels. Don't worry, it's fun—especially when you apply it to voices. If you listen to lots of classic rock FM radio, you know what we're talking about here.

One way today's digital reverb boxes classify their available effects is by room sizes: small club, large club, small concert hall, medium concert hall, stadium, and so on. This gives you an idea how important reverb is. Although recording studio engineers have to worry that reverb can't easily be extracted from a recording, this should not be an issue for you unless you are doing complex, professional-level mixes for retail products. Figure 13.4 shows an example of an inexpensive reverb box.

Mixers

As most audio engineers will tell you, the most essential part of any audio production suite is the *mixer* (or, in the case of a professional recording studio, the mixing *board*). For desktop video producers, there is a large complement of equipment to choose from, starting with simple four- or six-channel stereo mixers for under $100 and going up to eight-channel mini-

Figure 13.4
An Inexpensive Reverb Box

Audio Standards on Video Equipment

Figure 13.5
An Inexpensive Stereo Mixer

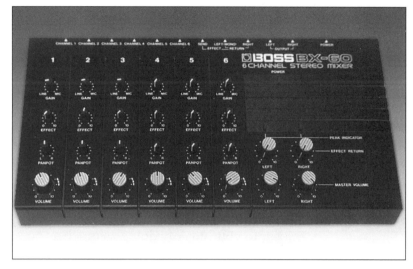

consoles—with good quality EQ and effects channels built in—for under $1,000. Figure 13.5 shows an example of an inexpensive stereo mixer.

Do you need a mixer? It depends on how capable you want your capture station to be, and how much time you want to save. Recabling everything for each job is a drag compared to throwing a few switches. If you want to add background music or ambient sound, you will have to have some way to mix it with your foreground audio. At the low end, the feature sets are very easy to assess. We suggest cruising a few music stores and asking some questions.

Phasing

Beyond the standard audio effects (EQ, reverb, and compression) are the modern breed. Most, if not all, of these new effects are digital. One prominent example is *phasing*, which uses digital techniques to place voices, instruments, and other audio subjects at various locations in a virtual 3-D space surrounding the listener. You may have heard of Q Sound, which is a proprietary technology based on phasing.

The value of phasing techniques for multimedia producers is clearly enormous. Being able to play a fast-paced interactive game with sound coming at you from both sides *and* front and back (and everywhere in between) will be a significant step in credibility for the industry as a whole. The big question is when will these techniques be available to the independent desktop video producer?

Is There a Better Way?

Can you do as good a job optimizing your desktop audio tracks at the analog level as you can with computer-based tools once the audio is digitized? One answer is that you will get a lot closer to your goal by doing as much as possible on the analog side first. Also, some people feel that working with audio at the analog level produces more natural sounding results, while others like working completely onscreen. Since each serious production is different, you will need to be the ultimate judge on this and similar issues.

Analog Audio on the Mac and PC

Having left one box and possibly been processed by another box or two, the analog audio signal from your video deck finally arrives at the destination box: your Mac or PC. On a Mac, it might have flowed into one of the audio connectors on a breakout box, such as the one used by the Radius Video Vision card. If your PC is a Windows box, the audio cable is likely hooked up to the line in jack of your Windows-compatible sound card.

What happens now depends on the sophistication of your hardware and software. Remember that our focus here is still on trying to do as much as possible to optimize our analog audio signal before it gets digitized. Although there is less we can do at this final stage than at the interim box stage, a few avenues are still open. Let's look at how we can accomplish our goal on each platform.

Analog Audio on the Macintosh

We need to preface this section by saying that parts of it do not apply for some Macs, especially the new AV models: the Quadra 840AV and 660AV (formerly the Centris 660AV). These machines have built-in sound digitizers and digital signal processors. As of this writing, we do not have enough experience with the AV boxes to give sure-fire advice on *all* the places where you can set parameters for incoming sound.

Let's assume you are using a Macintosh without native sound recording capabilities. Depending on which video capture card you are using, you may or may not need a sound digitizer board. Early adopters of the Video Spigot often used it with Macromedia's MacRecorder (which attached to a serial port), although SuperMac now ships the Spigot and Sound solution. Each of the Holy Trinity cards (the Digital Film, Video Vision, and Editing Aces) has onboard audio digitizing, along with special user interface software to control the process.

As an example, we'll consider a Video Vision card installed in a Mac IIci. (This is exemplified in Chapter 19.) We are looking for all of the places where you can exert control over the character of the incoming analog signal. A good place to start, naturally, is the Mac control panel folder.

Let's go to the *Sound* control panel, where you will see the icon for the corresponding audio digitizer software—in this case the Radius product. Clicking the Options button brings up the Video Vision audio settings dialog (or the dialog for whatever capture card you have installed). You can set input values for Level (volume), Bass, and Treble. There is even a color-coded thermometer next to the Level control to calibrate it. Figure 13.6 shows this dialog.

A good habit at this point is for you to start your source audio components rolling and watch how the thermometer fluctuates. Adjust the level control so that the green mercury only turns red (and barely) at the peak volumes. When you are satisfied that your level setting is optimal, you should then try some test captures. Don't forget to try different bass and treble settings.

Figure 13.6
The Video Vision Sound Settings Dialog

The next place you can experiment with audio parameters is in your capture application. MovieRecorder, for instance, has a Sound Settings dialog that lets you adjust both Volume and Gain (basically the signal-to-noise ratio), as shown in Figure 13.7. It also has a thermometer-like indicator for dynamic calibration of the overall audio level.

Another program with its own sound setting controls is Adobe Premiere, which even has a special facility for capturing audio-only files, as shown in Figure 13.8. Many people actually prefer to capture with Premiere, since it is more configurable and provides ways to control a video deck directly from its user interface. Unfortunately, you cannot cut, copy, or paste audio in Premiere.

Once you have set your audio parameters in these two areas—the control panel and the capture application's sound settings dialog—you have generally exhausted the high-level options for managing incoming analog audio prior to digitization. As

Figure 13.7
The Sound Settings Dialog in MovieRecorder

Figure 13.8
Premiere's
Audio Capture
Interface

new hardware and software for handling sound keeps getting added to the Mac's arsenal, more options will become available. As of this writing, most desktop producers with slightly older Macs use just the two methods we've mentioned.

Analog Audio on the PC

All of the video capture cards we have experience with (the ones profiled in Chapter 8) allow the sound card to handle the audio. In fact, the audio cables from your video deck—or whatever interim box you are using—normally plug directly into the sound card. This arrangement stems from the fact that sound is implemented on the PC as an afterthought. Most often, this is in the form of a Microsoft Windows extension, although many sound cards come with DOS-only software as well.

Consequently, the controls for setting audio input levels for movie capture on a Windows machine are more centralized than on a Mac. They are also more limited, at least for now. The current preferred method is to use one of the available multimedia mixers. A popular mixer program ships with Windows 3.1 itself: MIX.EXE. Others come packaged with sound cards, such as Media Vision's PMIX.EXE.

Chapter 13 Audio Hardware Standards

Figure 13.9
The Media Vision Pocket Mixer Set for Movie Capture

While differing in appearance, all of these mixers are responsible for the same basic functions: setting the input and output volume for all attached sound equipment. A few of them offer additional functionality, such as bass and treble control, and even boosting of internal and external gain. Unfortunately, most people find them extremely frustrating to use.

We'd like to present our suggestions for operating one of the mixers, since we are still addressing analog audio handling. We will keep them simple, because you only have to understand a few basic principles to figure out the rest. If you already have your own M.O. for dealing with this, feel free to move on.

Incoming audio during movie capture is handled by the auxiliary slider. This is the control with the connector plug icon sitting on top of it, as shown in Figure 13.9. The rest of the sliders should be dragged all the way down, except for the master volume control, which should be set to an optimum level.

This auxiliary fader is not always represented by the same icon. In the MIX.EXE program, for example, the fader icon is a black box with a question mark. One good way to see what faders mysterious icons in new mixers correspond to is to fire up both the new program and your mixer of choice. Presuming you are fully checked out on your familiar mixer, move its faders around and watch what happens on the new interface. The corresponding faders should move in lock step.

For movie playback under Windows, your mixer will need new settings. Since the sound tracks of AVI movies are essentially WAV files, you will need to drag the WAV fader up and all the rest down (except the main volume), as shown in Figure 13.10. The WAV fader is under the icon that looks like a waveform.

Figure 13.10
The Media Vision Pocket Mixer Set for Movie Playback

A tip we can offer you here is to save the settings for both your record and play modes using mnemonic file titles. Some names that work for us are AVI-REC.MIX and AVI-PLAY.MIX. We also use one for QuickTime for Windows playback named QTW-PLAY.MIX, but it has the same settings as AVI-PLAY.MIX. Besides, QuickTime for Windows has a keyboard interface for adjusting the volume.

We started this section by asserting that you could view the way analog audio got to your digitizer as a series of boxes. In terms of wiring things together, this analogy is certainly true. As far as understanding how and where you can make changes to the audio signal's inherent quality, this analogy is much more useful. You don't have to be a sound engineer to make your movies sound good, just be careful and consistent. As we said at the beginning of this chapter, we'll talk about how to modulate sound *after* it is digitized in Chapter 25.

Solving Analog Video Problems

MOST OF THE TROUBLE YOU WILL HAVE WITH ANALOG VIDEO CAPTURE WILL RESULT FROM ITS STORAGE MEDIUM.

By its nature, analog video is subject to more problems than digital video. That's why there is so much equipment to filter and otherwise correct analog video. Of course, any sort of technology that depends on precision movements of small parts (as in tape transports) is prone to imperfection and, occasionally, outright malfunction. Even slight imperfections on the analog side can get blown out of proportion when they cross over to the digital side, as we will soon see.

The problems get worse when working with miniaturized equipment. Although smaller camcorders and decks (and the more delicate tapes they use) are changing the way desktop producers make movies, the strain they put on their internal mechanisms to achieve the quality found in bulkier video equipment is tremendous.

This observation highlights an important point: Most of the trouble you will have with analog video capture will result not from the inherent qualities of the analog signal, but from its storage medium, specifically video tape. There are other ways

for an analog video system to experience problems (like using poor-quality connectors or unshielded cables), but our experience is that it usually comes down to the tape or the tape deck—especially Hi-8 decks.

The good news is there are only a few such problems you need to be aware of. The bad news is these problems can be downright nasty. If you are going to make movies from tapes gathered from a wide range of sources (as opposed to shooting everything yourself), chances are you will run into these problems sooner rather than later.

In this chapter, you will learn:

- What time base correction is
- What dropout is
- What, exactly, nonlinear editing is
- Some tips for shooting video specifically for digitization

Time Base Correction

Without a background in professional video production, you may be at a loss for how to deal with *time base correction* (TBC) problems when they first occur. You may not even know that you *have* a TBC problem, and spend a lot of time trying to fix symptoms that just won't go away. Once you understand what's going on, naturally, it makes perfect sense. But like with most technical problems, it's that in-between time than can drive you to the clock tower with a deer rifle.

Most TBC troubles manifest themselves as a particular kind of distortion. Figure 14.1 provides an example, as does the movie named TBCPROB1.MOV on the companion CD-ROM. Another TBC gremlin is a dark fringe down the left margin. The movie named TBCPROB2.MOV shows what this problem looks like.

Once you've seen your share of TBC trouble, it becomes a fairly easy problem to diagnose. Unfortunately, effective exorcism requires yet another significant investment in equipment. We'll recommend some at the end of this section. The movie on the CD-ROM named TBCFIXED.MOV shows how the tainted clip looks with the TBC problem corrected.

Figure 14.1
A Movie Frame with an Advanced TBC Condition

TBC problems occur for several reasons. Any one of them can be a major annoyance, but often they hunt in packs. Here are the categories these problems fall into:

- Analog video is highly dependent upon the delicate moving parts inside the tape transport mechanisms of VTRs, VCRs, and video cameras. These components can slip and grind, throwing off the precise timing processes used in generating the video signal. When this happens, horizontal frame skewing (called *flag waving*) can occur. These are called *synchronization* problems, and are common with Hi-8 and 8mm decks. An often used analogy for this process is a dam that releases water unevenly through a controlled sluice.
- Analog color and brightness values are just that—analog. Sometimes they don't translate well among various equipment components. This is especially true of conversion between analog and digital formats. Such poor translations give rise to *level* and *chroma noise* problems.
- Multiple video sources can deliver signals that do not match up in terms of color and intensity calibration, producing *phasing* problems. (This class of problem is more likely to affect the analog video technician than the desktop video producer.)

In general, consumer-grade video equipment is much more forgiving of TBC problems (especially synch, level, and chroma noise errors) than your digitization board. That's why distortion in captured clips doesn't always show up when you run the same video signal through your NTSC monitor. Not knowing this when the evil spirits appear can make you look for solutions 180 degrees away from the actual problem.

As noted above, the only way to solve TBC problems is to get a time base corrector. You might think at first that you can repair damaged frames or reshoot whole clips, but this approach can get old in a hurry, especially when you're working with deadlines. If you are going to work in this area for the long haul, you are eventually going to shell out for one. Thankfully, nearly every common video problem can be cured with such a device.

Many of the TBC solutions currently available are outboard units, ranging in price from around $1,100 to $1,500. Recently, however, TBC add-in cards have started appearing. One product we have used extensively and can recommend is the TBC/PCB Time Base Corrector and Synchronizer Board from Prime Image, Inc., located in San Jose, CA.

The TBC/PCB is a full length ISA card costing just under $1,000. It comes with both composite and S-video connectors plus an attached remote control pad that you can operate next to your keyboard. For further information, you can call Prime Image at (408) 926-5177. The professional video magazines advertise other such products.

Regardless of the TBC unit you ultimately select, some important features to look for are:

- Infinite window memory (the ability to store an entire NTSC frame), which is especially important for Hi-8 and 8mm VTRs
- Types of video ins and outs (try to get both composite and S-video)
- Processing amplifier controls (for adjusting color, intensity, and saturation)
- Frame synchronization
- Phase controls
- Dropout compensation
- Freeze frame
- Remote control

Dropout Problems

As noted in the Ten Commandments of Hi-8 Video Tape Management, dropout is the process in which minute particles of metal

oxide fall off the surface of a video tape—taking with them crucial information needed for rendering your video content. The problem normally appears as specks on your movie frames.

As luck would have it for the desktop video producer, Hi-8 tape is infamous for this sort of behavior. The two principal ways it occurs are:

- Footage is recorded onto unconditioned tapes containing rocky particles (see the Ten Commandments for how to condition a tape). Jostling or subsequent use dislodges those particles, which contain important video data.
- Condensation creeps into recorded tapes and evaporates, creating bumps and craters on the tape surface. Subsequent playing causes the tape heads to wreak havoc on the new uneven terrain.

Sadly, there is not much you can do after the fact. Some analog video processing equipment has dropout compensation circuitry, but it can't re-create what isn't there. The best approach, as always, is preventative: Treat your tapes with the utmost respect and try to digitize them as soon as possible.

Again, if you have the resources, you should try to digitize your tapes with as much video data retained as possible—in other words, at high frame rates and large frame sizes. Doing this can be an insurance policy if they are damaged or destroyed. If you archive your key raw footage in high-quality JPEG at, say, 30 fps with a 320-by-240 frame size, you might have something almost as good as the original tape for future desktop video productions.

Other Gray Areas

In terms of problems you will be forced to deal with on a regular basis, TBC and dropout are the most notable. Depending on the nature of your desktop video projects, you may have to confront some of the more esoteric issues in analog video from time to time. While an exhaustive listing is beyond our scope, the following group will give you a flavor of what's out there.

Transferring Film to Video

There is a cottage industry based on transferring Super 8 home movies to VHS cassettes, similar to the one for dubbing video to video. Many video service bureaus (look under *Video* in the Yellow Pages) also offer this service. These businesses use dedicated equipment for doing the transfer, which is outside the budget of the desktop producer. Depending on the skill of the equipment operator, the results will be of varying quality. You should be aware that transferring from Super 8 film can damage the source film if the job is done with poor quality equipment.

Still, if you have film footage you need converted to video, our general advice is to let a service bureau handle it. You may think that pointing a video camera at a film projected on a screen is a viable do-it-yourself approach, but you will see flickering in the resultant video—just like you see in computer screens or television monitors that have been videotaped or filmed.

The reason for the flickering, of course, is the differing refresh rates of the capturing equipment as opposed to the subject. In the case of video versus film, it is 30 fps versus 24 fps. But even when video is shot of scenes including video monitors, the precise timing requirements for dead-on synchronization make flicker-free results for those monitors almost impossible.

All this being said, you can still *reduce* the flicker significantly if you are truly driven. By experimenting with the settings on your camcorder and shooting from varying distances, it is possible to find the point where videotaping a projected film meets acceptable levels of synchronization. Some pioneering work in film and video was actually done this way, but those film and video makers were not desktop video producers with other time-consuming issues to contend with.

When feature films are transferred to video tape for commercial broadcast, expensive high-end gear is used to scan them frame by frame into a digital format. They are then stored on high-end digital tapes, such as D1 or higher. Interestingly, transferring film to laser disc is effectively still an analog process, and does not necessarily adhere to broadcast-quality standards.

The 3/2 Pull-Down Issue

One technical issue worth mentioning is known as *3/2 Pull-down*. You will often hear this term used in detailed discussions of the film-to-video transfer process. What they are talking about is a process in which, essentially, 24 frames per second (film) are turned into 30 frames per second (video). Figure 14.2 illustrates this process.

Drop/NonDrop Problems

A final interesting but esoteric analog mismatch is the drop/nondrop dichotomy in SMPTE time code. As a desktop producer, you will not need to worry about this unless you are digitizing longer clips at 30 fps. For a more detailed discussion of the problem, see the SMPTE section in Chapter 11.

What Is Nonlinear Editing?

It was difficult to find a good place to talk at length about nonlinear editing, but given that this discussion will contain plenty of references to analog video, and that nonlinear editing does (in a certain sense) solve an analog video problem, this chapter seems the most appropriate. If you are involved professionally in digital video at any level, you are probably acutely aware of

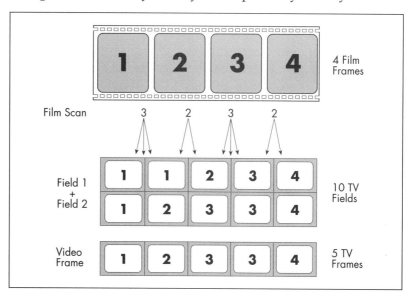

Figure 14.2 The 3/2 Pull-down Process

the definition of this term. For desktop producers with non-video backgrounds, there are some points worth making.

If you are a PC or Mac geek who has never worked with videotape, imagine that you have just finished a long and intensive analog editing session. You show it to a client who, after telling you this was the *final* final, insists that a shot somewhere in the middle has to be deleted. If you were back on your computer and working in, say, Adobe Premiere, all you would have to do is delete the offending clip and drag everything to the left.

Not so in the analog realm. Redoing any edit session (especially when you thought it was final) is a migraine-inducing world of pain—a *linear* world of pain. This is why video tape editors are generally excited about desktop digital video, although many of them are still highly skeptical of AVI and even QuickTime.

The Old Way

Actually, a different style of nonlinear editing (so-called) has been in use for a while already, depending on how you judge such things. Using the prior version, you first copy your master tapes onto VHS tapes or, depending on the system you are using, laser discs. Then you make your editing decisions working with the VHS copies or laser discs and enter those decisions as an *Edit Decision List* (EDL) into a dedicated workstation using a special protocol.

Next, you mount the VHS tapes or laser discs into an array of playback machines controlled by the workstation. The workstation uses your EDL to assemble a working edited tape to show your client. As noted earlier, this is called offline editing. If your edits are deemed final, you take your EDL and master tapes to an online editing suite where a master tape is prepared in the same manner.

The New Way

Now, with all-digital technology available, a nonlinear system refers to something slightly different. Instead of the VHS tapes or laser discs used in the previous description, copies of the original footage are stored on hard disks. Editors work with the digi-

tized footage in a graphical environment that automatically creates EDLs (since the digital copies carry time codes). Those EDLs are used in online sessions to create the finished master tape.

The difference is that the new way is completely random access, which is basically what nonlinear means. Since the footage is stored on randomly accessible media (hard disks) the act of editing is facilitated by what computers do best. It also proceeds at a much faster pace with much less waiting time, not counting compression.

The promise is that any independent desktop producer will be able to conduct online sessions on his or her desktop—in other words, print directly to the master tape from hard disk. It is not so hard to imagine a time when we can all record from digital camcorders to hard disk on location, and edit on our laptops. When this is possible, the video editing playing field will change yet again.

From an analog perspective, the benefits of full-fledged nonlinear video editing are:

- No more worrying about generation loss
- No possibility of tape damage during editing
- No more searching through canisters for misfiled tapes
- No more headaches from fast-forwarding to find the right scene

How to Shoot Video for Digitization

The tip list below assumes you don't have the luxury of setting up your shots with complete control over your subjects and the background. Following it as closely as possible will decrease your chances of having to deal with analog video problems.

1. Always keep your clips as short as possible, within reason. We don't mean finished productions here. We mean continuous raw takes that may be digitized into single, continuous movie files prior to editing with a PC.

2. Always edit in the camera. In other words, discipline yourself not to shoot unnecessary footage. If you are going for a continuous take from several perspectives, keep the camera paused until you are in the next position. This assumes, of course, you have set up the shots in your mind's eye. If you think you might miss something important, keep the camera running.
3. Always move in for close ups, as opposed to zooming and panning. Full-frame motion doesn't digitize well.
4. Always use a tripod whenever possible. Human frailties don't digitize well either.
5. Always try to frame your subjects against solid colored, unchanging backgrounds. This approach *does* digitize (and compress) well.
6. Always use the dominant light source in a mixed lighting environment to manually calibrate your camera's white balance control (if it has one).
7. Never shoot without your headphones if you are capturing audio along with your video.
8. Never (okay, rarely) go for long shots, if you can help it. Stay in as close as possible, with the occasional medium shot for variety. This is especially true for human subjects.
9. Never record at slow tape speeds.
10. When using Hi-8 gear, never start shooting from the start of a tape cartridge. Five minutes in is a good conservative place to start. See the *Ten Commandments of Tape Management* at the end of Chapter 11 for other tips regarding tape handling.

How PCs Digitize Video

HERE'S YOUR CHANCE TO FIND OUT EXACTLY WHAT HAPPENS TO A VIDEO SIGNAL WHEN IT ENTERS YOUR SYSTEM.

As promised earlier, this chapter begins with a detailed discussion of the mechanics of digitization. In the next four chapters, we'll address the roles of the various system components (to see if they are performance bottlenecks), examine movie file structures, compare compressor types and look at the mechanics of playing movies. Since many of the basic issues we'll cover are the same for both Macs and Intel-based PCs, you can assume that the techniques we present will apply to both platforms, unless we we tell you otherwise.

In general, we'll be less concerned with the electronics involved in processing video signals and more focused on how captured video data is compressed, processed, and organized into data files. Understanding the latter can be very helpful when you are using the available tools to troubleshoot badly performing movies.

In this chapter, we'll cover:

- The role of the capture card in acquiring data
- The role of the CPU and hard drive in processing and storing data

- All of the bottlenecks that affect the digitization of desktop video

Meta System Redux

We will use the *meta system* model introduced in Chapter 4 as a framework for discussing the individual components involved in the process. By the end of this chapter, you'll have a detailed map showing where all of the possible data transfer log jams are for both video digitization and playback.

Although the video source was identified as one of the components of our meta system, we will not talk about its role in detail here. We'll assume you are already using your VTR or camera of choice (based, we hope, on our earlier survey of video equipment) and are now interested in finding out exactly what happens to a video signal when it enters your system.

What the Capture Card Does

Many types of add-in boards for personal computers acquire data. Network cards receive transmissions from other PCs on a local area network (LAN) and pass that data on to the CPU for processing (in this case, the incoming data is already digital). Sound boards digitize (sample) analog audio signals. Certain specialty cards do even more esoteric things, such as digitizing electrical impulses produced by, say, the electrodes in a liquid chromatography device. In all of these cases, as shown in Figure 15.1, the card must deliver data to a program that wants it, in the way the program wants it.

The role of a video capture card is to provide a stream of data to a program whose job it is to get that data encoded into movie files. (Some cards also capture high-quality still images.) If the card has built-in compression capability, and the user specifies it, freshly sampled video frames are compressed by the card before they are passed to the capture program—thus ensuring that more frames can be captured, depending on the speed and power of the computer. Otherwise, frames are encoded raw and supplied to the computer as fast as the computer can handle them.

What the Capture Card Does

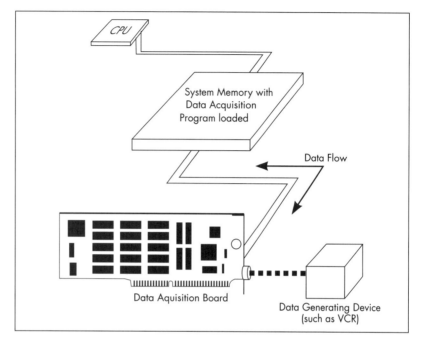

Figure 15.1
A Generic Data Acquisition Board

Just in case any confusion remains, it is important to emphasize that the capture board itself does not create movie files. All it does (which is no small accomplishment) is convert an incoming analog video signal into digitized samples. To the computer, these samples are just more data traveling along its data bus.

Life in the Fast Lane

High-end capture cards have plenty of time to both capture and compress—that is why you can get 30-fps, full-screen movies out of them if you ask for it. Without onboard compression circuitry, high-end cards are still able to digitize at 30 fps, but the resultant amount of uncompressed data will choke even the most powerful PCs available today, as illustrated in Figure 15.2.

The point we are trying to make is that high-end capture cards work at their own speeds—with or without engaging their compression capability—and generally digitize video a lot faster than a capture application running on a PC can make use of it. When compression is engaged on the card, a capture program is simply able to process more and bigger frames.

Figure 15.2
A Capture Card's Wasted Miracles

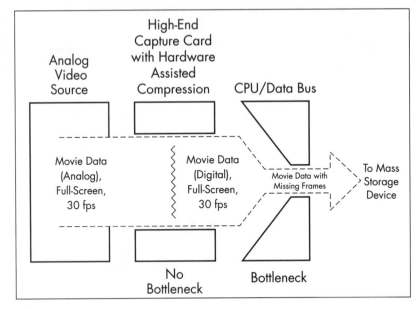

Lower-end capture cards are a somewhat different story—not all of them do such a great job. Then again, not all of them are supposed to. Many of the low-end cards that don't provide onboard compression have been engineered for sampling performance that just clears the bar for sub-quarter-screen movie capture at middling frame rates. Understanding this discrepancy leads to fewer questions as the role of the capture card is examined in detail.

It is worth noting that manufacturers of video capture boards are currently getting mixed signals from their markets, apparently causing them to make many design decisions on faith. The belief is that end users want video on their desktops, but expect high quality—based on how desktop video is typically being marketed.

On the other hand, systems manufacturers (especially on the Intel-based PC side) often feel that video is being rammed down their throats by capture card makers (and other types of multimedia hardware firms) and the software industry. Trying to play video on underpowered systems can make the whole idea look bad. As with SVGA display adapters in the late 1980s, designing and building today's digitizing hardware involves a substantial gamble.

Checking out the Action

To better illustrate some of these ideas, let's begin putting them in context. Assume we have a card installed in an Intel-based PC that has no built-in compression capability, but is otherwise a decent performer. After invoking the Video for Windows capture program—VIDCAP.EXE—and setting a few parameters, we start recording. In slow motion, here's what happens next:

1. Depending on the frame rate you ask for—let's say 15 fps—VIDCAP asks the appropiate VfW driver to put a sampled image from the incoming video signal into a designated frame buffer in the PC's high memory every fifteenth of a second.
2. The driver then asks the card for the video data, actually copying the sampled image available at that instant to the PC's frame buffer, as shown in Figure 15.3.
3. The program appends the image in that frame buffer to a file it has opened to receive movie data.

Figure 15.3
Moving Frames off the Capture Card

4. Steps 1 through 3 are repeated until you terminate the program, at which point the capture card receives no more instructions to sample incoming video.

Theoretically (based on reasonable capture parameters), VIDCAP should report that very few, if any, frames were dropped. But what happens if we push the fame rate to 30 fps? We know from experience that a substantial number of frames *will* be dropped. (The frames get dropped by the capture program and not by the capture card.)

In other words, we are asking for more than we can handle (and we should know better, since our card has no built-in compression). People often talk about a capture board dropping frames, but this is misleading. The board itself is likely doing a yeoman's job of digitization (unless it's a bargain basement model). If the card isn't also *compressing*, however, it is probably overwhelming the capture program with available data.

A Funny Thing Happened on the Way to the Hard Drive

The reason the capture application gets overwhelmed (in this extreme case) is that it gets held up by the hard drive. The system bus, assuming it is ISA, is on the verge of culpability as well. Huge amounts of data are being sent to the hard drive, but at a rate the drive can't completely handle. We will see this dramatized in the next section. For now, the result is that frames go missing in action.

Another factor determining the rate at which frames are dropped during capture is their screen size. To illustrate this relationship, Figure 15.4 shows a rough approximation of frame rate plotted against frame size. The rate/size coordinates under the diagonal line represent conditions under which frames were dropped when we captured a series of movies on a 486 DX2 66 using a capture card with no onboard compression.

Now let's consider a card that *does* have hardware compression assistance. Capturing uncompressed video with such a card (such as the Intel Smart Video Recorder) will produce dropped

Figure 15.4
Frame Rate/
Frame Size
Tradeoffs

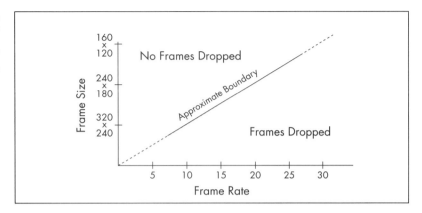

frames in a pattern similar to our non-compressing board. Engaging compression, however, will result in no frames dropped at significantly larger window sizes or greater frame rates. Of course, the images will be slightly grainier since compression is applied.

How far can we take this idea? You can experiment with it yourself by capturing movies to a RAM drive (assuming you have enough extra memory), which will not have the same throughput restraints as a physical hard drive. You might remember that we recommend RAM drive capture as a good way to capture short movies without dropping any frames.

But even this scenario has a limit if your system has an ISA bus. Under Windows, the roughly 4 megabytes per second (mbs) ISA throughput rate can be taxed fairly significantly, leaving barely enough bandwidth for movie data being transferred to a hard drive. These days, efficient IDE hard drives can handle 1 mbs to 1.5 mbs. Local bus video can certainly put a positive dent in this situation, but remember that it is only used for video *display*. The bottom line is, compression only works as well as the rest of your system will let it.

Shifting the Blame

These comparisons do a lot to define the role of the capture card in the meta system we proposed in Chapter 4. For one thing, it puts the blame back on the computer and its *other*

peripherals as the head slackers in the digitization process. A capture board with built-in compression can make a PC or Mac look better, but it is hard to say that such a card is a bottleneck just because it doesn't have hardware compression capability.

For another thing, the issue of image quality can be isolated. As we have seen, boards similarly positioned in the market often sample video frames at different resolution standards. (We're talking about the aesthetics of digitization, not digitization speed.) A good example is the output of the VideoLogic Captivator versus the other boards in its class. Since the Captivator has been specifically engineered to produce sharp video images, it outperforms its peers in this area.

Why is this issue important for you to understand? Because image quality is an area where capture card performance *can* be improved, even though it is not a bottleneck in our meta system. We stress the importance of clean source video throughout this book, but it is all for nothing if you are going to push it through a dirty grinder.

This is, of course, less of an issue on the Macintosh, where desktop video capture cards generally produce better looking movies (and are consequently more expensive). As the industry matures, image quality will likely become more of an issue. Card manufacturers looking for features to push when selling their products could do worse than start there.

In a way, the generic capture card component of our meta system can now be seen as more akin to the video source component. Both are overachievers at their jobs, compared to the other players in the loop. In other words, both supply a stream of goods that is never in danger of running dry, even as the demand is increased. This is why one of the criteria for the capture card component of our meta system was that it have onboard compression.

Comes the Revolution

It is interesting to ponder the implications of the previous discussion in regard to the coming (we believe) wave of video

What the Capture Card Does

adapter/video capture cards that will embody built-in hardware assistance for both digitization *and* playback. In a perfect world, they would adhere to a universally accepted codec supported under both QuickTime and VfW. In reality, they will probably all use proprietary codecs in an attempt to create standards, which is one of the main reasons QuickTime and VfW have so far been software-only solutions.

If a competitively priced card using a royalty-free codec could receive compressed video data via a local bus, decompress the data without involving the CPU, then blast it out to the monitor, much better performance than our proposed desktop video standard could be attained—maybe even full motion, full screen.

We know that existing capture cards with compression built in can easily handle high-speed digitization followed by compression, so why not the opposite? In fact, the high-end Mac cards already do this—except that they use proprietary compressors (generally JPEG-based). Like they say about global food shortages, it's a matter of politics as opposed to resources and technology. Unfortunately, politics are the real world.

With the role of the capture card component now fully illuminated, let's begin building an annotated diagram of the meta system we introduced in Chapter 4 (with the bottlenecks quantified). Figure 15.5 provides the first overlay to this big picture. The other layers will be added shortly.

Figure 15.5 The Role of the Capture Card

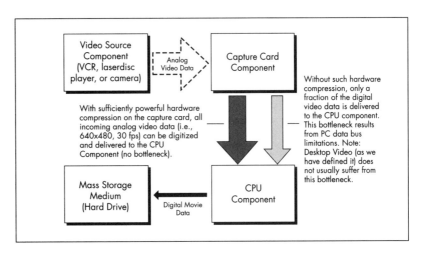

What the CPU and Hard Drive Do

With the heat off the capture card in the bottleneck lineup, there are two suspects left: the CPU and the mass storage component(s). We already know both are partners in crime, but let's hear their stories now in full detail. People who just want to make movies can skip ahead—maybe you'll return later while your data rates are being adjusted.

We'll start with a bold question, just in case it had already occurred to you: Why *are* personal computers so limited when it comes to processing video? This question immediately leads us to another: If a serious problem (and a market opportunity) exists, why isn't it being addressed? Here are the quick answers:

1. The original PC and Mac designers had to take short-term perspectives to get their products out the door. While they certainly envisioned personal computers handling video at some point, it was too complex a standard to adequately plan for. And, once the dies were cast and the money was rolling in, no one wanted to mess with success.
2. The situation *is* being addressed. This is where technology like the new PCI bus standard comes in. Unfortunately, it is unclear to what extent existing machines can be retrofitted. The truth is, personal computers *could* have been designed differently but it was too big a gamble and not all the associated technology was in place at the time. Of course, this is much more obvious in hindsight.

Admittedly, these answers are brief, but more detailed responses are outside the scope of this book. We just wanted to assure you that we are well aware of the questions. Since this book is concerned with systems that are *currently* available, let's return to our discussion of them.

So just what *are* the roles of the CPU and hard drive in digitization, and at what point do they become bottlenecks? The explanation is somewhat complex, so we'll break it down into individual topics:

What the CPU and Hard Drive Do

- The CPU's role in data transfer management
- The hard drive's role in data transfer management
- The CPU's role in encoder execution

Data Transfer Management

Let's go back to the point where we pushed the OK button to start digitizing. We already know what the capture card is going to be doing. Assuming we're still using VIDCAP.EXE as our capture application and the Intel Smart Video Recorder as our digitizer, here's what happens from the CPU's point of view:

VIDCAP enters a loop of making calls to the capture card driver to get video frames off the card and into a movie file as quickly as possible. Presumably this file is on a local hard drive. To effectively sustain this activity, the CPU must move a large amount of data across the bus. Depending on the size of the individual file writes, this activity can use up a large amount of valuable CPU cycles all by itself. When the user ends the capture (or the drive runs out of room), the capture program writes all buffered data to the target movie file and closes it.

Unfortunately, doing any *advance* math to try and ferret out the bottlenecks can be unreliable, since you can't always be sure how a particular third-party encoder is going to work. For instance, the Indeo Video Raw codec, which you would expect to encode in 24-bit color (the standard mode for the ISVR), actually encodes in YUV9 (9-bit color).

If you had calculated the size of your capture file based on 24-bit color (3 bytes per pixel), you might be wondering what happened when the file turned out to be around a third as big as you expected. Luckily, we knew about the discrepancy in advance, but attempting to understand these principles by quantifying them is what turned up the problem—a good example of the value of the empirical approach we have tried to take in this book.

Fortunately we *can* measure the size of the resultant movie file. The number of bytes in the captured file on the hard drive represents the amount of data the CPU had to transfer over the

Chapter 15 How PCs Digitize Video

bus during the time the movie was being captured. This relationship is shown in Figure 15.6. Because we are dealing with movie files, we already know the load is going to be extremely heavy.

Here is a test you can perform to better appreciate your system's performance level on the data transfer management front:

- With a tool like Norton's SI.EXE (for benchmarking system components), you can first determine your hard drive's transfer rate. Newer IDE and SCSI-1 drives can top out over 1 mbs.
- Perform a series of ten-second captures to your hard drive at increasingly higher frame rates. While progressively more frames will be dropped, the resultant file sizes should max out to a fairly uniform number after a certain point.
- Divide the maxed-out file size by ten to produce a number close to the one determined by your benchmarking program (after factoring in overhead). For example:

```
   1.6 mbs (benchmark)
-   .4 mbs (overhead)
─────────────────────────
 = 1.2 mbs (actual capture result)
```

Your results should indicate that your hard drive is a major bottleneck to high performance digitization. Even with compression on your capture card, you will probably find that 320-by-240 captures at greater than 15 fps (with at least 16-bit color and minimal audio) will entail dropped frames.

Figure 15.6
How Movie Data Gets to the Hard Disk

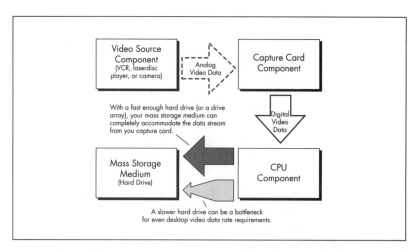

What the CPU and Hard Drive Do

Capturing to a RAM disk or a correctly configured SCSI-2 hard drive will formally introduce you to the next bottleneck on the Intel-based PC: the ISA bus. On the Mac, the NuBus is roughly comparable to the PC's EISA standard, which is why higher-end Macs can simply be outfitted with hard disk arrays to capture full-motion, full-screen video (using high-end cards with hardware compression).

Encoder Execution

In between file writes, the CPU is also executing instructions to prepare the next block of movie data for writing to disk. If you choose both to digitize and compress using software (with a capture board like the Captivator or the Spigot for Windows), there are even more steps involved. These extra steps are one reason we recommend that you always capture raw video on either Macs or PCs if you have the disk space available. If you don't, get some more.

Because there is always data on the capture card available for transfer, the digitization program does not have to pause between encoding and disk writing iterations in its capture loop, as illustrated in Figure 15.7. The capture application can just keep pumping away until you tell it to stop or your system runs out of disk space. Of course, this keeps the CPU extremely busy (and the little hard drive light glowing).

In cooperative multitasking systems like Windows 3.1 and System 7.1, there is always overhead involved in managing the

Figure 15.7
A Capture Machine Working Overtime

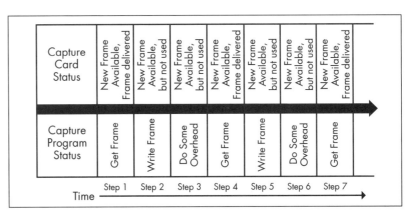

overall environment. If you have optimized your system for capturing (shutting down nonessential tasks, configuring virtual memory correctly), the CPU should be almost completely free to concentrate on digitization.

Clearly, the efficiency of the CPU is critical to both data transfer and encoder execution, since both proceed at an extremely rapid pace during digitization. This is even more true for movie playback, since desktop video as we have defined it always uses software-only *de*compressors. This is one of the reasons we said in Chapter 2 that you can generally make better movies than you can play back. The other reason is, of course, that you will often be playing back from CD-ROM.

Bottlenecks Revisited

In terms of overall system bottlenecks, the results from the various tests suggested in this chapter tell the story. Mass storage is the principal culprit. Not just CD-ROM drives, however, but actual hard drives, too. Even *fast* hard drives. Coming in a close second on the PC platform is the ISA data bus. By adding these components to our evolving annotated meta system, we can now present our master overview of the great desktop video bottleneck crisis.

Here are what we believe to be some valid observations about digitization on desktop computers:

- Without hardware-assisted compression on your capture card, you will not easily be able to capture video on Macs or PCs according to our desktop video standards.
- Without a relatively fast hard drive on either platform, you will hit a glass ceiling if you try to capture desktop video movies (as we have defined them) in raw format.
- The next performance breakthrough will likely be in hardware-assisted movie playback cards using standard (or ubiquitous) decompressors.

Movie File Formats

THE QUICKTIME AND VIDEO FOR WINDOWS FILE FORMATS ARE THE BASIC DATA STRUCTURES THAT ARE GOING TO ENDURE.

This chapter is as technical as the book gets. You'll find the information valuable if you are a software developer and are planning to write programs that play and capture movies. If you are more interested in just digitizing video, we think it might give you a better appreciation of the results of your efforts from a data-processing perspective.

As mentioned in the preface, we are involved in writing some of the system-level software used by movie capture and playback applications running under Windows. In the course of those efforts, we have had to become extremely intimate with both the QuickTime and Video for Windows (VfW) file formats, as well as the encoder/decoder technology that supports them. Presenting both standards side-by-side is a good a way to dramatize their differences.

Regardless of new hardware or new compression algorithms that may come along, the QuickTime and VfW file formats are the basic data structures that are going to endure in the world of desktop video as we have defined it. It is interesting to think

that when broadcast-quality digital video finally gets downsized to the Mac and PC desktops, it will likely be in either or both of these file formats.

In this chapter, we'll cover:

- The QuickTime file format
- The Video for Windows file format
- Sound encoding formats

The QuickTime File Format

Let's start by taking a look at the QuickTime movie format. Because we are basically Windows programmers, we will use the Windows implementation. Although this is a strict subset of the Mac QuickTime file format (making life a lot easier for cross-platform content providers), the data stream is exactly the same.

A consequence of using the Windows implementation is that the byte ordering of structured data is Motorola's, not Intel's (because the Mac implementation came first). This may make it a bit confusing at first to relate parts of this discussion to a hex dump of a QuickTime file, although some people find Motorola hex much easier to read.

QuickTime files have a recursive, atom-based format. An atom is prefixed by a 32-bit length and a 32-bit identifier. It can contain either data or more atoms. Figure 16.1 shows the basic atom layout.

The semantics of an atom are implied by its identifier. Each atom identifier is a four-character mnemonic, which is also the

Figure 16.1
Basic Atom Format in a QuickTime for Windows Movie File

Length	Ident	Data of Atoms
0 32	64	n

value of the identifier itself. This may seem odd to Windows programmers, to whom constructs like

```
#define SOME_ATOM_ID 0x12345678 /* unreadable value */
```

are more familiar. On almost every other platform in existence, 32-bit compilers have been quite happy to accept character constants like **moov** or **mdat**.

A QuickTime movie can be viewed as a tree structure. Normally, trees have a single root. QuickTime for Windows movies, however, have two. This is because, on the Mac, movie data (video frames and sound samples) is stored in the file's *data fork*, while the atoms that describe that data are stored in the *resource fork*. DOS, of course, does not support this concept, so both tree structures are concatenated, or *flattened* in the QuickTime jargon. Fortunately for cross-platform developers, QuickTime on the Mac is quite happy to play flattened movies.

Movie data is stored in the **mdat** atom, which always comes first. It contains only data, not other atoms. This data includes the video frames and sound samples that comprise the actual movie. The **moov** (pronounced *moo-vee*) atom is the root to a structure of atoms that act as an index to the movie data. Figure 16.2 shows the basic structure of all QuickTime movies on the PC.

The moov Atom

We noted above that movie atoms are arranged into trees. Table 16.1 shows the basic tree structure of the **moov** atom. We'll look at some of the important atoms in more detail shortly. Note that while the semantics of a particular atom constrain it to a certain level in the tree, the ordering of atoms at a given level is arbitrary.

Moreover, software that parses the tree is expected to ignore atoms it doesn't recognize. It is this simple facility that gives

Figure 16.2
Basic QuickTime Movie File Structure

Length	**mdat**	Movie Data
Length	**moov**	Atoms Indexing Data

Table 16.1 The **moov** Atom Tree Structure

Atom	Purpose
moov	Movie Atom.
-mvhd	Movie Header. Defines the *time scale* and *duration* of the movie.
-trak	Track Atom.
--tkhd	Track Header. Defines the *dimension*, *time scale*, and *duration* of the track.
--edts	Edit List.
--elst	Edit List Entry. Allows selections of the track be played out of sequence.
--mdia	Media Atom.
--mdhd	Media Header. Defines the characteristics of the media holding this track's data.
--hdlr	Handler. On the Mac, defines the component that handles the media.
--minf	Media Information.
----vmhd or smhd	Video or Sound Media Information Header. Defines basic media requirements.
----hdlr	Handler. On the Mac, defines the component that handles the video or sound.
----dinf	Data Information.
----dref	Data Reference. On the Mac, can point to another file holding this track's data.
----stbl	Sample Table.
----stsd	Sample Description. Describes how the track's video or sound is compressed.
----stts	Time-to-Sample. Gives the duration of each video frame.
----stss	Synch Sample. Indicates the location of key frames.
----stsc	Sample-to-Chunk. Groups video frames or sound samples into chunks.
----stco	Chunk Offset. Gives the offset into the mdat atom of each chunk.
----stsz	Sample Size. Gives the size of each video frame or sound sample.
-trak	As many additional tracks as required.
--...	

The QuickTime File Format

the QuickTime movie file structure the flexibility to adapt to future needs. Although examining each atom in detail is too esoteric to include here, there are two sources for complete information. First is Apple's *QuickTime Movie Exchange Toolkit*, available from Apple by calling (800) 282-2732. Second is Canyon's *Movie Toolkit*, available by calling (415) 398-9957.

You can explore this structure for yourself by using Apple's DUMPMOOV.EXE program. Under DOS, it generates output like the following:

```
moov (16658) Movie Atom
  mvhd (108) Movie Header
  -Version/Flags: 0x00000000
  -Creation Time: Thu Aug 19 13:26:31 1993
  -Modification Time: Thu Aug 19 13:26:31 1993
  -Time Scale: 1000 per second
  -Duration: 127000
  -Preferred Rate: 1
  -Preferred Volume: 0x00ff
  -Matrix:        1             0             0
                  0             1             0
                  0             0             1
  -Preview Time: 0
  -Preview Duration: 0
  -Poster Time: 0
  -Selection Time: 0
  -Selection Duration: 0
  -Current Time: 0
  -Next Track ID: 2
  trak (5524) Track Atom
    tkhd (92) Track Header
    -Version/Flags: 0x0000000f
    -Creation Time: Thu Aug 19 13:26:31 1993
    -Modification Time: Thu Aug 19 13:26:31 1993
    -Track ID: 0
    -Time Scale: 0 per second
    -Duration: 127000
    -Movie Time Offset: 0
    -Priority: 0
    -Layer: 0
    -Alternate Group: 0
    -Volume: 0
    -Matrix:      1             0             0
                  0             1             0
                  0             0             1
    -Track Width: 320
    -Track Height: 240
    edts (36) Edit List
      elst (28) Edit Entry
      -Version/Flags: 0x00000000
```

Chapter 16 Movie File Formats

```
        -Number Of Entries: 1
        - Entry 0: Duration 127000, time 0, rate 1.
mdia (5388) Media Atom
  mdhd (32) Media Header
    -Version/Flags: 0x00000000
    -Creation Time: Thu Aug 19 13:26:31 1993
    -Modification Time: Thu Aug 19 13:26:31 1993
    -Time Scale: 11025 per second
    -Duration: 14001750
    -Language: 0x0000
    -Quality: 0x0000
  hdlr (32) Handler
    -Version/Flags: 0x00000000
    -Component Type: mhlr
    -Component Subtype: soun
    -Component Manufacturer: appl
    -Component Flags: 0x00000000
    -Component Flags Mask: 0x00000000
  minf (5316) Video Media Info
    smhd (16) Sound Media Information
      -Version/Flags: 0x00000000
      -Balance: 0
    hdlr (32) Handler
      -Version/Flags: 0x00000000
      -Component Type: dhlr
      -Component Subtype: alis
      -Component Manufacturer: appl
      -Component Flags: 0x00000000
      -Component Flags Mask: 0x00000000
    dinf (36) Data Info
      dref (28) 00 00 00 00 00 00 00 01 00 00 00 0c
                61 6c 69 73 00 00 00 01
    stbl (5224) Sample Table
      stsd (52) Sample Description
      -Version/Flags: 0x00000000
      -Number Of Entries: 1
        raw  (36) Sound Description
        -Data reference ID: 0x0000
        -Version: 0x0000
        -Codec Revision Level: 0x0000
        -Codec Vendor: appl
        -Number of Channels: 1
        -Bits/Sample: 8
        -Compression ID: 0
        -Packet Size: 0
        -Sample Rate: 11025.
      stts (24) Time To Sample
      -Version/Flags: 0x00000000
      -Number Of Entries: 1
      - 0: Sample Count 14001750, Sample Duration 1.
      stsc (3832) Sample To Chunk
      -Version/Flags: 0x00000000
      -Number Of Entries: 318
      - 0: First Chunk 1, Sample per Chunk 4410,
```

The QuickTime File Format

```
            Chunk Tag 1.
        ...
        - 317: First Chunk 318, Sample per Chunk 1500,
              Chunk Tag 1.
      stsz (20) Sample Size
      -Version/Flags: 0x00000000
      -Sample Size: 1
      -Number Of Entries: 14001750
      stco (1288) Chunk Offset
      -Version/Flags: 0x00000000
      -Number Of Entries: 318
            8 18268 71942 125877 181638 239367
            295397 351595 408044 466170
      -Dumping 1232 bytes
trak (11018) Track Atom
  tkhd (92) Track Header
  -Version/Flags: 0x0000000f
  -Creation Time: Thu Aug 19 13:26:31 1993
  -Modification Time: Thu Aug 19 13:26:31 1993
  -Track ID: 1
  -Time Scale: 1000 per second
  -Duration: 127000
  -Movie Time Offset: 0
  -Priority: 0
  -Layer: 0
  -Alternate Group: 0
  -Volume: 0
  -Matrix:        1          0          0
                  0          1          0
                  0          0          1
  -Track Width: 320
  -Track Height: 240
  edts (36) Edit List
    elst (28) Edit Entry
    -Version/Flags: 0x00000000
    -Number Of Entries: 1
    - Entry 0: Duration 127000, time 0, rate 1.
  mdia (10882) Media Atom
    mdhd (32) Media Header
    -Version/Flags: 0x00000000
    -Creation Time: Thu Aug 19 13:26:31 1993
    -Modification Time: Thu Aug 19 13:26:31 1993
    -Time Scale: 1000 per second
    -Duration: 127000
    -Language: 0x0000
    -Quality: 0x0000
    hdlr (32) Handler
    -Version/Flags: 0x00000000
    -Component Type: mhlr
    -Component Subtype: vide
    -Component Manufacturer: appl
    -Component Flags: 0x00000000
    -Component Flags Mask: 0x00000000
    minf (10810) Video Media Info
```

Chapter 16 Movie File Formats

```
                    vmhd (20) Video Media Information Header
                    -Version/Flags: 0x00000000
                    -Graphics Mode: 64
                    -Op Color: 0x0000, 0x0000, 0x0000
                    hdlr (32) Handler
                    -Version/Flags: 0x00000000
                    -Component Type: dhlr
                    -Component Subtype: alis
                    -Component Manufacturer: appl
                    -Component Flags: 0x00000000
                    -Component Flags Mask: 0x00000000
                    dinf (36) Data Info
                      dref (28) 00 00 00 00 00 00 00 01 00 00 00 0c
                                61 6c 69 73 00 00 00 01
                    stbl (10714) Sample Table
                      stsd (102) Sample Description
                      -Version/Flags: 0x00000000
                      -Number Of Entries: 1
                        cvid (86) Image Description (cvid)
                        -Version: 1
                        -Revision Level: 1
                        -Vendor: appl
                        -Temporal Quality: 0x3ff
                        -Spatial Quality: 0x3ff
                        -Width (in pixels): 320
                        -Height (in pixels): 240
                        -Horizontal Resolution: 72
                        -Vertical Resolution: 72
                        -Data Size: 0
                        -Codec name: Movie Toolkit (cvid)
                        -Depth: 24
                        -Dumping 2 bytes
                    stts (24) Time To Sample
                    -Version/Flags: 0x00000000
                    -Number Of Entries: 1
                    - 0: Sample Count 1270, Sample Duration 100.
                    stss (356) Sync Sample
                    -Version/Flags: 0x00000000
                    -Number Of Entries: 85
                          1 16 31 46 61 76 91 106 121 136
                    -Dumping 300 bytes
                    stsc (28) Sample To Chunk
                    -Version/Flags: 0x00000000
                    -Number Of Entries: 1
                    - 0: First Chunk 1, Sample per Chunk 1, Chunk Tag 1.
                    stsz (5100) Sample Size
                    -Version/Flags: 0x00000000
                    -Sample Size: 0
                    -Number Of Entries: 1270
                          13850 12357 12148 12439 12320 12338
                          12323 12481 12383 12499
                    -Dumping 5040 bytes
                    stco (5096) Chunk Offset
                    -Version/Flags: 0x00000000
```

```
      -Number Of Entries: 1270
            4418 22678 35035 47183 59622 76352
            88690 101013 113494 130287
      -Dumping 5040 bytes
```

This dump should give you an idea of the level of sophistication embodied in the QuickTime movie file format. Now let's take a look at some of the important atoms.

The mvhd Atom

The **mvhd** atom defines the overall characteristics of the movie, principally its *time scale* and *duration*. A time scale is simply the units (in events per second) in which time values are expressed. For example, a time scale of 1,000 means that time values are interpreted as milliseconds. However, time scales of 100 or 1,000, while seemingly convenient, are not often used. You will more likely see scales of 600 because it has more factors, allowing integer arithmetic to be performed with less loss of precision.

The Movie Header time scale and duration provide the key to *synchronization*. Rather than synchronize video and sound to a particular fixed frame rate (like analog systems or Microsoft's AVI), QuickTime synchronizes all its tracks to the Movie Header. In particular, in digital video (as opposed to analog video), frame rates do not have to be constant.

The stts Atom

Unlike a celluloid movie driven by sprockets through a beam of light, a single digital image can be displayed on the CRT for as short or as long a time as necessary. This is where the **stts** atom comes into play. Conceptually, the **stts** atom is an array of durations for each frame in the movie, each of which can, of course, be a different value.

In practice, a simple compression scheme allows a single value to be applied to multiple frames. For example, the extract below specifies that all 1,270 frames have the same duration of 100:

```
stts (24) Time To Sample
-Version/Flags: 0x00000000
-Number Of Entries: 1
- 0: Sample Count 1270, Sample Duration 100.
```

The trak Atom

QuickTime movies may contain an arbitrary number of **trak** atoms, reflecting each of its tracks. Like their analog counterparts, tracks can hold video or sound. Additionally, QuickTime supports text tracks, although they are not yet implemented in the Windows version. Any number of video tracks can be present.

QuickTime will choose the one track that will look best when played on the target device. For example, you could digitize video into three tracks using 8-bit color, 16-bit color, or 24-bit color. If the movie is played on a PC with a video adapter capable of only 8-bit color, the 8-bit color track will be chosen.

Similarly, any number of sound tracks may be present. Each could be recorded in a different language. QuickTime will select the track that matches the current Windows language specification. Tracks can, and typically do, have time scales and durations different than those in the Movie Header. For example, the natural time scale for a sound track is its sampling rate, say 11.025kHz.

Not only can a QuickTime movie have any number of tracks, no one type of track is conceptually favored. For example, it is not required that movies have video tracks, and sound-only movies are quite common. They are often used in multimedia presentations, along with more conventional movies, instead of Microsoft .WAV files. In this way, a single API can be used to control all aspects of the application.

The elst Atom

A track may have an arbitrary number of **elst** atoms, which are mainly generated by movie editing software like Adobe's Premiere. The **elst** atoms allow selected parts of a track to be played out of sequence. In the movie *Manhattan Murder Mystery*, for example, Woody Allen and Diane Keaton attempt to blackmail their neighbor by recording his girlfriend's audition for a play. Then they literally cut-and-paste the tape to produce a convincing, but quite different, shake-down message. In QuickTime, **elst** atoms are the digital equivalent of their razor blade.

The stsd Atom

The **stsd** atom tells QuickTime how the track's video or sound data is compressed. While a track may have multiple **stsd** atoms, it is hard to see why this is useful. It implies that different parts of the track can be encoded using different compressors, and appears to be a somewhat esoteric feature. But consider a movie editing package that might glue together parts of existing movies to form a new movie.

If the source movies used different compressors, but multiple **stsd** atoms weren't supported, the new movie would have to be recompressed using a single compressor. However, each time a frame is compressed with a lossy compressor, it loses quality, much like a video tape that is copied.

The stsc, stco, and stsz Atoms

The **stsc**, **stco**, and **stsz** atoms are used to extract data from the **mdat** atom. The **stsc** atom allows video frames or sound samples to be grouped into chunks, to improve performance on playback. (Typically, chunking is performed by post-production optimization software.) The software gives the size of each chunk, and the number of video frames or sound samples in that chunk. The **stco** atom gives the offset of each chunk within the **mdat** atom (discussed next). The **stsz** atom gives the size of each video frame or sound sample.

The mdat Atom

The **mdat** atom is simply a stream of video frames and sound samples. Theoretically, the physical ordering is unimportant because the **stsc**, **stco**, and **stsz** atoms are used as indexes. When playing back from slow devices like CD-ROM, however, seeks must be avoided at all costs. Consequently, physical ordering is extremely important in actual practice. QuickTime prefers that video frames and sound samples be physically grouped into half-second chunks, with sound leading. The section on sound encoding techniques later in this chapter discusses how sound samples are stored.

The Video for Windows File Format

AVI files are stored as a specialization (*form*, in Microsoft's jargon) of Microsoft's RIFF (Resource Interchange File Format) standard. Microsoft defines RIFF as "a tagged-file specification used to define standard formats for multimedia files." Other forms are WAVE for waveform audio data and RDIB for bitmaps.

An introduction to RIFF in general can be found in the *Windows Multimedia Programmer's Guide* and to the AVI form in particular in the *Video for Windows Development Kit Programmer's Guide*. The AVI RIFF form starts with a standard 12-byte header, as shown in Figure 16.3.

Of course, Intel byte ordering is used for all fields. So that identifiers (such as RIFF and AVI) can be coded naturally, Microsoft provides the **mmioFOURCC** macro. For example, the following type of construct is commonly seen:

```
#define formtypeAVI mmioFOURCC('A', 'V', 'I', ' ')
```

In general, RIFF files consist of *chunks*, lists of chunks, or some combination of both. The AVI form specifies which chunks are defined and the order in which they are expected. All programs that read RIFF files are expected to ignore chunks they don't recognize (but preserve them when the file is written).

A chunk is very similar both in form and in concept to a QuickTime atom. It consists of a 4-byte identifier and a 4-byte length, followed by the chunk data, as shown in Figure 16.4. The semantics of a chunk or list are implied by its identifier.

A list of chunks is prefixed by a 12-byte header, as shown in Figure 16.5.

Figure 16.3
AVI RIFF Form Header

RIFF	File Size	AVI
0	4	8

Figure 16.4
The Basic Chunk Format

Ident	Length	Data
0	4	8 ... n

Figure 16.5
The List Header Format

LIST	List Size	Ident	List or Chunks
0	4	8	12 ... n

Microsoft supplies two good tools for exploring AVI files: RIFFWALK.EXE and FILEWALK.EXE. The RIFFWALK.EXE program works under DOS, and generates output like that shown next. As we saw with the QuickTime movie dumper, DUMPMOOV.EXE, it is worth taking a look at this listing. Armed with the information we've discussed so far, you'll be able to infer a lot about the AVI file structure. FILEWALK.EXE displays similar output under Windows.

```
00000000    RIFF (00E5DE86) 'AVI '
0000000C        LIST (000007D4) 'hdrl'
00000018            avih (00000038)
                        TotalFrames   : 1270
                        Streams       : 2
                        InitialFrames: 8
                        MaxBytes      : 307200
                        BufferSize    : 30720
                        uSecPerFrame  : 100000
                        Rate          : 10.000 fps
                        Size          : (320, 240)
                        Flags         : 0x00000710
                            AVIF_HASINDEX
                            AVIF_ISINTERLEAVED
                            AVIF_VARIABLESIZEREC
                            AVIF_NOPADDING
00000058        LIST (00000074) 'strl'
00000064            strh (00000038)
                        Stream Type   : vids
                        Stream Handler: cvid
                        Samp/Sec      : 10.000
                        Priority      : 0
                        InitialFrames : 0
                        Start         : 0
                        Length        : 1270
                        Length (sec)  : 127.0
                        Flags         : 0x00000000
                        BufferSize    : 14654
```

Chapter 16 Movie File Formats

```
                               Quality         : 7500
                               SampleSize      : 0
    000000A4              strf (00000028)
                               Size            : (320, 240)
                               Bit Depth       : 24
                               Colors used     : 0
                               Compression     : cvid
    000000D4    .     LIST (0000005C) 'strl'
    000000E0              strh (00000038)
                               Stream Type     : auds
                               Stream Handler  : <default>
                               Samp/Sec        : 11025.000
                               Priority        : 0
                               InitialFrames   : 8
                               Start           : 0
                               Length          : 1399470
                               Length (sec)    : 126.9
                               Flags           : 0x00000000
                               BufferSize      : 1103
                               Quality         : 7500
                               SampleSize      : 1
    00000120              strf (00000010)
                               wFormatTag      : WAVE_FORMAT_PCM
                               nChannels       : 1
                               nSamplesPerSec  : 11025
                               nAvgBytesPerSec : 11025
                               nBlockAlign     : 1
                               nBitsPerSample  : 8
    00000138              vedt (00000008)
    000007E8         LIST (00E4E7F6) 'movi'
    000007F4              LIST (0000045C) 'rec '
    00000800                  01wb (0000044F)
    00000C58              LIST (0000045A) 'rec '
    00000C64                  01wb (0000044E)
    000010BA              LIST (0000045C) 'rec '
    000010C6                  01wb (0000044F)
    0000151E              LIST (0000045A) 'rec '
    0000152A                  01wb (0000044E)
    00001980              LIST (0000045C) 'rec '
    0000198C                  01wb (0000044F)
    00001DE4              LIST (0000045A) 'rec '
    00001DF0                  01wb (0000044E)
    00002246              LIST (0000045C) 'rec '
    00002252                  01wb (0000044F)
    000026AA              LIST (0000045A) 'rec '
    000026B6                  01wb (0000044E)
    00002B0C              LIST (00003A7E) 'rec '
    00002B18                  00dc (0000361A)
    0000613A                  01wb (0000044F)
    00006592              LIST (000034A8) 'rec '
    0000659E                  00dc (00003045)
    000095EC                  01wb (0000044E)
    00009A42                  ...
```

```
00E4E9CA           LIST (00000614) 'rec '
00E4E9D6                00dc (00000608)
00E4EFE6           idx1 (0000EEA0)
00E5DE8E
```

Table 16.2 shows a schematic of the required chunks and lists of chunks in an AVI file. We'll discuss the highlights of the important chunks shortly (but defer details to Microsoft's documentation). Unlike QuickTime atoms, the *ordering* of AVI chunks is important.

The **hdrl** list must come first in the AVI file. Its function is analogous to that of the QuickTime **moov** atom. The **avih** chunk

Table 16.2 The AVI File Structure	
Chunk	**Purpose**
RIFF AVI	File header
LIST hdrl	Defines structure of data in the movi list
avih	Defines basic movie format
LIST strl	One strl list per stream (that is, video or sound data)
strh	Defines stream format
strf	
LIST strl	
strh	
strf	
...	
junk	Optionally provides padding (otherwise ignored)
LIST movi	Contains actual movie data
LIST rec	Groups video and sound data for efficiency
##wb	Sound data
##dc	Video data
LIST rec	
##wb	
##dc	
...	
idx1	An optional index into movi list

defines the overall characteristics of the movie, principally the number of *streams* (more conventionally known as tracks) the movie contains and the frame rate and size of the video. There are three problems with this scheme:

- There is a bias toward video. It is conceptually impossible for an AVI file *not* to have a video track (like a QuickTime sound-only movie).
- All video tracks must have frames of identical size.
- AVI movies are bound to the old analog concept of a fixed frame rate.

As we noted earlier, digital video engines are free to display frames for as long or as short a period of time as they like. Let's take a look at exactly why this is important, because the reasoning is not immediately obvious. After all, digital video is always *captured* at a fixed frame rate.

Recall that CD-ROM transfer speed is currently a tremendous limiting factor on a movie's playback rate, regardless of the rate at which the movie was recorded and the speed of the decompressor. For example, a double-speed CD-ROM drive can sustain a transfer rate of about 150 kbs. Simple arithmetic shows that if each frame is 10K, a maximum 15-fps frame rate can be expected.

To compensate for this condition, some sophisticated post-production software has been written to limit the data rate of digital video movies. Apple's MovieShop for QuickTime does a decent job all the way down to 90 kbs (for single-speed CD-ROM playback). At the risk of oversimplifying, one technique it may use is to combine similar frames. All it has to do to preserve sound synchronization is to adjust the length of time the frame is displayed in the stts atom. This technique cannot be used for AVI movies.

The hdrl List

The **hdrl** list contains one **strl** list for each track. Currently, VfW requires exactly one video track, and at most one sound track. The ordering of the **hdrl** lists is unimportant. But, for reasons that will become apparent when we look at the **movi** list, the

first list is denoted as stream 00, the second as stream 01, and so on. The **strh** and **strf** elements further define the characteristics of each track (such as the sampling rate and size for sound).

Video and sound tracks are not synchronized to a common time base. Instead, video is expected to be played at its frame rate and sound at its sampling rate, with some element of faith that they will match up. This simple scheme does not allow, for example, effects such as discontinuous sound without artificially inserting periods of silence (and increasing the data rate).

The movi List

The **movi** list follows the **hdrl** list, and contains the actual movie data. It is analogous to the QuickTime **mdat** atom. Often, the **movi** list is preceded by a junk chunk so that the first data chunk is aligned on a 2K boundary, improving playback performance from CD-ROM. These chunks are used only for alignment and have no other semantics.

Data in the **movi** list can be structured in one of two ways: either in chunks or in lists of chunks. Sound data is stored in **##wb** chunks and video data in **##dc** chunks, where **##** represents the corresponding stream number. VfW prefers that sound and video chunks be paired, with the video chunk holding a frame and the corresponding sound chunk holding a frame's worth of sound.

For efficiency, these sound-video chunk pairs can themselves be grouped inside a **rec** list. The playback engine will read the entire contents of a **rec** list at once. Frequently the list will end with a junk chunk so that its length is a multiple of 2K.

The idx1 Chunk

Although it is technically optional, almost all AVI movies end with an index (**idx1**) chunk. Each entry in the index points to a chunk or **rec** list in the **movi** list. Figure 16.6 shows their format.

If the index is present (as denoted by flags in the **avih** chunk), you are expected to use it to parse the data in the **movi** list. The ordering of index entries defines the order in which video and

Figure 16.6
AVI Index Entry Format

Ident	Flags	Offset	Length
0	4	8	12

sound chunks must be played. One trick about using the index is worth noting: It normally records chunk offsets relative to the start of the **movi** list.

However, Microsoft reportedly changed its mind during the V fW beta period, and some early encodings record chunk offsets relative to the beginning of the file. To determine which is being used, try reading the first index entry. If its chunk offset is large (greater than 2K), you can assume the old encoding. If it is small, assume the new.

Sound Encoding Formats

Both QuickTime and AVI store sound in similar ways. Table 16.3 summarizes the encoding techniques used by each.

When sound is digitized, analog signals are converted to numbers. The size of those numbers is referred to as the *sample size*, the rate at which the analog signal is sampled is called the *sample rate*. In general, the larger the sample size and sample rate, the better the quality of the digitization. As a point of reference, CD-DA (standard audio CDs) is the equivalent of 16-bit, 44.1kHz sound.

Table 16.3. Encoding Techniques used by QuickTime and AVI

	QuickTime	AVI
Sample Size	8-bit, 16-bit	8-bit, 16-bit
Sample Rate	Continuum of rates, normally between 11.0kHz and 44.1kHz	Normally the discrete MPC rates of 11.025kHz, 22.05kHz and 44.1kHz
Channels	Mono and stereo	Mono and stereo
Interleave	Half-second chunks, sound leading	Frame-by-frame, sound skewed ahead by 0.75 second

For sample sizes of 8 bits, each sample represents one of possibly 256 different values. For 16-bit samples, 65,536 discrete values can be represented. You might visualize the difference in quality to be analogous to that more easily perceived between 8-bit color and 16-bit color. Each sample represents the deviation of a waveform from a midpoint.

Two conventions exist for the midpoint. In AVI, 8-bit samples use 0x80 as the midpoint (so-called *raw* format), and 16-bit samples use conventional signed numbers with 0x0000 as the midpoint (so-called *two's complement* format). QuickTime can use either format with either sample size. Figure 16.7 shows these two formats more clearly.

To complicate matters a little, Microsoft does not actually use the jargon *raw* and *two's complement*. Instead, it uses the acronym PCM to refer to its 8-bit and 16-bit encodings. To convert between the two formats, a programmer can simply XOR each sample with 0x80 or 0x8000 as appropriate.

QuickTime stores 16-bit sound samples in Motorola order, while AVI uses Intel order. Consequently, 16-bit sound samples must be flipped when converting from AVI to QuickTime and vice versa. Byte ordering is moot for 8-bit samples.

Figure 16.7
Raw and *Two's Complement* Sound Compared

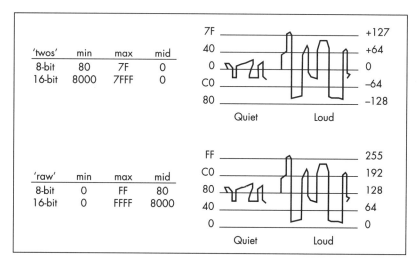

Most PC sound cards can only digitize and playback at the three standard MPC rates: 11.025kHz, 22.05kHz, and 44.1kHz. When QuickTime movies are captured on the Mac, their sample rates can appear as weird numbers like 11.12754kHz. Both QuickTime and AVI share the same convention for stereo sound in that the left channel sample appears before the right channel sample in the stream.

The interplay of sample size, rate, and number of channels has a great effect on the ability of the QuickTime or AVI engine to play back a movie. For example, CD-DA quality sound (16-bit, 44.1kHz, stereo) requires a *sustained* data transfer rate of 176.4kbs. Single-speed CD-ROM drives are capable of a *peak* rate of 150kbs, which clearly doesn't leave a lot of room for video.

For this reason, most digital video movies you'll see today use 8-bit, 11.025kHz mono sound (which doesn't sound too bad through most tinny PC speakers). This situation is unlikely to improve much until we see a quantum leap in hardware performance. You might remember that we recommend 22.05kHz audio for movies containing music.

Interleaved Audio and Video

Interleave is a primary characteristic of digital video files, so much so that the AVI file format is named after the concept. However, interleave is mainly a factor for slow playback devices such as CD-ROM. The trick that both the QuickTime and AVI engines have had to master is to stream enough data from the CD-ROM to keep themselves busy. It is a delicate balance of RAM buffer sizes, transfer rates, seek times, and playback rates.

Note that *streaming* is actually quite the opposite of the more conventional *caching*. A cache (like SMARTDrive) attempts to improve performance by anticipating that data, once read, will be read again. Streaming assumes that data will be read once, from beginning to end, and attempts to steadily supply that data at the same rate it is consumed.

Although QuickTime and AVI acknowledge the same concept, their engines have different requirements for interleave.

QuickTime prefers sound and video in half-second chunks, with sound leading. AVI prefers sound and video interleaved on a frame-by-frame basis. That is, each video frame is physically followed by a frame's worth of sound. When an AVI file is converted to QuickTime, or vice versa, the interleave factor should be adjusted to these preferred values. If it is not, playback performance from CD-ROM can be expected to be poor.

How to Read and Write AVI Movie Files

If you are a programmer, you might be interested in the following code listing showing how to parse a basic AVI movie file. For clarity, error checking has been omitted.

The Windows multimedia I/O calls (**mmioOpen**, **mmioClose**, **mmioRead**, **mmioWrite**, **mmioSeek**, **mmioDescend**, and **mmioAscend**) are designed to process RIFF files. In particular, **mmioDescend** and **mmioAscend** allow chunks and lists of chunks to be processed quite conveniently. By comparison, QuickTime provides no such assistance, and dealing with AVI files is considerably simpler.

```
void ParseAVIMovie (char *szFileName) {

    MMCKINFO ckAVI, ckAVIH, ckHDRL, ckSTRL, ckSTRH, ckSTRF,
       ckIDX1, ckMOVI;
    MainAVIHeader avihdr;
    AVIStreamHeader strhdr;
    AVIINDEXENTRY avindx;
    HMMIO hmmio;
    long lStream;

    // Open file
    hmmio = mmioOpen (szFileName, NULL, MMIO_READ);

    // Read the AVI header
    mmioSeek (hmmio, 0, SEEK_SET);
    ckAVI.ckid = ckidRIFF;
    ckAVI.fccType = formtypeAVI;
    mmioDescend (hmmio, &ckAVI, 0, MMIO_FINDRIFF);
    ckHDRL.ckid = ckidLIST;
    ckHDRL.fccType = listtypeAVIHEADER;
    mmioDescend (hmmio, &ckHDRL, &ckAVI, MMIO_FINDLIST);
```

```
ckAVIH.ckid = ckidAVIMAINHDR;
mmioDescend (hmmio, &ckAVIH, &ckHDRL, MMIO_FINDCHUNK);
mmioRead (hmmio, (HPSTR) &avihdr, sizeof(MainAVIHeader));

// Read each stream header
for (lStream = 0; lStream < (long) avihdr.dwStreams;
     lStream++) {
   ckSTRL.ckid = ckidLIST;
   ckSTRL.fccType = listtypeSTREAMHEADER;
   mmioDescend (hmmio, &ckSTRL, &ckHDRL, MMIO_FINDLIST);
   ckSTRH.ckid = ckidSTREAMHEADER;
   mmioDescend (hmmio, &ckSTRH, &ckSTRL, MMIO_FINDCHUNK);
   mmioRead (hmmio, (HPSTR) &strhdr,
      sizeof(AVIStreamHeader));
   mmioAscend (hmmio, &ckSTRH, 0);

   // Is it video?
   if (strhdr.fccType == streamtypeVIDEO) {
      /* your code */
   }

   // Or is it sound?
   else if (strhdr.fccType == streamtypeAUDIO) {
      /* your code */
   }

   // Loop until all streams processed
   mmioAscend (hmmio, &ckSTRL, 0);
}

// Done reading headers
mmioAscend (hmmio, &ckHDRL, 0);
mmioAscend (hmmio, &ckAVI, 0);

// Locate movi data
mmioSeek (hmmio, 0, SEEK_SET);
ckAVI.ckid = ckidRIFF;
ckAVI.fccType = formtypeAVI;
mmioDescend (hmmio, &ckAVI, 0, MMIO_FINDRIFF);
ckMOVI.ckid = ckidLIST;
ckMOVI.fccType = listtypeAVIMOVIE;
mmioDescend (hmmio, &ckMOVI, &ckAVI, MMIO_FINDLIST);
   /* your code */
mmioAscend (hmmio, &ckMOVI, 0);
mmioAscend (hmmio, &ckAVI, 0);

// Locate index
mmioSeek (hmmio, 0, SEEK_SET);
ckAVI.ckid = ckidRIFF;
ckAVI.fccType = formtypeAVI;
mmioDescend (hmmio, &ckAVI, 0, MMIO_FINDRIFF);
ckIDX1.ckid = ckidAVINEWINDEX;
mmioDescend (hmmio, &ckIDX1, &ckAVI, MMIO_FINDCHUNK);
```

```
        /* your code */
    mmioAscend (hmmio, &ckIDX1, 0);
    mmioAscend (hmmio, &ckAVI, 0);

    // Close file
    mmioClose (hmmio);
}
```

The basic methodology used in the listing is:

1. Seek to an offset of 2K into the file.
2. Write out all the movie data (video frames and sound chunks) in the desired order.
3. At the same time, accumulate in internal tables the information you'll need to build the **hdrl** list.
4. Seek back to the beginning of the file and create a RIFF chunk and the required chunks in the **hdrl** list.
5. Create a junk chunk to pad the end of the **hdrl** list to the beginning of the **movi** list.
6. Create a **movi** list chunk.
7. Seek to the end of the file and create an index chunk.

Which File Format Is Better?

We are often asked by content developers whether they should develop for QuickTime or VfW. It is not an easy question to answer. As far as production is concerned, the Intel Smart Video Recorder (ISVR) card can capture QuickTime and AVI movies with equal ease, and products like Adobe's Premiere bring first-rate editing capabilities to both.

On the Mac, where VfW is, of course, not even a player, there exists a vast pool of equipment, software, and (most importantly) production talent, all dedicated to QuickTime. That being said, Apple is fast losing ground to Microsoft by daring to play in its sandbox. The decision to do so was a bold one, but unless Apple exhibits a much stronger commitment to QuickTime for Windows, it will ultimately be overwhelmed.

Note: This chapter appeared in a slightly different form in an article entitled *Digital Video File Formats* by Mark Florence, in *Dr. Dobbs' Sourcebook of Multimedia Programming, Winter 1994.*

Movie Compressor Types

TO MASTER THE ART OF CREATING DESKTOP VIDEO, YOU'LL NEED TO KNOW ABOUT THE KEY MOVIE COMPRESSOR TYPES.

As you have seen, it is hard to talk about desktop video (or digital video in general) without talking about compression. A careful reading of Chapter 16 takes this idea a step further: What actually gets compressed are not whole movies *per se*, but the frames that comprise them.

If you read the magazines devoted to desktop video and multimedia, you may notice what great copy this stuff makes. Unfortunately, much of what is currently being published in the industry periodicals on this subject is misleading. In some cases, it is flat out inaccurate.

There seems to be an arms race to create the most powerful compressors. To maintain a level playing field, we will limit our discussion as much as possible to available, installable codecs for Macs and Windows machines. Although powerful new products are in development (and near fruition), we would rather err on the side of conservatism as far as this subject is concerned.

Chapter 17 Movie Compressor Types

In this chapter, we'll cover:

- Audio Compression
- The Mac QuickTime codecs
- The Video for Windows codecs
- The QuickTime for Windows decompressors
- Emerging compressors and decompressors
- How decompressors are selected at playback time

Audio Compression

If you are wondering where movie audio compression fits into this realm, the short answer is that it is just now coming into the spotlight, at least on the Windows platform. This is not to say audio compression *techniques* don't exist. They do, and the field is large and complex. It's just that desktop audio compression has not been pursued with the same level of publicity accorded to desktop video compression.

For Windows developers, Video for Windows 1.1 (VfW) includes API-level support for a component called the ACM (Audio Compression Manager). Essentially, ACM is a Windows multimedia extension that remaps function calls to installed hardware devices. This allows audio data being passed to or from those devices to be processed in certain ways, including filtering, format conversion, and, most importantly, compression.

Because ACM is being implemented at the developer level, it will be generally transparent to the user. At some point in the near future, however, you should probably expect to see program menus allowing you to specify certain types of audio compression along with sample size, sample rate, and mono versus stereo.

On the Mac, audio codecs are available to the user in the form of MACE (Macintosh Audio Compression and Expansion) compression. You can see this in the MovieRecorder application, for example, when you go to the *Sound Settings* dialog. If you click the *Compressor* control, you can select from among two MACE options or None.

Recording a movie with one of the MACE audio codecs will compress your sound, but playback will suffer accordingly—just like with video. Plus, audio compression is especially cruel to sound with a lot of high frequencies. Unless you have a compelling reason to do the opposite, we suggest you stick with uncompressed sound.

The QuickTime Codecs

The original QuickTime codecs were Raw, Animation, Graphics, JPEG, and Apple Video (affectionately known as Road Pizza). CinePak came later. Unlike the standalone codecs on the Windows side, the core Macintosh codecs are folded into the QuickTime init. By design, when new codecs are created by third-party developers, they can be placed as standalone files in a Mac's system folder for recognition and use by QuickTime. This concept is illustrated in Figure 17.1.

As of this writing, the most recent release of QuickTime is version 1.6.1. Its roster of codecs still embraces those mentioned above, but now includes the mighty CinePak (formerly known as Compact Video). CinePak is a powerful video compressor that is also implemented under VfW—a boon for cross-platform developers. Further details on CinePak are provided in the capsule codec descriptions in the remainder of this section.

Figure 17.1 Core QuickTime Codecs vs. Third-Party Codecs

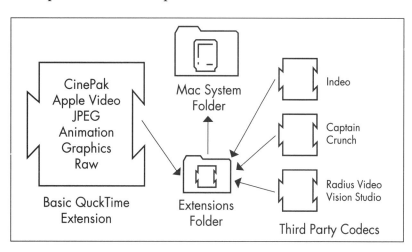

Some examples of third-party compressors are the ones that come with the Holy Trinity of Mac capture boards (Digital Film, Video Vision, and Editing Aces). True to QuickTime's extensible design, these third-party codecs are selectable at capture time (assuming you have the appropriate capture card installed to utilize the codec selected), and are available as targets when you want to convert from one codec to another with a program such as MovieConverter.

In the list that follows, we provide brief overviews of the existing QuickTime codecs. Although you will probably end up using CinePak for most—if not all—of your finished desktop video productions, Road Pizza is often an appropriate choice for test captures and quick and dirty interim versions of working movies (like when using Adobe Premiere).

To get a gut sense of how the other compressors actually behave, we highly recommend experimenting with them on different kinds of content. Once you establish routines for producing good looking clips, you might be less inclined to play around with alternatives, forgetting that the other codecs do have their merits at times.

Raw

Raw is not a codec per se, but is a selectable movie encoding format nevertheless (it shows up as the *None* option when you select a codec using, for example, MovieRecorder). No significant compression is applied to captured frames when digitizing with this option. Images of all pixel depths are supported under the Raw encoder.

Animation (RLE)

As the name suggests, the Apple Animation codec was created to compress and play back animation clips. You can experiment with it using real video, but your results will usually be disappointing since the algorithm employs RLE (Run Length Encoding), which is not well suited for the frequent color transitions in video frames. What the Apple Animation codec does best is lossless compression and decompression of sequences of drawn or rendered still images.

Roughly speaking, here's how it works, depending on the color depth (all color depths are supported under the Apple Animation codec): Starting in the upper-left corner of the movie frame, a pixel's color value is sampled and held. If the pixel to its right is the same, a counter is incremented. This process continues to the end of the scan line.

If any pixel in the scan line is different from the one being held, the new pixel is held as the basis of comparison. When that happens, the value of the counter is stored and associated with the color value of the pixel just released. When the end of the current scan line is reached, the operation starts over with the next scan line.

When frames are decompressed, pixels with identical color values are repeated left to right within scan lines depending on the numbers in their associated counters. Again, this is a generic RLE example and does not take into account such implementation-specific issues as frame header format, line skipping, and so forth. The Animation codec supports frame differencing.

Graphics (SMC)

Similar to the Animation compressor (in that it was developed principally for use with Macintosh 8-bit graphics), the Graphics codec is a lossless compressor that generally outperforms RLE in both speed and compression ratios. The reason this codec is sometimes referred to as SMC is because of its developer, Sean M. Callahan, who holds the patent on it.

Unlike RLE-based Animation, Graphics operates on blocks of pixels in a frame. Working from a fixed set of block types, each 4 x 4 pixel block is tagged with a particular type. If the block contains a color pattern of between two and eight colors, the frame's data stream will contain a pointer to a table uniquely describing those colors.

The number of unique colors in a block is the chief factor in dictating how that block gets compressed. In general, an image with fewer repetitions of identical pixels in its scan lines will produce a better compression ratio (will be smaller) than an image compressed with the RLE codec.

As we noted earlier, for all but certain extreme cases, SMC will do better animation and graphics compression than RLE. (The reason RLE is included with QuickTime is that it has deep historical roots in the data compression field.) If you look at SMC as the thinking person's RLE, it is clear that Sean Callahan has done a lot of thinking. Like Animation, this codec supports frame differencing.

JPEG

The JPEG (Joint Photographic Experts Group) compressor is a bit more complex. It is based on the ANSI standard for JPEG compression (ANSI Document 10918-1), but implements only a subset of that standard, as do most other PC and Mac-based implementations. (Very few of the other implementations offer more options than Apple's.) Of all the Apple codecs, it is the only one that does not support frame differencing. Also, it is hardwired for 24-bit color.

In theory, JPEG is a fabulous compressor—especially for the still images it was designed to work with. As a software-only video codec, it is a poor performer during playback. When given hardware assistance, however, JPEG switches back to overachiever mode. In fact, it is the algorithm used in some of the high-end, hardware-assisted capture cards that can digitize and play back at full motion, full screen.

Like most of the other QuickTime codecs, the JPEG compressor works with pixel blocks, but in this case the blocks are bigger. These larger blocks are effectively run through a compression wringer that employs Huffman encoding, DCT (Discrete Cosine Transformation), and YUV color space transformation.

While the Radius Video Vision Studio, SuperMac Digital Film, and RasterOps Editing Aces cards all use JPEG compression to achieve high performance, only Digital Film's implementation is currently 100-percent compatible with QuickTime's native JPEG codec. In general, JPEG is a lossy compressor, but can be used in lossless mode also. Under QuickTime, it is implemented as lossy.

Apple Video (Road Pizza)

The original QuickTime compressor, Apple Video is a *symmetrical* codec developed specifically by Apple to handle video. Symmetrical means it can capture and play back in real time, and takes about as long to compress an image as it does for decompression. For movie frame sizes of 160-by-120 and under, Apple Video delivers acceptable playback performance. For anything larger, you will have to use the CinePak compressor (discussed next) to get acceptable frame rates.

Apple Video is decidedly lossy, and supports frame differencing. The compressor operates on 4 x 4 pixel blocks positioned in the RGB color space, which it tries to average down in several steps to achieve compression, sort of like the way a truck tire averages down the colors of a skunk. As a symmetric codec, it still has an important role to play in the QuickTime pantheon—despite being overshadowed at times by CinePak.

CinePak

Originally named Compact Video, CinePak is the compressor that rules the QuickTime movie world (for now). Licensed to Apple Computer by SuperMac, the CinePak codec was specifically created to compress movies for fast software decompression and playback off of CD-ROM at 320-by240 pixels in 24-bit color.

CinePak does its work on 4 x 4 pixel blocks in the YUV color space and supports frame differencing. It achieves its power by making all of its color mapping decisions in advance, using lookup tables for possible playback environments. This way, very little computational overhead is incurred making decisions at playback time, and movies are able to chug right along.

The consequence is that CinePak is highly asymmetric—that is, it can take several hours to compress only a few minutes of video (and that's on a Quadra!). However, CinePak does its job so well that no one has been able to improve on it. Chances are it will be your compressor of choice the more movies you make.

The Video for Windows Codecs

While efficient compression and decompression are every bit as important to VfW as they are to QuickTime, the individual codecs are handled differently. For one thing, they are all implemented as standalone Windows driver files (for example, MSRLE.DRV), as opposed to being embedded in a larger system-level file like the QuickTime init on the Macintosh. Driver files are actually DLLs (dynamic link libraries), which have the .DRV extension.

Different again are the QuickTime for Windows (QTW) decompressors, which are implemented as traditional DLLs, although they carry the extension .QTC (QuickTime Component) and are handled by the QTW component manager. We will cover these differences in greater detail at the end of this chapter.

When VfW 1.0 was released, it only shipped with three compressors: RLE, Video 1, and Indeo Video. Like the Raw encoder in QuickTime, a noncompressing encoder called YUV9 was also included for full-frame digitization. CinePak came later and was somewhat difficult to get hold of, although it can easily be added to your environment via the Windows Control Panel.

CinePak now ships with VfW. It is installed for you when you run the setup program, along with the RLE, Video 1, and Indeo Video codecs. As noted in Chapter 8, Indeo Video also ships with Intel's Smart Video Recorder capture card, and Video 1 is now implemented in hardware on Media Vision's Pro MovieStudio board.

The current arm wrestling match for the best Windows video codec is between Indeo Video and CinePak. Each has its advantages: Indeo Video is symmetric (real time capture and playback, like Apple Video) while CinePak is asymmetric but recognized as the current best way to go cross-platform). Our feeling is that CinePak is superior in playback performance, as it was designed to be. Figure 17.2 plots the theoretical performance levels of some Windows-based codecs.

Figure 17.2
Rating Windows Codec Performance

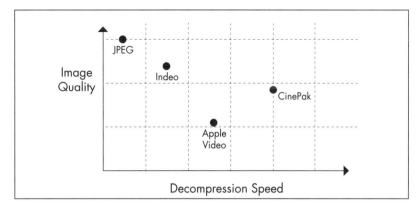

What complicates performance for video under Windows is, of course, GDI (Graphics Device Interface)—the great equalizer of graphical display on the Windows desktop. While GDI allows for the virtualization of all display devices (monitors, basically), it was not designed with video in mind. But, like any well-behaved Windows software, the VfW drivers that display movie frames must do so through GDI.

One of the advantages of QTW is that it bypasses GDI completely, instead writing directly to the video hardware—if it can identify the hardware. If QTW can't identify the video card, specifically the card's chip set, it writes to the Windows driver for the card. In Chapter 7, we provided a table of the specifically supported chip sets under QTW as of this writing.

To date, it is generally agreed that movie performance under QTW is superior to performance under VfW, especially on less powerful machines. With its new VDI (Video Device Interface) software, Intel is achieving in VfW the same levels of performance found in QTW. Like the Apple product, VDI effectively bypasses GDI (but does cooperate with it) and writes pixels directly to the video controller's frame buffer.

Is Microsoft happy about this? Not really. Although they acknowledge that it is kosher to improve software-only movie playback in this manner, they have stated (again, as of this writing) that they consider the implementation premature. May the best software monolith win.

Indeo Video

As noted earlier, Intel's Indeo Video is a symmetric codec specifically engineered to utilize the i750 chip for both capture and playback, depending on how the chip is implemented. One current implementation of the i750 is in the Intel Smart Video Recorder, which uses it for capture only.

When used without hardware assistance on Intel-based PCs, Indeo Video competes directly with CinePak for top honors in performance—provided the competing movies are both in the AVI format. A CinePak QuickTime for Windows movie will, by design, outperform an otherwise identical Indeo Video AVI movie.

A lossy compressor supporting frame differencing, Indeo Video now includes a *super compressor* option that greatly improves image quality at lower data transfer rates, but does so asymmetrically. In other words, you have to capture, recompress under VidEdit, and wait for a while—depending on the length of your movie. Sort of like CinePak.

The compressor itself operates in YUV color space, works on 4 x 4 pixel blocks, and utilizes a variety of compression techniques. Although Indeo Video captures in 24-bit color, it will dither noticeably when playing back on 8-bit systems. By engaging the i750 chip, Indeo Video currently captures at 15 fps with a 320-by-240 movie window.

Microsoft Video 1

As the saying goes, Microsoft makes money the old fashioned way: It acquires third-party software (and shuns royalty agreements). Video 1 was such an acquisition, originally developed by Media Vision. A compressor for 8-, 16-, and 24-bit video sequences, you can use the hardware-assisted version of it if you get Media Vision's Pro MovieStudio capture card. An early advantage of Video 1 was that it was distributed with VfW 1.0, while CinePak and the then-latest version of Indeo Video were not. Since all three are now distributed with VfW, this advantage has been lost.

Microsoft RLE

Similar to the Apple Animation (RLE) codec, Microsoft's RLE compressor also works on individual pixels in scan lines as opposed to pixel blocks. Unlike the Apple RLE codec, it only supports 4-bit and 8-bit color depths. If you are going to be doing animation under VfW, this compressor will serve you well.

CinePak

Recently ported to the Windows world, the CinePak compressor works just like its counterpart on the Mac. In fact, the data stream is exactly the same for a QuickTime CinePak movie as it is for an AVI CinePak movie. Compression can still take hours, but the performance and resulting file size justify it.

It is worth mentioning here that the data stream congruence noted above uncorks one of the bottlenecks to cross-platform movie playback. Simply put, since the movie data is the same in a given CinePak clip regardless of its original platform (Mac or Windows), if we could convert the file type, the movie should play on the opposite platform.

In fact, it will. There just aren't too many applications that can do the conversion. One of them, TRMOOV.EXE, is available on this book's companion CD-ROM. Load up, say, an AVI movie compressed with CinePak, specify a new name for it, and TRMOOV.EXE will convert it to a QTW movie in the CinePak format while you wait. You can play the resultant movie either on your Windows desktop (if you have QTW 1.1 installed) or on a Macintosh if you have QuickTime 1.5 or greater. Figure 17.3 shows TRMOOV's user interface.

JPEG

In May 1993, Microsoft announced a standard DIB (Device Independent Bitmap) extension format for storing JPEG-encoded still images and JPEG-encoded motion images. Based on the ISO 10918 specification, these two formats are extensions to the standard DIB format defined by Microsoft. As of this writing, no JPEG codec is shipping with VfW.

Chapter 17 Movie Compressor Types

Figure 17.3
The User Interface for TRMOOV.EXE

The QuickTime for Windows Decompressors

Because it is strictly a playback technology, QTW only comes with decompressors. With version 1.1, the decompressors are completely in step with QuickTime 1.6.1 compressors on the Mac, except that the QTW Compact Video decompressor has not yet changed its name to CinePak. Apple has stated that they intend to keep the codecs in synch.

Other Codecs

You may have heard about some of the other codecs and types of codecs being developed. One frequently discussed contender is Media Vision's Captain Crunch, which reportedly does 15 fps at 320-by-240. Also getting some press is the new MPEG standard, which many feel will be the vehicle for getting digital video to the masses.

Beyond specific products and standards are the algorithms and mathematical approaches to compression/decompression. Magazine articles often mention exotic technologies such as fractals, wavelets, and motion prediction. These *are* some of the development areas poised to deliver bold new compressors and decompressors. How soon they will be packaged up as

installable codecs for Macs and Windows machines is unclear as of this writing.

Decompressor Selection at Playback Time

Clearly, a great strength of both QuickTime and VfW is their open architecture for compressors and decompressors. Without this flexibility, the new codecs that are being developed (those using wavelet and fractal compression techniques) could not be easily integrated into the QuickTime and VfW environments.

We believe it is absolutely essential for both QuickTime and VfW to continue accommodating such growth without changing their file formats or architecture. So far, they have followed through on this necessity, and we are starting to see some powerful new codecs from Apple, Microsoft, and third-party developers.

QuickTime Decompressors

QuickTime decompressors are structured as *components*. Components are a Mac concept, ported to the PC in QuickTime for Windows. A component is a special kind of DLL (in Windows, they normally use the .QTC extension) that negotiates its capabilities with its callers through a predefined set of entry points.

A single .QTC file, which Windows views as a DLL, can contain multiple components, each of which can have a wide range of capabilities. A detailed discussion of components is beyond the scope of this book, but you can find full details on this and related subjects in Apple's QuickTime documentation.

As you may recall from Chapter 16, the **stsd** atom describes how a track's video is compressed. It does this by encoding the four-character identifier of the compressor. The assignment of these identifiers is regulated by Apple to ensure that they remain unique across all third-party developers. For example, **cvid** is assigned to SuperMac's CinePak codec.

When QTW starts to play a video track, it negotiates with all the decompressor components it can find, using the standard Windows **LoadLibrary** search strategy. Each decompressor is asked if it can handle the identified encoding. But it also has the opportunity to check if a preferred environment (for example, special hardware) is present.

In any event, the decompressor will report whether or not it can perform the decompression. If the answer is yes, it will ask how fast. The answer is measured as the number of milliseconds necessary to decode a 320-by-240 frame (on that particular computer, of course). QuickTime then uses the fastest decompressor from among all the possible candidates.

Even when a movie is playing, QuickTime can switch decompressors. For example, if the video frame becomes clipped by another window, QuickTime will repeat the decompressor selection process. It does this because a decompressor that uses hardware assistance may wish to defer to a software-only decompressor for non-rectangular frames.

This elegant scheme is simple and effective, although it does place a burden on the decompressor writer to develop the correct negotiation logic. It also has the advantage that decompressors can be installed on a user's system without any changes to the Windows SYSTEM.INI file.

For example, content providers can deliver a CD of movies and a proprietary QuickTime decompressor without fear of a conflict with the existing environment or special installation requirements. Further, multiple decompressors for the same encoding can be present and QuickTime will automatically choose the most appropriate.

Video for Windows Decompressors

As noted earlier, VfW decompressors are drivers (DLLs with a .DRV extension) written to the specification documented by Microsoft in their Vf W Development Kit Programmer's Guide.

Decompressor Selection at Playback Time

In a manner similar to QuickTime, the AVI file format encodes the four-character identifier of the compressor in the video stream header, **strh**.

Like Apple does for QuickTime, the assignment of these identifiers is regulated by Microsoft to ensure uniqueness, although we can be sure that the level of coordination between Apple and Microsoft themselves is fairly low. Fortunately, where an encoding is supported in both systems, its identifier is constant. For example, Microsoft has also assigned **cvid** to SuperMac's CinePak codec.

Before it plays a video stream, VfW simply takes the encoder identifier, prefixes it with **VIDC.**, and uses it to look up the name of the codec in the [drivers] section of SYSTEM.INI. For example, your [drivers] section might look like this:

```
[drivers]
VIDC.MSVC=msvidc.drv
VIDC.YVU9=isvy.drv
VIDC.IV31=indeor3.drv
VIDC.RT21=indeo.drv
VIDC.CVID=iccvid.drv
VIDC.MRLE=msrle.drv
```

The scheme is simple and effective, but it does have disadvantages compared to QuickTime. An installation procedure of some kind is required, and multiple decompressors for the same encoding cannot co-exist. This means that a new version of a decompressor cannot specialize the capabilities of existing versions—it must totally replace them.

Imagine, for example, that Intel wants to develop a new version of the Indeo Video decompressor optimized especially for the XYZ video chip set. Under QuickTime, it need only perform this one task and can defer to other decompressors if the XYZ chip is not present. However, under VfW, it must assume all the functionality of prior versions.

The Mechanics of Movie Playback

UNDERSTANDING THE MECHANICS OF MOVIE PLAY WILL HELP YOU TO PERFECT YOUR CAPTURE SKILLS.

In the three previous chapters, we looked at how movies are digitized, compressed, and organized into files on Macs and PCs. Using that knowledge, we'll now explore how movies are uncompressed and played back. Remember that overall movie performance will ultimately labor under the bottlenecks discussed in Chapter 2 and, in greater detail, Chapter 15.

As usual, we will examine this subject from the data processing perspective. Movie playback (as opposed to capture) is essentially an exercise in getting movie information off a hard disk, CD-ROM drive, or some other storage medium, and onto your screen. There are no analog video or audio matters for you to be concerned with during this process. Everything is digital in desktop video playback and, as such, much more quantifiable—which allows it to be manipulated in interesting ways.

Also, though we discussed specific compressors in Chapter 17, we have not yet covered one of the basic strategies that most of them use: *frame differencing* (where appropriate, we did note which codecs were *capable* of frame differencing). And, it is

Chapter 18 The Mechanics of Movie Playback

difficult to talk about frame differencing without mentioning *key frames*. We'll get into both of these terms shortly.

To help you conceptualize the playing of a movie as clearly as possible, we'll discuss each *layer* of the process individually, from the macro perspective of how codecs are used by applications to the micro viewpoint of how individual frames are handled. Understanding the mechanics of movie play at these different levels will help you, we hope, to perfect your capture skills.

In this chapter, you will learn:

- The composition of a movie data stream
- What key frames are
- What frame differencing is
- The function of data and media handlers
- How audio data is handled
- The importance of the compressor in movie playback

Composition of a Movie Data Stream

Let's begin with an image we hope is indelibly etched on your brain: a PC furiously reading data off a hard drive or CD-ROM and pumping pixels across its bus to a monitor. Clearly, we are dealing with a torrential data stream. But what, exactly, is it composed of? We know from earlier chapters that its main ingredients are video frames and sound chunks, and that the video data is likely to be compressed in some way. What we have not covered in much detail yet is how individual movie frames and audio chunks get from a storage medium to your screen and speakers.

Earlier, we used the idea of the film strip and movie projector. Down in the guts of QuickTime and VfW, however, this parallel only goes so far—especially when compression is added to the mix. A better analogy, at least for the video track, is that of a high speed assembly line with strict quality control and tough deadlines. If finished frames come off this assembly line on schedule, *then* they can be sent to the movie projector.

The Assembly Line Perspective

Here's a more detailed view of our analogy: Raw data arrives at the image factory to build video frames. It is used immediately and none of it goes to waste. But only *finished* video frames are allowed out the door (and onto the screen), and only if they can be built in the very brief time period allotted. Otherwise they are dropped in the trash. Audio data is routed to another department for similar handling (but is never dropped in the trash).

Sometimes a new frame will be partially cloned from its predecessor—therefore requiring less raw data from the stream and less time to build. In this case, the new frame is a *differenced* frame and the preceding image is the *key* frame (which might *itself* be a differenced frame). While this is only a rough analogy, it shows you the basic process. We've also illustrated it in Figure 18.1.

Figure 18.1 The Movie Frame Sweatshop

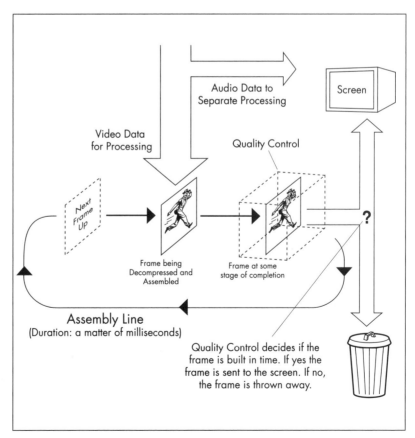

So, to answer the earlier question regarding the composition of a movie data stream, we can begin by listing three basic elements:

- Key frames
- Differenced frames
- Sound chunks

As we saw in Chapter 16, the mechanism that processes these elements is the decoder used by the program playing the movie. It will help here to visualize movie-playing software like QuickTime and VfW as well-oiled engines. When the QuickTime engine (for instance) opens a movie file, one of the first things it does is look for the best installed codec to handle that movie. When this is determined, the appropriate codec is loaded and pressed into service.

While the movie is playing, it is the responsibility of the engine to retrieve movie data from the storage medium. The engine does this by utilizing a series of data and media handlers, then passes the retrieved movie data to the decoder. We'll cover the details of that process later in this chapter. For now, let's remain focused on how individual frames are handled.

What Key Frames Are

A key frame has all of its data self-contained. It does not depend, nor is it based on, any other frame in the movie. If you capture video raw (with no compression), it will contain all key frames. Unfortunately, movies composed solely of key frames generally will not exhibit smooth performance under normal playback conditions.

Key frames may exist either compressed or uncompressed. If they are compressed, they are done so *spatially*, which is the same as *intra-frame* compression. At least one codec, the QuickTime implementation of JPEG, only handles key frames, and therefore only compresses them spatially. Key frames are what differenced frames (discussed next) are based on.

Earlier in this chapter, we introduced an assembly line analogy for discussing movie play at the frame level. Imagine now that

a movie running in our analogy is all key frames. Movie data is retrieved from a movie file, processed by the codec, and then sent to the movie window. If the movie dimensions are fairly small, say 120-by-90, there is a good chance that all the frames will make it off the production line. We will use this scenario, shown in Figure 18.2, as our most basic model of movie play.

Now let's suppose that the movie frame dimensions are 240-by-180 (at 15 fps). As we know, because of bandwidth restrictions, probably not all of the video data can be displayed in the movie's overall running time. The only recourse the engine has to stay on schedule while it plays the movie is to drop frames. In the assembly line analogy, these are the frames that can't be built on deadline and thus get thrown in the trash.

Under our evolving hierarchy, this is the next most complex model of how movies are played. Specifically, if a movie is composed entirely of key frames (complete images), but the frames are too big to all get played in the movie's allotted running time, some of them will be dropped. Depending on how many get dropped, movie performance can suffer greatly. To

Figure 18.2
A Movie Composed of All Key Frames, which All Get Played

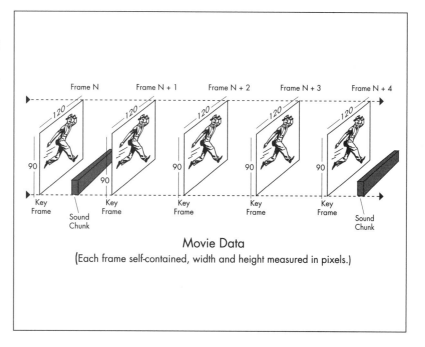

mitigate this problem, we need to graduate to the next model, which includes frame differencing.

What Frame Differencing Is

As noted, frame differencing is a generic compression strategy used by most of the QuickTime and VfW codecs. It is not a codec itself. The purpose of frame differencing is to eliminate redundant image information from frames that follow key frames in a movie data stream. It is most effective if the frames that follow don't change much from a given key frame. It is least effective when all or most of the pixels in succeeding frames have changed. Figure 18.3 illustrates this concept.

When you capture a movie using compression, you can usually set the key frame frequency (remember that capturing raw produces all key frames). Both VidCap and MovieRecorder allow for this. If you bring a movie into an application like VidEdit or MovieShop, you can recalibrate and save it with a new key frame cycle.

Figure 18.3
How Frame Differencing Works

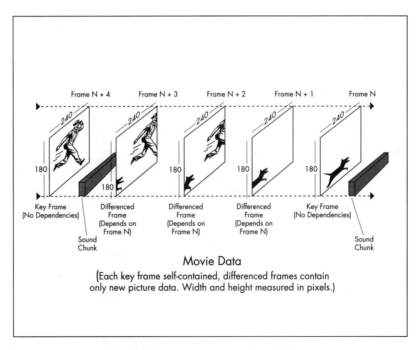

Some desktop video experts advise you to tie your key frame intervals to your frame rate—one key frame per second, or every half-second, for example—while others recommend basing it on the quality of your content. In general, we recommend going with a key frame every second or half-second until you have a feel for working with a variety of content types.

Where frame differencing gets tricky can be dramatized with a couple of rhetorical questions:

- What if you increase your key frame frequency and recompress? You might expect that the resultant movie will perform better since it has more key frames. Unfortunately, this is not the case.
- During playback, what if the most recent key frame is dropped? What are subsequent differenced frames supposed to be based on? Figure 18.4 illustrates this dilemma.

If you reflect on these questions long enough, you can begin to appreciate the issues faced by codec programmers. For instance, if an inexperienced user selects a too-large key frame interval, a decoder may have to reach too far back for a key frame—a

Figure 18.4
The Problem with Key Frames

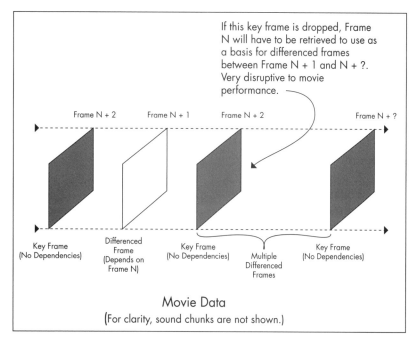

chain reaction of data seeking, additional frame dropping, and related overhead could develop in which the whole movie playing process grinds to a halt.

In fact, there are some frame differencing schemes that use special *interim* key frames to alleviate just such a situation from occurring. But, while such approaches initially sound promising, they are often rife with special cases and offer only incremental performance benefits when you look at the big picture.

A Movie with a Difference

In keeping with our hierarchical model, let's now consider a movie composed of both key frames and differenced frames. Using our assembly line analogy, let's say that a key frame has just gone out the door and is now headed for the movie projector. Since we know it was a key frame, we also know where to find it again.

Because we expect the next frame in the data stream to be a differenced frame, we also expect it to be incomplete. What happens is that the differenced frame is, in effect, superimposed on the preceding key frame. Then, since the result is a *complete* frame, that image can be sent out the door in less time than it would have taken to build it from scratch.

Regardless of which codec an application uses to process a movie data stream, frame differencing (if the codec supports it) will basically adhere to this model. While employing differencing will not guarantee that no frames are dropped, it will generally ensure that more frames are played in situations where key frames would otherwise be dropped.

You might think that a differenced frame would be a lot smaller than its key frame (as a good way to conceptualize them), but often differenced frames are only fractionally smaller, depending on the nature of the source video. Figure 18.5 shows a representation of a data stream with relative key and differenced frame sizes.

If you are wondering what a differenced frame actually looks like compared to a key frame, the variance is visually straightforward—especially when there is not much differencing. Generally, a

Figure 18.5
How Key Frames Compare to Differenced Frames in Size

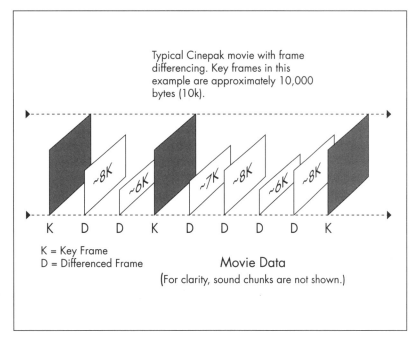

differenced frame looks like the key frame minus the part of the background that stays the same.

Let's summarize our progress here. Our goal is to understand the process by which movies are played—down to the single frame perspective, if possible. At the *macro* level, we know that if we load a movie-playing application, it in turn loads a codec that can decompress individual frames from an incoming movie data stream.

At the *micro* level, we now have a conceptualized view of how individual frames are played. Whether or not those frames are differenced, they still must move off the production line fast enough to get sent to the movie window. If they get slowed down for any reason, even due to system overhead, they are dropped.

The next question is: What unifies these two bookend processes? In other words, how is movie data actually handled after a codec requests it—and from whose perspective? The answer lies in the architecture of the particular enabling technology, in this case either QTW or VfW (although the overall approach is similar on other types of systems).

Components and Data Handlers

To understand how data is handled on our two designated platforms, we can begin by talking about the concept of *components*. Because QuickTime is a more mature digital video technology than VfW, with a more sophisticated component structure, we'll use it as the sample environment here. Since we are talking conceptually, we can safely include both the Macintosh and Windows implementations.

The Component Manager

At the highest level in this discussion is the QuickTime Component Manager, which classifies components according to their function. According to Apple's documentation, a QuickTime component is a software object that extends the capabilities of QuickTime. In practical terms, such components can be almost anything—codecs, data handlers, even specialized math routines. Figure 18.6 shows this idea.

A level of abstraction exists between QuickTime components and their clients—which themselves can be applications or even other components. The benefit is that, rather than implement support for a specific data format or protocol, you simply employ

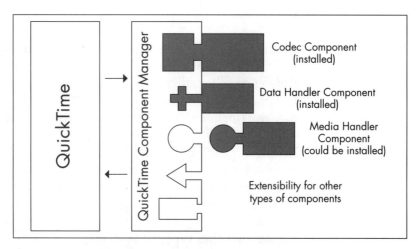

Figure 18.6 Various QuickTime Components

a common interface by which your program can communicate with all components of a particular functional type.

If your application needs a component of that type, the Component Manager can locate and query all such components. You can determine how many components of a specific type are available, and also get additional details regarding a component's abilities without opening it. The Component Manager keeps track of each component's name, resources, and other characteristics.

A QuickTime application must use the Component Manager to gain access to a component. You can either find it yourself or let the Component Manger locate a suitable component for you. Once an application has opened a connection to a component, it can use the services provided. When it is finished, the application must close the connection to that component.

If this discussion sounds overly theoretical, that's because it is—unless you are a software developer and can appreciate the perspective it gives you when designing applications that play movies or components that handle movie data. What it does for the desktop movie producer is demonstrate the flexibility of the QuickTime architecture—and provide a framework for the next layers down: the data and media handlers.

Data and Media Handlers

The QuickTime data and media handlers are basic component classes. In the *data* handler department, there are two principal types: video and audio. Like with all QuickTime components, the default handler for either video or audio can be easily replaced by a custom component—for example, one that employs a special type of caching.

Under each type of data handler are the QuickTime *media* handlers: specific components for interfacing with hard drives, CD-ROM drives, flopticals, and so on. These, too, are pluggable entities. If a new kind of movie storage device is invented, being able to develop a media handler for it according to recognized standards clearly benefits both the developer and the end user of the new equipment.

A good example of the value of this approach concerns the emerging network video servers. Ordinarily, a codec looks to a local storage device (a hard disk or CD-ROM drive) for movie frames. If the expected video data stream was instead coming across a LAN, a very sophisticated media handler would have to be employed to channel it back to the codec.

Let's retreat a bit here and consider an overview of how these components work together:

- While playing a movie, the QuickTime engine asks the data handlers for sound and video data.
- The data handlers ask their media handlers for this data, which the media handlers procure from the media they are controlling.
- All this happens synchronously—in other words, no other processes get service from the CPU until the engine gets the data it requested.
- The engine processes the data, makes calls to available QuickTime display services to get the frames onto the screen, then asks for more data from the handlers.

As we noted earlier, the engine runs the show while the movie is playing. When the movie is stopped, control returns to the application. Because there are many layers and components involved, it is important to keep in mind from whose point of view things are happening while a movie plays.

Audio Handling

While working with a movie's audio is more straightforward than handling it's video, getting them properly synchronized (from a programmer's point of view) is a rather complex process. However, because compression and bandwidth limitations are generally not involved (at least not for 22kHz, 8-bit, mono audio) our original movie projector is a better analogy than the assembly line model we used for video.

When the QuickTime engine asks a sound handler for some audio data, the sound handler calls the appropriate media handler. The media handler then reads the data from the storage medium. Instead of building a frame, however, the sound chunk

Components and Data Handlers

Figure 18.7
Sound Chunks Placed at the Beginning of a Movie

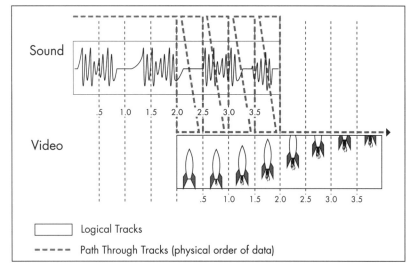

is handed off to the PC's sound card (on a Windows machine) or the Sound Manager (on a Mac).

Under QuickTime, a half-second of sound data is usually interleaved with video data every half-second (with sound leading), regardless of the frame rate. With a tool like MovieShop or ComboWalker, you can specify that several sound checks precede the first video frame in a movie, which is recommended. Under VfW, the sanctioned approach is to interleave audio and video data on a single frame basis. Figure 18.7 shows the layout for QuickTime movies.

The QuickTime for Windows Approach

Let's add a few additional layers here. Say we have a simple Windows application whose sole purpose is to open and play QTW movies. Embedded in the program's executable code are calls to functions that cause the movie to be behave in certain ways—start playing, stop playing, and so forth. Because we are operating in the Windows environment, however, we can reasonably expect those functions to be located physically outside our simple movie playing application, as indeed they are.

As you might guess, the functions are located in the code libraries that comprise QTW. These libraries are traditional Windows

Chapter 18 The Mechanics of Movie Playback

Dynamic Link Libraries (DLLs). Thus, any program that wants to play a QTW movie has access to the functions that allow it to do so, provided that QTW is properly installed. This serves two basic purposes:

- An application that plays QTW movies doesn't need to physically contain those movie-playing functions.
- All applications that manipulate QTW movies will do so in consistent ways.

The beauty of QTW is that a QTW-enabled application is bound to QTW at runtime. Normally, a program utilizing DLLs is bound to them at link time. If references to the specified DLLs are not resolved at load time, the program fails to load. QTW provides access to its functions *after* the program has loaded. If QTW is not installed, the program will fail to play movies but otherwise will run normally. Figure 18.8 shows this idea in more detail.

If you were the developer of a presentation program, for instance, you might want to add the ability to play movies but not cripple the product because it failed to load on a non-QTW system. QTW will accommodate you on both of these scores. In

Figure 18.8
The Beauty of QuickTime for Windows

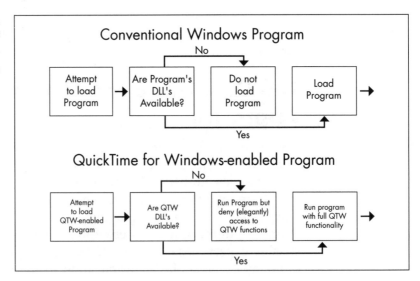

effect, you can develop a QTW-enabled program without worrying about whether the QTW DLLs will be present on future host systems.

The most important thing to remember is that QTW is not a program per se, but a collection of code libraries. You don't *run* QTW—your programs ask it to perform services involved in playing movies. The same basic idea applies to VfW and QuickTime on the Macintosh, although the actual implementations are different in those cases. In general, this is how all PC-based enabling technologies work.

The Importance of the Compressor in Movie Playback

It is important to note, from a performance standpoint, the exact role of the codec's decompressor versus its compressor (see Figure 18.9). Since end users of movies generally see only the decompressor in action, they naturally assume that, if the movie

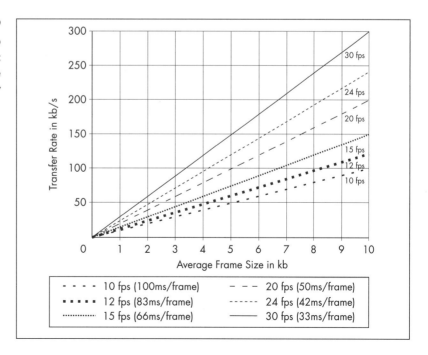

Figure 18.9 The Relationship between Codec and Storage Media Efficiency

plays well, the decompressor must be quite efficient. While most commercial decompressors do a good job, an equally important factor affecting movie play is how well it was *compressed*—at the frame level. In other words, a good codec will attempt to solve two problems:

- Compress the data as tightly as possible—which gates the *maximum* playback rate.
- Compress the data for decoding as quickly as possible—which gates the *actual* playback rate.

For example, if the average frame size in a given movie is 10K and the movie will be playing from a single-speed CD-ROM drive (150 kbs peak), then no more than 15 fps can ever be expected, regardless of the speed of the decompressor. If the compressor were able to get individual frames down to an average size of 5K, the maximum playback rate would be doubled. Figure 18.9 plots this relationship for a range of values.

Test Driving Windows and Mac Systems

NOW'S YOUR CHANCE TO TAKE AS MUCH TIME AS YOU NEED TO PLAY AROUND WITH VIDEO CAPTURE TECHNIQUES UNTIL YOU FEEL COMFORTABLE.

Before we hit the open highway of complex and time-consuming digitization techniques, let's take a spin around the block and work with systems on both the Windows and Mac platforms. The obvious benefit is that you can make sure your hardware is working. Another is that you can derive a pre-road capture check list for each platform. Once you do enough captures, this will all become second nature, but it can be useful in the beginning.

The look and feel of each test run will be somewhat dependent on the software used, but the overall sequence of events will be the same for each system. To use the meta system model established in Chapter 4, we'll assume you have an appropriately powerful CPU, a capture card with compression assistance, a hard drive with at least 100Mb free, and some kind of standard consumer VCR (or better).

Chapter 19 Test Driving Windows and Mac Systems

In this chapter, you will learn:

- The work involved in a basic Windows capture
- The work involved in a basic Macintosh capture
- Specific platform-related details affecting successful captures

A Basic Video for Windows Capture

Currently, the basic way to digitize video under Windows is with the program VIDCAP.EXE, which comes with Microsoft's Video for Windows. Also, Intel is shipping an alternative application called SMARTCAP.EXE, which has a similar interface but offers some enhancements, such as the ability to save in the QuickTime file format. This software will presumably ship with their ISVR capture board at some point. For this test drive, we will use the ISVR.

Setting Up

Before invoking VIDCAP, let's dispense with a few items on our proposed pre-flight check list.

1. You'll have to decide whether you want to defragment your hard disk. If a capture application can write movie data to contiguous file sectors, as shown in Figure 19.1, playback performance will be noticeably improved. The program DEFRAG.EXE (which comes with DOS 6.0) is a good tool for this, as is *Speed Disk* in the Norton Utilities.
2. Make sure your capture card is connected to your video source. If your video source is a regular consumer VCR, you are probably using a composite video cable. If you are employing a more sophisticated video source that offers S-video, you should use this option as long as your capture board can accept the cable. See Chapter 11 if you need illustrations of these different types of cables. You will be telling VIDCAP which type of connection to expect in a dialog box shortly.
3. Make sure your audio source is connected. Capturing sound under Windows requires you to cable the audio outs on your VCR or video camera to the audio in on your computer's

Figure 19.1
Contiguous File Sectors on a Hard Disk

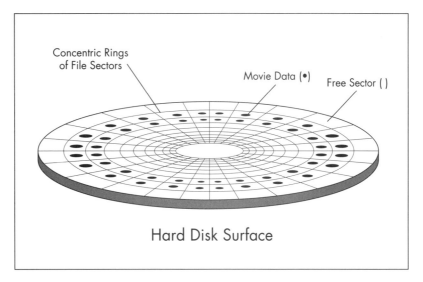

sound card. Since the majority of Windows-compatible sound boards want stereo input, your cable should have a double-notched mini phone plug on this end, shown in Figure 19.2, and a pair of male RCA connectors on the end that plugs into the video source (for the left and right stereo channels).

Since most consumer VCRs only have a monaural line out jack, you may need an additional Y connector cable to accommodate the stereo connectors from the audio cable mentioned above. While this may sound needlessly complicated, you will only have to deal with it once to ensure acceptable sound transmission to your sound card, and both cables are basic Radio Shack items. Many video cameras actually have stereo outs, which means you only have to worry about the first cable. Figure 19.3 illustrates these wiring concerns.

Figure 19.2
A Standard Y Cable for Plugging into a Sound Card

Figure 19.3
Wiring Your Video Source to Your Sound Card

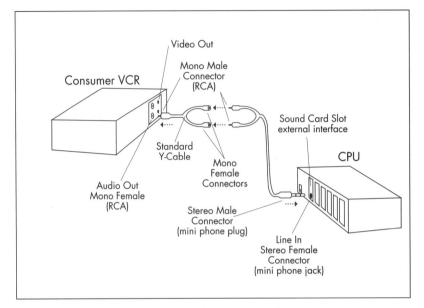

4. Set your audio level. Like many users of the various Windows-based sound mixers, you have probably considered a contract hit on the interface developers and their documenters. If you already have your onscreen mixer tamed, please jump to point five. Otherwise, you might want to use the settings presented in Figure 19.4. This figure shows the Media Vision Pocket Mixer (PMIXER.EXE).

 Note that the center fader in the group of seven shown in Figure 19.4 should be toggled green. The rightmost fader in the group should be toggled red. Also note that different settings will be necessary for playback, which we will cover in a moment.

5. Invoke VIDCAP.EXE, which displays its main user interface. Before we set any of the video parameters, let's make sure to set the name of the capture file. You can change it later if you need to. The capture file is where VIDCAP will

Figure 19.4
Capture Settings for the Media Vision Pocket Mixer

Figure 19.5
The VIDCAP Video Source Dialog

store the movie data for the video clip we are about to digitize. The filename you supply will be used until you reset it or exit the program.

6. Click the *Options* item in VIDCAP's main menu and select *Video Source* from the drop down menu. A dialog will come up from which several parameters can be set as shown in Figure 19.5. For this test drive, the only important parameters are the radio buttons for Composite versus S-video and the Input Type VCR check box.

 Assuming your video source is a VCR, be sure to check that box. If you have read Chapter 11, you should already be familiar with the difference between composite and S-video connections, so go ahead and click the appropriate radio button. The rest of the controls can be ignored for now, although you can click the *Restore Factory Defaults* button for completeness if you wish.

7. Select the video format options by again dropping down VIDCAP's *Options* menu and clicking *Video Format*. A dialog appears based on the current capture driver that you have installed, as shown in Figure 19.6. From this dialog you can

Figure 19.6
The VIDCAP Video Format Dialog

set the compressor and movie frame size, as well as other parameters such as quality and data rate, depending on the capture driver. For our purposes, we need only select from the first two categories. Since we are using the ISVR, let's go with the Indeo Video R.3 compressor and the 240-by-180 movie frame size. Other cards will have different compressors available.

8. Set the audio options. Once again, drop down VIDCAP's *Options* menu. This time click *Audio Format* to bring up the dialog box that handles these parameters, shown in Figure 19.7. We'll select 8-bit, mono, and 11.025kHz as the audio parameters for this test. Most of the movies you will make will likely use these settings, although 22.05kHz sound is good when you're including music.

Starting the Capture

Now we are ready to do the capture. First, make sure you have enabled (checked) the *Preview Video* menu item under *Options* so you can monitor your video source during capture. From VIDCAP's *Capture* menu, click the *Video* option. The Capture Video Sequence dialog will then appear. From this dialog, you should set a frame rate of 15 fps and click the *Capture Directly to Disk* radio button.

Assuming you have specified your capture file, a few seconds may pass while your system sets up for digitization. A message box will then come up as shown in Figure 19.8, allowing you to commence or cancel the capture. Start you video source rolling, then hit the Enter key when the image is stable (you'll want to use the *preroll* technique for serious movie captures). Wait a few seconds, then hit the Escape key to end the capture.

You can play back the just-captured movie by clicking *Edit Captured Video* in VIDCAP's File menu. This invokes the program

Figure 19.7
The VIDCAP
Audio Format
Dialog

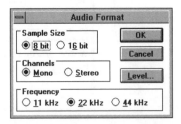

A Basic Video for Windows Capture 311

Figure 19.8
The OK to Capture Message Box

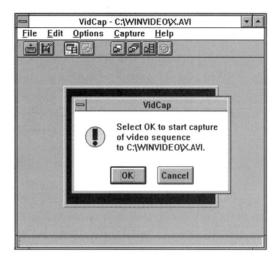

VIDEDIT.EXE, with which you can edit the movie (or any AVI movie). We covered the use of VIDEDIT in Chapter 10. For now, we just want to view our movie. Click the play button (the large, right-pointing triangle button near the bottom) to check it out.

You may want to adjust your onscreen audio mixer here for playback as opposed to capture. Depending on how your system is configured, playing back movies when a mixer is optimized for capture can cause distortion. In almost all onscreen mixers, it is the slider under the waveform icon that controls movie playback volume.

This concludes our test drive for a basic Windows capture session. If you completed all of the items in the check list, your movie should perform at least adequately. You may wish to adjust a few of the settings right away (for example, movie frame size and frame rate) to see how the resultant movies differ from the one just created.

Unless you have a project that can't wait, or you're eager to get into the advanced material, we suggest you spend some time experimenting with all the settings. As we said at the beginning of this book, you are supposed to have some fun with this equipment. Presumably you paid good money for it.

A Basic Macintosh Capture

Unlike the current Windows 3.1 environment, the Macintosh gives you a number of application-specific ways to capture video sequences. To make the test drive on the Mac as close in comparison as possible to our Windows jaunt, we will use the MovieRecorder application that comes with major releases of QuickTime. We'll assume you have QuickTime installed on your Mac, preferably version 1.6.1 or higher.

Again, keeping with the meta system model established in Chapter 4, we'll assume you have an appropriately powerful CPU, a capture card with compression assistance, a hard drive with at least 100Mb free, and some kind of standard consumer VCR (or better). We'll use the same pre-flight check list we did with the Windows system, modified accordingly for the Mac.

1. You need to decide if you want to take the time to defragment your hard disk. Playback performance can be measurably improved if your capture software writes to consecutive file sectors, which can be provided by an application such as *Speed Disk* from Norton Utilities for the Mac. We recommend that you defragment your hard disk as often as convenient.
2. Check your video cable connections. If you have a consumer-grade VCR, you are probably using composite video. If you have a video source sporting S-video, you should use this standard if your capture board has a connector for the cable. See Chapter 11 for illustrations of these cables. You will be providing all of this sort of information to MovieRecorder in a moment.
3. Ensure that your audio cables are under control. The uptown Mac capture boards have easy-to-find-and-use audio connectors, but the lower-end Spigots need special hardware to make synchronized audio capture happen. As noted in the product descriptions, some of the lower-end Mac cards actually capture with a proprietary application (not MovieRecorder) because they can't create QuickTime movie files directly. Assuming you are using a capture board compatible with MovieRecorder, you may have stereo-to-mono (or vice versa) issues to resolve at this point. See Figures 19.2 and 19.3 for clarification.

A Basic Macintosh Capture

4. Set your audio record level. Depending on the software that came with your capture hardware, this interface will vary in appearance. Often the default value will be fine for all your captures, but this is worth experimenting with to give you a sense of its range.
5. Launch MovieRecorder, which displays its main user interface. Here we depart slightly from the order of events in the Windows capture check list. One big difference is that you don't have to set a capture file first. **MovieRecorder** will create a temporary movie file that you can blow away if you don't like it.
6. From the *Settings* menu, select *Video Settings*. In the Video dialog that appears, go to the list box in the upper-left corner and select *Source*. The Video dialog will now display the video source controls, shown in Figure 19.9. Open the Input control and select either Composite or S-video, depending on how you have your video source device connected. Also click the appropriate radio button for either TV, laser disc, or VCR.
7. Use the top-left list box to select *Compression* and wait for the interface to show the compression controls, as shown in Figure 19.10. Choose *Video* from the Compressor box. Next, set the *Frames per second* to 15 fps and the *Key frame every* to 15 (and check that box). For completeness, slide the *Quality* control to the highest position (all the way to the right) and select 256 colors from the *Depth* box.

 To set the movie frame size, you can either drag on the grow box in the bottom-right corner of the interface (once the *Video* dialog is dismissed) or use the *Resize* menu to select *Quarter Size* (160-by-120). If you change the movie frame

Figure 19.9
Movie Recorder's Video Source Dialog

Figure 19.10
Movie
Recorder's
Video
Compression
Dialog

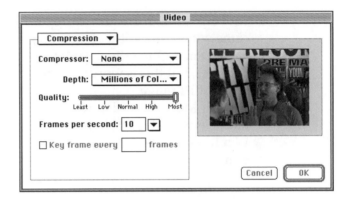

dimensions via the grow box, make sure the x and y dimensions are multiples of 4 or performance will suffer.

8. From the *Settings* menu, select *Sound Settings*. In the dialog that comes up, use the list box in the upper-left corner to cycle through the available categories. Your settings should be for 8-bit, mono, and 11.025kHz in the *Sample* category—whatever is appropriate for your sound hardware in the *Source* category (assuming your capture board is compatible with MovieRecorder and its digitizer is installed correctly)—and *None* in the *Compression* category. You can monitor the audio signal and set an acceptable level for it in this dialog.

The final parameters to check before clicking the *Record* button are also in the *Settings* menu. For this test drive, make sure the *Post Compress* item does not have a check mark next to it. Also, see where the *Record To* menu item is pointing. This is where the movie temporary file will be stored as it is captured. Assuming you have a single internal hard drive (until you get into this deeper), the name of that drive should appear when *Record To* is clicked.

Starting the Capture

Ready to capture? Roll your tape and press the *Record* button whenever you are ready. As we noted in the Windows test drive, you will want to get familiar with preroll techniques eventually so that the image from the tape is stable when you start digitizing. Wait for five or ten seconds and then click the same button again (which now says *Stop*).

When MovieRecorder has finished, a QuickTime movie with *Untitled* in its title bar will appear on your screen. You can play this captured clip from its movie controller just like any other QuickTime movie. If you dismiss it, you will be asked if you want to save it (it is currently just a temporary file).

This concludes our test drive for a basic Macintosh capture session. If you completed all of the items in the check list, your movie should perform at least adequately. As with the Windows test drive, you may wish to adjust a few of the settings right away (for example, movie frame size and frame rate) to see how the resultant movies differ from the one just created.

Again, unless you have a project that can't wait, or are eager to get into the advanced material, we suggest you take as much time as possible to play around with things until you have a gut feel for what the movie capture process feels like. If you are not having fun at this point, you may not want to get in any deeper.

Exploring Frame Rates and Sizes

AS A DESKTOP VIDEO PRODUCER, YOU'LL NEED TO MASTER THE ART OF CHOOSING FRAME RATES AND SIZES TO MAKE YOUR MOVIES PERFORM AS WELL AS POSSIBLE.

The purpose of this chapter is to show you how differences in frame rates and frame sizes affect movie performance (and, as a result, the overall impact of your movies on an audience). We'll take a slightly less technical approach than in the last several chapters, since there is more subjectivity involved with these particular issues.

Since our frame *rate* examples are best observed playing live, we have included examples on the CD-ROM companion to this book. We also provide frame *size* examples on the CD-ROM, as well as screen shot illustrations of different-sized movies. Ultimately, of course, you should experiment as much as possible with different frame rates and sizes on your own movies.

In this chapter, you will learn:

- How a movie performs at different frame rates
- How a movie performs at different frame dimensions
- When particular frame rates work best
- When particular frame dimensions work best

Observing Frame Rate Differences

As a desktop video producer, you want your movies to perform as well as possible. While faster frame rates and bigger frame sizes are *generally* better, there will be times when you find these movie attributes governed by factors other than CD-ROM data rates and CPU processing power.

Issues surrounding frame rate and size tend to be the same for both Mac and Windows machines, assuming they are similarly configured and powered. For instance, a cross-platform CinePak movie with a frame rate of 12 fps and dimensions of 240-by-180 pixels will perform on a 486-25 PC about as well as on a Quadra 610, assuming it plays from the hard drive of each.

Let's begin with some basic examples. As noted earlier, you can find these examples on the companion CD-ROM. What we want to demonstrate here are various levels of performance across a spectrum of reasonable frame rates. The biggest observable difference between any two movies will be the degree of jerkiness (or smoothness, depending on how you look at it).

We have constructed these sample movies so that the one with the highest frame rate should be able to play all its frames, depending on the power of your PC. Otherwise, you might not perceive any difference in smoothness between it and one of the others with a lower frame rate. These movies are listed in Table 20.1.

Table 20.1 Specifications for the Sample Frame Rate Movies			
File Name	**Frame Rate**	**Frame Size**	**Running Time**
20-1-5.MOV	5 fps	240 x 180	30 Seconds
20-1-8.MOV	8 fps	240 x 180	30 Seconds
20-1-10.MOV	10 fps	240 x 180	30 Seconds
20-1-12.MOV	12 fps	240 x 180	30 Seconds
20-1-15.MOV	15 fps	240 x 180	30 Seconds

Since we wanted as level a playing field as possible for the movies in this example, we based them all on the one with the highest frame rate, 20-1-15.MOV. To produce the others, we ran the Mac program MovieShop five times on the *raw* version of 20-1-15.MOV, reducing the frame rate with each iteration. This approach produced more consistent results for comparison than performing five separate captures.

When you run these movies on your Mac or Windows machine, we suggest that you start with the one having the fewest frames per second (20-1-5.MOV) and watch the action get smoother as you work up to the one with the most (20-1-15.MOV). You should notice a significant improvement each step of the way.

Framing a Perspective

Let's recall our recommended attributes for *desktop video* from Chapter 2. We proposed that a desktop movie should play at a rate of between 10 and 15 fps, depending on how slow or fast the action is in the source analog video. The top of this range resulted from CD-ROM bandwidth constraints (considering our other desktop video parameters). The bottom end was based strictly on acceptable performance levels.

Of course, if you reduce a movie's frame size in this balancing act scenario, you will be able to increase its frame rate accordingly. In particular, if you make your dimensions 160-by-120, you may actually be able to achieve 24 fps or even 30 fps (without dropping frames) if you compress with CinePak and play the movie on a fast enough machine.

We hope that, by playing and studying the movies listed in Table 20.1, you will see why our proposed range of frame rates for desktop video (as we have defined it) make sense. If you believe that desktop video is evolving into its own medium, based on—but not tied to—analog video, you may be even more inclined to agree with our proposal. (Remember, we are in CD-ROM territory here.)

Then again, you may believe that there is just no way around 15 fps (at 240-by-180 with 16-bit color and 22.05kHz sound) as an

absolute minimum frame rate for all desktop video. Or, you might feel that those five frames per second between 10 and 15 fps are viable bargaining chips when you want to upgrade your audio or the overall resolution of your movie.

Wherever you stake your claim, we encourage you to do it as a result of direct experimentation. As mentioned earlier, while we think that quantifying most aspects of desktop video is a good idea, we are prepared to allow for some subjectivity in deciding on appropriate frame rates and sizes.

Choosing the Best Frame Rate

With the basics covered, let's move on to some more complex matters. For starters, you may be wondering if there are many cases where substantially lower frame rates (sub-10 fps) make sense. Unless you are doing special effects, the short answer is generally no. Here are some exceptions:

- Very slow moving source video (like a sunset, for example)
- An MTV-style dropped frame look
- Simulated time-lapse photography

Unfortunately, if you produce clips with low frame rates, they will generally have to be standalone movies. On the Mac, if you edit together clips with differing frame rates using an application like MoviePlayer, the performance of the resultant saved file can be unpredictable at best. Under VfW, movies with sections pasted in are saved at the frame rate of the original file (unless you specifically reset it).

One of the reasons there can be a problem on the Mac under these conditions is because an *edit list* is created when you cut, copy, and paste movie sections together. An edit list is an internal data structure maintained by a QuickTime movie that has been edited in particular ways. When QuickTime (QTW) plays such a movie, its edit list is continuously consulted to see if seeking is required on the movie storage medium—which can affect performance.

Running your edited movie through MovieShop will make this problem go away (see Chapter 24 for a full discussion of MovieShop), as will bringing it into Premiere and outputting it as a new movie. Another way around the problem on the Mac side involves making movies with different tracks, but that solution is outside the scope of this discussion.

Increasing the Frame Rate

Essentially, when you increase the frame rate on an existing movie, you are duplicating frames. For example, assume we have a movie with a frame rate of 6 fps. We open this movie with VidEdit (or MovieConverter on the Mac), change the frame rate to 12 fps, and save it under a new name.

If we stepped through the resultant movie, we would see that each individual frame has a copy next to it. Of course, this frame duplication would be consistent for all the frames in the new movie because we exactly doubled the frame rate. If we had gone from, say, 10 fps up to 15 fps, we would expect to see every *other* frame duplicated as we stepped through the movie.

To bring this example to life, open the movies 20-2-6.MOV and 20-2-12.MOV on the companion CD-ROM. Stepping through 20-2-6.MOV one frame at a time will show you a series of unique images. Doing the same for 20-2-12.MOV will reveal pairs of unique frames. Actually, some of the images in the pairs may be slightly different due to frame differencing and data rate limiting, but the basic idea should be clear.

As you experiment with different frame rates, you may find some anomalies, especially in the higher range. For instance, capturing in the 18 to 22 fps range (with equipment capable of doing this) can produce white frames and occasional garbage frames, depending on your capture card and videotape deck.

On the other hand, using frame rates that are even divisors of 30 fps (analog video) and 24 fps (film) will almost always give you good results. These rates include: 30, 24, 15, 12, and 10 (rates below 10 fps are not used in most desktop video productions).

Our advice is to stick with one or more of these rates and spend your experimenting time in other areas.

The Milli Vanilli Factor

What's the best frame rate overall? One very rudimentary rule of thumb (at least for video with talking heads) is if the lip synching looks good, don't worry about the frame rate. Just make sure the lip synch *stays* in synch. Within the range we propose for desktop video (10 fps to 15 fps), the rest is up to you.

Actually, a personal experience we can relate has to do with our CD-ROM title, *Canyon Clipz*. When it was remastered for the CinePak edition, we spent a fair amount of time looking at the difference between 10 fps and 12 fps. Because many of our clips contain music, we needed to capture the audio at 22.05kHz.

Unfortunately, the increased data rate requirement caused by upping the audio made the image quality of the individual frames look much worse at 12 fps than at 10 fps after we ran the clips through MovieShop. It put us in a quandary for a while, but ultimately we chose 10 fps. Admittedly, it was a gut level decision.

What this experience shows is just how sensitive the balance is between all of the attributes of any well-made desktop video clip. It is easy to think at first that such small variations don't matter, but this is an assumption you will quickly abandon once you start making movies in earnest.

Observing Frame Size Differences

As we did for frame rates, we'll start our discussion of frame sizes with a few simple examples. Again, there are sample movies on the companion CD-ROM, but we will also show you screen shots of individual frames from different sized clips here in the text. Our goal is to dramatize the feel that differently sized movies can give to your desktop. The sample movies available for playing are listed in Table 20.2.

Observing Frame Size Differences

Table 20.2 Specifications for the Sample Frame Size Movies

File Name	Frame Rate	Frame Size	Running Time
20-3-120.MOV	12 fps	120 x 90	30 Seconds
20-3-160.MOV	12 fps	160 x 120	30 Seconds
20-3-240.MOV	12 fps	240 x 180	30 Seconds
20-3-320.MOV	12 fps	320 x 240	30 Seconds

Figure 20.1 is a screen shot of four movies positioned on a Nanao 16-inch monitor connected to a Macintosh using the Radius Video Vision capture board. Figure 20.2 is this 480-by-360 movie running on the same monitor. Note the slight blurring of the full screen image compared to the other four movies.

As you can see, all of these standard sizes conform to a 4 x 3 aspect ratio. If you have a background in video, you know that 4 x 3 ratio is not arbitrary. In fact, it is the proposed aspect ratio for the emerging HDTV standard. Because of how pixels are

Figure 20.1
Movies with Dimensions of 320 x 240, 240 x 180, 160 x 120 and 120 x 90

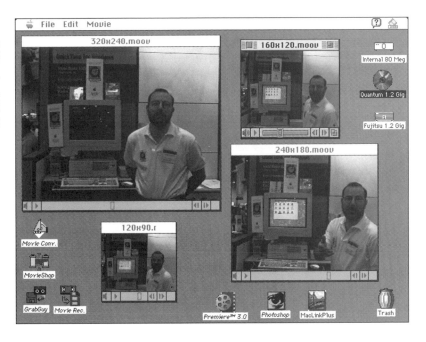

Figure 20.2
A 480 x 360 Movie

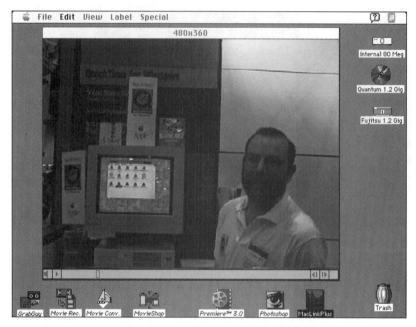

displayed, 4 x 3 appears roughly square on most computer monitors.

Above a certain minimum size, you can capture and convert movies into any aspect ratio that you wish—as long as the vertical and horizontal dimensions are even multiples of 4. Using movie widths and depths that do not conform to this rule will cause significant performance problems in most codecs, especially CinePak.

Choosing the Best Frame Size

In our proposed desktop video standard, we are firm about the 240-by-180 frame size. Experience has shown us that anything larger can cause impaired performance using software-only decompression in both single and double-speed CD-ROM environments. This is even more true for VfW, although that situation is changing as of this writing.

In the ongoing hype battle surrounding capture cards (specifically the Windows-based products), the 320-by-240 movie window

gets a lot of attention. While boards like the Intel Smart Video Recorder and Media Vision's Pro MovieStudio can easily capture into this frame size, smooth playback of movies with such frame dimensions is another matter—especially when they are played from CD-ROM.

Realistic Frame Sizes

For desktop producers integrating video into multimedia products, frame size can carry a different set of aesthetics. In Chapter 26, for instance, we've published an interview with a developer who chose movie dimensions based on how much of the overall user interface the video clips might cover up. How those movies compared in size with other graphical objects in the production was also a factor.

In the same vein, Voyager's *A Hard Day's Night* uses a nonstandard movie size of 208-by-156. While this might seem arbitrary at first glance, the overall integration of movie size, background design, text scrolling, and interface control placement gives the product a well-balanced feel.

Interestingly, there are some people who avoid CinePak altogether and work strictly in the 160-by-120 format (these tend to be Mac people) using the Apple Video codec. Because of their production environments, they can't afford the long waits necessitated by the CinePak compressor and have scaled back their operations accordingly.

This predicament leads into our closing point. On the Mac, CinePak is the codec that makes video movies possible in frame sizes larger than 160-by-120 (some types of animations can have bigger frames with other codecs). Under Windows, both CinePak and Indeo Video will do the trick—plus Indeo Video has real-time compression. These points are worth thinking hard about as you develop your production strategies.

Exploring Image and Audio Quality

PRODUCING GREAT LOOKING FINISHED MOVIES DEPENDS ON KEEPING IMAGE QUALITY HIGH UNTIL YOUR FINAL COMPRESSION.

This chapter will get down to basics for image and sound aesthetics. While differences in audio quality are fairly easy to distinguish and quantify—and are essentially uniform for Macs and Windows machines—image quality is generally measured or determined with two sets of criteria: color depth and degree of resolution (which you can set at capture or compression time).

The apparent color depth of a movie is just as much a function of the Mac or PC that the movie is running on as it is of the movie itself. For instance, an AVI movie captured with 24-bit color (roughly 16 million colors) played on a Windows system with an 8-bit color card will never display more than 256 colors in any frame. Conversely, a movie digitized with 8-bit color will never show a frame with more than 256 colors either—even on a 24-bit color system.

Image quality, by contrast, has to do with the actual resolution of the movie when it is captured or recompressed. On both the Mac and the PC, you can set the quality of the frames you are

Figure 21.1
Image Quality Selection in MovieRecorder

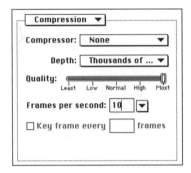

about to digitize, usually by moving a slider in the application's interface between maximum and minimum points, as shown in Figure 21.1. Higher image quality requires more data, of course, and can affect the smoothness of your new movie when you play it back. Since all of these assertions are best demonstrated with real movies, we have included some on the CD-ROM.

In this chapter, we will show you:

- How a movie looks at different color depths
- How a movie looks at different quality settings on the Mac
- How a movie looks at different quality settings on the PC
- How a movie sounds at different audio sample frequencies and sizes

Observing Movies with Different Color Depths

Let's look at some of the sample color depth movies on the companion CD-ROM. Even though color is handled differently on the PC versus the Mac, these examples will provide you with the same range of color depths regardless of your playback platform. They were captured on the Mac then made cross-platform with MovieConverter.

The most observable differences are between the 4-bit (16 colors) and 8-bit (256 colors) movies, and between the 8-bit and 16-bit (roughly 65,000 colors) clips. The 8-bit example with the custom CLUT (Color Lookup Table) is a special case (which we

Observing Movies with Different Color Depths

will discuss in Chapter 25) but it is still useful as a reference point. Although there is a visible difference between 16-bit and 24-bit (roughly 16 million colors), it is much more subtle than between the other examples

As you will see, 4-bit color is not really viable for desktop video production, and is included here for comparison purposes only. (Although some types of animation look passable in 4-bit color, this book concentrates on real video.) The movies we suggest you play and study are listed in Table 21.1.

As with the frame rate samples we showed you in Chapter 20, all of the movies in Table 21.1 are based on the clip with the deepest color depth, 21-1-24.MOV. To produce the rest, we ran MovieShop three extra times on the raw version of 21-1-24.MOV, reducing the color depth with each iteration. Because of its special nature, the 8-bit example with the custom CLUT was captured separately, but from the same source video.

We noted earlier that the number of colors your movie frames display at runtime is limited not only by the color depth at which they were digitized, but also by the color depth of the video adapter used to display them. This is particularly cumbersome on Windows machines with 8-bit color cards, where dithering of movies with greater color depths can look downright crappy, depending on the video card manufacturer.

Fortunately, while 8-bit color boards still comprise the largest installed base, 16-bit color is fast moving into the Windows homeland, especially among power users who want to play

Table 21.1 Specifications for the Sample Color Depth Movies

File Name	Color Depth	Frame Size	Running Time
21-1-4.MOV	4-bit	240 x 180	30 Seconds
21-1-8.MOV	8-bit	240 x 180	30 Seconds
21-1-8C.MOV	8-bit custom CLUT	240 x 180	30 Seconds
21-1-16.MOV	16-bit	240 x 180	30 Seconds
21-1-24.MOV	24-bit	240 x 180	30 Seconds

their movies in the best environment possible. On the Mac, of course, 8-bit color looks the same on all machines, and not half bad by comparison.

Observing Movies with Different Quality Settings

Quality settings have little, if anything, to do with color depth. In fact, a movie's image quality is not a discrete attribute or property; rather, it is a degree of resolution resulting from user input when the movie is digitized. In other words, compressors use quality settings as guidelines when encoding movies. Setting the quality to a certain level basically determines how much data will be needed to represent individual movie frames. Again, higher quality requires more data.

The difference in resolution exhibited by movies captured at maximum and minimum quality settings is quite noticeable. Movies created or recompressed with lower-quality settings can look as though they were based on very low-quality analog video, while movies made with maximum quality settings can actually cause certain compressors (Apple JPEG, for example) to operate in lossless mode.

While image quality may be selected at both capture and compression time with either Mac or Windows software, the results are (in our opinion) more predictable under QuickTime, at least as of this writing. Figure 21.2 shows the difference between movies captured on the Mac with the *Least* and *Most* quality settings.

To give you a sense of the full range of resolution possible using image quality controls, we have provided another set of movies with varying image quality settings. These clips are listed in Table 21.2. Take a moment to run them (on either platform) and observe the aesthetic differences.

These movies were created with GrabGuy on the Mac. Each one has the same number of frames, the same frame rate, and the same color depth (16-bit). The only variant is the quality

Observing Movies with Different Quality Settings

Figure 21.2
QuickTime Movies with *Least* Quality (Left) and *Most* Quality (Right)

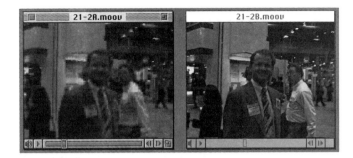

Table 21.2 Specifications for the Sample Image Quality Movies (QT)			
File Name	**Quality Setting**	**Frame Size**	**Running Time**
21-2-5.MOV	4 (Most)	240 x 180	4 Seconds
21-2-4.MOV	3 (High)	240 x 180	4 Seconds
21-2-3.MOV	2 (Normal)	240 x 180	4 Seconds
21-2-2.MOV	1 (Low)	240 x 180	4 Seconds
21-2-1.MOV	0 (least)	240 x 180	4 Seconds

setting, which we adjusted for each case at capture time using the slider control in GrabGuy's user interface, as shown in Figure 21.3.

As noted earlier, image quality specification is the most commonly used means of overall data rate adjustment. While setting the image quality parameter does not constitute a standalone form of compression, the quality specifications you supply can be used by many of the standard codecs in making movie files smaller.

Post processing applications like MovieShop accept even more detailed image quality parameters, as you will see in Chapter 24.

Figure 21.3
GrabGuy's Image Quality Control

Unfortunately, specifying significant quality reduction with any application allows image degradation to rip through the frames of your movies like a hollow point bullet.

Image Quality under Windows

As of this writing, image quality is selectable under VfW in both VidCap and VidEdit. The quality scale, however, is not yet as clearly calibrated as it is for Mac capture and compression software, where the settings *Least, Low, Normal, High*, and *Most* are considered somewhat standard plateaus. Figure 21.4 shows the quality slider in VidEdit.

You can set the quality of an AVI movie at capture time from 1 to 100—as long as you are going to capture with compression. Likewise, you can compress a captured movie with VidEdit along the same scale. Figure 21.5 shows the difference between an AVI movie with a quality setting of 1 versus the same movie with a quality setting of 100.

Like with QuickTime, recompressing an already-compressed AVI movie (even under maximum quality settings) is akin to making a copy of a copy on a Xerox machine. Figure 21.6 shows a series of three movie frames based on the same analog source frame. The left frame was captured raw, the middle frame was

Figure 21.4
VidEdit's Image Quality Control

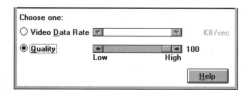

Figure 21.5
AVI Movies with Quality 1 (Left) and Quality 100 (Right)

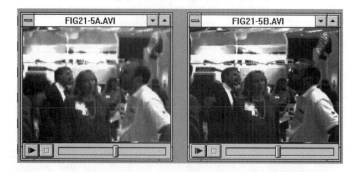

Choosing the Best Color Depth and Image Quality

Figure 21.6
The Effects of Recompression under Video for Windows

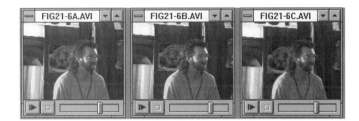

compressed with maximum image quality, and the right frame was recompressed—again with a quality setting of 100.

To give you an idea of the gradations produced with differing quality settings in VfW, we have provided a series of AVI movies on the companion CD-ROM. As with the QuickTime quality examples, they span the whole spectrum in even intervals from 0 to 100. These movies are listed in Table 21.3.

Choosing the Best Color Depth and Image Quality

As with many of the other elements in desktop video, selecting digitization parameters depends on the nature of your source content. However, assuming that you are going to be working with real video (as opposed to graphics or animation), the process of producing the best looking *finished* movies depends on keeping image quality high until your final compression. Let's consider the implications of this condition for both color depth and actual image quality.

Table 21.3 Specifications for the Sample Image Quality Movies (AVI)			
File Name	Quality Setting	Frame Size	Running Time
21-3-0.AVI	0	240 x 180	15 Seconds
21-3-25. AVI	25	240 x 180	15 Seconds
21-3-50. AVI	50	240 x 180	15 Seconds
21-3-75. AVI	75	240 x 180	15 Seconds
21-3-100. AVI	100	240 x 180	15 Seconds

Selecting Color Depth on the Mac

When capturing on the Mac with applications ranging from MovieRecorder to Premiere, your range of color depth options will depend on the sophistication of your digitization hardware. For re-encoding movies, the power of your capture card doesn't matter—in fact, you don't even need one. Back in Chapter 6, we covered a variety of Mac digitizing boards, and specified their capabilities.

If you are using a card in the same class as the Radius Video Vision, you will be able to digitize video at 24-bit color which we recommend. Although 8-bit color was used in the movies that shipped with some early commercial products, the public now expects better, although 8-bit color on the Mac looks good enough as a *playback* environment in many cases.

Interestingly, unlike in the Windows environment, few Macintosh video adapter cards support 16-bit color as their highest level of operation. In other words, they go all the way to 24-bit, leaving 8-bit color to the Mac itself. This is important for you to understand if you are using a digitizer that allows you to capture with 16-bit color. Figure 21.7 shows the dialog in MovieRecorder where color depth is selected.

If you are making movies strictly for the Macintosh, you should always capture video at 24-bit color (or higher—though this is

Figure 21.7
Selecting Color Depth in the Mac MovieRecorder Program

Choosing the Best Color Depth and Image Quality

not common for desktop video as of this writing). On the other hand, when you digitize movies that you'll subsequently make cross-platform, you should consider making them 16-bit—with one exception: CinePak. (The importance of 16-bit color for cross-platform video is covered in a moment.)

CinePak was designed to work with 24-bit color. In fact, it stores files padded out for 24-bit color whether you specify that depth or not. Since you will likely be using CinePak as your codec of choice for finished movies if you do your capturing on the Mac, you will have to make the decision between 16-bit and 24-bit color yourself, perhaps based on personal preference.

This dilemma can be summed up as follows:

- Movie files compressed with CinePak will be the same size regardless of whether they were digitized with 16-bit or 24-bit color. On an otherwise level playing field, the same clips encoded with another compressor at 16-bit color could be smaller.
- Many Windows video cards don't support 24-bit color—most support 8-bit, while a fast growing number support 16-bit. An 8-bit driver is likely to dither 24-bit color poorly. A 16-bit driver will probably do a much better job, but the results are not guaranteed.

All this being said, our CD-ROM product—*Canyon Clipz*—was originally released with its cross-platform movies digitized under Apple Video at 16-bit color. They looked great on 24-bit color Macintoshes and adequate on 8-bit color Macs. Similarly, they looked fine on all the 16-bit PC video cards we tested, and passable on most of the 8-bit cards (though some didn't cut it).

When we remastered our clips with CinePak, staying with 16-bit color, the results were essentially the same in terms of perceived color and image quality (although we did alter the saturation and contrast slightly to get a less coagulated look, and upped the audio sampling frequency to 22.05kHz from 11.025kHz).

Selecting Color Depth under Windows

Since few cross platform movies are being digitized under Windows as this book is written, the issues here are quite straightforward: You should digitize at the highest color depth your Windows capture card allows. Presumably, if you are making movies on your system, you will have invested in something better than an 8-bit video card for playback.

As we noted in Chapter 8, a few of the upscale Windows capture cards (like the Intel Smart Video Recorder) capture at 24-bit color by default. As on the Macintosh, increasing a movie's color depth with a program like Premiere for Windows will not necessarily improve its appearance. Decreasing its depth will, of course, have an adverse effect.

Selecting Image Quality

There are two reasons why you should always capture at maximum image quality on both the Mac and Windows machines. First, as we have already mentioned several times, the best looking finished movies are always guided through the production process with the highest possible image quality levels maintained. Only at final compression (when MovieShop is used on them) should they be compromised.

Second, if you capture raw on either a Mac or Windows box, the image quality control may be disabled or function differently. This makes sense if the frames are going to be uncompressed anyway, although some capture programs (like GrabGuy) do allow for image quality calibration prior to raw captures.

Observing Audio Quality Differences

When it comes to dealing with audio settings on either the Mac or the PC, observing them and setting them can feel more like dealing with color depth than image quality. The reason, of

course, is that the granularity of audio quality in the desktop video world is very low. In fact, as we have seen, there are only two real choices:

- 11.025kHz, 8-bit, mono
- 22.05kHz, 8-bit, mono

Once again, however, to cover the territory as completely as possible, we have provided a selection of movies on the companion CD-ROM to let you hear not only the practical alternatives, but the extremes as well. Some of these clips are QuickTime *sound-only* movies (no video track is included—a concept foreign to VfW). The others are AVI files with dummy video frames. Table 21.4 itemizes these movies.

Like with some of the earlier video samples, all of the above clips are based on the one with the richest attributes: 21-4416S.MOV. To produce the others, we used Premiere, changing the sample frequency, size, and stereo/mono settings in successive iterations. There is a lot of variety here, which we encourage you to dig into.

Of course, without a 16-bit sound card on your machine, you won't be able to appreciate the 16-bit examples. Still, there is enough differentiation among even the 8-bit mono examples to give you a good idea of the range.

File Name	Sample Rate	Sample Size
21-5-8M.MOV	5kHz	8-bit, mono
21-11-8M.MOV	11.025kHz	8-bit, mono
21-22-8M. MOV	22.05kHz	8-bit, mono
21-11-8M. AVI	11.025kHz	8-bit, mono
21-22-8M. AVI	22.05kHz	8-bit, mono
21-1116M. AVI	11.025kHz	16-bit, mono
21-2216M. MOV	22.05kHz	16-bit, mono

Table 21.4 Specifications for Sample Audio Quality

Choosing the Best Audio Quality

Among the reasonable alternatives for desktop movie soundtrack quality, 22.05kHz, 8-bit mono is the best, especially if music is involved. If you are prepared to filter your sound carefully, both at capture time and later with digital audio editing tools, you may come up with techniques to make 11.025kHz audio sound acceptable in all cases, but this can take long hours of practice if you are not an experienced audio engineer.

Regardless of your capture platform (Mac or PC), we recommend that you use 11.025kHz for talking heads and voice-over narratives—basically anything non-musical. If you are digitizing something with music or layered sound effects, we suggest that you make the necessary trade offs with your video track (such as a lower frame rate or less image quality) to accommodate a 22.05kHz audio track.

Developing Capture Strategies

It's now time to develop some good working strategies for day-to-day video captures.

After you have been digitizing for a while, you will likely develop your own system and strategies. In fact, as we noted earlier, the mechanical capture process can become the least enjoyable part of digitization once the initial magic wears off. In a way, this is good—especially if you have deadlines to beat. Devising tried-and-true methods to achieve fast, good-quality captures over and over again will let you get on with even more brain-draining activities—like editing.

In another way, embracing rote methods of digitization can be dangerous—unless you are active in desktop-video user groups and read all the trade magazines (and are still able to keep an open mind). As you are by now aware, the technology is changing so rapidly that there are always quicker and better ways to do things, not all of which require additional investments in hardware.

However you approach capturing physically, you will be unhappy if you can't keep on top of the process conceptually. Like with anything mechanically complex, it is quite satisfying to

walk around thinking about how your system works, how you might be able to push it to even better performance levels, how you are going to archive new footage, and so forth. Maybe we sound like computer geeks here, but we said at the beginning that this was supposed to be fun.

With the above ideas in mind, we'd like to present what we think are some good working strategies for day-to-day captures, and also some scenarios for dealing with digitization in situations requiring unusually high quality. Perhaps by mulling over *all* of these approaches, you can put together your own personal capture strategy that combines the best elements of each.

In this chapter, we will cover:

- How Mac and PC capture environments differ
- Real time versus frame-accurate digitization
- The value of preliminary captures
- 15 steps to better movies, revisited

How Platforms Determine Capture Environments

As of this writing, the Macintosh is the best platform for digitizing video that plays well on both Macs and PCs. (We have to stop short of calling the Mac the best cross-platform development environment overall—even though it often seems like it—because defending that statement often takes all day). You *can* capture very good-looking AVI movies on a Windows machine, but they can be difficult to convert and generally don't play as well on Macs when you do convert them.

The key to this situation is, of course, QuickTime. Movies captured on the Mac are easily made playable under Windows and, when transported to PCs, perform as well (or better) as they do back on the Mac (provided you have QuickTime for Windows installed). Also, movies made on Macintoshes currently look better than movies made under Windows from the same source because of the better digitizing cards available to serious Mac producers, as illustrated in Figure 22.1.

Figure 22.1
The World According to QuickTime

Platform	Macintosh	Windows PC
Quality of Digitizers Available	Excellent (for desktop video)	Fair to Good (for desktop video)
Ease of movie portability to opposite platform with acceptable performance	Easy (if capturing QuickTime Movies)	Complicated (if capturing AVI movies)
Quality of Data Rate Limiting Software	Excellent (for desktop video)	Fair to Good (for desktop video)

Mac Envy Lives

What's the significance of all this? Depending on what you want to do with your movies, you may feel limited if you invest in a Windows-based capture suite, then see very highly resolved QuickTime movies running on both Macs and PCs. You'll have to make and observe a lot of desktop videos before this feeling kicks in significantly, but it can send you on a roller coaster ride of indecision if you are a dedicated desktop producer.

Of course, a lot of this perspective is our particular point of view, but most of the cross-platform title developers we talk to say they feel the same way, at least for the time being. They know that very high quality digitizing hardware and effective data rate limiting software is on the way for Windows, but they want these things now—and they want their AVI movies to play well on the Mac.

As a result, the most sophisticated capture strategies we'll discuss are Mac-based, although many of the general principles apply to both platforms. We'll begin by talking about how we digitized the movies included with our own products, then move on to methods recommended by others.

On-the-Fly versus Frame-Accurate Digitization

One of the first decisions you will have to make (regardless of your digitization platform) is whether you want to capture in real time or with software that controls an industrial or better class video deck. Several factors are involved in resolving this issue, depending on the desired attributes of your target movies:

- The power of your CPU
- The sophistication of your capture card
- Whether you can get additional benefits from purchasing a professional video deck, aside from using it for frame-accurate capture

When we created the first version of our CD-ROM, *Canyon Clipz*, we (fortunately) did not have to make this decision. The product contained movies digitized with the Apple Video codec at 160-by-120, which we could capture in real time at 15 fps in 16-bit color on a Mac IIci using the Radius Video Vision card (without the Studio upgrade). Because this is still a viable strategy, we will detail it here.

The physical capture process was completely straightforward, once we knew what we wanted. After a few dry runs with varying frame rates, color depths, and audio sample rates, we created a short check list of parameters to consult before each capture. We then digitized over 50 clips ranging from 15 seconds to four minutes long. Everything was stored on a 667Mb external SCSI hard drive.

To keep things as simple as possible, we used MovieRecorder for our capture program. Because we used the Apple Video codec, which compresses in real time, we didn't need any *interim* hard disk storage. Once a movie was captured, we brought it into MoviePlayer, trimmed frames as necessary off the beginning and end, then fed the clip into MovieShop. No muss, no fuss (although those early versions of MovieShop did crash with annoying frequency).

Our video deck was a four-head consumer VHS machine, since most of our source video was provided to us on VHS cassettes. Some of it did come on Hi-8 tapes, which we played into the Video Vision card from a Sony TR-81 video camera. The sound-only movies included in the product were digitized by hooking up the audio connectors on the Video Vision breakout box to the audio source (a boom box) and disabling the video in the MovieRecorder user interface.

The finished clips took up slightly over 300Mb. Since our plan was to make the disk playable on both Macs and PCs, we then had to create a separate version of each movie that would play under Windows, which we did using MovieConverter. At that point, we had slightly more than 650Mb of video, which would just fit onto a CD-ROM. It was not a true hybrid disk, since there were two copies of each movie (instead of one), but it was, strictly speaking, cross-platform.

Aside from MovieShop crashing intermittently, there were few holes in this methodology—except that everything took four times longer than scheduled (essentially because we were new to it at the time). One minor problem that caused us to re-digitize and re-shop some of the movies was that certain clips were a lot darker and murkier when played under QuickTime for Windows.

Technically speaking, this problem has to do with a video issue known as *gamma correction*. From a practical perspective, gamma correction can be accomplished in a quick and dirty way by adjusting the contrast and brightness controls in the user interface of the particular Mac capture software you are using. Had we appreciated the value of doing test captures (discussed next) we could have saved considerable time here.

Ah, the Early Days

That was our complete capture strategy at the time, and it worked—back when life was simpler and user expectations low. The stakes are higher now that terrific-looking CD-ROM-based desktop video is showing up in new entertainment and education titles, and expectations in the market are rising accordingly.

To give you an idea of the kind of capture strategy it takes to get to the next significant level of desktop video quality, we'll discuss how the clips in the current version of our title were digitized. These movies actually meet the criteria for what we defined as *desktop video* in Chapter 2 (basically, 240-by-180, 10 to 15 fps, 16-bit color, 11.025kHz or 22.05kHz sound).

The first thing we had to do was make the decision not to digitize in real time. Remember, we're still talking about capturing on the Macintosh here. Fortunately, the Mac has two field-tested (but unsupported) programs for doing this: GrabGuy (for VTR control) and the Captioned Pioneer Movie Maker (for laser disc control). We cover both of these in Chapter 10. Unfortunately, the equipment they can control is expensive for the independent desktop producer.

Because we didn't want to get laser discs pressed each time we acquired new content, the GrabGuy/VTR method seemed more promising. We rented a couple of decks first and did some trial captures with them, then decided to purchase a Sony EVO 9800A (the *A* means it has S-video connectors), which is detailed in Chapter 12. At that time, the price was around $4,000.

Switching to CinePak

What precipitated our move to non-real time capture was the fact that the Mac IIci/Video Vision combination couldn't digitize more than five or six frames per second at a 240-by-180 frame size. We needed to go to those dimensions because CinePak (then called Compact Video) had become available for QTW. Encoding with CinePak lets movies play well at 240-by-180 with 10 to 15 fps, while Apple Video does not, except on very fast machines.

We also foresaw a time when we might need the ability to capture up to 30 fps at 320-by-240 (the highest frame size GrabGuy supports) for special projects, many of which ultimately came to pass, or to make high-quality dubs of Betacam tapes (using just the Hi-8 deck itself) for archival purposes.

We understood that getting a high-end Quadra or a Digital Film card was a viable alternative for achieving the frame rates

On-the-Fly versus Frame-Accurate Digitization

we wanted at 240-by-180, but both of those solutions were more expensive than our Sony deck and didn't provide the sort of flexibility we needed, or the assurance that we could digitize exactly the frames we wanted all the time. The trade off was, of course, that captures would take longer.

Since CinePak is an asymmetric compressor, we had to start capturing our video raw (uncompressed). We quickly discovered that our three- to four-minute music videos wouldn't fit on our 667Mb hard drive, so we had to purchase a 1.2 gigabyte model, for about $1,500. This drive became dedicated to raw captures only, and was optimized and reformatted regularly.

Once a raw GrabGuy capture was completed, assuming it didn't exceed hard disk capacity and necessitate a reformat, we shopped it and stored it on our 667Mb hard drive. Each three- to four-minute uncompressed movie took 12 to 18 hours to MovieShop on our Mac IIci (this, goes much faster on a Quadra). Fortunately, MovieShop was crashing less frequently by then.

That was the capture strategy we used then, and, essentially, it has not changed since. What has changed is the average quality of the source video we use. For any new content, we try to insist that it be at least Hi-8 or Betacam SP, if possible (for really important work). Sometimes, naturally, you just have to use what is available.

Once you have seen the result of a Betacam capture, and how much less it is degraded by MovieShop, you will find it hard to go back. Also, Betacam decks behave much more solidly when controlled by GrabGuy. The movie named BETACAM.MOV on the companion CD-ROM was digitized raw using GrabGuy to control a Betacam VTR, then shopped at 12 fps.

Capturing Big, then Scaling Down

This outlook leads to the next plateau in capture strategy, which you should only seriously consider if you are prepared to make the necessary hardware investments. The basic idea is to get the best video possible at 240-by-180 or 320-by-240 by capturing at larger frame sizes and then scaling back. In a recent White

Paper from SuperMac, the following check list was proposed for doing this type of capture in a consistent manner to help you make high-quality CinePak movies:

- Start with a pristine analog source.
- Set the color and brightness controls in your capture software to equal levels (actual values were provided in the publication, but they seemed to apply specifically to SuperMac's DigitalFilm card.
- Capture at 640-by-480 at 30 fps. Again, this value was meant to apply to the DigitalFilm card, but can be taken generically for any card with powerful enough onboard compression. This is where you will need significantly more hard disk space and high-end SCSI-2 capability.
- If you can't store that much data, reduce the frame rate before the frame size, down to the target frame rate, if necessary.
- Shrink the frame size down to your target size with After Effects, covered in Chapter 10, which offers the best resizing algorithms (if you can afford it).
- Run MovieShop (they say Premiere) to get the target data rate.

Capturing with Premiere

Some people prefer to do all their captures from within Premiere (on the Mac). We don't have a lot of experience in this area, mainly because Premiere only allows for *near* frame-accurate control of a VTR, and doesn't ensure that you will get all the frames you ask for (which we *can* get using GrabGuy). Chapter 12 provides an example of how Premiere's capture interface works.

Capture Strategies under Windows

Current higher-end Windows capture cards like the Intel Smart Video Recorder and Media Vision Pro MovieStudio achieve close to the same effect as the top-drawer Mac boards that have built-in compression. The quality of the digitization, however, isn't quite as good. This is not surprising, considering the difference in prices.

When we mastered *Canyon Clipz* into the AVI format with the Indeo Video codec, we used the ISVR and a Sony industrial VTR. At the time, we could only capture them at 160-by-120 for acceptable CD-ROM playback, since reliable data rate limiting software was not yet available. We did digitize them at 15 fps with 16-bit color and 22.05kHz sound, however.

That strategy was as simple as our original *Mac* strategy, which used the same frame rate and size attributes with 11.025 sound. Although we don't have (as of this writing) a version of our CD-ROM using the new version of Indeo Video that allows for smooth playback at 240-by-180 at 10 to 15 fps, we have nevertheless digitized quite a lot of content at these parameters using the ISVR, without the need for an application like GrabGuy.

If you use Hi-8 tapes or better (preferably Betacam SP), you can get decent results under VfW. Like on the Mac, capturing raw and compressing later is also recommended, provided you have enough hard disk space. We digitized the movie named WARDEN.AVI on the companion CD-ROM with the ISVR from a Betacam deck at 12 fps.

The Value of Preliminary Captures

One of the interesting things about desktop video is the way it fulfills the desire for instant gratification. You set up your digitization software, slap a video tape in your deck, push the play button, then click the record button in your capture program's user interface. A few minutes (or seconds) later, you terminate the capture process and watch the movie on your computer screen. Soon you start to think like a producer, imagining the crucial CD-ROM titles you could create.

Let's say you go for it. You license some content, assemble all the analog source tapes, set up a production suite, and sit down to make some high-quality desktop videos. What you'd like to do next is fire up your equipment, click the record button once for each of your clips, and maybe sip a cappuccino as you observe the digitization process. Unfortunately, it is not that easy.

Until you have an absolute gut feel for what you are doing, you will continue to agonize over better ways you could have set up your captures. Usually you will think of them after you have digitized entire clips—this is where the instant gratification effect comes in. You can save weeks of time by sampling and reviewing small sections of your source, then letting the full capture roll when you are satisfied with how the potential trouble spots look.

It requires some self-discipline to keep the impulse for instant gratification in check, but it is well worth it, especially when you are working on a deadline. We suggest you adopt this habit sooner than later and make it part of your overall capture strategy. Otherwise, you will always be wondering why getting any work done takes so long.

15 Steps to Better Movies

You might have seen or heard about an Apple document that shipped with the QuickTime 1.5 Developer CD-ROM called *15 Steps to Better Movies*. When it first appeared (circa 1992), this document was an invaluable reference for desktop producers, but it can use some updating in spots. Consequently, we have included a paraphrased version here, which we've broken down into capture, compression, and MovieShop tips. Clearly, this is a "Mac-centric" document, but many of the tips apply to digitizing video under Windows as well.

Capture Tips

1. Make sure your source is clean and as high up the standards ladder as possible. For serious retail CD-ROM productions, try to get Betacam SP. See Chapter 11 for more information on tape standards.
2. Use S-Video over composite. Again, refer to Chapter 11 for further details.
3. Adjust your levels carefully using the software that works with your capture card. For example, make sure the black areas in your video digitize as pure black pixels (many black-appearing regions are actually dark-colored noise).

The same goes for the white areas. This will have a big effect on frame differencing efficiency. We also suggest that you experiment with the contrast and saturation controls extensively to bring out your video's best color qualities.

4. Capture at a bigger frame size than your final movie will be then scale down offline. Most Mac digitizer cards do not do as good a job as QuickDraw (or third-party software such as After Effects) when reducing the frame size. Under Windows, this is not such a clear cut issue, but you should experiment with it if you have the time.
5. Capture using the QuickTime JPEG compressor at the highest quality setting. This tip sounds good in principle, since anything you lose (which is not all that much) will not be useful to CinePak anyway when you convert later. The problem is, you can't capture enough frames in real time using Apple JPEG, and using it with GrabGuy often causes so much playing and rewinding of the tape that tape stress causes bad frames. Consequently, it only really works where you are capturing from laser disc.
6. Capture audio at 22.05kHz. This is a good idea in general, but not for perfectionists. What you really want to do is capture at 44.1kHz, then use a digital audio editor to buff the sound, downsampling to 22.05kHz or 11.025kHz in the final MovieShop session. This technique is covered in Chapter 25.
7. Get the frame rate right. Basically, the message here is that if your source was originally shot on video (30 fps) your captured movies should have frame rates of 10 or 15 fps for best performance. If your source was shot on film (24 fps), you should digitize movies at 12 or 24 fps (not really an option for software-only playback). This rule is especially important when capturing with GrabGuy.

Compression Tips

8. Get the frame size right. Essentially, this means that 160-by-120 is the best frame size for the Apple Video compressor, while 240-by-180 is optimal for CinePak (as of this writing). If you are using CinePak, it is important that your frame dimensions are multiples of four for best performance.
9. Use the Compact Video Compressor. Now called CinePak, this compressor is optimized for CD-ROM playback—so

much so that it has built-in data rate limiters. Unfortunately it is highly asymmetric. In other words, it can take a couple of hours to compress a minute of video on a Mac IIci.
10. Use MovieShop. This Macintosh program is almost required now for processing movies that will play from CD-ROM. See Chapter 24 for a full discussion of MovieShop.

MovieShop Tips

11. Get the data rate right. You'll have to make your own decisions here. All we can do is give you the background: The place where you adjust the data rate on the Mac is MovieShop. Under Windows, you use VidEdit. Data rate adjustment is crucial for playback from CD-ROM. For single speed drives, 90 kbs is recommended. For double-speed drives, 150 kbs seems to be a safe plateau, but you should experiment with higher rates. As for the brand new (as of this writing) triple speed drives, we haven't done enough testing to comment reliably. Some reports we've heard say you can go as high as 300 kbs.
12. Video Settings. This point pertains to MovieShop's Video Quality Preferences dialog. Again, please see Chapter 24 for a full discussion of how to use MovieShop.
13. Sound Settings. This item concerns MovieShop's Sound Preferences dialog. As noted in tip number 6, you should keep your audio quality as high as possible for as long as possible. Since we are discussing using MovieShop here, and thus talking about final compression, the choice is between 22.05kHz and 11.025kHz. For video that has music in its soundtrack, we recommend 22.05kHz audio. If your soundtrack is only speech or background noise, 11.025kHz will probably suffice.

The *Video to Sound* control has caused some confusion. What it does is specify how much sound data is placed at the start of the movie so that audio is smooth when the movie starts rolling. It does not affect the interleaving frequency, which is normally set by QuickTime to half-second chunks every half-second, so that there is a second's worth of sound for every second of video. MovieAnalyzer will confirm this. You must, however, check the *Interleaved sound* box. Ex-

perimenting with it unchecked will quickly show you why, particularly in longer movies.
14. Scaling and Cropping. Also under MovieShop's *Preferences* menu, this dialog allows you to change your movie's frame size or slice pixels off the edges. Once you really get into making movies, you might start doing a lot of cropping—to concentrate more on your main subjects. The original version of *15 Steps to Better Movies* recommends that you crop the edges of your final production to eliminate noise and jitters. We agree, and recommend that you actually capture at a frame size eight pixels larger in each direction than your final window. Then, when you shop your movie, crop off four pixels from the top, bottom, and each side. For example, capture at 248-by-188, then crop four pixels all around to get down to 240-by-180. Remember that your final dimensions must be in multiples of four to get optimal performance from CinePak.
15. Methods. This relates to the *Methods* dialog. Once again, please see Chapter 24 for more information.

Fixing Fresh and Damaged Movies

TO CREATE COMMERCIAL-QUALITY VIDEO, YOU'LL NEED TO HAVE A SYSTEM FOR INSPECTING YOUR MOVIES AND CORRECTING PROBLEMS AS YOU FIND THEM.

Even if you always capture with complete frame accuracy, you'll probably still need to trim a few frames off the beginning or end of any freshly digitized movie. And, when digitizing video for inclusion in a retail product, you will likely want to step through and inspect every frame for defects before you consider a clip ready for prime time.

It's good for you to have consistent approaches for these activities, and to correct problems as you find them. This chapter will show you some approaches to cleaning up new captures and fixing damaged movies. Whether you are working on a Mac or with Video for Windows (QuickTime for Windows is playback-only as of this writing), the basic ideas are the same. Manual processes are involved, and they require a careful eye.

Tedious as these tasks may sound, they often provide much of the satisfaction involved in digitizing video. The reason is because they border directly on the editing process. If stepping though video frames and appreciating how feelings and ideas

are communicated doesn't bring out a little of the film editor in you, you should think twice about becoming a desktop producer.

Working at the single-frame level with captured video can do a lot to clarify your feelings about the process. One question that comes up quickly is: Who are you trying to please with all your hard work? Because people have mixed expectations about desktop video (at least for now), should you worry that there is a tick in your sound track when you cut a damaged frame? Should you recapture a busy action sequence because your time base corrector let a minuscule ripple slip by?

The general answer is the same for any craft: If you are dissatisfied with your work overall, others will probably feel the same. If you have faith in your productions but worry about a few tiny flaws, people might not notice unless you point them out. In other words, perfectionists can easily find less nerve-wracking fields to work in than desktop video. It pays to work hard, but there are some rat holes you just don't want to go down.

In this chapter, we will cover:

- Normal cleanup of fresh captures on the Mac
- Repair of damaged captures on the Mac
- Normal cleanup of fresh captures under Windows
- Repair of damaged captures under Windows

Cleaning Up Fresh Captures on the Mac

If you do all of your capturing from within Premiere (or a similar program), your approach to handling fresh movies will be different than if you use one of the basic QuickTime utilities, such as MovieRecorder or GrabGuy. If you have the luxury of controlling a high-end video deck from Premiere with a product like the Selectra VuPort, you will be even more insulated from the harsh realities of clip grooming.

In either case, your movies can be effectively trimmed within Premiere by setting their in and out points—as opposed to

physically chopping off leading and trailing frames. When you tell Premiere to make a movie from its assembled clips, only the frames between the marked ins and outs are incorporated into the finished production.

Since most Betacam decks (and many of the better industrials) have some level of TBC (Time Base Correction), your chances of capturing damaged frames are low when working with these machines. When you hook up to one of them through a Premiere device controller, you generally won't have to touch the deck again. All tape transport functions can be handled through the VCR-like interface that pops up beneath your Premiere capture window.

You can start your tape rolling, click the capture button, stop the tape, and end the capture all in the same dialog. You can then drag the captured clip into one of Premiere's video tracks, where you can set the in and out points right away or redo them later. It's one of the beauties of digital video and a very easy way to work. Many producers adopt this method immediately and never look back. If you are one of them, you can safely skip the rest of this chapter.

Real Digitizers Don't Use Premiere

For the rest of us, there are the redoubtable MovieRecorder and GrabGuy (and the proprietary capture applications that come with most of the hardware-assisted JPEG boards). Actually, since this chapter is concerned with *cleaning up* captured clips, we will be more concerned with using MoviePlayer to *edit* captured movies. In the Windows section, we'll talk about using VidEdit in the same context.

Assuming you have just captured a clip with one of the basic QuickTime utilities, here is a check list for using MoviePlayer to review and manicure your freshly digitized movie:

1. If necessary, close the capture application and the open movie it just produced, making sure to save that new movie when prompted.
2. Double-click on the movie to re-open it under MoviePlayer.

Figure 23.1
Getting Information about a QuickTime Movie on the Mac

3. Select the *Get Movie Info* item under *Movie* in the main menu to check that the file size and frame dimensions are correct, as shown in Figure 23.1.
4. Play the movie all the way through once to check for any gross problems.
5. Position the buckle of the movie controller at the extreme left and play or step through the first dozen or so frames to see if you need them. Depending on your analog source, for instance, you may have a fade-in title that takes too long to materialize. You can edit out the fade-in frames by selecting and cutting them via the *Edit* menu.
6. Similarly, go to the end of the clip by dragging the movie controller buckle to the far right. See if you need to cut any frames there, or if your capture ended before you got all you wanted from the analog source (a creative decision).
7. Play the clip again to see if it feels right. Vary the volume with the movie controller and with your analog equipment (depending on your speaker system) while the movie plays to see if it might need digital adjustment later.
8. Starting with the first frame, use the movie controller to step through your movie one frame at a time. Look for images with ragged edges (TBC problems), black spots (tape dropout), and fuzziness at color borders (the dreaded chroma crawl). If you captured raw, all your frames will be key frames and should thus highlight these problems if they occur. If you do have problems, read the next section on clip repair. If you are satisfied with the clip, you should consider it a ready candidate for MovieShop.

These basic steps will help ensure that your captured movies can be pronounced *in the can*. As noted earlier, this sort of work can be quite pleasurable. It is engrossing (depending on the content, naturally) and often requires at least some degree of critical judgment. Best of all, doing it while your movies are fresh can save you time in the long run.

Repairing Damaged Captures on the Mac

Finding a damaged frame or frame sequence in the middle of an otherwise pristine movie can be quite dismaying, especially late at night or under a deadline. The reason it's a problem is that simply cutting even that single frame can cause a noticeable hiccup in the sound track, especially if there is speech at that instant or, worse, music—especially with vocals.

The movie named HICCUP.MOV on the companion CD-ROM is a short clip taken from a larger music video, from which we have removed a single frame. You should be able to hear this timing glitch easily when you play the clip, even though the video track is apparently unaffected. Such are the vagaries of time-based digital media.

As the title of this section suggests, there are ways around these problems, if you are willing to proceed carefully. Doing the job right can be fairly painstaking. Unlike trimming and inspecting fresh captures, it is often *not* a fun process (unless you're being well paid by someone who doesn't know how to do it).

The very first thing you should do is try to recapture the clip. Unfortunately, this may not always be possible. The Betacam deck you paid for by the hour may be on its way back to the rental store, or the movie may have been given to you by a third party who was unaware of the problem. If you are stuck with going with what you've got, you can approach the problem from three basic directions: single-frame replacement, adding a new sound track, or editing the sound track digitally.

Single Frame Replacement

To fix a clip that has only one or two damaged frames, follow these steps:

1. Make a copy of the movie that needs the surgery. Hey, it's digital—the copy will be perfect! Do all your work on the copy. Since Mac naming conventions accept long text strings and blank spaces, put the word *copy* in the new filename.
2. Scrub to the bad frame in the copy. *Cut* the frame to the clipboard (do not *clear* it).
3. Back up in the movie five to ten seconds and play it past the cut. Maybe you'll be lucky and the effect on the sound track will be negligible. If you are a musician or an audiophile, this is unlikely. Listen to it a few times to be sure. *Undo* and *Redo* the cut a few times to be even more sure.
4. If you can't live with the absent time slice, advance the movie controller one frame in either direction (forward or backward) from the cut and copy that frame to the clipboard. Position the movie controller to where the bad frame used to be and insert the copied frame there.
5. As in Step 3, move back a ways and play over the insertion point. Again, maybe you will get lucky: The timing will be restored and the inserted clip will have carried no distinctive audio qualities. More likely, you will hear a tick as the sound samples in the new adjacent frames fail to mesh nicely. If it *does* work, you're done. And consider yourself lucky. Remember to try copying frames on both sides of the removed frame.
6. If you are still unsatisfied, you face the question mentioned earlier. How much is it worth to you to continue in this vein in search of excellence? What if the tick noise is just barely audible? Can you allow one such imperfection but not ten? In our product, we had these exact problems. The noticeable ones we fixed by adding a new sound track (which we'll describe next). The barely noticeable ones are still in there. Our customers think our movies look and sound good—considering that they are desktop video. The movie DUPFRAME.MOV on the CD-ROM is a version of HIC–CUP.MOV that contains a duplicated frame with a mildly noticeable tick.

Adding a New Sound Track

If you have a lot of damaged frames, the above approach won't suffice on its own. It *is* a viable way to repair the video track, but the audio track will be unacceptable with too many battle scars. What would be nice is if you could lay in a sparkling new audio track and lift out the old one—as long as the new one fit perfectly. As it turns out, you can—with Premiere. Other movie-editing software is capable of this also, but we have the most experience with the Adobe product. Here are the basic steps:

1. Make a copy of your original movie with the damaged frames intact. Name it as we suggested in the previous section.
2. Cut the bad frames out of the original movie and paste in copies of the adjacent frames, making sure it has the same number of frames when you finish as it did when you began. Don't worry if the sound track is affected adversely.
3. Open Premiere. Import the original movie and drag it into the first video track slot. When it seats in, delete its sound track (the bad one).
4. Import the copy (with the original, unedited sound track). Seat it in the second track slot, then remove its video track.
5. What you should have left is a good (repaired) video track and an untouched sound track that fit together like the original sound and video tracks. Set your encoding parameters and tell Premiere to make you a movie.

Clearly, you must already have an application like Premiere to fix a movie in this manner. If you are—or are going to become—a desktop producer, it is a fair assumption that you will eventually procure such a sophisticated editing package for your arsenal. For the record, the process of adding a sound track just described is just scratching the surface of the capabilities of products like Adobe Premiere and Avid VideoShop.

Editing the Sound Track Digitally

If you really want to have fun, you can edit the sound track digitally before adding it back to the video track. You can do this with a high-level program like DigiDesign's Pro Tools, or a lighter weight application such as Macromedia's Sound Edit

Pro (we are still talking about the Mac). The market is beginning to expect high-quality audio from desktop video products, and the tools are available to achieve it. In Chapter 26, we will discuss in more detail how to make movies sound better with digital audio tools.

Cleaning Up Fresh Captures Under Windows

Like on the Mac, if you capture under Premiere for Windows or a comparable program, your method of dealing with new clips will be different than if you digitize with a standalone capture program like VidCap or SmartCap. Earlier in this chapter, we detailed these differences. (Note, however, that device control of VTRs from within Premiere for Windows has not been implemented as of this writing.)

Real Digitizers Don't Use Premiere for Windows, Either

We'll repeat our check list for examining and pruning a just-captured movie. This time we'll be using VidEdit instead of MoviePlayer.

1. Start up VidEdit and open the appropriate movie from the *File* menu.
2. Start up your mixer program of choice and either manually calibrate it or open a saved file with good settings for AVI movie soundtrack playback.
3. Select *Statistics* under *Video* in the main menu to check that all of the movie's attributes are correct.
4. Play the movie all the way through once to check for any gross problems.
5. Position the buckle of the movie controller all the way to the left and play or step through the first dozen or so frames to see whether you need them. Depending on your analog source, you may have a fade-in title that takes too long to materialize. You can edit out the fade-in frames by selecting and cutting them via the *Edit* menu.

6. Similarly, go to the end of the clip by dragging the movie controller buckle to the far right. See if you need to cut any frames there, or if your capture ended before you got all you wanted from the analog source (a creative decision).
7. Play the clip again to see if it feels right. Vary the volume with your onscreen mixer and your analog equipment (depending on your speaker system) while the movie plays to see if the sound track might need digital adjustment later.
8. Starting with the first frame, scroll through your movie one frame at a time. Look for images with ragged edges (TBC problems), black spots (tape dropout), and fuzziness at color borders (chroma crawl). If you captured raw, all your frames will be key frames and should thus highlight these problems if they occur. If you do have problems, read the next section on clip repair. If you don't, and you are satisfied with the clip, you can assume it is ready for recompression with data rate limiting.

These are the fundamental steps to ensure that a movie captured under Windows can be considered ready for the public. Again, this sort of work can be pleasantly absorbing and, depending on the content, demanding of aesthetic discrimination. Like on the Mac, cleaning up it things while they are fresh can save you time in the long run.

Repairing Damaged Captures under Windows

Since the method described earlier for repairing individual frames in Mac movies is conceptually the same under Windows in terms of cutting and pasting, we won't repeat it here step by step. If you have an AVI movie infected with bad frames due to TBC problems, dropout, and so forth, refer to the Mac section earlier in this chapter for a detailed solution, as well as for how to add a whole new sound track using Premiere for Windows.

Fixing Problems in QuickTime for Windows Movies

As we have noted, QTW is currently playback-only. What this means from a practical standpoint is that you can't easily create or edit QuickTime movies on a PC like you can on the Mac with programs like MovieRecorder and MoviePlayer (where you can cut, copy, and paste frames into new movie files).

Of course, you can use a powerful editing program like Premiere for Windows to output movies in the QuickTime file format, but this is more the exception that proves the rule. You can't edit out bad frames with the player that comes with the runtime version of QTW. By design, the current version was only meant to allow movies created on the Mac to be played under Windows.

With this in mind, fixing problems in QTW movies on the PC should be viewed as a non-issue until these movies can be created and edited on the PC by design—with the assurance that they will play just as well on the Mac. In the meantime, you can use programs like Premiere for Windows to output QuickTime movies, (but don't be surprised when they behave strangely, especially when ported back to the Mac).

Using MovieShop and MovieAnalyzer

HERE'S YOUR CHANCE TO LEARN HOW TO USE MOVIESHOP AND MOVIEANALYZER TO OPTIMIZE YOUR MOVIES FOR PLAYBACK AND TO TROUBLESHOOT THEM.

Until recently, MovieShop and MovieAnalyzer constituted a single entity—MovieShop. The developer, George Cossey, has seen fit to split that original program into two leaner and meaner applications, each of which will continue on its own upgrade path. The latest released versions are MovieShop 1.1.4 and MovieAnalyzer 1.1.3.

At the end of this chapter, Mr. Cossey will present his view of the role of each application in readying QuickTime movies for public consumption, and where you might find bugs in the most recent versions. In the meantime, we'll try to give you the benefit of our experience, which we have submitted to Mr. Cossey for review.

One of the many ironies of the Apple world is that MovieShop is not officially supported (neither is GrabGuy, for that matter).

Given that it was included in the distribution package for each new QuickTime developer's upgrade, and that *shopping* a movie (using MovieShop to process it) is considered essential prior to its commercial release, it is hard to understand why Apple's full faith and credit have not been extended to the product(s).

We can only hope that MovieShop and MovieAnalyzer will soon be brought in from the cold and turned into the profit centers they deserve to be. While we're on the subject, it would also be nice if there were similar programs for AVI movies. The market is definitely out there and set to expand dramatically as more AVI movies get pressed onto CD-ROM.

In this chapter, we will cover:

- How to use MovieShop
- How to use MovieAnalyzer
- How the author of these programs feels about them

Using MovieShop

The main purpose of MovieShop is to optimize movies for playback off of CD-ROM. This idea is underscored by the fact that, at its most sublime, MovieShop requires only that you supply it with a data rate (to impart to the resultant, optimized movie). Using it solely at this level, however, belies its true power.

What seems to confuse most people about MovieShop is that it gives them so *much* power over how their movies perform. They see all the options available in the *Methods* list and they wonder how they can find the time to know what combination is best—especially since the descriptions of these methods suggest that an in-depth knowledge of movie composition is necessary.

Consequently, our approach is to focus on the desired attributes of a finished movie and how to use MovieShop to achieve those attributes. We hope this approach will inspire more confidence than just saying, "here, do this, and your movies will play better." After creating some sample movies, we'll examine them with MovieAnalyzer to see if we got what we wanted.

Getting Off Easy

As noted earlier, it is a completely valid approach to run MovieShop at its default settings and never think twice. The performance of your shopped movies when playing from CD-ROM will be smooth and the audio should be unbroken. If that is all you are after, you don't need to read much further in this chapter.

From MovieShop's primary interface, just import the movie you want to shop and press the *Make the movie* button, shown in Figure 24.1. (Check that your target compressor is correct first.) You can watch the program work if you are interested or come back later when it's all done. If your target movie is CinePak format, it could be *much* later. Source attributes like frame rate and audio quality will be preserved in the resultant movie if you take this simple approach.

As you can see in Figure 24.1, the default data rate is 90 kbs. While this setting will be fine in almost all cases, there are a couple of details worth noting. First, the number is derived from the *sustained* performance delivered by single-spin CD-ROM drives. Second, not everyone agrees on this number. Some will insist that it can be much higher—even as high as the *peak* single-spin rate (150 kbs). They are mistaken.

In the documentation for MovieShop, Mr. Cossey states that movies compressed with Apple Video at a data rate of 90 to 95 kbs will play adequately off an Apple SC CD-ROM drive connected to a Mac LC.

He goes on to say that using the Compact Video (now CinePak) codec will allow you to up this number to 100 kbs. This increase

Figure 24.1
MovieShop's Main User Interface

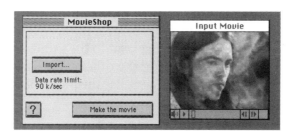

is because the CinePak decompressor is faster than the Apple Video decompressor, so there is more time available to spend reading the data off of the CD-ROM.

A Report from the Field

We can substantiate these figures by reporting on the performance of the first edition of our CD-ROM, *Canyon Clipz*, which contained over 50 movies compressed with Apple Video and uniformly shopped at 90 kbs. Whether played on Macs or Windows machines (our product is cross-platform), the movies performed quite well from single-spin drives.

Of course, MovieShop had to blur them slightly in getting the data rate down. But even on 386SX-20 machines (the minimum hardware standard for QTW 1.0) the movies play smoothly and don't drop any audio data. The same holds true when we play them on a Mac IIci.

For the latest edition of our product, we remastered all the movies using the CinePak compressor. Although we raised the audio sampling rate to 22.05kHz and made the movie window 240-by-180 (as opposed to 160-by-120 with 11.025kHz audio for the first edition), we kept the data rate at 90 kbs for all the movies when we shopped them.

Although the documentation said we could go to 100 kbs, we didn't want to mess with success—especially since many of our movies have music that would not suffer audio dropouts very well. The results were very good. In fact, the movies actually look and sound much better than the 160-by-120, 11.025kHz versions.

Developers we talk to say they routinely test shop their movies at the high end of this 90 to 100 kbs range to squeeze out every last bit of performance. In these data flow restricted times, we recommend that you do the same. After a while you will notice a difference. On the other hand, if you just want to get it over with and move on, use the MovieShop defaults and don't worry about it.

Shedding the Weights

Even when you are not bound by CD-ROM data rates, it is still a good idea to shop your movies, if only to guarantee they are properly homogenized. Mr. Cossey suggests a data rate of 300 kbs for movies that will only be played from hard drives, and you will see much better image quality at this data rate. He also states that a rate of 900 kbs will ensure no loss of quality from the original raw format. This is an easy number for the newer IDE hard drives to handle.

Some good news is that with the triple-speed drives that are just coming out, a 300 kbs sustained data rate is now possible for CD-ROM playback. Double-speed drives boast this rate for peak performance, but the sustainable pace is often down in the low 150 kbs range. In other words, as good as your movies look at 300 kbs off your hard disk, they will now look as good when playing from triple-speed CD-ROM drives. Of course, they will still shine by comparison when played at 900 kbs.

The Beauty of CinePak

Let's get our bearings here for a moment. You now know that you can use MovieShop pretty much as a one-button program for all your movies. We also promised that we will explain how to use the program at its deeper levels, which is coming up. What we need to do first is talk about a fortunate anomaly: using MovieShop on CinePak movies.

CinePak is a so-called *intelligent* compressor. This means it has built-in routines for data rate reduction while at the same time preserving image quality. The consequence is that none of the *Methods* available in MovieShop for reducing the data rate need to be agonized over. All you have to do is follow these steps:

1. Check the box labeled *Prefer Natural key frames over forced key frames,* shown in Figure 24.2. In older versions of MovieShop, the methods are presented as numbered items in a list box. If you have an older version, simply make sure the first three items in the list are numbered 1, 8, and 18. Anything below 18 is disabled.

Figure 24.2
The MovieShop Methods Dialog

2. In the *Special* box, a number will appear when you mark the box discussed in step 1. Make sure it is the default, which should be provided automatically. (The default is suggested by some text in the *Special* box.) In the new version of MovieShop, this number is expressed as a percentage. In earlier versions, it is an integer recommended to be around half of the key frame rate that you can set in the *Video Quality Preferences* dialog.
3. In the *Video Quality Preferences* dialog, make all the *Maximum* values 1023 and all the *Minimum* values 1. This will ensure that CinePak does the best job possible.

Unless you want to change the frame rate, the audio quality, or make the movie cross-platform, you can now click the *Make the movie* button. These other options are discussed in the full MovieShop treatment. Kind of nice, isn't it? Since CinePak is likely to rule the software-only codec roost for a while, your MovieShop Ph.D. can be an honorary degree. For further information on how MovieShop actually works with CinePak movies, we recommend that you read Mr. Cossey's documentation.

The Guts of MovieShop

If you have read this far, we'll assume you are interested in the satisfaction of knowing how your movies are organized internally. As noted earlier, this requires going further into the program. A workable analogy here is hiring a professional building

contractor to construct a house for you (assuming, of course, that he or she is reputable).

If you know nothing about home construction but do have some ideas about how a livable dwelling should look and feel, you can simply tell the contractor to call you when it is finished. Based on the look and operation of the finished house, you'll soon know if you got your money's worth. We have already covered this part of the analogy (treating MovieShop as a one-button program).

If you also happen to be an architect, you will probably want to tell the contractor what kind of materials to use, how to handle the wiring and plumbing, and where to add special reinforcement. As you continue to occupy the dwelling or make subsequent alterations to it, the detailed knowledge you have about how it was constructed may provide additional benefits. Or maybe you just like visualizing how the house was put together from time to time.

Using our knowledge of movie internals gained from Chapters 16, 17, and 18, we can create movies structured in ways that will deliver optimal performance under most conditions. You can now apply some of these construction principles to your CinePak movies if you wish.

If MovieShop will produce a movie based on our design, then we need ask nothing more of it. And, we can use MovieAnalyzer to confirm that the job was done correctly. (If we bring the movie over to a Windows machine, we can use our PC-based utilities for additional verification.) Approaching MovieShop in this manner does a lot to mitigate its power of intimidation. Our criteria are:

- Key frame frequency
- Quality/data rate settings
- Platform independence

Welcome to the Machine

The first two criteria are geared to one purpose: ensuring as uniform a data flow as possible to QuickTime. What wreaks

havoc in nonshopped movies are data spikes (such as multiple key frames in a row or sound chunks next to key frames) and track changes (which incur housekeeping overhead).

The third criterion determines whether our resultant movie will be playable on nonMac computers—specifically, on the Windows platform. In the new MovieShop, you can enable this feature by checking the box labeled *Single fork movie, platform independent* in the methods dialog shown in Figure 24.2. Unfortunately, the latest version we have tested, MovieShop 1.1.4, crashes at the end of its processing cycle when this box is checked.

In older versions, some people think you can achieve platform independence by checking a box labeled *Single fork movie* (also in the *Methods* dialog). Unfortunately, the results in this case are not 100-percent reliable when it comes to playability on Windows machines. As noted earlier, the tried-and-true method in the early days was to use MovieConverter for this purpose—a practice we still highly recommend. Unfortunately, MovieConverter only shipped with QuickTime 1.0. The ComboWalker program, included on the QuickTime 1.5 Developer CD-ROM, also seems to be good for this purpose, although we have not used it extensively.

In any event, since we know the movie attributes we want control over, let's try plugging in some actual values. We'll take a movie that isn't built just how we want it, examine it with MovieAnalyzer to be sure, run MovieShop on it with our desired settings, then look at it again with MovieAnalyzer to see the changes.

We'll also run MovieShop on it with just the data rate set (the one-button approach) to see how this differs from the other two examples. For the record, we will use MovieShop version 1.1.4 and MovieAnalyzer version 1.1.3. If you plan on being a control freak when it comes to movie internals, we salute you.

First, let's capture a movie. We'll use GrabGuy to capture a short, raw, 10 fps, 160-by-120 movie with 22.05kHz sound. This movie is on the companion CD-ROM (24-1-RAW.MOV). Because the movie is raw, we will expect it to contain all key frames of equal size and sound chunks interleaved by default (a half-second chunk every half second).

Every Picture Tells a Story

Next, let's run MovieAnalyzer and import the captured movie (24-1-RAW.MOV). For the purpose of this example, we'll only use a few of MovieAnalyzer's features. The full treatment, described later in this chapter, will provide information on all its capabilities. From the main user interface, we can click the *Play* button to display some graphics showing the movie's frame organization, individual frame sizes, and data rates.

Figure 24.3 shows what these graphics can look like. (The *Play Comments* dialog will also appear, which you can dismiss for now.) What we are looking for are key frame frequency, audio interleave frequency, and data rate levels (platform-independent status doesn't matter here). These will be our baseline standards to compare to the other examples.

Since we captured raw, all the frames are key frames with sound chunks occurring at the expected positions. Although MovieAnalyzer provides several types of data rate indicators, the one we are interested in is shown by clicking the second check box in the first column of check boxes (*Data rate*).

Figure 24.3
MovieAnalyzer's Playability Dialog

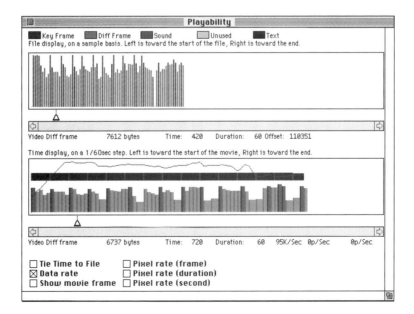

Checking this box causes a horizontal blue line to be drawn over the tops of the green frame bars. Note the frame size and data rate readouts under the scroll bar when the slider is positioned under individual frame ticks. Each of the full frames is in the 10K to 14K range, with the data rate varying from roughly 100 kbs to 140 kbs (not surprising, since our frame rate is 10 fps).

With this control group established, lets now run MovieShop. Our settings will be:

- Key frame frequency: Every five frames
- Data rate level: 95 kbs (the default)

Now comes the interesting part: methods and quality settings. This is where newcomers to MovieShop often get overwhelmed. The overview is that MovieShop wants to achieve your data rate but it needs to know your image quality standards, which are subjective. Remember that this is not an expert system. Do you want it smooth and blurry or jerky but sharper? Most likely, you want some of both.

A particularly murky area is the distinction between *Spatial* quality and *Motion* quality. Spatial quality has to do with how individual frames are compressed. Motion quality determines frame differencing. You will have to make separate decisions for each of your movies if you want to use these controls effectively.

Let's consider the example of a close-up of a person's face. If the *Spatial* quality is set low, then the face will be blurry. If it is set high, the face will be sharp and clean. Now let's say that the face winks one eye at us. If the *Motion* quality is low, that difference in the full image will not be noticed by the compressor and the resultant movie will not contain the wink.

If the *Motion* quality is higher, it will raise the threshold used by the compressor in finding differences from one frame to another. Consequently, the compressor will see the changes around the eye and they will be in the resultant movie. The drawback is that the amount of data for that frame is greater and the movie data rate has to go up.

Another Balancing Act

As you can see, we are once again entertaining the idea of the balancing act. What's worse, *you* are arbiter of taste and may have to do some field tests to get the best results. This will probably involve shopping your movies a number of times to get the right combination of methods. Once again, all hail CinePak (for freeing us from this tedium).

You can actually circumvent some of this trial and error by lowering the frame rate outside of the *Methods* dialog (using the *Frame Rate* menu). This is a good place to experiment when you are using CinePak. In nonCinePak cases, however, choosing your methods and quality settings carefully will allow you to fine tune your performance results a little closer.

MovieShop can be harsh if you let it. You can specify that it simply remove adjacent, identical frames, or even nearly identical ones. You can let it have carte blanche in simplifying frames that it thinks will cause spikes in your data rate. At this point, you can start to sense the power of the program.

If you are willing to learn how to use MovieShop as it was intended, you can effectively tell it to do the following:

- Keeping a running data rate level, go through the movie and compare each frame to the one that preceded it.
- If a frame is identical to the previous one, get rid of it (a big data rate improvement).
- If the frame is different, try to simplify it instead (an okay data rate improvement). Just don't simplify it more than you're told—although you can completely mangle the frame if you're given zero as a minimum standard.
- If you still can't keep the data rate down, just bump the frame anyway.
- Use the specific criteria provided in making these decisions.

This is the critical path for MovieShop operation when the compressor is not CinePak. Again, the bottom line is experimentation. If you bear the above methodology in mind when you ponder the descriptions of the methods and the video quality settings, suddenly everything will make sense.

As MovieShop does its work, it also recompresses the movie using a codec that you specify. Conceptually, shopping a movie is a form of compression, since the resultant file is smaller, but the QuickTime compression algorithms work in significantly different ways. One quick point of reference is that a movie can be processed four ways: raw and unshopped, raw and shopped, compressed and shopped, or compressed and unshopped.

Returning to our example, let's now calibrate our methods and quality settings prior to running MovieShop. For this illustration, we'll go for a middle-of-the-road effect. Clicking the *Default* button lights up the default settings: all of the above processes. In the *Video Quality Preferences* dialog, as shown in Figure 24.4, we'll also go with the defaults.

Now we can run the program. For convenience, we have also included the shopped version of 24-1-RAW.MOV on the companion CD-ROM. It is named, appropriately enough, 24-1-MS.MOV. If you choose to run MovieShop on 24-1-RAW.MOV yourself, you should look at the status line while the individual frames are being processed. MovieShop will tell you what it is doing to each one.

With our shopped movie now in hand, let's compare it to its raw cousin on an apples-to-apples basis, again using MovieAnalyzer.

Figure 24.4
MovieShop's Video Quality Preferences Dialog

- *Key frames*. In the raw movie, they were all key frames. In the shopped version, every fifth frame is a key frame, just as we specified, except for when there is a natural key frame (a frame substantially different from its predecessor, like a jump cut or a scene change).
- *Audio interleave*. In the raw movie, the sound chunks were evenly spaced. In the shopped version, they're slightly less regular in an attempt to move them away from key frames.
- *Data rate*. Checking the *Data rate* box will draw you a line showing the fluctuating level. In the raw movie, the average was between 100 kbs and 140 kbs. In the shopped version, the figures range from the high 80s to the low 90s. You can move the slider around to confirm this.

As far as the movie looks, you'll have to be the judge. Too blurry? Up the minimum quality settings. Too jerky? Don't let it kill frames. If you are not going to be using CinePak as your exclusive compressor, you should find some time to experiment with these and similar types of performance scenarios.

As a final example, let's do the one-button approach on our raw movie, again using a target data rate of 95 kbs (and the Apple Video compressor). For completeness, we'll throw away the MovieShop Prefs file. Although an already-processed version of the resultant file is included on the companion CD-ROM (24-2-MS.MOV), you can shop it yourself if you'd like. Running MovieAnalyzer on the CD-ROM version will reveal the following:

- *Key frames*. Noticeably fewer than in 24-1-MS.MOV.
- *Data rate*. Generally the same as 24-1-MS.MOV.

This is the extent of MovieShop's magic. The hard part is getting in the mood to do the trial-and-error work if you are not going to use CinePak. We hope you take some time to look at all the options the program has to offer, since you will ultimately have to depend on it for making your CD-ROM-based productions shippable.

A couple of tips before covering the menu items in detail:

- To reset *all* of your MovieShop settings, simply erase the MovieShop Prefs file.

- Remember that reshopping previously shopped movies is like making a copy of a copy with a Xerox machine. You should only run MovieShop once on a given movie, keeping your source quality as high as possible until then.

The File Menu

Input Movie: Does the same thing as *Import* in the main interface dialog, which opens a movie for shopping. Multiple movies can be open at the same time.

Close: Closes the selected input movie.

Page Setup: Presents the user with the standard *Page Setup* dialog.

Print: Prints the movie frame currently showing in the highlighted movie window.

Quit: Exits the program.

The Edit Menu

Undo: Reverses an edit action.

Cut, Copy, Paste, Clear: Implemented for standard DA support, but not used directly by MovieShop.

The Movies Menu

Output Movie: Toggles the focus to the shopped movie, if there is one open.

Input Movie: Toggles the focus to the input movie.

Show Poster: Displays the poster frame (if one has been set) of the movie with the focus. Otherwise, the first frame in the selected movie is displayed as the default poster.

Set Poster: Sets the poster frame for the movie with the focus. Move the thumb of the movie controller to the movie's desired frame and select this menu option.

The Preferences Menu

Video settings: Used to pick your quality standards. You also set color depth, key frame spacing, and compressor choice here. The check box for *Use previous compressed video* is slightly more complex. As we saw in Chapter 18, frame differencing compressors work by comparing the current frame to the previous

frame, then compressing based on the difference. Since a given compressor may compare the current frame to either its actual predecessor or what its actual predecessor was compared to, different results are possible. Leaving the box checked is recommended, although (of course) experimentation is encouraged.

Sound settings: You can use this dialog to set the quantity of sound chunks placed at the beginning of the movie, and to change the audio sample rate.

Cropping: Lets you resize and crop the edges of your output movie.

Methods and data rate: As discussed, this is where you make some of the major trade-offs between clarity and smoothness. You also set your data rate here and enable platform independence (essentially, playability on Windows machines). The *Special* box allows you to supply additional parameters to selected methods.

Show decompressed: Essentially, this dialog box allows you to speed up processing. If you do not show the decompressed image (the one just compressed by MovieShop), it will process the movie faster than if you do. This can be useful for long movies and batch jobs when you don't need to watch MovieShop work.

Log details: Creates a log file with detailed information about how a movie was shopped.

Reset preferences: Returns to the defaults (just like killing the MovieShop Prefs file).

Program debugging: Added to ferret out those hard-to-reproduce problems. With this option enabled, MovieShop will enter the debugger to generate error messages if errors occur—as opposed to handling error conditions and doing the best it can.

The Frame Rate Menu

Allows you to change the output movie's frame rate, or use its natural frame rate.

The Batch Menu

Lets you select a group of movies to shop in unattended batch mode, presumably overnight, all with the same settings.

The Sound Menu

This menu has evolved significantly from the older versions of MovieShop. You can now shift a movie's sound track forward or backward in thirtieth-of-a-second increments (useful for lip-synch problems) and also shorten or lengthen the audio associated with a video frame. These features were added to handle sound sampling errors Mr. Cossey observed using different equipment. For example, when movies lasting 45 to 60 minutes were captured, they would play fine for the first 75 percent, but then start slipping out of synch with the audio track—basically due to sound sampling errors. The items in this menu allow you to compensate for this.

Using MovieAnalyzer

When MovieAnalyzer was part of MovieShop, the perceived learning curve for the original program was even steeper. On its own, it seems disproportionately small compared to the now-standalone MovieShop. Nevertheless, it is an invaluable (and currently one-of-a-kind) program for graphically analyzing QuickTime movies.

The real value of MovieAnalyzer is as a troubleshooting tool, although it is also interesting to use it as a reality check on all of your movies. For clips that have been processed with Movie-Shop, the really useful graphics are in MovieAnalyzer's *Playability* dialog. Since shopped movies consist of only a single video and audio track, the graphics in the other dialogs aren't nearly as rich.

We believe it is a very good idea to have a working familiarity with MovieAnalyzer. We have solved some important problems, both for ourselves and for other people, by having MovieAnalyzer handy for a quick look under the hood of a badly performing movie. It is a fact that movies can be output by applications that build them incorrectly, especially when multiple tracks are concerned. To give you some help in mastering this program, we would like to quickly run down the various controls for using MovieAnalyzer to its best advantage.

The Menu Bar Items

Under *File*, there are the standard *Open Movie, Close, Print*, and Quit items. *Page Setup* presents the user with the standard *Page Setup* dialog. Selecting *Open Movie* does the same thing as clicking the *Import* button on the main user interface. As with MovieShop, more than one movie can be open at the same time.

Under *Edit* are the expected *Undo, Cut, Copy, Paste*, and *Clear* items that allow you to manipulate selections in the currently selected open movie.

The first five items under *Info* (*General Info, Tracks in Movie, Data in File, Edits*, and *Playability*) do the same thing as the corresponding buttons on the main user interface. *Play Comments* shows you an information window with categorized diagnostic messages based on clicking the *Play* button or selecting the *Playability* menu item. *Explain Comments* provides explanations for each type of diagnostic message generated in the *Play Comments* information.

The *Movies* menu shows a list of the currently open movies, and allows you to select among them.

The Info Button

Brings up a dialog with a lot of metric information about the selected movie, such as file size, frame size, creation date, number of tracks, preferred rate, volume setting, and so on.

The Tracks Button

Invokes a fairly simple graphic of the audio and video tracks in the movie, and allows you to view them in expanded or condensed formats. This feature is of much more value when there are more than two tracks in the movie.

The File Button

Displays a bar graph-like view of the composition of a movie file in terms of audio and video media types. Good for a quick diagnostic overview.

The Edits Button

Shows you graphically where the various edits are in the selected movie (assuming there are some). If there aren't any, this dialog won't appear too interesting. The *Edits* button is more useful than the *Tracks* and *File* buttons.

The Play Button

The most substantive feature of MovieAnalyzer. As we saw in the examples when we were looking at MovieShop, a movie's most significant attributes can be examined in the dialog that this button invokes. Two views of the selected movie are presented: a file composition view and a time view. Different media types (audio, video, text) are color coded for easy reference.

This is where you can do your most serious diagnostic work if you are investigating a poorly performing movie. One thing to remember is that when you first bring up this dialog, you have to drag the triangle-shaped markers under each of the two graphs to start seeing specific data about frames and time positions.

Using ComboWalker

ComboWalker, shown in Figure 24.5, is worth mentioning here because it can perform a couple of very useful functions that MovieShop cannot. For instance, you can add (or remove) a custom icon to your movie, or attach a preview. Like with MovieShop, you can also set your interleaving ratio, flatten your movie, make your movie datafork only (in effect, playable on both Macs and PCs), and set the poster frame.

You can also *walk* your movie (put it through its paces) with user-configurable settings to monitor performance under different conditions. While not a substitute for MovieShop, ComboWalker is nevertheless an extremely useful tool for certain MovieShop-like functions. It's real strength, of course, is in batch-processing movies and still images. We suggest that you run it through its paces to get a complete picture of its utilities.

Figure 24.5
Using ComboWalker to Make a Movie Cross-Platform

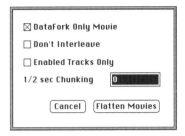

A Few Words from George Cossey

The following text was given to us verbatim by Mr. Cossey, who has generously allowed us to reproduce it here:

MovieShop tries to fill two vastly different needs. It tries to make movie processing very easy for the person that wants the *one button* approach. It also tries to provide a great deal of power and control for the person that wants all the control that he or she can get over the movie making process.

The main goal of MovieShop is to make data rate limited movies that play well from CD-ROM. Before CinePak, there were no compressors that did any data rate control at all. If you are using the Animation or Graphics compressor, or any of the others besides CinePak, then MovieShop is the only way that I know to limit the data rate to play the movie from CD-ROM.

CinePak has some nice data rate limiting in it, but it could be improved further. It does not have the ability to completely drop a frame, although the size of the data for an empty frame is very, very small. MovieShop still helps in eliminating extra key frames from the movie, at the cost of compression time.

The sound processing in version 1.1.4 of MovieShop handles the standard sound very well. This is 11kHz or 22kHz, 8-bit, non-MACE (audio compression), and mono. It can do 16-bit sound and also stereo, but this area is fragile and needs to be checked after the movie is made. Once support for the new

Sound Manager is added to MovieShop, it should be able to mix and translate all sound with no problems. This support should be added in a later version.

MovieAnalyzer was originally a separate program from MovieShop. This was before QuickTime was released. It was later merged into MovieShop to try to blend the diagnostic features with the processing features. As MovieShop grew into a fairly large and very complex program, I decided to break MovieAnalyzer out again. This has resulted in easier-to-maintain programs, as well as separating the basic making and checking features.

The only area that MovieAnalyzer is weak in (that I am aware of) is in checking very long movies (in the one hour range). Because of the memory requirements in displaying all this data, as well as the limits of controls to scroll larger than 32K values, some problems result in checking this long of a movie.

The thing that I had wanted most, and never really got, while doing these programs was feedback from the users of them. I got some bug reports, and a few people sent detailed questions and comments. But, on the whole, I hardly ever got comments back from users. If there is a program that you use a lot, then help yourself and everyone else by giving the developer feedback.

I have recently started working in other areas and am not working on MovieShop at this time. Please send all comments and questions about it to the Apple QuickTime group.

Making Movies Look and Sound Better

ONCE YOU HAVE CAPTURED YOUR MOVIES YOU'LL NEED TO DEVELOP A SET OF PRODUCTION TECHNIQUES TO MAKE THEM LOOK AND SOUND BETTER.

In the top ten list of tips to make your movies look and sound better, the first five are the same: Make sure your analog sources are of the highest possible quality. In the excitement of simply digitizing *anything* when you first get a capture card, it is easy to miss the importance of this maxim. Within a few months (or even weeks), however, it will become your most important rule. And once you follow that rule, you'll start appreciating footage that was shot *for* digitization.

You can feel the weight of this argument if you use a Betacam deck and digitize a few sequences off it raw, then encode them with CinePak or Indeo Video. Depending on the content, highly resolved (Betacam) compressed sequences look even better than the same sequences captured and compressed from, say, VHS. In other words, compressor degradation of movie frames gets disproportionately worse as source resolution decreases.

The same basic concepts apply for audio. As you become accustomed to observing desktop movies, both your own and those made by others, you will always know when the sound could be better. Again, the single best way to ensure the integrity of your final digital audio track is to start with a pristine analog source and, once it is digitized, keep its quality high as long as possible. Making this happen is similar but not identical to working with the video track, as you will see shortly.

The thrust of this chapter is to show you how to make movies look and sound better *after* they are captured. We'll assume you have already followed our basic recommendations, such as cabling with S-video (if your equipment supports it), making sure your system is fully optimized at capture time, and so on. We'll now concentrate on some post production techniques.

In this chapter, we'll show you how to make captured movies:

- *Look* better on the Mac
- *Sound* better on the Mac
- *Look* better on the PC
- *Sound* better on the PC

Separating Technical and Aesthetic Issues

The techniques you can use to make your desktop movies look their best fall into two general categories: technical versus aesthetic. Even movies that perform somewhat badly from a technical standpoint will be memorable if they are edited and scored by someone with skill and imagination. Such is the nature of the video medium.

This is a distinction you rarely have to consider in film or analog video, since movie performance as such is not an issue in those domains, but it does lend some perspective. A real movie can be judged good or bad based solely on the talents of the film makers and the actors. Unlike desktop video, it is taken for granted that the tools and presentation platforms for film and analog video are, if not perfect, at least highly stable.

Unfortunately, how to edit desktop video effectively and dramatically is not the province of this book. What we *can* talk about in some detail, however, are the technical, empirical ways to make movies look and sound as convincing as possible. Let's begin with the Macintosh.

Making Movies Look Better on the Mac

Outside of digitizing from a high-caliber video source, you can use the following techniques to improve a clip's quality after it has been digitized on the Mac:

- Experiment with movie metrics: frame rate, frame size, and color depth
- Adjust the movie's data rate
- Redigitize with different color, brightness, and saturation values

Because video content can take so many different forms, the best way to realize a captured clip's full dramatic potential is to simply experiment with it, at least at first. After a while, you'll become adept at exploiting its good qualities simply based on the type of content it embodies.

Experimenting with Movie Metrics

As you saw in Chapter 21, using different frame rates, sizes, and color depths can give your movie a different feel with each incarnation.

If your original capture is rich with movie data (high frame rate, large frame size, 24-bit color), you can experiment with all kinds of different settings simply by downsampling with MovieConverter, MovieShop, or an editing workbench like Premiere. If you capture a clip at, say, 10 fps at 240-by-180 and you want to compare it to the same movie digitized at 15 fps at 320-by-240, you'll have to recapture the second clip.

This is a good place to elaborate on a point we made earlier: When capturing master sequences, keep the quality for both

audio and video as high as possible. Even if your final movie conforms to our proposed desktop video standard, your digitization settings should be as high as your capture equipment (and your hard drive) will allow. In other words, let your postproduction software do the downsampling for you. Your final movies will look and sound better for it.

Doing any kind of experimentation involving movie metrics can give you a lot of empirical knowledge. For example, we have found (after making and watching hundreds of movies) that well-produced talking heads often work just as well at a frame size of 240-by-180 as they do at 320-by-240. Making the frame size smaller lets you increase the frame rate for better lip synching and, consequently, better dramatic effect.

Reducing the frame size may also allow you to improve the audio quality, which can go a long way toward humanizing the sound of the talking head's voice—thus making your overall presentation more engaging. If you take the time to bring out the human frequencies in the audio track (discussed later in this chapter), your presentation will be even more persuasive.

Then there is the color depth factor. A talking head rendered at 320-by-240 with only 8-bit color will not look as good as a 16-bit version with a 240-by-180 frame size—unless it is played back on an 8-bit system. This brings up the often confusing subject of palettes, which we will discuss in a moment. In general, good color depth and audio quality should be generally considered the *top* priorities for most video involving talking heads (in our opinion).

Admittedly, some of these points are highly subjective, but they do hark back to an effect we discussed in Chapter 2. Watching a movie on a PC monitor is a much different experience than watching it on a television screen, mainly because of how we have been trained to use computers. (Serious video game players may disagree here.)

When we manipulate most types of data with a standard Mac or PC, we like to have it feel leashed and manageable. Watching large-sized (and possibly loud or noisy) movies play on

your monitor can challenge this feeling, especially if they show close-up human faces. If you keep your talking heads small but lifelike, your audience might be more comfortable with them. (This is an especially fine balancing act for makers of adult-oriented desktop movies.)

On the other hand, there are movies composed of medium and long shots—crowds, landscapes, and so forth. Depending on how fast the panning action is in such a movie, you may be able to drastically reduce its frame rate and thus buy a larger frame size (although panning needs a higher frame rate). Often such movies work well with ambient sound or background music, which, by its nature, might be acceptable at 11.025kHz (8-bit mono).

These are some of the types of movies for which different sorts of frame and color metrics may be appropriate. Remember, we are talking about digitized *video* here. All kinds of different rules come into play when you are dealing with desktop movies based on animated sequences and rendered computer graphics.

Experimenting with the Data Rate

As we saw in Chapter 24 on how to use MovieShop, the reason for changing a movie's data rate is to make it play more smoothly, especially from a CD-ROM. Of course, the only direction in which it makes sense to adjust the data rate is downward. To increase it in any meaningful way, you would have to *re*-redigitize the movie at a higher frame rate or frame size (or color depth).

To ensure that your movies perform well on CD-ROM drives down to the single-spin models, conventional wisdom states that you should limit your data rate to 90 kbs (95 kbs for CinePak). However, other developers we know have reported significant performance plateaus at only slightly higher settings.

For example, setting the data rate to 100 kbs in some movies can make a perceptible difference in the mosaic effect (wherein movies appear to made of small colored tiles—you'll know it when you see it) while not adversely affecting overall playback smoothness. If you are producing clips for the public, you will

not regret experimenting in this range. MovieShop, by the way, is not the only program that can gate a movie's data rate. Premiere will do it also (although not as well, in our opinion).

Redigitizing with Different Color, Brightness, and Saturation Values

Let's now back up in the production process to where we can talk about recapturing movies (as opposed to downsampling them), using various filters on the incoming analog signal. Tuning such filters carefully can make a radical difference in how your movies look and, in some cases, perform.

Most movie capture software that runs on the Macintosh gives you access to these filters in the form of scroll bar controls. In MovieRecorder and GrabGuy, for example, the controls appear as variable sliders for hue, saturation, brightness, contrast, sharpness, black level, and white level, as shown in Figure 25.1

In general, the factory presets are acceptable, but you may want to increase the contrast and brightness values, and decrease the saturation setting for most movies—especially if you will play them under Windows. Another good practice is to adjust your white and black levels to make sure your black or white backgrounds are truly pure. Near black or white pixels that creep into such backgrounds can adversely affect compression.

This brings up an issue touched on earlier in Chapter 22: *gamma correction*. Because of design differences between Macintosh

Figure 25.1
Movie Recorder's *Image* Settings

video hardware and most PC-based video hardware, movies captured on the Mac often appear dark and murky when played on Windows machines. While you can mitigate this problem to a large degree by adjusting the Image settings in the basic Mac capture programs, it does not really get to the root of the problem.

Fortunately, Premiere has a specific gamma correction filter. We have found that setting it to .7 or .8 will lighten up QuickTime movies created on the Mac to an acceptable level when you bring them over to Windows, without adversely affecting the movie's highlights or shadows. Unfortunately, you have the added step of running your movies through Premiere.

QuickTime Movies and Palettes

If you digitize on a Mac in an 8-bit color environment (256 colors), a palette is created for your captured movie. Consequently, each frame consists not of actual color values, but of references to colors in the attached palette. The bytes in 16-bit and higher Macintosh images, by contrast, contain *actual* color values.

The digitizing software creates a palette for the movie file that it thinks will make the movie look as good as possible (this is called *color reduction*). Thus, the palette for frames in a movie heavily weighted with the color blue will have a lot more blues in it, to better represent the images. Imagine a picture of a sunset with only a limited number of color values for all the reds, oranges, and yellows and you begin to get the idea.

The overall effect is that movies with properly palletized frames can look quite good despite the individual images having only 256 colors to work with. Since color on the Mac is handled in a much more consistent way than under Windows, 8-bit QuickTime movies can often look nearly as good as 16-bit movies, depending on the color variation in the content (unfortunately, this is not always the case with DOS-based machines).

Macintosh palette-related issues crop up when movies digitized on 16- and 24-bit color systems are played back in 8-bit environments. In these cases, the Mac resorts to *dithering* (using

patterns of pixels with simple colors to emulate more complex colors), which brings down the quality of the images but does not incur any performance hits. Although QuickTime dithering software works the same on both Macs and PCs, the inconsistent quality of the lower-end Windows video cards (and their drivers) can often make it seem that the Mac does a better dithering job overall.

If you are worried that your high-quality movie images are going to get trashed on 8-bit color Macs, you could recapture them or convert them all to 8-bit color with MovieShop. (You can use MovieConverter to do this if you are working on an 8-bit system.) It's often a difficult decision, but one that will fade away as hardware improves and gets cheaper.

Making Movies Sound Better on the Mac

As of this writing, there are no shipping products we know of that allow you to open a QuickTime movie file and work on its audio track, in place, at the waveform level. Some have been announced, and they are presumably being rushed to market to take advantage of the growing demand for this sort of capability.

The finest level of audio quality control now available for QuickTime movie files is the ability to downsample from, say, 22.05kHz to 11.025kHz, or from 16-bit to 8-bit. You can do this with a program such as MovieShop, but the results are often unsatisfactory since sound data is literally thrown away during the conversion.

If you want to work on movie audio tracks at the waveform level to apply such techniques as digital noise gating, reverb, amplification, and so forth, you have to first separate them from the video track. One of the most visible tools for doing this is Premiere. By saving off a movie's sound track as a standalone AIFF (Audio Interchange File Format), you can bring it into a digital audio editor to apply whatever effects you want, then paste it back into the movie and kill the original weak audio track (using Premiere).

Making Movies Sound Better on the Mac

To give you a feel for this process, we'll walk you through a brief editing session using Premiere and MacroMedia's SoundEdit Pro application. More sophisticated audio editing software is available, such as DigiDesign's Pro Tools, but SoundEdit Pro is a good workhorse product and has been used to create many of the CD-ROM-based desktop video titles now in circulation.

The movie used in this example was captured with 22.05kHz, 8-bit mono sound. If we had captured it with much richer audio attributes (perhaps at 44.01kHz, 16-bit), our final sound track would be even richer sounding after it was *intelligently* downsampled to 22.05kHz, 8-bit. This demonstration, however, is meant to explore *other* sorts of digital effects. With these particulars in mind, here's the drill:

1. Invoke Premiere, go to the *Import* item in the *File* menu, and bring a movie into the *Project* window. Drag the clip from the *Project* window to the *Construction* window, then *Save* your work.
2. Open the clip from the *Project* window. Go to the *File* menu and *Export* it to the AIFF format. Keep Premiere open if you have enough memory at this point.
3. Invoke SoundEdit Pro. Go to the *File* menu and *Import* or *Open* the AIFF file you saved under Premiere.
4. The opened AIFF file will be displayed in SoundEdit Pro's main user interface. By adjusting the display parameters slightly, you can make it look as it does in Figure 25.2.

Figure 25.2
SoundEdit Pro with an AIFF File Loaded

5. Here is where you can work some magic. The most useful features of any digital audio editor used to enhance desktop movie sound tracks are its abilities to *equalize* and *normalize*—especially for human speech. Other effects will come in handy from time to time, but being able to isolate and boost desired frequencies can make the difference between a fair clip and a great clip. While SoundEdit Pro doesn't have a dedicated normalize control (the more expensive sound editors do), it actually does have sophisticated EQ and gain functions. We encourage you to make at least one digital audio editor a basic part of your production suite, and to experiment freely to determine what settings work best for your style of production.
6. Assuming you have fattened up your sound satisfactorily, save the audio file in the AIFF format, then exit SoundEdit Pro.
7. Return to Premiere and import the AIFF file you just worked on. Lay it into the second open audio track slot, just beneath the original. Change to the single frame view and go to the start of the movie.
8. You should be able to observe that the parallel waveforms of both the original and modified audio tracks are in synch time-wise. If for some reason they are not, carefully drag the *new* one until they are.
9. Preview a few seconds of the movie to make sure the two audio tracks are synched up, then delete the original and tell Premiere to make (assemble) the whole movie. When you play the new clip, you should find the audio and video tracks in synch—and that the movie sounds better, depending on how much work you did on the new audio track.

Making Movies Look Better on the PC

Like on the Macintosh, the methods you use to enhance movies captured under Windows fall into three categories:

- Playing with the frame rate, frame size, and color depth
- Trying out different data rates
- Recapturing with different analog filters (color, brightness, saturation, and so on)

Again, the key to achieving the best overall effect is experimentation. In a short time, with enough patience, you'll get an instinct for which methods work best for certain types of content. Since we covered experimenting with movie metrics such as frame rate and size earlier in this chapter, we don't need to repeat the discussion here. Refer to *Making Movies Look Better on the Mac*, earlier in this chapter, for more details.

As you will see, in terms of frame rates and sizes, the basic principles are just the same for AVI movies as for QuickTime movies. You can use VidEdit to experiment (as opposed to MovieConverter on the Mac side). The main difference between platforms in this regard is how they handle 8-bit color, which again brings up the concept of palettes.

AVI Movies and Palettes

Earlier we noted that Mac graphics software (such as QuickTime) ordinarily works with palletized images when operating in an 8-bit environment. As it turns out, so does Video for Windows. If you digitize in 8-bit color (256 colors), VfW creates a palette for your captured movie. Each frame contains references to colors in the attached palette. 16-bit and higher images contain *actual* color values. (See *QuickTime Movies and Palettes* earlier in this chapter for more information on palettes in general.)

Like on the Mac, palette issues surface when movies captured on 16- and 24-bit color systems are played back with 8-bit display adapters. To render such movies as accurately as possible, dithering is used. Unfortunately, the quality of Windows display hardware (and drivers) varies wildly and is often unacceptable. This variance is often made clear when QuickTime movies created on the Mac are played under QuickTime for Windows.

If you are worried that your 16- and 24-bit AVI movies may get dithered beyond recognition when played on Joe Schmo's display adapter, Microsoft humbly suggests in the VfW documentation that you digitize them in the 8-bit palletized format to begin with. If you want to convert existing 16- and 24-bit movies to 8-bit, you can use VidEdit to do so. We suggest you follow the directions in VidEdit's help system to make this happen. (You

may also want to experiment with palette *capture*, details of which are also in VidEdit's help system.)

It's hard to know exactly how to deal with palette issues at this stage of the multimedia revolution. Many Windows-based title publishers who want to use high-quality desktop video, especially QTW clips, are afraid to get their feet wet, others are jumping in regardless—with the belief that the issue will quickly fade away as the market upgrades its playback platforms. For the record, we've joined with the latter.

Trying Out Different Data Rates

Data rate adjustment under VfW is not yet as sophisticated as on the Mac. While the basic goal is smooth playback from CD-ROM, the software tries to steer you to what it thinks are reasonable performance plateaus for different playback media. Figure 25.3 shows the data rate settings available for saving a movie from VidEdit.

If you are saving an AVI movie under CinePak, setting a CD-ROM data rate won't significantly affect the movie encoding time, since CinePak is notoriously asymmetrical (but worth it). If you use Indeo Video 3.1 or higher, however, you must specifically set a data rate (by checking the *Data Rate* box in the *Details* section of the *Compression Options* dialog) to engage Indeo's asymmetric encoder, significantly lengthening compression time but producing a better performing movie at lower data rates.

Assuming you wish to squeeze as much performance as possible out of your CD-ROM-based AVI movies, it is worth experimenting with in-between data rate numbers (as opposed to the suggested plateaus), which you can also specify in the *Details* section of the *Compression Options* dialog. As on the Mac, you will find that approach can pay off in spades—depending on the nature of your content, of course.

Figure 25.3
Data Rate Plateaus for AVI Movies

Redigitizing with Different Color, Brightness, and Saturation Values

For the most part, these operations work just like they do on the Macintosh (as we discussed earlier in this chapter). However, since the Mac currently supports a higher class of top-end capture cards, and these cards produce crisper digitizations, you might find adjusting the image filters under VfW software a bit like wearing gloves by comparison (if you are used to the Mac).

As for gamma correction, the issue is only really a problem for QTW movies. While you can bring a QTW movie into Premiere for Windows and do the gamma correction there, we highly recommend doing it on the Mac in the first place and not attempting to deal with it under Windows.

Making Movies Sound Better on the PC

As a rule, the tools for working with audio on the Macintosh are more sophisticated than those available for Windows. When working with desktop movies, however, the score evens up a little. Earlier we noted there are no products we know about for opening a QuickTime movie file and working on its audio track at the waveform level. Under VfW, there is ATI's MediaMerge—specifically its Audio Editor.

If you have an AVI file with a weak (as opposed to damaged) sound track, you can open it with the MediaMerge Scene Editor and shore up its audio track in place (without first separating it from the video track) using some impressive editing tools. Or, if you wish, you can follow the method we described earlier in this chapter that uses Premiere. Either way, we still recommend MediaMerge's Audio Editor for reprocessing the associated WAV file.

To give you an idea of the complexity of this procedure, we'll take the MediaMerge Scene Editor through its paces. The movie used in this demonstration was captured with 22.05kHz, 8-bit

mono sound. As in our Mac example, if we had digitized it with better audio attributes (perhaps at 44.01kHz, 16-bit), our final output would be correspondingly better after it was *intelligently* downsampled. Once again, here's the procedure:

1. Start up Scene Editor. From the *Get* menu, select the *Video* item and import your AVI movie.
2. From the *Edit* menu, select *Edit Source File*, then enter the Audio Editor. When the movie's WAV file component is loaded, the interface should look like Figure 25.4 Play the track once to get a baseline feel for how it sounds now.
3. To get some results right away, go to the *Edit* menu and click *Select All*. Then go to the *Effects* menu and click *Normalize*. After a few seconds, the waveform representation of the track will fill up the allocated dynamic range. Play the track now to hear the improvement (assuming the original could *stand* improvement).
4. Select *Save* from the *File* menu to let the new sound track replace the old one in the AVI movie file.

If you wish to hear the difference between an un-normalized and normalized movie soundtrack, check out the movies UNNORMAL.WAV and NORMAL.WAV on the companion CD-ROM. Although we have found the Normalize feature in MediaMerge's Audio Editor to be extremely useful, the program also has other powerful functions, which we strongly encourage you to explore. (See the overall product review in Chapter 10).

Figure 25.4
The User Interface for MediaMerge's Audio Editor

Talking with Developers

HERE'S YOUR CHANCE TO LISTEN TO SOME WORDS OF VIDEO WISDOM FROM TWO REAL MASTERS—MATTHEW LONDON OF EDEN INTERACTIVE AND BRITT PEDDIE OF MONDO MEDIA.

In the last few chapters, we've been talking about how things are *supposed* to work. While the methods we suggest for improving desktop movie performance are effective, you might be concerned that we are operating under laboratory conditions. To assure you that there is practical value in our advice, we interviewed a couple of third-party product developers to substantiates our findings.

We needed to find people with dedication to high production standards. Even better would be small companies with products whose nature would hold them to those high standards. We chose Eden Interactive, a San Francisco-based multimedia firm owned and operated by Matthew London and Minoo Saboori, and Mondo Media, whose employee Britt Peddie gave us his perspectives.

Eden's work, *American Visions: 20th Century Art from the Roy R. Neuberger Collection,* is both a CD-ROM-based retail product and a kiosk-based learning system that will be installed at the

Neuberger Museum of Art at the State University of New York (SUNY) at Purchase. Eden Interactive plans to continue publishing CD-ROMs in its *Journeys Through Art* series.

Mondo Media's project, *Critical Path*, was recently released by Media Vision. It is a Windows-based adventure game employing state of the art desktop video clips, all originally shot for incorporation in the product. Peddie was the lead digitizer for *Critical Path*.

In this chapter, we will cover:

- The value of remaining faithful to your analog source
- The value of having an analog video background
- How much effort is involved in creating high-quality desktop video
- Why it's important to stay on the bleeding edge of this technology

About Eden Interactive's Project

The subject of the first of the *Journeys Through Art* is 20th century American painters. All of the works included are from the Roy R. Neuberger collection. The main user interface is designed as a gallery in which you can explore the worlds of particular artists and their works by clicking on carefully rendered painting and artist icons. In many cases, digitized video of the artist discussing his or her works is available, as well as clips of the collector himself.

To do justice to the quality of the material, Eden Interactive had to push their tools to the limit. Doing so often turned up surprising "features" in those tools—dilemmas that Eden solved in inventive ways. The problems concerned not only capturing video and audio, but how to get information that could help solve those problems.

We talked to London and Saboori about the lessons they learned in getting the initial installment of *Journeys Through Art* off the

design table and into the market (and the museum). The remainder of this section is a transcript of that interview.

Remaining Faithful to Analog Sources

What platforms do you develop on?

In terms of production hardware, we use the Macintosh Quadra—several of them, in fact. We decided early on we would compromise on almost everything but tools. Time is just too valuable. We wanted to use the most leading edge tools available, so we spent a lot of time researching them before we made any decisions. As for software, our product is basically written in Director.

Should desktop video strive to be faithful to analog video?

Not at all. Desktop video is its own animal. It is also its own art form. While there will be situations where fidelity to the source is paramount, the ability to add to the transcribed source with the available digital postproduction tools is what really makes a difference. Having these tools available invites more creativity than when you are working with straight analog video.

If you do strive for it, is it worth going to extreme measures to get the best looking digitization possible?

Absolutely. The cases where we try to be especially faithful are with talking heads—when somebody is making a point about something—or when we are trying to represent a still image such as a painting in a video sequence. We spend a tremendous amount of time and energy striving for fidelity in these areas.

If you are going for a non-faithful approach, do you, as the creative influence, have to work hard to find ways to make it seem different than sloppy digitization?

When you turn on the TV today, you see a lot of video that is intentionally downgraded, even though they may be using traditional analog techniques. You get the sense they are trying to

make it look like desktop video. We've heard of feature films in production now that use these techniques to make them look "digital" even though it's all analog.

We're being sold equipment now and bombarded with advertising that promises that we can produce things that look more and more like real video. The assumption is that this is a good thing. Is it?

I think it is necessary to have the tools evolve along those lines. Because you have to master the tools first before you can do your best work once you depart from faithful reproduction of real video. Just like in photography, you have to be able to know how to make your tools transparent. Our goal is to make our digital video tools transparent and then decide how we want to deal with the content.

American Visions *requires tremendous fidelity to the original material, not only the works themselves but the interviews with the collector and the artists. What are the biggest obstacles—especially the hidden obstacles and the trapdoors—to someone who wants to undertake such a project?*

Three things, and they are all kind of tied together. First is money, second is technology, and the third is time. Money because in order to capture this high-quality video, you need to start with the highest quality source material. We found that there is absolutely no substitute for this. If we had more money, we would have started off with 16mm film. The next best thing after that for what we are trying to do is Betacam SP.

Every step of the way, once you have recorded material on Betacam SP, you have to have equipment to play it back on. We have managed to get around this potential problem by having a project that is really exciting and attracts people to it. Our camera person, who also shoots for *60 Minutes*, gave us an incredible rate because he was very interested in the project.

Should you be willing to cancel the project if you can't get that high-quality source?

No, not at all. You should go forward, but every bit of ingenuity and drive that you can put up front toward maximizing the money, technology, and time will pay off down the line. When

we talk about money, we are talking about being able to afford high-priced equipment for serious projects. I should say that while people are obviously more important than equipment, our feeling is that we want to work with people who feel the same way—who are willing to sacrifice to afford tools that will let them do their best work.

Working On the Bleeding Edge

As for the technology, when you are creating this kind of work, you must be willing to work on the bleeding edge. And you will bleed.

Would you say then that there is a direct payoff to devoting, say, a half-hour or an hour each day to reading the various publications devoted to this area?

Actually, when the magazines devoted to this subject come out they are already several months out of date to be really useful to us. What we have found to be much more valuable are online services. I spend a lot of time on America Online, CompuServe, The Well, and other services. That is where you will find other people on the bleeding edge who will be helpful to you. I can communicate with people in the broadcast industry, in the multimedia industry, and so on.

Can you give some examples of instances where communicating with these people saved you a week?

It's hard to quantify it at that level, but one great thing about online services is that you can get access to the engineers that created the products, which can be extremely useful. A good case is Randy Ubillos, the lead developer of Adobe Premiere. He was on America Online and I was trying to find a way to speed up previews.

He gave us some very good suggestions—such as making sure that the preview size was the same as the capture, since if you shrink it down you are actually creating more overhead. Admittedly a quick example, but an indication of the kind of direct support you can get by using the online services.

Another thing is that out on the bleeding edge of the hardware world, there are always going to be incompatibilities that you need to be aware of in advance before you invest in new equipment. The only way to find out about patches and software upgrades is through these services. So the answer is, yes, it is an investment that pays off in time saved.

This leads into the third thing, which is time. Everybody knows that accomplishing real goals in this field takes much more time than your first estimates. The trick is in trying to quantify that somehow. For example, when we sit down to digitize a lot of material, the setup time itself takes hours longer than we imagine. Again, though, if you are striving for high quality, even the unexpected time spent is going to pay off.

Is an Analog Background Necessary?

Do you have to have a background in the analog video field to successfully complete a project such as American Visions?

This industry is too new for anyone to have a background in the *multimedia* field. It is more important to have the dedication to learn these new tools. But there is something to be said about the basic principles of video, and just as important, film. Especially in being able to edit. To that end, we knew going in that we were going to need someone who had extensive experience in that area.

We found an extremely talented person named Richard Robertson, who is willing to get into this now, unlike some of his peers who are waiting till the technology matures before really embracing it. He's an example of someone who's going to be way ahead of the curve when the convergence does happen. We can even see that now, based on how *American Visions* has come out.

If you were talking to a small company with an ambitious project such as yours, would you encourage them to hire a video consultant?

Yes, because there are so many different elements involved. It's a lot more than just shooting and digitizing. You have to consider

lighting techniques, miking techniques, and so forth; real experience which is hard won. One thing that Richard provided right from the start, for example, was the knowledge that in an interview, there is a big difference between someone who is looking directly at the camera and someone who is looking off-camera.

Someone who is looking into the camera strikes the audience as authoritative, while someone looking off-camera comes across as providing anecdotal information. An average person with a camcorder probably wouldn't know about these subtleties, which can make an enormous difference in the final production.

Also, being able to score productions with music and audio effects needs a professional for the type of work we are doing. Desktop video needs to work harder than television to keep people's attention, which can only be accomplished with effective edits and transitions, both of which need professional attention—which film and video professionals can provide. Of course, once you understand those principals, the PC-based tools we now have make it much easier to put them into practice.

Everybody uses the word video, but we strive to give our work as much of a filmic quality as possible. We want to carry this over to our future work as well. I was reading an article recently that talked about the early days of the film industry where there was the Hollywood model and the avant-garde model. The point was that, although the Hollywood model eventually won out, it could just as easily have been the other way around. Maybe with desktop video we are at that same fork in the path again, since the tools for producing highly creative finished movies are available not just to big studios but to individual producers as well.

Here's a really open ended question: Is CD-ROM a mature medium for distributing good-looking digital video?

Yes. It's a completely viable medium—right now. The important thing for us as a content-driven company is that, just as the tools must become transparent, so must the delivery mechanism for the content become transparent. To that end, we take a lot of care to make sure our products play back very smoothly from CD-ROM.

That being said, I don't see CD-ROM as the end all for the delivery of our content. I am comfortable with it, basically because there is a growing market for it today. But when something better comes along, we'll be there ready to take advantage of it. There's no point in cursing it in the meantime, however, because you are going to push every new technology and discover its shortcomings in the process. For a project like *American Visions*, CD-ROM is a *viable* medium at this point.

How Much Effort Is Required?

How much trial and error is involved in your work? Do you expect to solve many of your problems by trial and error?

Yes, I would say most of them. Usually what happens, though, is that we ultimately fix the problem with new software or hardware that eliminates the original problem, because we're always on the lookout for it. We're talking about technical trial and error more than aesthetic trial and error. From the technical perspective, it is really important to conceptualize the problem and not do endless iterations of dead-end approaches. A lot of people get caught up in this and it wastes a lot of time.

How much time does it take to produce a very high-quality 30-second finished clip?

About a year (laughter). That's almost too hard to answer, mainly due to our approach. For example, one clip in *American Visions* involved going to New York for various interviews with the collector, carefully transcribing the tape, and then condensing it down to 30 seconds. We approached it just like making a traditional film.

I don't want to be too circumspect for your readers, but there are so many factors involved. I guess I could say that if you had all your materials in place and a professional video editor ready to sit down and start working, you might be able to produce the same clip in a couple of days. But real life isn't like this.

You have had to make some decisions about frame size and rate for your project. Did you decide for any aesthetic reasons that certain frame dimensions were better than others? In other words, is bigger necessarily better?

We're not interested in full-screen video. You can turn on your television for that. What is interesting to us is to use video as a media type in context with the other media types that we use. In the case of our title, the video is of the collector and the artists, and the works themselves. It was very important for us to juxtapose these elements with the works and photographs of the artists.

To that end, we wanted a small video window so that the video could be seen in relation to the other elements. We've chosen a window size of 240-by-180 pixels. That gave us a window that could either be in an upper corner of the screen or repositioned by the user. It was a very balanced size that provided a very aesthetically pleasing feel.

Could you have gone to 320-by-240 and made it work?

No, but only partially due to technical limitations. The real reason its that a window of that size would have covered up too much of the other elements on the screen, such as the paintings themselves. In other words, it would have overpowered the screen. Other titles that we do will have different needs, which we'll make design decisions about accordingly. Each project has its own geometries that need to be addressed individually.

The frame rate is another issue altogether. This title takes two forms. One is a consumer CD-ROM, but the other is an interactive kiosk at the museum where the quality of the video is very important to us. Because of this, we are using the Radius Video Vision card as a playback mechanism in the kiosk.

We were originally going to use a laser disc player inside of the kiosk, but when we saw the quality of the Video Vision Studio card, we decided to go with it instead. Because of this, the kiosk system will have full, 60 fps video, but still at the 240-by-180 movie frame size. It's a big improvement over the laser disc concept.

So, even with the power to go full motion and full screen, you stayed with your original design?

Yes. Now in terms of the consumer title, we had some decisions to make. We ultimately chose 15 fps, primarily because of the lip synch issues involved in dealing with talking heads. Using 12 fps just didn't work for the level of quality we were trying to achieve, once we saw the final compressed video.

As new Macs come out that can easily handle 15 frames per second, we feel we'll be glad we went with 15, since we hope *American Visions* will have a longer-than-average life for CD-ROM titles. Because we kept the quality high at all phases of the production, the lip synching was pretty much dead-on when we did the final MovieShopping of the clips.

The Importance of Audio

How important is sound to your work?

Sound is extremely important. I'm recalling a famous experiment involving two television sets, one with a cruddy picture and great audio and the other with reverse attributes. Reportedly, people thought the one that sounded better also looked better. This has been as big an issue for us as good quality video, in fact.

We believe that to achieve optimal sound you have to follow a certain procedure. First, you have to make sure your audio signal comes into the computer at 16-bit, 44.1kHz. Stereo isn't as big an issue, but the others are. The hardware we use for capturing allows us to do this. Some of the lesser boards can't.

The reason for getting this quality up front is that it gives us the ability to use tools on the sound at that higher quality, which can make the final scaled down audio much richer than using the 8-bit, 22.05kHz version that the digitizer board can capture directly. We use ProTools to down-sample and normalize all of our audio. There's just no substitute for this.

It should be just like your approach to video. Start with as high a quality as you can, and keep it high for as long as you can. The same thing goes for audio, although not everybody approaches it this way. You are interested in knowing to what lengths we

go to maintain high quality, and this is a good example.

With a tool like ProTools, you have a lot more control over the subtleties in your audio track. Whether it's music or spoken words or ambient sounds, you can do equalization, fattening of the mid-ranges, gating, and so forth. It's just a really valuable tool, and the improvement you can make is completely worth the effort.

But again, if your audio has already been downsampled by your capture board, the tool won't do you nearly as much good. So you must capture at maximum audio settings to begin with. In your final compression step, you can reduce things. We use the standard for most CD-ROM products: 8-bit, 22kHz, mono.

Do you keep the door open to different approaches?

Yes. This applies to both audio and video. Specifically in this title, we used a lot of archival footage shot in the '40s, '50s, and '60s. Some has been transferred from film to one-inch to three-quarter-inch to Betacam to VHS, and so on. Lots of multi-generational stuff, recorded with lousy audio equipment to begin with.

Of course, the interesting thing about desktop video is that it suits this type of material very well. It looks authentic when it's jerky. And this is also true for the audio. This allows for some opportunities to trade off in quality—since you expect one component to be bad, you can enrich the other for a better overall effect.

What is your backup procedure?

We have a DAT backup device for our server, and we also back up onto CD-ROM. We have a CD-ROM burner, but we only store the raw, uncompressed video there because that is not going to change. When we do final compressions, we output to our hard drives, drawing from our CD-ROM players.

Looking Forward

What do you think will be the next big breakthrough in making video look good?

In terms of video quality, we already get performance that looks better than television when playing off the Video Vision Studio.

I would love to see much better compression that doesn't degrade the images so much, but there are some serious time and storage issues here. I think the potential for desktop video to seriously challenge analog video is very high.

Some of the details are also important. Professional audio line levels need to be supported in desktop equipment, as do such simple things as connectors. Who wants to have to make constant trips to Radio Shack for XLR connector adapters? There are many subtle differences between professional gear and consumer gear, even *pro*sumer gear, that need to be smoothed out before digitizing video is a straightforward process.

Hard drive speed, capacity, and bandwidth need to get better. And they will. A recognition by the manufacturers that the people using their tools are rooting for them and will make great use of all their new features. There are so many areas where improvements can be made for people actually making titles, it's hard to get too specific.

What is your biggest frustration in trying to digitize high-quality video?

If we were starting our project right now with the tools and the knowledge we currently possess, we could have much more time to spend in the creative end. Of course, this is inevitable. I guess I have no overriding frustration, since our dedication to making tools work paid off. In our next project, we'll be able to start at a higher level of competence.

Do you think that interactivity is an over-hyped idea—that it's just a way to sell multimedia products? How important is video to interactive multimedia?

Interesting question. Ultimately, what's important is the communication aspect. If you spoon-feed content to people, they are not encouraged to think or explore. Video speeds up this process, and it is the most powerful data type, but it has to be handled very thoughtfully to be truly effective. Since we must use less than full-screen video windows today, they must mesh with the rest of the elements on the screen, otherwise it's just technology for technology's sake. And that's not very interesting.

Let's turn that question around. Is there a place for desktop video that is not interactive?

I think there is. A good example is language learning tapes, which have traditionally been on audio cassette. When they came out on audio CDs, all of a sudden you could random access them. The same idea can now apply to other educational products. I guess you could say this is a low form of interactivity, but I think it can be fairly categorized as simply a means of jumping quickly to a particular section and then letting it roll without further interactivity. Desktop video will be great for this.

Are people who work with computers predisposed to enjoying desktop video more than those who don't?

It's hard to say. But coming at it from the other side, I'd say it's analogous to working in a darkroom for the first time. I'll never forget the first QuickTime movie I made. It's a pretty magical thing.

Have you succeeded in what you set out to do with your project?

Yes, we have. Absolutely.

Eden Interactive has allowed us to include an outtake from *American Visions* on this book's companion CD-ROM. We encourage you to look at the movie named EDEN.MOV to see and hear the result of maintaining extremely high standards of quality. Also, you might be interested in reading a feature story about this project that appeared in the September 1993 issue of *Publish* magazine. You can reach Eden Interactive directly by calling (415) 241-1450.

About *Critical Path*

Critical Path is an interactive adventure in which the player guides a protagonist through a hostile island labyrinth to a helicopter pickup site. All original footage was shot for the title, on sophisticated sets you would normally expect to find in the traditional film and video worlds. Much of the footage of the characters was recorded against blue screens so that the characters could later be composited onto rendered backgrounds.

In postproduction, Mondo Media was faced with some serious challenges, which they ultimately overcame. The end result sets a new standard for CD-ROM based adventure games. *Critical Path* is absorbing, visceral, and uses desktop video in new and imaginative ways. The rest of this chapter is a transcript of an interview with Britt Peddie, the technician who oversaw the digitization and postproduction processing.

Desktop Video Hurdles

Based on working on Critical Path, *is it your feeling that desktop video should strive to be faithful to analog video?*

Yes, if only to gain more acceptance. People often laugh at it now, or treat it with condescension. For what it does currently, desktop video is a great tool but I really don't expect it to totally replace analog video for another ten years.

Will the experience of editing digital video when that happens be the same as editing analog video?

That will change immensely, just as the experience of editing audio changed immensely over the last few years with the advent of digital audio workstations. You can buy an eight-track tape deck now for next to nothing because the professionals all have digital audio editing equipment. You just can't get the same amount of work done with analog as you can with digital. You can haggle over the quality issues, but if it ends up on CD, its going to be digital anyway.

Do you think there is much irony in the fact that digital video piggy backs off of analog since you have to capture from a tape?

I suppose, but that's simply where the vast majority of video assets currently reside. Until all of that material, or at least the useful parts, has been digitized, the condition will persist.

Do you see a day on the near horizon when people will just go out with digital video cameras and record straight to hard disk?

I hope so. It's certainly not practical now, although direct to disk recording of audio is a current technology and is forging the way for video. Of course, bandwidth is the problem in this area, just like in playback.

Do you think it is worth going to extraordinary measures to get as good-looking desktop video as possible? Should you knock yourself out?

I think you should do whatever is possible with budget and time constraints. There are a lot of blind alleys to go down when you first get into this that feel like they will be worth the effort, but then don't pan out. If you know exactly what you are doing, you can safely take the extra measures knowing they will be worth it. On the other hand, everybody wants to put out high-quality stuff, because if it's good it will drive the industry, since the industry is still pretty small.

You see MTV footage and trailers for commercial television shows that have that dropped-frame look, as if somebody decided that newsreel-like footage will convey more authenticity. Is this a new art form in which desktop video can be a viable tool?

There are different ways that people can use tools. TV producers are always battling to make things stand out, and new approaches are usually based on new tools. Since digital video workstations have been downsized to Quadras with Digital Film cards, more people are getting a chance to try new approaches. Music videos and trailers are good targets and of a length suitable for exploitation with desktop video tools.

Do you get the feeling that not only are these trailers grainy and jerky, but there are also fast forward—to give you more information about the feature they are advertising? Is this an enforced speed-reading sort of thing?

Sounds reasonable. To me, it makes it seem like they're trying too hard.

If it's worth going to extreme measures to get good-quality desktop video, what have you found to be the biggest obstacle, in a production context?

Processing power is my biggest inhibitor. The more compression you do, the more you need powerful processors. It's that simple. Especially if you are adding effects at the same time. For production-quality stuff, you often have to try things a few different ways to get it right, and each time is a new compression step.

Should companies that get money to do CD-ROM titles frontload their budgets for all the extra Quadras they can get, to make sure that they don't get caught in tight situations just because they couldn't get the content compressed quickly?

If possible. We wouldn't have gotten our project done on time if we didn't go out and rent some extra hotrod machines when we needed them—just to do compression and compositing.

Your Papers, Please

How valuable is a background in analog video for doing what you do?

In some ways it helps a lot, but in others it is not essential. Many of the processes and procedures that are part of the analog video technician's average workday just go away with digital video. Knowing how to calibrate certain machines, get the bars and tone right, stuff like that, goes away with the new technology. On the other hand, a good eye for editing will always be valuable. I happen to have an audio background and a computer background, but not much prior experience in film or video editing, which I could have used in working on *Critical Path*. To get around that, I just tried things different ways till I was satisfied.

What kind of money do you need to set up a home desktop video production studio?

Twenty thousand dollars is a number that makes sense when you add it all up. For ten thousand dollars, you can get a workable, basic system, but you will have a certain amount of inconvenience.

Which would you sacrifice first if you were on a tight budget, video gear or computer gear?

Personally, I would always put the computer first. That's my most powerful tool. If I need a special video deck, I can go out and rent one.

Were you spoiled by seeing the quality you can get from a Betacam deck?

Well, you always go with what you can get, but it is hard to go back to digitizing from a VHS deck once you've done Betacam SP. Still, I think Hi-8 is a really good medium for desktop video.

Do you consider CD-ROM technology, as it stands now, a mature medium for distributing PC-based digital video?

Actually, I consider CD-ROM a technology on its way out. It was invented so long ago—in computer years—that it just plain doesn't hold enough and it is too slow. In a way, the CD-ROM is the floppy disc of the future. It's a great way to distribute applications, but not video until it is somehow redesigned.

How much trial and error is there in your work?

Ninety-five percent (laughter). It's a huge part of this industry. Anyone who says differently is bluffing, at least when you're working on a big project with lots of variables.

Do you rely on online services to get information about new products and strategies?

I read all the weekly magazines, such as *PC Week* and *MacWeek*, and try to follow up interesting stories and announcements, even if it's peripheral to what I'm working on, since conversations with the firms producing new products often lead to other contacts. I will get on a bulletin board if I have a specific problem, but not really to browse or chat. I've found that stuff on company BBS systems, such as drivers, is actually old news. I guess the feeling is that if its available to anyone it had better be mature.

The Role of the Camcorder

A lot of the desktop video press is devoted to the independent producer who has a video camera and supposedly goes out there and shoots footage, then goes home and digitizes it. Do you find this misleading? Especially since most of the real work available out there is in digitizing existing, professionally produced video? In other words, is it safe to say that, in setting up a small business based on digitizing video, you will actually use your own video camera very little?

Yes, that is the reality, for better or for worse. But I do use my camera to try stuff out in a non-money making context, which completely justifies having it around. And, done right, a Hi-8-based product is basically viable—which you could use a Hi-8 camera for.

So the culture that is being spawned of roving, camcorder equipped investigative journalists really has little intersection with the desktop video world?

Yeah, it seems that way. The so called prosumer market is pretty thin. The pros aren't using that stuff, and the consumer will settle for less. It's nice to have the quality trickling down, but who's buying it?

Certain large corporations are trying to promote corporate V-mail and other in-house uses of desktop video, apparently hoping that employees will get used to it like they did for, say, Lotus and Word, and then take it home and starting building up their home systems with this technology. Is this misleading?

It's not a bad way to get users comfortable with a new technology, but there are elements of force-feeding that seem to come up. Then again, a lot of this new technology is too expensive to have people be exposed to it any other way.

Where are the connections between the kind of work that you do and the corporate implementations of desktop video?

We're more focused on entertainment, but the kinds of technology we're using would have a real place in non-entertainment kinds of businesses. It's just a matter of making it a transparent means of communication.

When you come home from work, do you have enough energy left over to pursue your own personal projects?

I wish. I love doing this, but I don't have nearly as much time as I'd like. That doesn't mean I don't have ideas stacked up for personal projects, but working in a small company is not the same as a regular corporate job.

Are you aware of many outlets for amateur desktop video work?

There seems to be a growing number of events like the QuickTime Film Festival. There are certainly lots of user groups who like to share video files and organize small competitions and so forth.

Magazines like Wired *would have you believe that there is a digital underground of people doing exciting work, sharing it through privileged channels, and so on. Do you buy into any of this?*

Unfortunately, I think there are only a few people out there doing the kind of thing that the press wants you to believe is about to erupt. There's no true digital underground at this point.

Will there be?

I think so. Ironically, it's going to start in big corporations who have the money to get the primitive systems rolling and to pay for the information highway. Who gets on that highway is a whole different issue.

Talking Shop

If somebody gave you a tape, how long would it take you to digitize a finished 30-second clip?

Probably an hour, if I could use a Quadra for MovieShopping it. Maybe an hour and a half.

What type of hardware would you use or consider adequate for this job?

At least a Quadra 650, tons of RAM, a Radius Video Vision Studio, a SCSI accelerator, two one-gig hard drives. That covers the essentials.

Do you capture with Premiere or with MovieRecorder?

Now I mainly use Premiere. I used to use MovieRecorder but the VideoVision Studio makes it very easy to work from within Premiere.

Can you do 30 fps with that configuration?

No problem. I've been having some difficulties with 640-by-480 grabs, but 320-by-240 is very stable.

Do you grab at those dimensions with the expectation of downsampling to 240-by-180?

If I were going for those dimensions, I would probably grab at around 260-by-200, then crop, to make sure I completely got rid of the video noise around the edges.

What about the idea that, for letter perfect captures, you should capture substantially bigger and then shrink down at final compression?

I think that alleged quality gain is minimal. It depends more on what kind of content you are dealing with. File size requirements have much more of a priority.

What do you consider the optimal frame rate for CD-ROM based video?

For *Critical Path*, we went with 15 fps because of all the action. Actually 12 seems like an odd number to me. It's not based on video. So either 10 or 15 feels good, depending on the content. Obviously, your frames will be a lot clearer at 10 fps.

Is your optimal frame size—240-by-180—based on performance or aesthetic considerations?

Performance, basically. 160-by-120 is too small. Quarter screen is great, but hard to pull off across the board.

How much video would you trade off to get good sound? Would you ever go down to 160-by-120 to get, say, 16-bit sound?

I don't think so. I'd rather not have video at all in a case like that instead of being forced to seriously compromise it. Actually, we found that 22.05kHz audio, unless it's done really well, just lets you hear more high-frequency noise.

Do you use digital audio tools to work on movie sound tracks?

Yes. But we also do a lot of work on the analog sound as well. The audio layering in *Critical Path* was done digitally, but we had racks of gear to process voices when we shot the footage originally.

Can you really do a lot with a program like Sound Edit Pro?

You bet. We used that product extensively, but we plan to get even more powerful software for future projects.

What do you see as the issues involved in bringing movies created on the Mac over to Windows?

Gamma correction, for one. Our movies are a little dark on the PC. Since the backgrounds were rendered dark, it's less disconcerting. Doing it the right way, for another. The software available for flattening QuickTime movies on the Mac or assembling them with editing software on the PC is not all rock solid.

What do you consider essential software for desktop video capture and production?

Premiere, maybe After Effects. Actually, we're working on some of our own tools. We'd like to start taking advantage of the Alpha Channel and finding ways to utilize non-movie data in the movie data stream. For example, if you continuously update structures with incoming data, your program can have different action paths at different points in time.

Does this imply that desktop videographers need a background in programming?

I certainly think it helps. You have to be awfully computer literate anyway, especially on the PC side. If you're predisposed to this, programming is not such a big hurdle.

If you've made the investment to set up a workable studio at home, and you are looking to make a career change, how easy is it to actually get a job?

If you're not here already, pack all your stuff in a van and move to San Francisco. Everybody I know who is interested in this field is busy. Not just digitizers, but programmers and artists also. From my perspective, the industry is healthy and growing. Just make sure to differentiate yourself from the analog professionals and concentrate on what computer skills you have, at least at first.

Would you advise people looking to break in to press their own productions onto CD-ROM and put that in their resume?

Certainly. But make sure to stress the creative aspects, not your technical proficiency, since that's what you should have pretty much mastered already.

Mondo Media and Media Vision have allowed us to include an outtake from *Critical Path* on our companion CD-ROM. If you are interested, check out MONDO.MOV. You can reach Mondo Media by calling (415) 243-8671.

Mastering a CD-ROM

CD-ROM BURNERS ARE EXPENSIVE BUT THEY ARE ESSENTIAL FOR THE PROFESSIONAL MOVIE MAKER.

Once you start making desktop movies in earnest, you will find yourself becoming more involved with CD-ROM technology on a number of fronts. At the very least, you will probably start buying more CD-ROM titles to see what sort of movies other people are making. Or maybe you'll begin considering alternatives to hard disk storage. More importantly, you will be thinking about ways to distribute your latest movies, either as one-offs (on an ad hoc basis) or golden masters for replication.

Although prices for CD-ROM burners are falling, good ones still cost more than the PCs or Macs capable of digitizing the movies in the first place. As we noted in Chapter 9, the blank discs are not cheap either, even when purchased in quantity. Like desktop publishing, desktop video is not positioned to compete with high-volume pressing plants when it comes to mass production.

It is easy to get excited about the prospect of having your own CD-ROM writer (CDW), but hard to justify it financially until making movies becomes your day job and you need one to get

your work done. Even then it is a big step, as with any new type of expensive equipment. Of course, once you buy one and start using it regularly, you'll wonder how you managed without it.

While several brands of CDWs are available, the software that controls them is still fairly primitive, especially for making *hybrid* discs that can play on both Macs and Windows computers. In fact, not all of the burners are completely reliable as production machines. Our in-house CDW is the Sony 900E, which has performed quite well so far.

In this chapter, we will cover:

- Cross-platform playability issues
- Mastering ISO 9960, HFS, and hybrid CD-ROM discs
- Guiding a retail CD-ROM title through production

Understanding Cross-Platform Playability Issues

As this book is written, there is a lot of effort going into making personal computer products *cross-platform*. For our purposes, a cross-platform product is one that can be run on either a Mac or a PC from the same media (presumably a CD-ROM) and includes desktop video clips. Although other platforms certainly exist (NeXT, Sun, and so on), the term cross-platform does not specifically include them yet. The reason for all the excitement is, of course, that cross-platform media can reach much greater markets.

The product itself is actually cross-platform in an abstract sense, since there are very likely two copies of the executable application on the CD-ROM—one for the Mac and the other for Windows. If the producers of the product knew what they were doing, however, there should only be one copy of each video clip on the disc. Currently, such movies would likely be flattened, CinePak-encoded QuickTime movies.

In other words, it's not the programs that are cross-platform, but rather the data that they process: movie files, to be exact. A

CD-ROM product is technically cross-platform if you can put it in a CD-ROM player attached to either a Mac or a PC, fire up the program, and have the user interface be, if not identical, then functionally the same regardless of the platform. If there is only one copy of each movie on the CD, the product can be considered state of the art (from a production standpoint).

Making a Movie Cross-Platform

As far as the desktop producer is concerned, you can make movies cross-platform with a minimum of effort, as long as you do it right. We have seen many QuickTime movies play so poorly under Windows that they were ultimately erased. When we looked at them with MovieAnalyzer, it was easy to see why: bizarre interleaving, odd mixtures of key frames and differenced frames, video frames where audio frames should be, just to mention a few.

How did those movies get that way? The people that showed them to us had used movie-handling applications that allegedly supported QuickTime for Windows output, but didn't do it quite right when put to the test. If those producers had taken the time to check out those movies themselves with MovieAnalyzer, they would have been spared a lot of trouble, especially if they knew what to look for (which is why we recommend the architectural approach to using MovieShop discussed in Chapter 24).

As of this writing, making a movie cross-platform boils down to the following generic process:

1. Start with a QuickTime movie created on the Macintosh.
2. Subject the movie to a couple of operations (discussed next) that make it playable under Windows.
3. Play the movie on a Windows machine to make sure actual performance meets your expectations (optional but highly recommended).

While tools exist that can make AVI movies playable on the Mac, and that can convert between AVI and QuickTime movies on Windows PCs (as opposed to on Macs), the current cross-platform concept really only applies to QuickTime movies. And—in our opinion—you can only perform the operation 100% reliably on the Mac.

Like most dilemmas faced by desktop video producers, this one will undoubtedly disolve in due course. But sticking with QuickTime and doing the requisite conversion on the Mac will remain a solid approach for creating commercial cross-platform CD-ROM titles in the foreseeable future.

The Apple Way

The following procedure is adapted from information supplied in Apple's documentation for QTW. It is Apple's prescribed method for making Mac QuickTime movies playable under Windows, and we have found it to be completely reliable. We used it to make all of the movies in our products cross-platform, and the resulting performance under Windows was at least equal to the performance on the Mac.

Of course, you must have the appropriate decompressor installed for the movie to play when you bring it over to your Windows system. It is a good idea to always determine the movie's compressor type on the Mac first, to make sure you can use it before you convert it. A compatibility table is provided later in this chapter.

QuickTime movies playable under Windows need to be (1) self-contained, and (2) contained in a single fork file (flattened). Both of these concepts are covered later in this chapter. The application most often used for self-containment and flattening is MovieConverter, which is part of the original QuickTime Starter Kit. Unfortunately, it was not included on the QuickTime 1.5 developers CD-ROM and is harder than you might think to get a hold of.

As we mentioned in Chapter 24, you can also use ComboWalker (which *was* included on the QuickTime 1.5 developers CD-ROM) to prepare QuickTime movies for playback on Windows machines. ComboWalker has the added advantage of being able to batch process a folder full of movies, as opposed to doing them one by one with MovieConverter.

To use MovieConverter to make a Mac movie playable on a Windows machine, follow these steps:

Understanding Cross-Platform Playability Issues

1. Run the MovieConverter program.
2. Open the QuickTime movie that you want to convert.
3. Select *Save As* from the *File* menu.
4. Click *Make movie self-contained* to specify no references to other files (in other words, to make sure a fresh copy of all the movie data is contained in the file being saved.
5. Check *Playable on non-Apple computers* to specify a movie file that does not depend on resources (see the discussion of flattening later in this chapter). Figure 27.1 shows the user interface at this stage.
6. Save the file.

Once you've saved the movie file, you can take it to a Windows machine and view it with any program that supports QTW. If you follow this procedure, your converted movies will perform at least as well as they do on your Mac, provided the machines are of comparable power and have equally sophisticated graphics adapters.

To avoid confusion later, we suggest that you give your converted movies a DOS-compatible name at this point (up to eight characters), along with the extension MOV. If you are going to be doing conversions on a regular basis, you will probably want to settle on other naming conventions to keep everything sorted out.

As we have frequently noted, there are at least two other programs that support cross-platform movie conversions: MovieShop and Premiere. Though you may get acceptable results from them

Figure 27.1
The MovieConverter Save As Dialog

yourself, the only programs we can endorse with full confidence (for this particular task) are MovieConverter and ComboWalker. Feel free to experiment with the others—but at your own risk.

Understanding Flattening and Self-Containment

In the preceding section, we referred to the two key operations involved in making a QuickTime movie playable under Windows: flattening and self-containment. If you come from the Windows world, these concepts will need some explanation. People tend to use the terms loosely, when they actually have very specific meanings.

Making a movie *self-contained* means consolidating all of its video and audio data in a single file. To conserve storage space, QuickTime allows movies to contain references to data in other files, thus avoiding redundancy when working with clips embodying many megabytes. Figure 27.2 illustrates this principle.

For example, you can open a movie on the Mac with MoviePlayer, copy some of its data to the clipboard, create a new, empty movie from MoviePlayer's *File* menu, then paste in the data

Figure 27.2
Where a QuickTime Movie Can Store Its Data

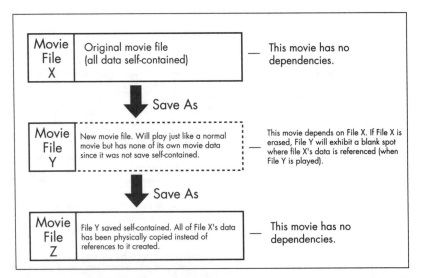

Understanding Cross-Platform Playability Issues

from the clipboard. When you try to save your new movie, the dialog will ask you if you want to make it self-contained or allow dependencies.

Choosing the latter will not make a significant performance difference when you play your new movie in the future, but it will require that the original movie be present on your system, preferably on the same storage device as the new movie. It is easy to see why QuickTime was designed with this sort of flexibility, but it can be a real problem if you start erasing movies that contain data needed by other movies.

Since this paradigm is not supported under Windows, you must ensure that your movie has no dependencies when you convert it. Failure to do so will make your movie unplayable on a Windows machine. Making this particular mistake once can be so frustrating that you will likely not make it again.

Flattening a movie is an even more Mac-centric operation. Unlike in the DOS world, a Macintosh stores files in *forks*. Different parts of a standard QuickTime movie file are stored in separate *data* and *resource* forks, both of which are transparent to the average user. Figure 27.3 shows how this concept is implemented.

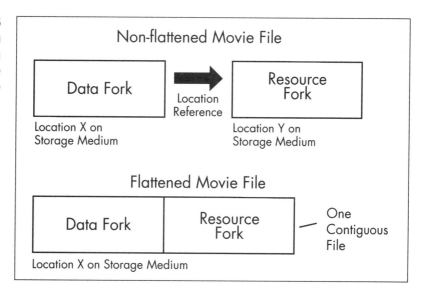

Figure 27.3
The Forks in a Macintosh QuickTime Movie

When you tell MovieConverter to make the resultant movie playable on non-Apple computers, the original movie's resource fork is simply appended to the end of its data fork, thus flattening the movie into one physical file. As with self-containment, failure to complete this step will render your movie unplayable on a Windows machine. For the record, self-contained and flattened movies will continue to play just fine on the Mac.

Cross-Platform Codec Compatibility

As we noted earlier, specifying that a QuickTime movie file be properly prepared for playback under Windows is only part of the battle. You must also make sure that the target environment is equipped with a decoder that can handle the incoming movie. As more codecs enter the desktop video arena, this situation will get much more complex, especially when Movies you create under Windows can be ported to the Mac.

For instance, until QTW 1.1 was released, there was no CinePak decompressor included in that product. While you could convert Apple Video movies and play them under QTW 1.0, converting a CinePak (then called Compact Video) movie and running it under QTW 1.0 generated an error message.

To get an idea of the extent to which the popular software-only codecs have currently been made cross-platform, refer to Table 27.1.

Table 27.1 The World of Cross-Platform Codecs			
Codec Name	Supported on the Mac	Supported by VfW	Supported by QTW
CinePak	Yes, in QT format, encode/decode	Yes, in AVI format, encode/decode	Yes, in QT format, decode only
Apple Video	Yes, in QT format encode/decode	No	Yes, in QT format, decode only
Apple Graphics	Yes, in QT format encode/decode	No	Yes, in QT format, decode only

Continued

Table 27.1 The World of Cross-Platform Codecs

Codec Name	Supported on the Mac	Supported by VfW	Supported by QTW
Apple Animation	Yes, in QT format encode/decode	No	Yes, in QT format, decode only
Apple RLE	Yes, in QT format encode/decode	No	Yes, in QT format, decode only
Apple JPEG	Yes, in QT format encode/decode	No	Yes, in QT format, decode only
Microsoft RLE	No	Yes, in AVI format, encode/decode	No
Microsoft Video 1	Yes*	Yes, in AVI format, encode/decode	No
Indeo Video R3.1	Pending	Yes, in AVI format, encode/decode	Pending
Indeo Video R2.1	Officially obsolete	Officially obsolete	Officially obsolete

* Not by Apple, and not up to production quality.

Clearly, this table omits some announced codecs such as Captain Crunch and various MPEG implementations, but a few interesting perspectives emerge nevertheless. For instance, it shows CinePak to be the *broadest* cross-platform compressor, even though CinePak-encoded movies exist in different file formats for the QuickTime and AVI implementations. By the time you read this book, Indeo Video will probably be much more of a player on the QuickTime stage.

Using a CD-ROM Burner

At the hardware level, most CD-ROM writers can burn discs for both DOS machines and Macs. In the evolving parlance, this dichotomy is expressed as "making an ISO disc" versus "making an HFS disk." The key words in these phrases refer to the file formats usable by the respective platforms. CD-ROMs formatted as ISO 9660 (A.K.A. *High Sierra*) can be read by both Macs and DOS computers. CD-ROMs burned with HFS formatting can only be read by Macs.

Most CD-ROM writers are SCSI devices. Of course, on the Mac they are standard plug and play. On the PC, if you haven't already got your SCSI garden planted and well-tended, you'll have to sacrifice another small animal. Since average CD-ROM capacity is around 660Mb, you'll need a big SCSI hard drive to hold your source files if you want to fill up a CD-ROM.

Making Platform-Dependent CD-ROMs

Mastering a CD-ROM that adheres to either the ISO 9660 or HFS format is fairly straightforward. The conceptual steps are:

1. Organize the files you want mastered on your source hard drive. Make sure they are in the same directory (DOS) or folder (Mac) structure that you want to see on the CD-ROM.
2. Run a hard-disk optimizer such as Norton's Speed Disk to make sure all movie file data is contiguous (for optimal movie playback).
3. If you are using a Mac, make sure to empty the trash—unless you want it included on the CD-ROM.
4. Run the appropriate software for your platform (Mac or Windows). Depending on the software you use, you may or may not be able to select which files on the hard drive are to be included on the CD-ROM. In other words, make sure that any files you *don't* want mastered are *not* on the source hard drive.
5. Again, depending on the particular software, you might have to create a *virtual image* of your CD-ROM data as a preparatory step prior to the actual burn. The program should guide you through this process fairly painlessly.
6. Once your new disc is mastered, test it in a CD-ROM player. If everything works, you can immediately put it to the task for which you intended it—from mass replicating it to sending it to a friend. You can (and should) identify it with a felt tip pen, as long as you write on the top side (as opposed to the readable side). The top side of a writeable CD-ROM is usually a metallic gold color, while the sensitive bottom side is more greenish.

Making Hybrid CD-ROMs

In the early days of this fast-evolving technology, if you wanted to make a CD-ROM that was playable on both Macs and PCs, you had to divide it into ISO 9660 and HFS partitions. If you wanted it to be functionally cross-platform, you had to see to it that copies of the same data were in each partition—effectively limiting the data available to either platform to half the capacity of the physical CD-ROM.

The original version of our product (*Canyon Clipz*) was mastered using this methodology. When you put that CD-ROM in a reader attached to a Windows PC, roughly 330Mb worth of movies are available for playing. Putting the disc in a Mac CD-ROM reader gave you access to copies of all the movies in the HFS file format. Redundant as that seems now, it was the only reliable way to go at the time. And, technically speaking, it *was* cross-platform.

A more recent innovation, the hybrid CD-ROM, lets you put a disc in a reader attached to *either* platform and have access to the full capacity of the disc. This innovation is possible because of differences in how ISO 9660 and HFS file allocation tables are maintained. Only Mac software is currently available for making such hybrid CD-ROMs, but the result is well worth it.

When you mount a hybrid disc, the CD-ROM reader is essentially tricked into thinking that the disc you just inserted is in the appropriate format, and goes along with the charade without further incident. So far, this has proven to be a stable technology, and we believe it will quickly become a standard. Being able to create a disc full of flattened movies without worrying about which platform they might be played on can be a real advantage.

Creating a CD-ROM Production Timeline

With the important conceptual and mechanical areas covered, we can now talk about the practical issues involved in producing a

retail CD-ROM product. If you have no interest in learning this process at the present time, you can skip this section. On the other hand, you may want to skim over it just to get a flavor of what's involved. We will draw from experience in producing our own title, which we produced on a tight budget and within a severely short time frame.

Assuming that your product will ship in a jewel case with an inserted booklet, one panel of which will constitute the cover, you should be aware that the associated printing process will normally take longer than the actual disc mastering, pre-press work, and final replication. Of course, you can always pay extra to have things done in a hurry, but we are talking about a standard production timetable here.

For the record, our CD-ROM didn't include a UPC bar code in the packaging, which turned out to be a minor headache later. If we had included this step, it probably would not have affected the critical path, but it's hard to say for certain. All of our future products will carry this marking to make it easier for distributors to handle.

Unless you are a graphic artist or your CD-ROM publishing operation has one on staff, you should hire such a professional to design the booklet for you. Make sure that the artwork and typography for the tray liner (to insert in the back of the jewel case), as well as design of the silk screen (used to print the title of your product on the top surface of the CD-ROM disc) are included in the job, since they will all share the same design elements.

Try to get the graphic artist to supervise the printing of the booklet and the production details involved in getting the finished inserts to (and approved by) the CD-ROM replicator. It's worth paying extra for having this done, as long as you have confidence in the artist's abilities.

A normal production schedule for several thousand booklets is around three weeks. If you master the CD-ROM yourself (the so-called *golden master*) and send it to the replication plant on the same day that you ship the booklet to the printer, the two

processes should dovetail well. Of course, you should always talk over any proposed schedule with the salesperson or plant scheduler. Most plants have different turnarounds for different prices.

Currently, there are only a handful of CD-ROM pressing plants in North America. One that we have used successfully is DMI, located in Anaheim, California. For further information, they can be reached at (714) 630-6700. Interestingly enough, most (if not all) of the adult titles currently in production are being replicated outside of the United States, since the major North American pressing plants have refused to manufacture adult content.

These are the main items to be concerned with in constructing a production timeline for publication of an independent CD-ROM title. As far as distribution, licensing, and bundling (with other peoples' hardware) are concerned, you are on your own. Fortunately, CD-ROM publishing is a very young industry with plenty of opportunity for talented entrepreneurs.

Setting Up a Production Studio

REGARDLESS OF YOUR ENVIRONMENT, THERE ARE SOME COMMON PRACTICES YOU SHOULD FOLLOW IN THE DAY-TO-DAY OPERATION OF YOUR COMPUTER AND VIDEO EQUIPMENT.

Back in Chapter 3, we listed the key components of several Mac and PC desktop video production suites in an effort to derive the total costs involved in putting those systems together. The bottom line for even the Euro-kitchen approach was, in a word, sobering. If you have read this far, however, we'll assume you have signed up for a few more Gold Mastercards and are ready to get to work.

You might also want to review the photos in Chapter 3 of real desktop video workstations where production quality QuickTime and AVI movies are produced and often incorporated into retail products. When you get your own death star fully operational, it will probably look very similar to one of these real-world studios.

Ultimately, the decision to go fully Mac or PC will probably be a function of the personal computer environment with which you are most comfortable (as opposed to the relative merits of either). If you have significant experience with *both* platforms,

you will likely incorporate elements of each, particularly if your movies will be made cross-platform. (These issues are addressed in Chapter 27.)

Due to the nature of the currently available desktop video tools, Mac producers are more likely to venture into the Windows world than vice versa—mainly to increase their markets. Still, experienced AVI movie makers can't help but be lured by the high-quality digitization afforded by the high-end Mac capture cards. Ah, the pleasures of diversity.

In this chapter, we will cover:

- Basic advice for arranging and connecting equipment
- Specific components of a Mac production suite
- Specific components of a PC production suite

Basic Studio Setup

Regardless of your environment (Mac or PC), there are some common practices you should follow in the day-to-day operation of your computer and video equipment. We have learned these lessons through trial and error, and usually at the worst possible moment. In general, these practices fall into two categories: practical and technical.

Practical Tips

- Sketch out your work area on paper before buying any new furniture. Include cabling and power distribution diagrams. Make sure your work space can handle the electrical load.
- Use tough metal and pressboard racks for all your gear. Why subject all that expensive Scandinavian design furniture to the inevitable wear and tear? Anthro carts are good if you expect to move your studio from room to room.
- Give all your equipment room to breath. In other words, only put one or two boxes on each shelf, and keep some space between them (this applies more to computer gear). Heat issues aside, you will want easy access to all connectors and controls at all times.

- Even if you are working in a small room, leave walking space behind your racks. You'll be going back there a lot.
- If you are using desktop computers (as opposed to the tower models) don't put anything on top of them—like monitors or mass storage devices. Keep the top of the case unscrewed. If you're a cutting edge producer, you'll be popping the top frequently to swap various adapter cards. There are few things worse than having to move heavily wired components off the top of your CPU when you need access to the internals (or watch them crash to the floor it they were precariously balanced).
- If possible, color code your data cables. Yellow seems to be appropriate for video, red for the right audio channel, white for the left. If you are truly obsessive (and again, we salute you), tagging each end of otherwise indistinguishable serial, ethernet, or SCSI cables can provide an even warmer and fuzzier feeling.
- Use switch boxes freely, especially with audio and serial cables.

Technical Tips

- Whenever possible, to keep things organized, number your SCSI devices in the order in which they are arranged on your chain. For example, make your external hard drive SCSI ID 1, your Syquest drive SCSI ID 2, your CD-ROM reader SCSI ID 3, and so on.
- Treat your big hard drives as your rapid deployment devices, free of old files and ready to do big raw captures whenever the need arises. If you have both Mac and PC equipment, keeping a monster hard drive clean means you will be able to switch it between the two platforms quickly and easily, since it will have to be reformatted.
- For real-time editing (with a program like Premiere) where you will be using, say, several hundred megabytes worth of clips (for a two- or three-minute final movie), burning those clips onto a CD-ROM to free up hard disk space can be a good idea gone bad, especially with a single-speed CD-ROM drive. If you want to see fast previews and speedy updates of your story board, you should (unfortunately) plan on keeping your working clips on a hard drive.

- If you plan to work with both a Mac and PC, or with two or more Macs or PCs, try to connect them together with a local area network (LAN). If you use a Novell solution, you will need yet another machine to be your dedicated network server (as opposed to, say, Lantastic). In the long run, network file transfers leave serial transfers (of the Desk-Link/Mac-Link variety) in the dust.

Using the Meta System

Another blast from the past: the meta system. In Chapters 4 and 15, we proposed this concept to make it easier for you to visualize how all the components in a capture system can either work together or limit each other—based on knowing where the potential bottlenecks are. When constructing your workstation, you should consider using this model as an overlay for all the componets you plan on integrating.

The particular equipment used in the Mac and Windows proto-studios described below passes the meta system test. If you want to change any of the components (but otherwise follow one of the models presented), we highly recommend that you carefully assess the new component's abilities and then refer to Chapter 15 for a review of the potential bottlenecks in a desktop video capture system.

Assembling a Mac Studio

Although we proposed configurations for both high and lower end Mac systems in Chapter 3, the suite of equipment described below combines the best elements of both. Our main purpose is to show you a collection of generic boxes that you can think about how to arrange and connect in your allocated work area. To keep things real, we made sure the system can achieve a recognized, standard goal—in this case a generic 3-minute clip with titling and mild special effects.

If you think that this configuration is a bit of an overkill, especially for this type of clip, remember that we are talking about real-world production here, where saving time is everything.

Doing the work on an old Mac IIci with 8Mb of RAM, a Video Spigot, and a consumer VCR in any sort of professional time frame would be an exercise in total frustration.

Computer Equipment

- Mac Quadra 840AV with 8Mb of RAM, a 230Mb internal hard drive, and an internal CD-ROM drive. Until PowerPC-based systems are in general release, have all the bugs shaken out of them, and are stable price-wise, the 840AV is the way to go for serious Mac-based desktop videographers. You will put its 40mHz 68040 processor right to work when you preview in Premiere, add special effects in VideoFusion, and do your final compressions with MovieShop.
- 32Mb of additional RAM.
- 16-inch Monitor. Not as cool for editing as those SuperMac 20-inchers, but more than adequate.
- 1.2 gigabyte external SCSI hard drive.
- 44Mb Syquest removeable hard disk drive.
- Radius Video Vision Studio capture card. Not only does this board come bundled with Premiere and VideoFusion (a $1,500 software savings, more or less), but it can output to an NTSC monitor or VCR at S-VHS quality.

Movie Making Software

- Adobe Premiere (bundled with the Radius board in this case)
- VideoFusion (bundled with the Radius board in this case)
- Digidesign's ProTools (for digital audio editing)

Video Equipment

- Sony CCD-TR101. The more work you do professionally, the more you will probably deal with content provided to you by the client. Most clients will likely provide work in Betacam format, which means you would have to rent a Betacam deck. (If you need to rent one, try to get the client to pay for it.) Still, no self respecting desktop video producer should be without a video camera. We shot some of the clips on the companion CD-ROM with the TR101. See the description in Chapter 12 for more information on this camera.

- Panasonic AG-1970 S-VHS video cassette recorder. While it is always nice to work with Hi-8 gear, this unit offers some nice features at less than half the price of the workhorse Sony EVO models. Most important, you can control it from within Premiere with almost complete frame accuracy for setting in and out points. Since we are using the Radius Video Vision *Studio*, we will be effectively *capturing* with frame accuracy also (using our desktop video standards). Because the AG-1970 has modest TBC circuitry built in, we may be spared having to get a separate TBC component. Again, see Chapter 12 for further information on this product.
- Selectra VuPort. You need this box cabled between your Mac and the AG-1970 VCR. You also need a Plug-in for Premiere to make the AG-1970 controllable through the VuPort. Fortunately, Premiere ships with one.
- Generic 19-inch NTSC monitor. You may consider this monitor optional in the long run, but for the extra two hundred dollars or so, it's nice to have for a reference when capturing (and if you ever do printing back to video tape). If you have one, you can attach it to the composite video out from the AG-1970.

Roughly speaking, the total cost of this system is somewhere between the two Mac-based systems detailed in Chapter 3 (as this book is being written). All of the components except for the NTSC monitor are essential, even the SyQuest drive, as you will see in the long run. Feel free to consider alternative components, but make sure they won't create new bottlenecks.

Miscellaneous Equipment

As the song says, "I could rule the world—if only I could get the parts." Taking this to heart, make sure you have a couple of cigar boxes worth of Y connectors, RCA to phone jack, RCA to mini phone jack, phone jack to mini phone jack, BNC to RCA, and BNC to phone jack connectors on hand, as well as the standard collection of loose cables to go with them.

Imagine that it's late at night and you are trying to get your friend's DAT recorder patched into your system so that you can add a great new ambient sound track to your exciting new work in progress. Unfortunately, you discover that you are in

the midst of a serious cable shortage. Radio Shack closed hours ago. Bummer.

Other miscellaneous items like microphones and headphones, as well as cheap analog audio components like mixers and EQ boxes, will also come in handy sooner or later, as will rip-ties and other types of cable organizers. Don't forget a generous selection of tools either—like various guages of screwdrivers and a pair of needle nose pliers.

Wiring Things Together

Figure 28.1 shows a diagram of the baseline connections necessary for the system we are discussing, along with suggested placements for the various pieces of equipment. Of course, you may have your own preferences for how the computer components should be arranged, but we have found this overall setup generally workable (at least for right-handed people).

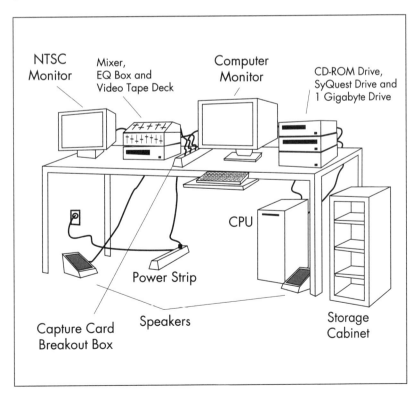

Figure 28.1
A Diagram of a Working Mac Desktop Video Production Suite

Chapter 28 Setting Up a Production Studio

Assembling a PC Studio

In Chapter 3, we also presented two levels of sophistication (based on price/performance trade-offs) for *PC* systems. As we just did for the Mac, we would now like to propose a single capture and production suite based on a Windows machine. To avoid redundancy, there will be some references back to the Mac material.

Our goals are the same: 1) Establish a specific collection of equipment that can be marshalled into a workspace, and 2) Verify that the equipment can, in fact, be used to make movies efficiently and under a good price/performance curve. Overlaying our meta system on this actual system will accomplish this goal.

Again, you may think that this system is too rich to bring to bear on such a short and simple project as a 2-3 minute finished clip. To repeat our position from the section on the Mac studio, a somewhat lesser system *could* be used to digitize and edit clips like the one mentioned above, but it would take significantly longer. This disadvantage would be multiplied in any real world production environment, to the point of complete frustration.

Computer Equipment

- A 486 DX2 66mHz (any decent brand name clone) with 16MBytes of RAM, ISA bus, local bus video, and large internal hard drive (300 to 400Mbytes). Until Pentium-based systems become common and lose their premium price-wise, a 486 DX2 66 is an excellent solution for the dedicated Windows-based desktop producer, especially when working in Premiere, MediaMerge or VidEdit (and encoding with CinePak) where sheer processing power makes the difference between boredom and enthusiasm.
- 16" Monitor.
- Adaptec AHA-1540B/1542B SCSI adapter card.
- Double-speed external CD-ROM drive.
- 1.2 Gbyte external SCSI hard drive.
- 44 Mbyte Syquest removeable hard disk drive.
- Intel Smart Video Recorder capture card.

Movie Making Software

- Video for Windows
- Adobe Premiere for Windows
- ATI MediaMerge (for its digital audio editor)
- Gryphon Morph for Windows

Video Equipment

Almost all of the video equipment discussed in the earlier section on setting up a Mac-based studio can be re-used here, with pretty much the same rationale. As of this writing, while you can capture from within Premiere for Windows, device control like on the Macintosh version has not yet been implemented. However, as noted in other chapters, the API for it exists in Video for Windows 1.1.

What this means is that device control for movie making under Windows is just around the corner. When MCI-based device control software starts shipping, VCRs like the Panasonic AG-1970 will likely be the first ones to press the advantage. It will be nice if SMPTE support under Video for Windows soon follows.

Roughly speaking, the total cost of this system is somewhere between the two PC-based capture suites detailed in Chapter 3. Like with the Mac proto-studio, all of the components (except for the NTSC monitor) are essential. Feel free to swap out some of the equipment, but check out the capabilities of any new components to make sure you are not creating any bottlenecks.

Miscellaneous Equipment

See the parallel heading in the earlier Mac section, since these concerns are exactly the same.

Wiring Things Together

Figure 28.2 provides a schematic of the cabling required, including proposed relative locations for each piece of computer

Figure 28.2
A Diagram of a Working Windows Desktop Video Production Suite

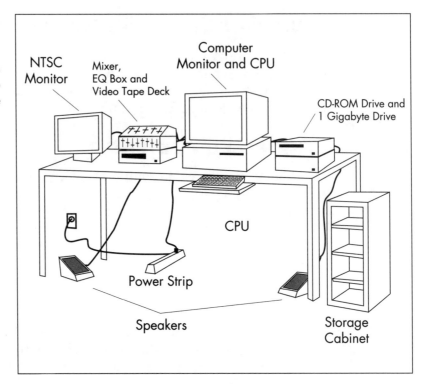

and video gear. Again, you likely have your own ideas about how such equipment should be organized, but we have found this overall setup generally workable (for right-handed people).

Glossary

1/4" Phone Plug This plug is generally found on old style and professional headphones as well as on microphones. 1/4" in diameter and 1 1/2" long, this type of plug is available in both mono and stereo formats. Microphones normally have a mono plug, while headphones are usually stereo.

1/8" Mini Phone Plug Use of the 1/8" mini phone plug has increased dramatically, reflecting the popularity of miniaturized consumer electronics. This plug is also available in mono and stereo. Camcorders generally use the mini plug for headphones and external mics.

32-Bit Addressing A feature of System 7 (Macintosh) that lets you use 4, 16, and 32MB SIMMs. With 32MB SIMMs, you can increase the RAM on a Mac to 256MB. You need this feature enabled to get access to RAM above 8 megabytes.

Access Time A standard hard drive (and CD-ROM drive) performance measurement. Simply put, access time equals seek time (the time it takes for the read/write mechanism to move to the proper track on the hard disk surface) plus latency (the time it takes the disk to rotate the data to the read/write head).

Alias A System 7 feature that provides a quick reference to the name and location of a specified file. Aliases can be maintained in separate locations from the actual files they refer to (on the desktop, for example), but clicking on an alias is effectively the same as clicking on the original file

Aliasing In bitmapped graphics, aliasing is the jagged boundary along the edges of different colored images. In audio sampling, aliasing is distortion cause by the sampling rate not being high enough to capture the tops and bottoms of the sound waves.

Alpha Channel A conduit for non-movie information in a movie data stream. In 32-bit QuickDraw, an image is stored as a collection of 8-bit red, green, and blue pixels (24 bits). The other 8 bits can thus contain other information, depending on the needs of the developer.

Analog A method of storing or transferring data in which that information is presented in an equivalent form. For example, the pattern of metal particles on a standard audio tape is an analog representation of the recorded sound.

Glossary

Analog-to-Digital Converter (A/D or ADC) A device that converts analog voltage level information into digital data representing the amplitude (level) of the analog signal over the course of the conversion.

Anti-Aliasing A technique for reducing the jagged appearance of aliased bitmapped images, usually by inserting pixels at the boundaries between adjacent colors.

Array (Drive Array) A mass storage system employing two or more hard disks working in concert, thereby increasing data throughput and access time.

Asymmetric Compressor A type of codec that takes longer to encode a frame than it does to decode that frame. Asymmetric compressors generally deliver significantly better playback performance than symmetric compressors. CinePak is a popular asymmetric compressor.

AVI (Audio-Video Interleaved) Microsoft's file format for desktop video movies.

Back Light A light source positioned behind a subject to help distinguish the subject from the background.

Bandwidth The amount of data that can be transferred in a given period of time, generally measured in megabytes or kilobytes per second in the desktop video world.

Bit Depth (Color Depth or Pixel Depth) The number of bits used to represent the color of each pixel in a given movie or still image. Specifically: Bit depth 2 = black and white pixels. Bit depth 4 = 16 colors. Bit depth 8 = 256 colors. Bit depth of 16 = 65,536 colors. Bit depth of 24 = (approximately) 16 million colors.

Cannon Connectors (XLR) A type of cable connector used in professional cabling. A large, three pin (male) plug, the cannon connector employs a locking mechanism to ensure a good connection between male and female plugs and jacks. Cannon cables are generally balanced and insulated.

Cardioid Microphone A type of microphone that picks up most of its sound from the area directly in front of it.

CD-I (Compact Disc-Interactive) A laserdisc-based, consumer technology developed by Philips for use with t.v. as opposed to personal computers.

Chroma-Key In analog video, the process used to position one video track on top of another. A portion of the top track is then usually made transparent so that the video track beneath it can be effectively combined.

Chrominance The color dimension of a video signal.

Clipping Audio distortion resulting from the level of an incoming signal being too high to record properly. A portion of the audio data is thus lost as it gets clipped off the top.

Codec (Compressor/Decompressor) A piece of software that encodes and decodes movie data, usually in a highly compressed format.

Color Depth See Bit Depth.

Component Manager The part of QuickTime that keeps track of information about the compressors, decompressors, video digitizers, and any other such components correctly installed on a system. The Component Manager provides applications access to all of its registered components.

Component Video A video format in which the red, blue, and green channels (along with the luminance, or brightness, channel) are handled separately to produce a high-quality video image.

Composite Video A video format in which the chrominance color (chrominance), brightness (luminance), and synchronization data are mixed together in one signal. Composite video is the standard for most consumer VHS and television equipment.

Compression Ratio The size of the original image divided by its size following compression.

Condenser Microphone A type of microphone characterized by being smaller and more senstive than other mics, but requiring a separate power source, such as a battery or a cable from a mixing board.

CPU (Central Processing Unit) In general, the guts of a personal computer—the primary microprocessor (such as an Intel 486 DX2), motherboard and system RAM. Sometimes refers to just the primary microprocessor.

Data Rate See Bandwidth.

Delta Frames See Differenced Frames.

Desktop Video In the context of this book, a new type of PC-based multimedia with the following attributes: 10 to 15 frames per second, 240 x 180 frame dimensions, at least 256 colors, and 11.025kHz audio.

Differnced Frames Movie frames in a video data stream comprising just the differences between the current frame and the previous frame. As differenced frames contain less data than complete images, they help form the basis of several key compression strategies.

Digital-to-Analog Converter (D/A or DAC) A device used to translate digital recordings back into analog form, so that the performance stored in a given digital recording can be experienced by a listener or viewer. Audio CD players use these devices.

Dithering A method used to improve the perceived quality of PC graphics. For example, because an 8-bit graphics card can only display 256 colors, a movie with 16-bit color ordinarily cannot get all its colors displayed. Dithering creates

patterns with the colors in an 8-bit palette to simulate otherwise unreachable color.

Dropout A type of video imperfection caused by metal particles flaking off the surface of a video tape. Common symptoms include pockmarks, image streaking, and occasionally, synchronization problems.

Dynamic Data In general, any information that changes over a period of time—like movie data.

Dynamic Microphone The most prevalent type of consumer mic. Hardy and inexpensive, but usually not too sensitive due to the large size of the diaphragm.

Edit Controller The piece of equipment that controls and synchronizes all the VTRs in an editing suite.

Edit Decision List (EDL) A list of instructions readable by high-end video equipment that specifies all the edits and special effects in a given video production.

Field Technically, half of the total number of scan lines in a video frame. The first field contains all the odd lines in the frame, while the second field is composed of all the even scan lines.

Fill Light A type of light used to provide an overall lighting level in a scene being shot for video or film. Specifically different from a spot light or a back light. Used extensively to dispel shadows in facial close ups.

Fork A Macintosh file system convention that provides two separate areas in which a file can store data: the *data fork* (straight data) and the *resource fork* (icons, cursors, PICTs, and so on).

Frame Film and video tape are composed of a series of frames that are displayed serially. Film normally gets played at 24 frames per second, while the standard for analog video is approximately 30 fps. To the human eye, such a series of frames appears as fluid motion.

Frame Accuracy A level of precision in desktop video recording. If a video deck can be externally controlled to provide all the frames on an analog video tape for digitization, it is said to be frame accurate.

Frame Differencing A strategy used in movie data compression. See Differenced Frames.

Full-Frame, Full-Motion In the desktop video world, 30 frames per second with a frame size of 640 x 480 pixels.

HDTV (High Definition Television) Touted as the next standard for high quality video. Employs a wide-screen image format (16:9) and takes the vertical resolution up to 1,150 scan lines. In the U.S., HDTV is primarily a digital standard.

Horizontal Resolution The amount of detail displayed from left to right in a video frame.

Glossary

Image Compression Manager The part of QuickTime that deals with compressing and decompressing data to and from the storage medium.

Indeo Video A popular codec developed by Intel. The latest version compresses in real time when used with Intel video capture hardware.

Interlaced Video A video rendering scheme that superimposes two fields to create a single frame. Each field is rendered by either the upward or downward pass of the electron gun in a monitor. The standard for composite video.

JPEG (Joint Photographic Experts Group) An image compression strategy, basically for still images, currently implemented in desktop video. No frame differencing is used—all frames are compressed spatially, one at a time. With hardware assistance, JPEG can keep up with desktop video data rate requirements.

Key Frame As opposed to a differenced frame, a key frame does not depend on another frame to provide a complete image, even though it may be compressed spatially.

Longitudinal Time Code (LTC) A variety of SMPTE time code recorded onto an existing track on a video tape (such as an audio track). Different that VITC time code, which is recorded onto the video track between frames. LTC cannot be read when a video deck is paused.

Lossless A compression strategy in which the compressor maintains the original image quality of the material it compresses.

Lossy As opposed to lossless, a compression strategy in which image quality is degraded in order to achieve storage space efficiency.

Luminance The brightness dimension of a video signal.

Macintosh Toolbox A standard set of routines available to developers programming on the Mac. The Toolbox is responsible for standardizing the Mac interface.

MIDI (Musical Instrument Digital Interface) The public domain protocol for communicating with electronic musical instruments. Used by personal computers and dedicated sequencing equipment to trigger such instruments when performing music.

MPEG (Motion Picture Experts Group) A *moving* image compression scheme (as opposed to JPEG) currently being implemented for desktop video. Planned as a distribution format—not for use in video editing systems.

Moire Effects Strange patterns in images, basically due to rounding errors in bitmap scaling.

Movie Toolbox The part of QuickTime that provides standard programming routines for movie handling.

Glossary

Movies In general, PC files that QuickTime and Video for Windows can play to deliver desktop video. Movies can be assembled from any kind of dynamic visual or audio data, not just video or animation sequences.

Navigable Movies Special movies in which the viewer can navigate spatially, generally with the mouse or keyboard. Still in their infancy, navigable movies comprise one of the most exciting areas of desktop video development

Noise In desktop video parlance, extraneous audio or video data, usually detracting from the quality or performance efficiency of a movie.

Non-Interlaced Video A video rendering scheme that displays a full frame with each pass of the electron gun (as opposed to interlaced video). The standard for newer computer monitors.

NTSC (National Television Standards Committee) The video standard for North America. See the discussion of this standard in Chapter 11.

Off-Line Editing An editing process in which copies of original footage are assembled and tested prior to performing an on-line edit to produce a master tape.

PAL The European counterpart to NTSC. See Chapter 11.

Palette A color table used by PCs running in less than 16-bit mode. For instance, when a Mac is in 8-bit mode, it employs a palette to handle the color values it displays on the screen. Each pixel in an 8-bit image corresponds to a value in the palette. This differs from 16-bit and 24-bit modes, where each pixel is stored as a real color value.

PIC A standard animation file format used on the Macintosh.

PICT A standard graphics file format used on the Macintosh.

Plug-in A software add-in product that provides extra functionality to another program. Both Premiere and Photoshop support plug-ins for incorporating third party special effects.

Post Process Any step in a standard movie production performed after the principle photography is completed.

Poster Frame The preview image of a movie displayed, for instance, in the Open File dialog box. A user can set or change a movie's poster frame with an application like MoviePlayer. The default poster frame is the first frame in the movie.

Poststriping Adding time code to a videotape after shooting the footage. Generally accomplished by laying the time code over a free audio channel.

Pulse Code Modulation (PCM) A method for digitally recording sound onto videotape. Hi-8 video uses both PCM audio and a regular audio track. PCM lets

you perform insert edits on the PCM audio track—in other words, you can re-record the audio track without erasing the video track.

Quantization Converting continuous data (such as movie data) into a series of individual steps. Desktop video compression strategies often employ quantization techniques.

QuickTime System software developed by Apple Computer for presentation of time-based media—specifically desktop video.

RCA Plugs One of the most common types of cable connectors—common in home stereo equipment and TV/VCR hookups.

Run-Length Encoding A common form of data compression, now implemented in desktop video codecs. See Chapter 17 for more information.

S-Video A video format used in S-VHS and Hi-8 video equipment. S-Video separates the luminance (brightness) and chrominance (color) of the video signal to improve image quality.

Sampling Rate In this context, the rate at which analog sound data is converted to a digital format. In desktop video, audio sampling rates are typically around 22,000 samples per second.

Saturation The degree of purity of a color relative to the amount of white mixed with it. A color that is pure blue with no white mixed in is completely saturated.

SECAM (Systeme Electronique Pour Couleur Avec Memoire) A French video standard that is used in France, Russia, and throughout Eastern Europe (as opposed to NTSC and, to a lesser extent, PAL).

Self-Contained In a desktop video context, free of references to other movie files. When you make a movie self-contained, all external movie data formerly referenced is copied to that (now larger) movie.

SMPTE Time Code (Society of Motion Picture and Television Engineers) A standard for determining the location of individual frames on videotape, available on professional equipment and prosumer equipment. SMPTE does not tell time—it simply numbers frames in the HH:MM:SS:FF format (hour:minute:second:frame).

Spatial Compression Compression of single frames only in a video data stream, as opposed to temporal compression (compression of a sequence of frames).

Switcher An analog video device that synchronizes and mixes video from all sources. Also used to add transitions (wipes, dissolves, and other effects).

Symmetric Compressor A type of codec that takes approximately the same amount of time to encode a frame as is does to decode that frame. Apple Video and Indeo Video are symmetric compressors.

Glossary

Synchronization The process of keeping audio and video track playback happening in the same time relative time frame, to reflect the overall action as it was recorded.

Temporal Compression Temporal compression involves analyzing what happens to images as they change over time, and removing redundant information. In a temporally compressed movie, only the changes between frames (except at key frames) are recorded.

Test Signal Generator An analog video device for producing reference test signals to measure performance of individual pieces of equipment in a video production system.

Time Code Generator A device that can stamp time code (for example, SMPTE) onto videotape. Some video decks have this capability built in.

Transcoding In the QuickTime realm, the process of recompressing a movie with different compression attributes. In analog video, transferring videotape from one format to another (such as Hi-8 to Betacam).

VDig (Video Digitizer Component) A system software component used to control a digitizer boards. Each different board has its own VDig.

Vectorscope An oscilloscope used to measure hue and saturation of colors in a video image.

Vertical Blanking Interval The blank area in a video signal used to hide the spot where one field ends and another begins. The black bar between frames (when your television loses vertical hold).

Vertical Interval Time Code (VITC) A variety of SMPTE time code recorded onto a video track in the space between frames (the vertical blanking interval). Preferred over LTC, which is usually recorded onto an audio track and cannot be read when a video deck is paused

Virtual Memory A memory expansion scheme used by personal computers which temporarily transfers data held in RAM to a hard disk.

Waveform Monitor An oscilloscope that typically displays the stability of both fields in a sequence of analog video frames.

Window Dub A copy of a videotape with time code superimposed. Window dubs are normally used during tape logging and off-line edits.

XCMD (External Command Module) XCMDs are used to allow HyperCard to communicate with other devices (such as CD-ROM drives and video decks) via the Mac SCSI and serial ports.

Suggested Reading List

QuickTime

Best of the QuickTime Forum, Christine Perey, ed., 110 pp., $49.95.

Inside Macintosh: QuickTime, Apple Computer, Addison Wesley, 600 pp., $29.95.

Inside Macintosh: QuickTime Components, Apple Computer, Addison Wesley, 817 pp., $34.95.

Mastering the World of QuickTime, Jerry Borrell, Random House, 218 pp., $19.00.

QuickTime Handbook, David Drucker/Michael Murie, Hayden, 748 pp., $34.95.

QuickTime How-To Book, Sam Miller/Arno Harris, Sybex, 411 pp. plus diskette, $29.95.

Multimedia Production

Apple CD-ROM Handbook: A Guide to Planning, Creating and Producing a CD-ROM, Apple Computer, Addison Wesley, 144 pp., $14.95.

CD-ROM: Facilitating Electronic Publishing, Linda Helgerson, VNR, 528 pp., $39.95.

CD-ROM Handbook, second edition, Chris Sherman, McGraw-Hill, 579 pp., $70.50.

Designing Interactive Multimedia, Arch Luther, Bantam, 318 pp., $39.95.

Desktop Multimedia Bible, Jeff Burger, Addison Wesley, 636 pp., $32.95.

Digital Nonlinear Editing: New Approaches to Editing Film and Video, Thomas Ohanian, Focal Press, 348 pp., $49.95.

MacWeek Guide to Desktop Video, Erik Holsinger, Ziff-Davis, 303 pp. plus CD-ROM, $34.95.

Multimedia Applications Development Using Indeo Video and DVI Technology, Mark Bunzel/Sandra Morris, McGraw-Hill, 265 pp., $29.95.

Multimedia Creations, Philip Shaddock, Waite Group Press, 430 pp. plus 2 diskettes, $44.95.

Multimedia: Making It Work, Tay Vaughan, Osborne, 544 pp. plus diskette, $27.95.

Multimedia Mania, Harald Frater/Dirk Paulissen, Abacus, 513 pp. plus CD-ROM, $49.95.

Multimedia Power Tools, Peter Jerran/Michael Gosney, Random House, 640 pp. plus CD-ROM, $50.00.

Multimedia Production Handbook for the PC, Macintosh and Amiga, Tom Yager, Academic Press, 382 pp., $35.95.

PC Video Madness, Ron Wodaski, Sams, 667 pp. plus CD-ROM, $39.95.

Virtual Worlds and Multimedia, Nadia and Daniel Thalmann, eds., Wiley, 216 pp., $59.95.

Windows Multimedia Production

Discover Windows 3.1 Multimedia, Roger Jennings, Que, 925 pp. plus diskette, $39.95.

Microsoft Windows Multimedia Authoring and Tools Guide, Microsoft, 280 pp., $24.95.

Multimedia Madness, Ron Wodaski, Sams, 632 pp. plus CD-ROM, $44.95.

Multimedia Programming for Windows, Steve Rimmer, McGraw-Hill, 370 pp. plus CD-ROM, $39.95.

Visual Design/Interface Design

Intelligent Multimedia Interfaces, Mark Maybury, MIT Press, 405 pp., $39.95.

Multimedia Computing: Case Studies from MIT Project Athena, Matthew Hodges/Russell Sasnett, Addison-Wesley, 324 pp., $32.95.

Multimedia Interface Design, Meera Blattner/Roger Dannenberg, eds., ACM, 438 pp., $42.95.

Multimedia Interface Design in Education, Alstair Edwards/Simon Holland, eds., Springer Verlag, 218 pp., $59.00.

Understanding Hypermedia: From Multimedia to Virtual Reality, Bob Cotton/Richard Oliver, Phaidon, 160 pp., $24.95.

Directories

CD-ROM Buyer's Guide & Handbook: The Definitive Reference for CD-ROM Buyers, third edition, Paul Nicholls, Pemberton Press, 450 pp., $44.95.

CD-ROMs in Print 1993: An International Guide to CD-ROM, CD-I, CDTV, Multimedia and Electronic Book Products, Regina Rega, Meckler, 736 pp., $95.00.

Directory of Multimedia Equipment, Software & Services, International Communications Industries Assn., 527 pp., $99.00.

New Media Showcase: The Digital Sourcebook, American Showcase, Inc., 200 pp., $35.00.

Miscellaneous

Optical Recording: A Technical Overview, Alan B. Marchant, Addison Wesley, 408 pp., $51.95.

Studies in Multimedia: State-of-the-Art Solutions in Multimedia and Hypertext, Susan Stone and Michael Buckland, eds, ASIS, 263 pp., $39.50.

Technologies for the 21st Century: On Multimedia, Martin Greenberger, ed., The Voyager Co., 263 pp., $24.95.

The Education of a CD-ROM Publisher by Chris Andrews, published by Pemberton Press/Eight Bit Books, Wilton, CT, 1993.

Magazine Articles

Computer Programs and Copyright's Fair Use Doctrine by Pamela Samuelson, *Communications of the ACM*, September 1993.

Rights of Passage by William Rodamor, New Media, September 1993.

The books presented in this suggested reading list are available from Computer Literacy Bookshops, 2590 North First St., San Jose, Calif., 95131. Phone: (409) 435-0744. FAX: (408) 435-1823.

Index

A

A Hard Day's Night, 325
A/B roll, 443
Abbate Video, 158
Accelerator board, 73
Access time, 443
ACM, 274
Action!, 107, 109
ActionMedia II, 103
Adaptec, 96–97
Adaptect 1542B, 117
Adjusted data rate, 25
Adobe, 40–41, 81, 83, 87, 137–38, 149–51, 401
AFDISK, 97
AFM, 201, 211
After Effects, 40, 81, 153–54
AIFF, 156, 390
AimTech Corporation, 42, 141
Aldus Corp, 81, 154
Alias, 443
Aliasing, 443
Alpha channel, 443
ALR, 92
Alysis, 122
America Online, 401
American National Standards Institute. *See:* ANSI
American Visions: 20th Century Art from the Roy R. Neuberger Collection, 397–98, 400
Amplifiers, 213
Analog, 444
Analog sources, 399–401
Analog video equipment, controlling, 142–44, 158
Analog-to-digital converter (A/D or ADC), 444
Andrews, Chris, 48
Animation Commander, 176
Animator, 135
ANSI, 113
Anti-aliasing, 444
Apple, 10, 16, 21–23, 26, 69, 71–75, 86, 88, 95, 135, 137, 146–47, 158, 422, 426
Apple Events, 157
Apple System 7, 17
Apple Video (Road Pizza), 279
AppleScript, 154, 156
Array (drive array), 444
ARTI, Inc., 156, 176
Asymetrix, 104, 141–42
Asymmetric compressor, 444
AT&T 3210 DSP, 72
ATI Graphics Ultra, 98
ATI MediaMerge, 42–43

ATI Technologies, 138–39
Atom-based format, 250
Audio
 attributes, 25, 28, 31–32
 compression, 274–75
 handling, 300
 interleave, 375
 peripherals (PC), 98–99
 quality, 327, 336–38
Audio hardware standards, 209
 amplifiers, 213
 analog audio, 218
 Macintosh, 218–21
 PC, 221–23
 equalizers, 214
 limiters and compressors, 214–15
 noise reduction, 215
 reverb, 215–16
 mixers, 216–17
 phasing, 217–18
Audio/video interleave. *See:* AVI
Authoring, 140–42
 IconAuthor, 140–41
 ToolBook, 141–42
 Visual Basic, 142
Authoring software, 154
 cost of, 40–43
 HyperCard Development Kit 2.1, 157
 Macromedia Director 3.1.1, 154–55
 Passport Producer Pro, 155–57
Authorware Professional, 155
Authorware Star SE, 105
Autodesk, 138
AVI, 23–26, 31, 61, 77, 444
 file structure, 263
 movie files, 269–71
Avid Technology, 150, 157
AVSS (Audio/Video Support System), 86

B

Back Light, 444
Backup, tape and DAT, 129
Bandwidth, 30, 33, 93, 444
Basic SCSI-2, 113
Bernoulli drives, 49, 126
Beta, 162–63
Betacam, 164
Betacam SP, 164–65
Bit depth, 444
Blackstriping, 180
Brazil, 30

455

Breakout box, 79–80, 81
Broadcast standards, 168
 HDTV, 170
 NTSC, 169
 PAL, 169
 SECAM, 169–70
Bus, 115
Buses (PC), 93–96

C

Cables, SCSI, 117–19
Caching, 268
Callahan, Sean, 278
Camcorder, 413
Camera, cost of, 40–43
Cannon connectors (XLR), 444
Canon, 177, 203
Canyon Movie Toolkit, 131
Captain Crunch, 284
Captioned Pioneer Movie Maker, 148–49
Captivator, 105, 107–09
Capture, 56
 Macintosh, 312–15
 VidCap, 132–33
 Video for Windows, 306–11
Capture Adapter, 86
Capture cards, 33–34, 39, 64–65
 cost of, 40–43
 New Video EyeQ, 78–80, 85–86
 PC, 101–02
 Captivator, 107–09
 Pro MovieStudio, 104–05
 Smart Video Recorder, 103–04
 Video Blaster, 106–07
 Video Spigot for Windows, 105–06
 WinMovie, 109–10
 Radius Video Vision Studio, 78–80, 82–83
 RasterOps Editing Aces Suite, 78–80, 84–85
 Sigma Designs Movie Movie, 88–89
 SuperMac Digital Film, 78–82
 SuperMac Video Spigot, 87–88
Capture strategies, 339
 capture tips, 348
 compression tips, 349
 damaged captures, 357–61
 digitization, 342–43
 MovieShop tips, 350
 platforms, 340
 preliminary captures, 347
Cardioid microphone, 444
CAV (Constant Angular Velocity), 207
CCD (Charge coupled device), 444
CD-I (compact disc-interactive), 444
CD-ROM, 17–21, 419
 cross-platform playability, 420–27
 hybrid CD-ROMs, 429
 platform-dependent, 428
 production timeline, 429–31
 readers, 128
 writers, 49, 127–29, 419

Centris, 64, 71
Centronics, 117
Chroma noise reduction, 187
Chroma-key, 445
Chrominance, 445
Chunks, 260
CinePak, 23, 25, 29, 45, 61, 89, 148, 279, 283, 344, 367, 426
Claris Corporation, 157
Clipping, 445
CLUT, 328
CLV (constant linear velocity), 207
Codec, 23–30, 61, 84–86, 103, 445
 compatibility, 426
 QuickTime, 275–79
 Video for Windows, 280
Color adapter, 70
Color depth, 23–25, 28, 31, 333–36, 444
Color reduction, 389
Colorado Memory Systems, 129
ComboWalker, 147, 380–81
Compact Video, 30
Compaq, 92
Component Manager, 298, 445
Component Video, 445
Components, 285
Composite video, 167, 445
Compositing, 152
Compression, 23–25, 29
 ratio, 445
 tips, 349
CompuServe, 50, 132, 401
Condenser microphone, 445
Connectors, SCSI, 117–19
Consumer decks, 190
Consumer grades, 162
Consumer Reports, 190
Consumer video cameras, 202
Control track indexing, 189
Control-L, 177–78
Control-M, 178
Control-S, 177
Conventional memory, 100
ConvertToMovie, 146
Convolution circuit, 83
Copyrights, 52–53
Cossey, George, 363, 365, 367–68, 381–82
Costs, desktop video, 39
 Macintosh-based system, 41
 high-end, 40
 PC-based system, 43–44
 high-end, 42
CPU (Central Processing Unit), 63–64, 445
Creative Labs, 61, 88, 99, 105–07
Critical Path, 398, 409–10
Cross-platform, 29, 58, 123, 137, 154, 335–40, 421
 codec compatibility, 426
Cues, 155
Cyclone, 72

D

DAT backup, 129
Data fork, 251, 425, 446
Data handler, 299
Data rate
 adjusted, 25
 adjustment, 30
 Macintosh, 387–88
 PC, 394
 See also: Bandwidth
Daughter card, 80, 84
 Capture Adapter, 86
 upgrade to Video Vision, 82
DayStar, 73
DCT, 278
DeBabelizer, 154
Decompressors, 23
 QuickTime, 285
 QuickTime for Windows, 284
 Video for Windows, 286
Dell, 92
Delta Frames. *See:* Differenced frames
DeskTop Video World, 39
Desktop video, 22, 24, 37, 55, 445
Desktop video software. *See:* Windows-based software *and* Macintosh-based software
Developers, 397
Device drive, 99
Diamond, 98, 107
DiaQuest, 81, 176
Differenced frames, 445
DigiDesign, 359
Digital Film, 78–82
Digital tape (D1, D2, D3), 165–66
Digital video, 2, 7–11
Digital Video, 78
Digital Video File Formats, 271
Digital-to-analog converter (D/A or DAC), 446
Digitization, 56, 235–36, 342–43
 capture card, 236–43
 CPU, 244–48
 hard drive, 244–47
DIN, 168, 177
Director 3.1.1, 154–55
Discman, 50
Disk space requirements, 112–13
Disk storage, cost of, 40–43
Dithering, 389–90, 446
DiVA, 150, 157
DLL (dynamic link libraries), 29
Dolby, 195, 215
DOS, loading high, 100
Double-speed CD-ROM, 25
 cost of, 40–43
 writers, 128
Downsampling, 385, 390–91, 416
DQ-Animaq, 176
DQ-TimeCoder, 81
Dr. Dobbs' Sourcebook of Multimedia Programming, 271

Drastic Technologies, 176
Drive 7, 122
Drivers, SCSI, 117–19
Drives
 Bernoulli, 49, 126
 5.25-inch, 124
 hard, 123–24
 magneto-optical, 126–27
 Syquest 125–26
 3.5-inch, 124
Drop/non-drop, 231
Dropout, 168, 228–29, 446
DSP (digital signal processing), 72
DVI (Digital Video Interactive), 86
Dynamic Data, 446
Dynamic Microphone, 446

E

Echo, 215
Eden Interactive, 397–409
Edit control protocols, 174
 Control-L, 177–78
 Control-M, 178
 Control-S, 177
 GPI, 177
 RS-232 and RS-422, 178
 VISCA, 178–79
Edit Controller, 176, 446
Edit Decision List (EDLs), 171–72, 232, 320, 446
Editing, 137–39, 149
 captures, 355–62
 Media Merge, 138–39
 nonlinear, 231–33
 Photoshop, 151
 Premiere, 149–50
 Premiere for Windows, 137–38
 software, cost of, 40–43
 VideoShop, 150
Editing Aces Suite, 78–80, 84–85
Education of a CD-ROM Publisher, The, 48
Effects, 139–40
 After Effects, 153–54
 DeBabelizer, 154
 Morph, 139–40
 VideoFusion, 151–53
Effects software, cost of, 40–41
8-bit color, 86
8-bit color adapter, 70
8-bit mode, 107
8-bit sound, 81, 84
8-bit video card, 86
8 millimeter, 163
EISA (Extended Industry Standard Architecture), 33–34, 92–93, 114
Electronic Arts, 16
elst atom, 258
EMM386, 100
Encoding (sound), 266
Equalizers, 214

Equilibrium Tehnologies, 154
ESDI, 114
Expanded memory, 100
Extended memory, 100
External speakers (Macintosh), 70
EyeQ board, 78–80, 85–86

F

Fahrenheit, 98
Fast SCSI, 113
Fast-Wide SCSI, 113
FastCache, 73
Field, 446
15 Steps to Better Movies, 348, 351
50-pin connectors, 117–18
File size, 17
Fill light, 446
Film to video, transferring, 230–31
Filmstrip format, 151
Flag waving, 227
Flattened, 251
Flattening, 422, 424–26
Flicker, 83
Flopticals, 126
Florence, Mark, 271
Flying erase head, 186
Footprint, 124
Fork, 251, 425, 446
486 DX, 92
Frame, 446
Frame accuracy, 446
Frame code addressing, 189
Frame differencing, 446
Frame rate, 25, 28, 31, 317–22
Frame replacement, 358
Frame size, 25, 28, 31, 317, 322–25
Full height drive, 124
Full-frame, full-motion, 447
Full-load, 186

G

Gamma correction, 343, 388–89
GateKeeper, 104
Gateway 2000, 92
Gating, 215
Gold Disk, 144, 158
Golden master, 430
GPI, 177
GrabGuy, 147–48
Graphic EQ, 214
Gryphon Software, 140

H

H-Bus, 83
Half height drives, 124
Hard disk surface, 307
Hard drive, 123–24
 hard disk arrays, 124–25
 mounting, 122
hdr1 list, 264

HDTV (High Definition Television), 170, 447
HFS, 427
Hi-8, 164
 videotape management, 179–81
High Sierra, 427
HighText Publications, Inc., 159
HIMEM.SYS, 100
Horizontal resolution, 447
Host adapters, 115–16
Huffman encoding, 278
Hybrid CD-ROMs, 429
HyperCard, 157–58

I

i750 chip, 86, 103, 282
IBM, 10, 74, 93
IconAuthor, 42, 140–41
IDE, 114
idx1 chunk, 265
Illegal color, 447
Illuminator-16, 143
Image Compression Manager, 447
Image quality, 327, 336
 color depth, 328, 333
 under Windows, 332
Impulse, 73
Indeo Video, 25, 30, 61, 103, 105, 282, 427, 447
Industrial decks, 191
Industrial grades, 162
Industrial Light and Magic, 9
Industrial video cameras, 202–04
Intel, 16, 25, 30, 65, 69, 74, 113
 BBS, 132
 DVI, 86
 ISVR, 42, 103–04
Intelligent compressor, 367
Inter-platform benefits, SCSI, 122–23
Interaction, 7–11
Interactive qualities, digital's, 7–11
Interlaced video, 447
Interleave, 268–69, 375
Internal bus speed, 27
Internal sound chip (Macintosh), 70
Internet, 7
Intra-frame compression, 292
ISA (Industry Standard Architecture), 33–34, 92
ISO, 427
ISO 9660, 122–23

J

Jack, Keith, 159
Journey Through Art, 398
JPEG (Joint Photographic Experts Group), 80–84, 148, 278, 283, 427, 447
JVC, 162
JVC BR-S605U, 195

K

kbs (kilobytes per second), 25
Key frame, 375, 447

L

LANC, 177–78
LANC-compatible, 143
Laser disc players, 205–07
Layered effect, SCSI, 119–20
Layering, 153
LC III, 73
Limiters and compressors, 214–15
Line level, 212
Lingo, 155
Local bus video, 34
Logging, 447
London, Matthew, 397–98
Longitudinal Time Code (LTC), 447
Lossless, 447
Lossy, 447
LTC, 172
Luminance, 447

M

Macintosh, 16–17, 21, 23, 29, 58, 64, 77, 79
 analog audio, 218–21
 capture, 312–15
 data rate, 387–88
 movie metrics, 385
 production studio, 436–39
 redigitizing, 388–89
 repairing damaged captures, 357–60
 selecting color depth, 334
 SCSI, 114–15
 SCSI connector, 118
 sound, 390–92
 systems, 69–71, 75
 cost and performance, 40–41, 71–73
 PowerPC, 74–75
 test drive, 305, 312–15
 upgrades, 73–74
Macintosh-based software, 144
 analog video equipment, controlling, 158
 Abbate Video Toolkit, 158
 authoring, 154
 HyperCard Development Kit 2.1, 157
 Macromedia Director 3.1.1, 154–55
 Passport Producer Pro, 155–57
 editing, 149
 Adobe Premiere, 149–50
 Avid VideoShop, 150
 Adobe Photoshop, 151
 effects, 151
 After Effects, 153–54
 DeBabelizer, 154
 VideoFusion, 151–53
 QuickTime, standard applications, 144
 Captioned Pioneer Movie Maker, 148–49
 GrabGuy, 147–48
 MovieAnalyzer, 147, 378–80
 Movie Converter, 146–47
 Movie Recorder, 144–45
 MoviePlayer, 145–46
 movies and palettes, 389–90
 MovieShop, 45, 73, 147, 350, 363–78
 PictureCompressor, 149
MACE (Macintosh Audio Compression and Expansion, 274
Macintosh capture cards, 77–78
 Digital Film, 78–82
 Editing Aces Suite, 78–80, 84–85
 EyeQ, 78–80, 85–86
 Movie Movie, 88–89
 Video Spigot, 87–88
 Video Vision Studio, 78–80, 82–83
Macintosh Toolbox, 447
Macromedia, 43, 105, 107, 109, 154–55, 359
Macromind Director, 40–41
MacWeek, 413
Magnetic fields, 127
Magneto-optical drives, 126–27
Mass communication, 5
Mass storage devices, 111–13
 Bernoulli drives, 126
 CD-ROM writers, 127–29
 flopticals, 126
 hard drives, 123–24
 hard disk arrays, 124–25
 magneto-optical drives, 126–27
 networks, 130
 SCSI standards, 113–15
 cables, connectors, and drivers, 117–19
 layered effect, 119–20
 terminations, 116–17
 SCSI system tuning, 120–22
 inter-platform benefits, 122–23
 Stacker, 129–30
 Syquest drives, 49, 71, 125–26
 tape and DAT backup, 129
Mass storage, 65–66
Matrox, 143, 158
Matsushita, 178
MCA (Micro Channel Architecture), 93
MCI driver, 134
mdat atom, 259
Media handler, 299
Media Merge, 138–39, 396
Media Player, 135
Media Vision, 99, 104–05, 284
Media Vision PMS, 42
MediaBlitz!, 104
MediaMontage, 139
MediaTime, 84, 158
Memory
 cost of, 40–41
 expanded, 100
 extended, 100
 virtual, 451
Meta system, 39, 55–59
 components, 59–63
 capture card, 64–65
 CPU, 63–64

Index

mass storage, 65–66
 video source, 66–67
Microsoft, Inc., 10, 17, 22–23, 26, 132, 142, 282–83, 427
MIDI (Musical Instrument Digital Interface), 156, 448
Mixers, 216–17
Moire effects, 448
Mondo Media, 397, 410–18
Monitors, cost of, 40–43
Moonlight Computer Products, 176
moov atom, 251–52
Morph, 139–40, 152
Motion quality, 372
Motorola, 16, 74
Mounting, 122
movi list, 265
Movie, 448
 capture, 56–59
 compressor types, 273–74
 audio compression, 274–75
 QuickTime codecs, 275–79
 QuickTime decompressors, 285
 QuickTime for Windows decompressors, 284
 Video for Windows codecs, 280
 Video for Windows decompressors, 286
 file formats, 249, 271
 AVI, 269–71
 QuickTime, 250–59
 sound encoding, 266–69
 Video for Windows, 260–66
 metrics, 385
 playback, 56–59, 289
 components and data handlers, 298–304
 data stream, 290–92
 frame differencing, 294–97
 key frames, 292–94
Movie Controller, 146
Movie Convert, 86
Movie Converter, 146–47
Movie Movie, 41, 65, 88–89
Movie Player, 87, 136–37, 145–46
Movie Recorder, 88, 144–45, 313–14
Movie Toolbox, 448
Movie Toolkit, 253
MovieAnalyzer, 147, 378
 Edits button, 380
 File button, 379
 Info button, 379
 Menu bar, 379
 Play button, 380
 Tracks button, 379
MoviePak, 82, 84
MovieShop, 45, 73, 147, 363–76
 Batch menu, 377
 Edit menu, 376
 File menu, 376
 FrameRate menu, 377
 Movies menu, 376
 Preferences menu, 376
 Sound menu, 378
 tips, 350

MovieTime, 84
MPC Specification, 21
MPEG (Motion Picture Experts Group), 448
MPLAYER.EXE, 135
Multimedia, 10, 18–24
Multisession, 128
Music copyrights, 52
mvhd atom, 257

N

National Television Standards Committee. *See:* NTSC
Navigable movies, 448
Networks, 130
Neuberger, Roy R., 398
New Media, 78
New Video, 78–80, 85–86
NextStep, 75
Nintendo, 4
Nirvana, 50
Noise, 448
 reduction, 187, 215
Non-interlaced video, 448
Nonlinear editing, 231–33
Norton, 100
Norton Speed Disk, 75
Norton Utilities, 306, 312
Novell, 130
NTSC, 40–43, 169, 448
NuBus, 34, 80, 82, 88, 114
Nyquist frequency, 448

O

Off-line edit, 448
Online digital editing systems, 9–10
OpenScript, 141
Optical reader, cost of, 40–43
Optical writer, cost of, 40–43
Orchid, 98, 107
Overlay, 138

P

P-connector, 117–18
Packing, 180
PageMaker, 47
PAL, 169, 448
Palette, 448
Panasonic, 178, 193–95
Parallel tracks, 150
Passport Designs, 155–57
PC, 2
 analog audio, 221–23
 AVI movies and palettes, 393–94
 data rates, 394
 redigitizing, 395
 sound, 395–96
 production studio, 440–42
PC capture cards, 101–02
 Captivator, 107–09
 MovieStudio, 104–05
 Smart Video Recorder, 103–04

Video Blaster, 106–07
Video Spigot for Windows, 105–06
WinMovie, 109–10
PC systems, 91–93
 audio and video peripherals, 98–99
 buses, 93–96
 cost of, 42–44
 retrofits, 97–98
 SCSI, 96–97
 system tuning, 99–100
PC Week, 413
PCI (Peripheral Component Interconnect), 34, 95
PCI Local Bus Special Interest Group, 96
PCM, 201, 211
Peddie, Britt, 397–98, 410
Pemberton Press/Eight Bit Books, 48
Pentium, 34, 64, 96–97
Pentium killer, 74
Performa 600, 73
Performance/040, 73
Peripherals (PC), 98–99
Personal Producer, 142–43, 158
Phase Alteration Line. *See:* PAL
Phasing, 217–18, 227
Phone plug, 443
Photoshop, 83, 151
PIC, 448
PICS, 156
PICT, 156, 448
Picture Prowler, 110
Picture Viewer, 137
PictureCompressor, 149
Pink, 75
Pioneer laser disc player, 148
Pioneer, 156
Pixel Depth, 444
Playback, 55–59, 73
Playback only, 26
Playback only card, 80
PLAYER.EXE, 136
Plug-in, 449
Portability, 47
Post process, 449
Poster frame, 449
Poststriping, 449
PowerBook, 74
PowerBook Duos, 73
PowerCache, 73
Powered speakers, 213
PowerPC, 34, 64, 75
 chip, 74
 SCSI, 113
Premiere, 81, 83, 86–87, 112, 137–38, 149–50, 346, 355
Preroll, 310
Prime Image, Inc., 228
Pro Audio Spectrum 16, 99
Pro Audio Studio, 99
Pro MovieStudio, 104–05
Pro-Designer IIGS, 98
ProAudio Spectrum, 64

ProDesigner IIs, 107
Producer Pro, 155–57
Production studio, 433
 basic setup, 434–36
 Macintosh studio, 436–39
 PC studio, 440–42
Production timeline, CD-ROM, 429–31
Professional decks, 195
Proprietary, 87
Proprietary file format, 17, 26–27
Prosumer decks, 191
Prosumer grade, 164
Prosumer video cameras, 202–04
Publish, 409
Pulse Code Modulation (PCM), 449
PZR (Pan/Zoom/Rotate), 152

Q

QEMM, 100
QSound, 6, 217
Quadra, 83, 124, 219
Quadra 610, 71, 73, 88
Quadra 650, 41, 71, 73
Quadra 660AV, 72, 77, 88
Quadra 700, 72
Quadra 800, 26, 64, 72, 78
Quadra 840AV, 64, 70, 72, 77–78
Quadra 900, 72
Quadra 950, 33, 40, 52, 71–73, 78
Qualitias, 100
Quantization, 449
Quarterdeck, 100
QuickTime, 22–26, 31, 69, 72–74, 77, 80, 83–84, 86, 449
 codecs, 275–79
 compression, 29
 converter, 105
 decompressors, 285
 file format, 250–59
QuickTime, standard applications, 144
 Captioned Pioneer Movie Maker, 148–49
 GrabGuy, 147–48
 MovieAnalyzer, 147, 378–80
 Movie Converter, 146–47
 Movie Recorder, 144–45
 MoviePlayer, 145–46
 MovieShop, 45, 73, 147, 363–78
 PictureCompressor, 149
QuickTime Film Festival, 415
QuickTime for Windows
 decompressors, 284
 movies, 362
 standard applications, 135–37
QuickTime Movie Exchange Toolkit, 253

R

Radius, 72–73, 78–80, 82–83
RAM, 75, 92
 disk, 75, 87, 112–13
 extended, 100
RAMDRIVE.SYS, 99

Random access, 6
RasterOps, 78–80, 82, 84–85, 158
RCA, 88
RCA plugs, 449
Real Digital Video, 11
Redigitizing, 395
Resource fork, 251, 425, 446
Retrofits (PC), 97–98
Reverb, 215–16
RGB, 168
RIFF, 260
RLE, 276, 283
 Apple, 427
 Microsoft, 427
Robertson, Richard, 402
Rocket, 73, 83
Rocket 33, 73
RocketWare, 73
Rotoscoping software, cost of, 40
RS-232, 178
 cable, 117–18
RS-422, 178
Run-length encoding, 449

S

S-VHS, 163
S-video, 168, 449
S/N ratio, 187
Saboori, Minoo, 397–98
Sample, 23, 160
Sample rate, 266
Sample size, 266
Sampling rate, 449
Saturation, 449
Scene Editor, 138–39
ScreenPlay, 87
Scripting, 154–55
SCSI
 adapter card, 96, 117
 address selector switch, 117
 Basic SCSI-2, 113
 cable, 117
 capability (Macintosh), 71
 chain, 114–16
 control protocol, 116
 Fast SCSI, 113
 Fast-Wide SCSI, 113
 hard drive, 117
 ID number, 115
 level, 124
 PC, 96–97
 probe, 122
 SCSI-1, 113, 118
 SCSI-2, 113–15, 118, 124
 SCSI-3, 113, 118
 terminator cap, 117
 Wide SCSI, 113
SCSI standards, 113–15
 cables, 117–19
 connectors, 117–19
 drivers, 117–19
 layered effect, 119–20
 terminations, 116–17
SCSI system tuning, 120–22
 inter-platform benefits, 122–23
SCSI Director, 122
SCSI-1, 113, 118
SCSI-3, 113, 118
SCSI-2, 113–15, 118, 124, 346
SCSI-2 Booster, 83
SECAM, 169–70, 449
Sega, 4
Selectra, 354
Selectra Corporation, 193
Self-contained, 422, 424–26, 450
Sequential access, 6
Serial cables, 80
Servo motor, 185
SGI Indy, 9
Sharp VL-HL100U ViewCam, 204
Sigma Designs, 65, 88–89, 109–10
Signal to noise ratio, 187
Silicon Graphics Workstation, 154
Single-speed CD-ROM, 25
Single-spin drives, 366–67
16-bit, 102, 104–07
 stereo, 86
68-pin P-connector, 117–18
Small Computer System Interface. *See:* SCSI
Smart Video Recorder, 65, 103–04, 132
SmartCap, 132
SMARTCAP.EXE, 103, 132
SMC, 277
SMPTE, 80–81, 156
SMPTE Time Code, 450
Soft VTR, 176
Software, 437, 441
Sony, 162–63, 176–77
Sony CCD-TR101, 203
Sony CCD-VX3, 203
Sony CDR 700E, 40, 42
Sony CDV-1000 Vdeck, 192
Sony CI-1000 Vbox, 191
Sony EVO, 40, 42, 192–93
Sony TR 101, 40–43
Sound
 card, 70
 encoding formats, 266–69
 importance of, 406–07
 Macintosh, 390–92
 PC, 395–96
 track, 359
Sound Manager, 70
Sound Pro, 87
Sound Blaster, 64
Sound Blaster Pro 16, 99
Sound Edit Pro, 359–60
Sound-only movies, 337
Soundtracks, and copyrights, 52–53
Source, 66–67

Index

Spatial compression, 292, 450
Spatial quality, 372
Speakers, cost of, 40–43
Spectrum Holobyte, 16
Speed Disk, 100, 306, 312
Speedstar 24x, 107
Spigot Compression, 106
Stacker, 129–30
Standards, 24–25
stco atom, 259
Stereo, 70, 82–86
Storage, 65–66
Storyboard Editor, 138–39
Strategic Defense Initiative, 52
Streaming, 268
Streams, 264
stsc atom, 259
stsd atom, 259
stsz atom, 259
stts atom, 257
SuperMac, 77–82, 87–88, 105, 346
SuperMac Digital Film, 33
Switcher, 450
Symmetric compressor, 450
Symmetrical codec, 279
Synchronization, 227, 257, 450
Syquest, 49, 71, 125–26
System 7.1, 75, 77

T

Tape backup, 129
Tape standards, 162–66
 Beta, 162–63
 Betacam, 164
 Betacam SP, 164–65
 digital tape, 165–66
 8 millimeter, 163
 Hi-8, 164
 S-VHS, 163
 VHS, 162
TBC (Time Base Corrector), 46, 226–28, 155, 355, 450
 cost of, 40–43
Tempest, 72
Temporal compression, 450
Tempra SE, 107
Tempra Show, 107
Terminations, SCSI, 116–17
Test signal generator, 450
32-bit addressing, 75, 443
3/2 pull-down, 231
386 Enhanced/Virtual Memory, 100
386MAX, 100
TIFF, 156
Time code generator, 450
Time code standards, 171
 Hi-8, 172–73
 SMPTE, 171–72
Titling, 151, 198
ToolBook, 141–42
Tracks, 138
trak atom, 258
Transcoding, 450
Transoft, 122
Transport mechanism, 185–87
Triple-speed drives, 367
Triple-speed CD-ROM writers, 129
True color, 70, 79
24-bit color, 70, 79, 86
24MxTV, 84
24STV, 84
24XLTV, 84

U

Ubillos, Randy, 401
Umatic format, 165–66
UNIX, 113
User bits, 172

V

V-LAN, 176
VDig (Video Digitizer Component), 451
Vectorscope, 451
Vertical Blanking Interval, 451
Vertical Interval Time Code (VITC), 451
VHS, 162
VidCap, 104–105, 108, 132–33, 309, 332
VIDCAP.EXE, 133
VidEdit, 105, 108, 134–35, 332
VIDEDIT.EXE, 134
Video 1, 282
Video Blaster, 106–07
Video cameras, 196
 accessories, 201
 color sensing, 198
 consumer, 202
 headphone and microphone jacks, 201
 image resolution, 199
 image stabilization, 196–97
 manual exposure and focus control, 197
 prosumer and industrial, 202–04
 remote control, 199–200
 sound standards, 200
 time code, 200
 title creation, 198
 video effects, 199
 white balance, 197–98
 zooming levels, 198–99
Video cards, 98–99
Video Demystified, 159
Video Director, 143–44, 158
Video equipment, 437–41
Video Expander NTSC, 84
Video for Windows, 22–23, 26
 capture, 306–11
 codecs, 280
 compression, 29
 decompressors, 286
 file format, 260–66
 standard applications, 132–35
 Video for Windows 1.0, 107

Video for Windows Development Kit Programmer's Guide, 260
Video Fusion, 40–41, 83, 86, 138, 151–53
Video Fusion Ltd. Partnership, 153
Video hardware standards, 159
 broadcast, 168–70
 edit control protocols, 174–79
 hi-8 videotape management, 179–81
 tape, 162–66
 time code, 171–73
 video signal, 166–68
Video Media, 176
Video peripherals (PC), 98–99
Video signal standards, 166
 Composite video, 167
 RGB, 168
 S-Video, 168
Video Snap, 109
Video source, 61 66–67
Video Spigot, 41, 43, 61, 77, 87–88
Video Spigot for Windows, 105–06
Video System Control Architecture. *See:* VISCA
Video tape decks, 184
 audio, 188
 consumer decks, 190
 external control compatibility, 189–90
 features, 187–88
 professional decks, 195
 prosumer and industrial decks, 191
 transport mechanism, 185–87
Video Toaster, 9
Video Toolkit, 158
Video Vision, 72–73
Video Vision Studio, 40, 78–83
Videography, 78
VideoLogic, 107–09
VideoShop, 86, 150
VideoTime, 158
VIEWER.EXE, 137
Viper, 98
Virtual memory, 451
VISCA, 156, 176, 178–79
Visual Basic, 43, 142
VITC, 172
VLAN, 156
Voyager, 325
VTR, cost of, 40–43
VuPort, 193, 354

W

Wall Street Journal, 170
Waveform Monitor, 451
Well, The, 401
White balance, 197–98
White Paper, 345–46
Wide SCSI, 113
Window dub, 173, 451
Windows, 11, 17, 22, 25, 29, 58, 63, 69, 97
 capture strategies, 346
 repairing damaged captures, 361–62
 selecting color depth, 336
 systems, test driving, 305–11
Windows-based software, 132
 analog video equipment, controlling, 142
 Personal Producer, 142–43
 Video Director, 143–44
 authoring, 140–42
 IconAuthor, 140–41
 ToolBook, 141–42
 Visual Basic, 142
 editing, 137–39
 Media Merge, 138–39
 Premiere for Windows, 137–38
 effects, 139–40
 Morph, 139–40
 QuickTime for Windows, standard applications, 135–37
 Movie Player, 136–37
 Picture Viewer, 137
 Video for Windows, standard applications, 132–35
 Media Player, 135
 VidCap, 132–33
 VidEdit, 134–35
Windows Multimedia Programmer's Guide, 260
WinMovie, 43
Wired, 415
WMTV, 109–1
XCMD (Exter

Y

Y cable, 307
YARC Nuspri
Y/C, 168, 449

Z

Zeos, 92, 96